Gender and Discourse
in Victorian Literature and Art

GENDER
AND
DISCOURSE
in Victorian Literature and Art

Edited by

ANTONY H. HARRISON

and

BEVERLY TAYLOR

NORTHERN ILLINOIS UNIVERSITY PRESS

DeKalb 1992

∞

© 1992 by Northern Illinois University Press

Published by the Northern Illinois University Press, DeKalb,

Illinois 60115

Manufactured in the United States using acid-free paper

Design by Julia Fauci

Library of Congress Cataloging-in-Publication Data

Gender and discourse in Victorian literature and art / edited by

Antony H. Harrison and Beverly Taylor.

p. cm.

Includes bibliographical references and index.

ISBN 0-87580-168-4

1. English literature—19th century—History and criticism.

2. Feminism and literature—Great Britain—History—

19th century.

3. Feminism and art—Great Britain—History—19th Century.

4. Authorship—Sex differences.

5. Sex role in literature.

6. Art, British.

I. Harrison, Antony H.

II. Taylor, Beverly.

PR468.F46G4 1992

820.9′008′082—dc20 92-272

CIP

We dedicate this volume to Beth Helsinger, Jerry McGann, and Elaine Showalter with gratitude for their services to Victorian and feminist studies.

A.H.H.

B.T.

CONTENTS

Contents

ANTONY H. HARRISON AND BEVERLY TAYLOR

INTRODUCTION

In recent years the work of feminist theorists and critics has transformed Victorian studies.[1] Most obviously, their labors have returned to prominence writers and works important in Victorian England but subsequently dismissed.[2] More significantly, feminist theory and criticism have taught us to hear different tones in voices from the past and to ask new kinds of questions of literary and visual texts. The essays collected here participate in this effort to recover more fully the textual agendas of Victorian poems, novels, and works of visual art that have inevitably been blurred by the cultural contexts of our own century.

Juxtaposing the revisionist readings advanced by several essays in this volume with interpretive views prevailing into the 1970s underscores this effort to hear Victorian voices more clearly. Whereas a scholar writing in 1975 could assume that Matthew Arnold "composed poems which described what it felt like to live in the middle of the nineteenth century for *anyone*" endowed with poetic sensibility and honest intelligence,[3] Mary Ellis Gibson detects a crucial intonation in Arnold's lyrics heretofore missed: his difficulty in speaking about, for, and to women in the reading audience. This feature of his poetic voice can be heard only when we approach his work in terms of gender relations. The distinction between a culture's dominant and muted groups delineated in recent anthropological and linguistic studies (and in Dale Spender's *Man Made Language*) has made it difficult to construe one gendered voice as that of a universal "anyone."[4] Gibson's Arnold, uneasily

engaged with gender conflicts in his own time, speaks more forcefully to (and for) contemporary readers than would a truly detached "Olympian."

Other essays in the volume, similarly attending to muted accents in Victorian voices, discern the implications of previously unexplained features of poems and novels. In the case of Thomas Hardy, for example, a 1977 commentator puzzling over the relative silence of Hardy's Tess finally judged her an unsuccessfully realized character: "the personality of Tess, as distinct from her surroundings or experiences or her representative quality, is of a distinctly limited depth and complexity: she speaks much less than most fictional heroines"; this silence and imagery representing her as "shy and vulnerable" may offer "an unintended clue to Tess's limitations as protagonist."[5] For William W. Morgan, however, the silence of Hardy's female characters does not bespeak the novelist's artistic ineptitude in matters of characterization but provides an index of his troubled and troubling exploration of gender relations. Morgan's approach to Hardy's novels and poems demonstrates that the questions readers now ask of texts (and the voices in which they ask them) have radically changed, and that we now expect and require less stable answers to those questions. Such a shift prompts Elizabeth Langland's exploration of the effects of narrative structure in Anne Brontë's *The Tenant of Wildfell Hall*. An authoritative handbook sixty years ago could conclude that the "one drawback" to the novel is Brontë's failure in characterizing the male narrator: "The Brontës had observed men not unclosely; but they were not able to see things through the eyes of men."[6] Less concerned with the verisimilitude or attractiveness of the male narrator, Langland discovers that the structure that "nests" the female character's narrative within the man's enables the novel to articulate female desire otherwise unauthorized in Victorian fiction.

All the essays in this collection similarly attend to previously unheard accents and ask new kinds of questions. The essays employ a variety of critical methodologies that reflect a level of diversity, sophistication, and complexity only recently attained by feminists working in Victorian studies.[7] Here psychoanalytic, Bakhtinian, intertextual, and Marxist commentaries appear strategically beside more traditionally historicist (but theoretically informed) analyses. The authors discuss a representative selection of artists—poets, novelists, painters, sculptors, playwrights, and dancers—offering wholly original discussions of gender issues and treatments of sexuality in the work of the Victorians. At the same time the essays generate implicit theoretical and methodological dialogues, and they demonstrate how groundbreaking feminist work of the last several decades is being put to use by scholars who do not identify themselves primarily as feminist critics.

The subjects of analysis here are disparate writers and artists: Alfred Tennyson, Elizabeth Barrett Browning, Matthew Arnold, Christina Rossetti, A. C. Swinburne, Gerard Manley Hopkins, Anne Brontë, Charles Dickens, George

Eliot, Rudyard Kipling, Thomas Hardy, Kate Chopin, Oscar Wilde, Margaret Giles, the dancer Maud Allan, and a number of lesser known women painters. The volume is organized generically, though some essays move between discussions of poetry and fiction or between literature and the visual arts. Within the three major sections, essays appear roughly according to the chronology of the works on which they focus.

Recognizing that literature is not a self-contained social phenomenon, these essays examine interconnections among literature and the fine arts—"popular" as well as "elitist"—and politics, economics, science, and other modes of cultural discourse. The essays ground poems and novels in medical, educational, and political debates and in arguments over women's rights to vote or to study anatomy. The underlying assumption is that literature participates in the larger ideological currents of the society that produces it—and literature in turn produces new ideologies. Central to this proliferation of "texts" is increasing attention to interconnections between literature and the visual arts. The final section of this volume focuses on ways in which visual representations—including paintings and cartoons, sculpture and architectural reliefs, drama, opera, and music-hall dance—participated in a variety of Victorian discourses. The connections to the literary texts discussed in the first two sections are direct: the painted images of female painters discussed by Susan P. Casteras and the sculpted representation of the mythological Hero analyzed by George P. Landow have their counterparts in literature; Amy Koritz's essay traces the metamorphosis of the "literary" Salomé of Oscar Wilde into a dancing image in the Edwardian music hall. The three concluding essays trace gender conventions and subversions through the visual, dramatic, and musical arts, extending from the early Victorian era to the turn of the century, and explore cultural contexts ranging from the sexual politics of the Royal Academy admissions policies to the links between theater censorship and political resistance to the women's suffrage movement. The essays of the final section thus extend a project begun in the opening essay of the volume, which reads poems by Barrett Browning and Tennyson in the context of educational and medical controversies of the mid-Victorian period.

*T*he critical inquiries pursued here offer new views of the artists under discussion, helping to unravel complexities, apparent contradictions, and (to twentieth-century students) hypocrisies deeply embedded in Victorian responses to gender issues and to issues surrounding human sexuality. The authors attend to the effects of Victorian cultural constructions of gender and sexuality on artistic representation and on ideology as a coherent system of values and beliefs that is always under assault and subject to change. A

theoretical assumption behind these critical essays is that an identifiable sex/ gender system pervades every culture at every historical moment of its existence. That system infuses all literary and artistic endeavor and consists of agents and social structures that "need to be understood historically in terms of each other." Social and institutional structures are "always constituting the sex/gender identities and behaviors of the agents by locating them in particular places and hence by locating in them particular consciousnesses, and the agents are always constituting the structure by their gendered practices."[8] Thus, as has been made clear in much recent feminist criticism, artistic documents, whether visual or written, are inescapable embodiments of ideology and counterideology and are therefore subject to political as well as aesthetic analysis. They tell us a good deal about relations between the sexes as well as about class relations. The essays included here reaffirm the conclusion that, with regard to institutionalized modes of discourse and the power structures of Victorian society, women for the most part constituted a suppressed and marginalized underclass whose victimization was a political fact of life resisted in diverse ways or complexly exploited by artists sensitive to the relations among power, authority, and gender. These analyses interrogate the ways in which women as artists and as subjects and icons in works by both sexes function either to challenge and revise or to reify their society's gender ideologies. In doing so the essays present heuristic discussions that extend and amplify earlier important feminist projects in Victorian studies, and they suggest opportunities for further work in this field that is central to the newly emergent directions in Anglo-American critical theory and practice.

A cluster of studies in this volume might be described as archival. They are committed to the recovery of work by women writers and artists previously ignored or unknown; or they attempt to retrieve historical contexts surrounding the production and reception of artworks that are gender marked in significant ways, and they do so in order to elicit new perspectives on what those works "meant" at the historical moments of their creation and dissemination. Clearly, they raise questions that would never have been formulated before the advent of modern feminist criticism. Among such archaeological projects are the essays by Beverly Taylor, Diane D'Amico, Susan P. Casteras, George P. Landow, and Amy Koritz.

Beverly Taylor's " 'School-Miss Alfred' and 'Materfamilias': Female Sexuality and Poetic Voice in *The Princess* and *Aurora Leigh*" is concerned with the ideological power exerted by cultural constructions of sexuality in Victorian England. Taylor examines Tennyson's *The Princess* and Elizabeth Barrett Browning's *Aurora Leigh* in the context of mid-Victorian medical and journalistic debates about female sexuality and its implications for women's education. She contends that both texts disrupt conventional constructions of women's nature, despite apparently conservative closures. Though ending

with marriages, both poems resist recuperating their women poets to the domestic sphere. Whereas Tennyson's text finally refuses to formulate its female protagonist's answer to the questions of gender it raises, Barrett Browning's poem "closes" by returning to the point of its opening, emphasizing that marriage has not silenced the heroine but enlarged her utterance to embrace the marketplace as well as the private realm of romance. In both works, claiming a fuller sexuality empowers the protagonist's poetic voice.

In her essay " 'Equal Before God': Christina Rossetti and the Fallen Women of Highgate Penitentiary," Diane D'Amico attempts fully to recover the originary contexts of Rossetti's poems on fallen women. She investigates the backgrounds of Rossetti's ten-year involvement with the Highgate Penitentiary and explores the effects of that experience on her poems about women betrayed in love. D'Amico's archival research brings to light new information about the founding and conduct of the Highgate Penitentiary and the roles middle-class Victorian women played in institutionalized attempts to reclaim women of all ages in a variety of "fallen" conditions. D'Amico's work enables a new perspective on Victorian attitudes toward "vicious" women, and the historical contexts she elaborates help to explain and to reinforce perceptions of Rossetti's sympathy toward the fallen characters her poems depict. They also help us to understand how these poems operate ideologically, both as critiques of the patriarchy and as aesthetic manifestos propounding the complete renunciation of the corrupt and corrupting world over which men preside.

Susan P. Casteras's " 'The Necessity of a Name': Portrayals and Betrayals of Victorian Women Artists" examines how portraits of artists by Victorian painters, both female and male, largely reinforced the institutional suppression of women painters. Discussing the period's literary depiction of female artists in works ranging from paintings to *Punch* cartoons, the essay contrasts representations of men and women artists, their studios, and their models to document the patronizing cultural reception of women in the arts. At the same time Casteras demonstrates the accomplishments of a number of women painters who only recently have begun to attract the attention of art historians. The second half of her essay focuses on two women whose paintings attempt to subvert prevailing cultural practices: Emily Mary Osborne, whose canvases challenged stereotyped images of women by evoking sympathy for women workers; and Florence Claxton, whose painting bitingly satirizes conventional gender roles.

In "Margaret M. Giles's *Hero* and the Sublime Female Nude," George P. Landow recovers the work of a nearly forgotten, prizewinning sculptor, one of a wave of female sculptors trained during the early 1890s. The entrance of women into sculpture resulted from changes in the technologies of the art, according to Landow, who examines Giles's adaptation of figural tradition as

a means of challenging conventional constructions of women. Departing widely from the iconographical tradition of the "woman-waiting-by-the-water," Giles's statue *Hero* represents passion, power, and freedom deriving more from the Burkean category of the sublime (essentially masculine) than from that of the beautiful (essentially feminine). The statue thus exemplifies the power of art as discourse to undercut gender ideology.

"Salomé: Exotic Woman and Transcendent Dance," by Amy Koritz, employs recent perspectives on orientalism to discuss the sexual politics of three Victorian and Edwardian incarnations of the Salomé figure and their reception by contemporary reviewers, as well as subsequent critics. From Oscar Wilde's *Salomé* and Richard Strauss's operatic treatment of the myth, to its reshaping in a sensationally popular music-hall dance by a now nearly forgotten performer, Maud Allan, the artistic and critical reconstructions of Salomé reveal contradictions inherent in the "dominant views of female sexuality," especially in "the polarized dichotomy between woman as a spiritual ideal and as bestial Fatal Woman." Registering ambivalent imperialist attitudes toward the Orient, as well as social and political anxieties related to the woman's suffrage movement and the emergence of the New Woman, extreme reactions to the three performance works, particularly to Maud Allan's dance version, exhibit the "cultural need to address—yet contain—the dichotomy that assigned women to the mutually exclusive realms of the sexual and the spiritual."

The essays by Deirdre David and Alison Booth, while not using archival material or recovering unknown artists, also employ historicist methods. David's essay, "Children of Empire: Victorian Imperialism and the Role of Women in Dickens and Kipling," focuses on representations of child protagonists' encounters with the foreign Other in *The Old Curiosity Shop* and *Kim* in order to argue that Victorian fiction is fully implicated in the era's imperialist project. This essay contributes to newly emerging theories of colonial/imperial discourse by demonstrating how "gender politics inflect imperialist politics" and how "imperialist politics inflect gender politics," concluding that "Victorian ideas about gender and race exist in . . . a relationship of reciprocal constitution." Reading Quilp in light of Dickens's nonfiction accounts of the "savage" and relating Little Nell to representations of Victorian women's roles in the spread of Empire, David measures Dickens's portrait of the Child of Empire against Kipling's celebration of Kim. The contrast tracks both significant changes in Victorian sentiment about Britain's global expansion and the consistency of Victorian gender dichotomies.

In " 'Not All Men Are Selfish and Cruel': *Felix Holt* as a Feminist Novel," Alison Booth is concerned with the operations of domestic politics in Victorian novels. She discovers in George Eliot's *Felix Holt, the Radical* an unassimilated feminist argument, the product of a woman writing self-consciously in the mode of Victorian sage discourse who is unable to suppress her own

ideological situatedness. *Felix Holt* indicts the injustices of the partriarchy using a drama of class and gender in a small Midlands town during the Reform Era, but the novel fails to align itself ideologically with the views of mid-Victorian feminists who attempted to advance the concerns and activities of women into the public sphere. Through a close reading of Eliot's novel in the dual contexts of Victorian gender roles and Reform Era politics, Booth determines that Eliot "disguised her arguments about gender and class in an apparently impartial history of everyday life." She also concludes that Eliot adhered to "an ideology of influence" in which women's capacity for sympathy should provide a basis for social reform. For Eliot the private sphere dominated by women and associated with personal relations and powerlessness in the public sphere is in fact "the predominant factor in human history."

While the essays described above employ historicist critical strategies, the remaining studies in this volume adopt a variety of other critical methodologies in the service of feminist inquiry. Mary Ellis Gibson's argument in "Dialogue on the Darkling Plain: Genre, Gender, and Audience in Matthew Arnold's Lyrics" relies on the theoretical work of Bakhtin. Gibson determines that the roles women play as audience, subjects, or silent presences in Arnold's "pseudo-dialogues," expose profound feelings of anxiety about audience at a time when "women were an increasingly important part of the growing audience for elite literature." In attempting to write a poetry from his culture's center, Arnold had first to create an "ideology of center." In this attempt female images often operate as vehicles "through which to criticize cultural failures," and the process always "prematurely silences female voices." Gibson's analysis invokes Bakhtinian descriptions of nineteenth-century poetry as an increasingly novelized genre and demonstrates how Arnold's poetry of cultural centrism resists the dialogism characteristic of the novel and undercuts the very project it attempts.

By contrast with Arnold, Tennyson ultimately "constructs poetic tradition within markedly female parameters," according to Deborah A. Hooker's reading of "Demeter and Persephone." In "Ambiguous Bodies: Keats and the Problem of Resurrection in Tennyson's 'Demeter and Persephone,' " Hooker undertakes a semiotic and Kristevan analysis of intertextual relations between the work of Tennyson and Keats. Responding in part to the anxieties of Keats's *Hyperion,* Tennyson "refigures tradition in terms of a maternality that connects all levels of existence and offers a model of poetic reciprocity that mitigates the burden of idealized precursors." Hooker argues that Demeter's monologue is rendered dialogic, that is, "radically Other," through the presence of the silenced daughter emerging at the site of her rape, which becomes also the site of her reclamation. In the ensuing dialogue, Tennyson in effect resurrects Keats—"through the allusive body of the daughter"—and with him "issues of poetic voice and questions about its genesis, its originality, and

its value." He thus employs mothers and daughters as figures uniquely appropriate to discuss the anxieties of belatedness that afflict poetic fathers and sons.

In "Swinburne and the Critique of Ideology in *The Awakening*," Antony H. Harrison is similarly concerned with intertextual relations, but his inquiry focuses on a process of revisionist appropriation that results in ideological subversion. Harrison argues that Swinburne's poetry constitutes the most important pre-text for Chopin's novel, and he presents a Marxist/feminist analysis of *The Awakening* that refuses to identify the values of its central character with those of the author. Rather, he sees Edna Pontellier as a failed heroine deployed in the novel both to critique the system of patriarchal amatory values central to Swinburne's work (as well as to Western culture as a whole) and to envisage a virtually prelapsarian, matriarchal fringe world that provides an alternate experiential field for women. Harrison employs a Bakhtinian analysis of the novel's dialogism to argue his case and to suggest that Chopin's attempt to subvert Swinburnean values is formal as well as ideological.

Elizabeth Langland's essay, "The Voicing of Feminine Desire in Anne Brontë's *The Tenant of Wildfell Hall*," defines as its theoretical foundation a precept central to Roland Barthes's analysis of fiction: that at the origin of every narrative is Desire. This is so because "at the heart of narrative operates an economic system, an exchange." Langland argues that the nested narratives of *The Tenant of Wildfell Hall* function within a transgressive economy marked by a complex exchange of gender roles. This narrative technique in which a female narrative is contained within a male narrative allows the "paradoxic voicing of feminine desire," a discursive move disallowed to Victorian women writers. Langland's analysis has important implications for all Victorian narratives concerned with the transgression of socially determined values or behavior.

Thaïs E. Morgan's "Creativity, Violence, and the Feminine: Poetics and Gender Politics in Swinburne and Hopkins" draws heavily on the theoretical feminist criticism of Susan Gubar and Eve Sedgwick. Morgan demonstrates how Hopkins in "The Wreck of the Deutschland" and Swinburne in "On the Cliffs" make use of the dramatic monologue form to explore problems of poetic vocation unique to Victorian male authors, especially as these problems intersect with ambiguities of sexual identity. Both poets generate a "double gendered discourse." Though they attempt to speak from a feminine position to depict creative receptivity, in the end they do violence upon the female bodies they temporarily appropriate in order to realign their gender identities and reassert their own masculinity. They thus finally restore a masculinist poetics. In neither case is "the feminine body or subject position valorized for its own sake: desire, power, and knowledge move" exclusively

between men. For both poets "the perceived connection between the feminine and creativity is simultaneously attractive and unbearable . . . because of their own investments in the construct of male effeminacy and also in its counterconstruct, or homophobic misogyny."

William W. Morgan is also interested in intersections of the political and the aesthetic. He demonstrates how Hardy's work constitutes a site for contesting "the most difficult political and aesthetic issues" associated with gender ideology and presents an analysis of the relations between sexual politics and sexual ethics in Hardy's poetry and novels. Morgan traces throughout Hardy's writing career a preoccupation with gender difference that is displayed in significant silences in his texts. From his early poetry through his fiction and late verse, Hardy's works are "significantly *under*determined— even indeterminate—at critical moments in their presentation of sexual politics." Concentrating on the novels, Morgan "reads" these gendered silences to trace a subtle shift in Hardy's representation of women. He moves from presentations of the female consciousness in the male "discourse of mastery," to muting the female position altogether, and finally to evoking female presence most intensely as absence and death. Hardy's work eventually recognized that "the only language it can speak is one that registers male consciousness—and therefore one in which femaleness is not subject but object."

*A*s these summaries indicate, the essays collected in this volume represent an attempt to reconstruct and to interrogate, from a variety of critical perspectives, the polyphony of gendered voices engaged in many modes of artistic discourse in Victorian England. The period claims our attention as the first in English history to conduct extended public debates—designated, with little awareness of the ideological implications of the phrase, "the woman question"—about the true or desirable relations between the sexes and their work in the world. The authors of these essays assume, with Mary Poovey, that "the representation of biological sexuality, the definition of sexual difference, and the social organization of sexual relations are social, not natural phenomena." Like Poovey, too, they insist that the "construction and deployment" of such representations "performed critical ideological work" in Victorian England, "that they were intimately involved in the development of England's characteristic social institutions, the organization of its most basic economic and legal relations, and in the rationalization of its imperial ambitions."[9] The essays that follow, we believe, also perform critical work as twentieth-century attempts to reveal how the discourses of art and literature in Victorian England functioned to resist, to expose, or to reify culturally inscribed gender ideology.

NOTES

1. Elaine Showalter, Sandra Gilbert, Susan Gubar, Mary Poovey, Margaret Homans, Judith Newton, Cora Kaplan, and Martha Vicinus, among other important feminist scholars, have profoundly altered the ways we think and write about the literary productions, as well as other social events, of Victorian England. Indeed, although a number of fairly revolutionary theoretical discourses have come to dominate the Anglo-American critical scene during the last three decades, feminism has been the most effective in permanently altering the discipline. That feminist critics of literature and the visual arts frequently enlist other theoretical methodologies in the service of their projects—from semiotics and deconstruction to Marxism and psychoanalysis—only points to the centrality of feminism to current modes of critical inquiry.

2. Elizabeth Barrett Browning's *Aurora Leigh*, a subject of the first essay in this volume, is a case in point. Despite its popularity among Victorians, it was derided in 1932 by the authoritative *Cambridge History of English Literature* as a "thin thread" of narrative "on which are strung the opinions of the writer on all manner of matters—educational, social, artistic, ethical." It was similarly dismissed in 1982 by another standard reference work, *The New Pelican Guide to English Literature*. Both volumes commend "Mrs. Browning" for the lyrical achievement of *Sonnets from the Portuguese*, which expresses "the sublime passion of the love of wife for husband"; Sir Henry Jones, "Robert Browning and Elizabeth Barrett Browning," *The Cambridge History of English Literature*, ed. Sir A. W. Ward and A. R. Waller, vol. 13 (Cambridge: Cambridge University Press, 1932), p. 75; *The New Pelican Guide to English Literature*, vol. 6, *From Dickens to Hardy*, ed. Boris Ford (Harmondsworth: Penguin, 1982), p. 79.

3. William A. Madden, "Arnold the Poet: (i) Lyric and Elegiac Poems," *Matthew Arnold: Writers and Their Background*, ed. Kenneth Allott (Athens, Ohio: Ohio University Press, 1976), p. 46; emphasis added.

4. Dale Spender, *Man Made Language* (London: Routledge and Kegan Paul, 1980; repr. London: Pandora, 1990), esp. chapter 3, "The Dominant and the Muted."

5. Norman Page, *Thomas Hardy* (London: Routledge and Kegan Paul, 1977), p. 43.

6. A. A. Jack, "The Brontës," in *The Cambridge History of English Literature* (1932), p. 414.

7. Some of the essays in this collection developed from papers presented in Chapel Hill at a Victorians Institute conference on Victorian gender issues.

8. Ellen Messer-Davidow, "Knowing Ways: A Reply to My Commentators," *New Literary History* 19 (1987): 191

9. *Uneven Developments: The Ideological Work of Gender in Mid-Victorian England* (Chicago: The University of Chicago Press, 1988), p. 2.

*Gender and Discourse
in Victorian Literature and Art*

POETRY

BEVERLY TAYLOR

"SCHOOL-MISS ALFRED" AND "MATERFAMILIAS"

Female Sexuality and Poetic Voice in The Princess *and* Aurora Leigh

"She knows that to speak she must swallow herself."
—Rachel Blau DuPlessis, "Pomegranate"

Writing to Robert Browning in 1846 Elizabeth Barrett described Alfred Tennyson's scheme for *The Princess,* then in progress, as a female university treated as a "fairy tale," a fancy she deemed unsuitable for a world too "fond of steam, for blank verse poems, in ever so many books, to be written on the fairies." Browning agreed, "locomotives . . . must keep the very ghosts of them away."[1] Her criticism of Tennyson's determination to handle the controversial issue of higher education for women in a romance displaced to a medieval setting reaffirmed her growing conviction that poets must express social and political views not by indirection in the romances and ballads that she had up to this point favored in her own popular verse but in aggressively modern situations and frank language. At the time of this exchange about *The Princess* (published 1847) Barrett had already conceived of writing such a narrative, but she would not realize her intention until the publication in 1856 of *Aurora Leigh.* In 1845 she had sketched the plan to Browning: "my chief *intention* just now is the writing of a sort of novel-poem—a poem as completely modern as 'Geraldine's Courtship,' running into the midst of our conventions, & rushing into drawingrooms & the like 'where angels fear to

tread'; & so, meeting face to face & without mask the Humanity of the age, & speaking the truth as I conceive of it, out plainly."[2]

The contrasts in setting, genre, and tone between Tennyson's *Princess* and Barrett Browning's *Aurora Leigh,* between the mask provided by his "mock heroic gigantesque" and her unmasked, serious social criticism, do not obscure their shared concerns with women's aspirations for new educational and professional opportunities and with new gender roles, particularly in marriage. In many ways *Aurora Leigh* continues the concerns of *The Princess* and answers what Barrett Browning must have judged inadequacies in Tennyson's treatment.[3] The two works have been associated especially by readers who see either one or both poems, which conclude with the heroines' accepting marriages they had originally rejected, finally as disappointing reinscriptions of cultural norms.[4] But through figurative patterns that link female sexuality and poetic voice both poems subvert prevailing mid-century views to affirm women's capacities and aspirations. The texts' disruptive reconstructions of woman are not so much undermined by conservative closures as they prepare readers to interrogate the seeming conservatism, to read the endings not as closure but as opening. The disruptive implications of both poems crystallize most fully when they are read in the context of Victorian debates about female sexuality and its implications for women's education.

Though associated as candidates for Poet Laureate in 1850, Tennyson and Barrett Browning are generally perceived quite differently in terms of their handling of the subject of female sexuality. Frequently charged with poetic effeminacy in his own time, Tennyson today is still often and wrongly judged prudishly reticent, whereas Barrett Browning is now prized for the outspokenness that disturbed Victorian readers. Tennyson is thought to have served a chaste muse, to have idealized female passivity and asexuality, and to have represented sexual women only to damn their pernicious effects on society.[5] In contrast, Barrett Browning unsettled nineteenth-century truisms of the appropriate subject matter and language for "poetesses."

When in 1846 Edward Bulwer Lytton castigated Tennyson as "School-Miss Alfred," his satire reviled Tennyson's "chaste delight" in the vapid and sentimental, a criticism anticipated in 1833 in the *American Monthly Magazine,* which sneered at a new school of poets led by Tennyson who "have a set of pretty little silly phrases, that mean about as much as the simpering sentimentalism of a boarding-school miss."[6] Twentieth-century critics and biographers have perpetuated the notion of Tennyson's school-miss sensibility, observing, for example, his "sexual reticence . . . both in his verse and in his life" and remarking that he was "predisposed to regard the highest type of woman as a rather unphysical being."[7] Tennyson apparently substantiated the criticism that he subscribed to the Madonna/Harlot dichotomy[8] by using a subtitle for the first edition of *Idylls of the King* (1859) that categorized his female

protagonists as *The True and the False*—on the one hand, a chaste maiden and a selfless wife (Elaine and Enid), on the other a seductress and an adulteress (Vivien and Guinevere). Though readers noted the active sexuality of the latter pair, their sensuality was ideologically acceptable in that it obviously advertised and corroborated the women's corrosive influence on the social body of Camelot. Actually, Tennyson's poetry recognizes sexual passions in women other than harlots—in Elaine, for example, whose tale is full of double entendre and sexual euphemism that complicate her character and situation without staining her. Nevertheless, Tennyson's treatment of female sexuality was generally perceived to be discreet, delicate, and in accord with conventional good taste.

Whereas Tennyson's tact drew charges of poetic effeminacy both then and now, Barrett Browning was castigated for indelicacy and unnatural virility, a criticism that lingered after her death and echoed in Dante Gabriel Rossetti's warning to his sister Christina to avoid the "falsetto muscularity" of "the Barrett-Browning style."[9] Barrett Browning confronted sexual topics with unsqueamish candor. A reviewer for the *Dublin University Magazine* judged *Aurora Leigh* "coarse in expression and unfeminine in thought," "a book which is almost a closed volume for her own sex." Barrett Browning wryly responded, "The 'mamas of England' in a body refuse to let their daughters read it," though she also remarked that having "expected to be put in the stocks and pelted with the eggs of the last twenty years' 'singing birds' as a disorderly woman and freethinking poet," she was surprised to hear of "quite decent women taking the part of the book in a sort of *effervescence*."[10] Thackeray in 1861 refused to print "Lord Walter's Wife," which shows a married woman challenging the double standard: she boldly flirts with her husband's friend in order to deride him for recoiling after he himself initiated the flirtation. Barrett Browning defended the propriety as well as the social responsibility of her poetic practice: "Has paterfamilias, with his Oriental traditions and veiled female faces, very successfully dealt with a certain class of evil? What if materfamilias, with her quick sure instincts and honest innocent eyes, do more towards their expulsion by simply looking at them and calling them by their names?"[11]

A poem often assumed to voice Tennyson's disgust with sexuality is "Lucretius" (1868), in which the Epicurean philosopher, aroused by a love potion administered by his neglected wife Lucilia, rages against his own carnality and finally kills himself. Some commentators have taken the sexual revulsion of the character as that of the poet himself, writing, to cite only one, "that in the guise of Lucretius he can do little more than gasp at the sight of the lustful satyr" and "throughout his life he found it difficult to feel comfortable with any sort of passion or sensual pleasure."[12] Rather than condemn the sexuality of Lucilia, the monologue points up the unnaturalness of Lucretius's denying both his wife's physical needs and his own.

In terms of language and imagery, the monologue should dispel lingering charges of school-miss reticence, for it describes not only Lucretius's disgust with his heightened sexual appetite but also the erotic dreams that have unhinged him. These dreams include an image of Helen of Troy's breasts threatened by a poised sword, which her beauty finally renders impotent to pierce. Victorian readers did not need Freud to identify the implications of such imagery, or of the provocative description of an Oread fleeing from a satyr, with the sunlight caressing "her budded bosom-peaks" (188–91). In at least this instance the reputed "school-miss" was more explicit than his publishers could countenance, for *Macmillan's Magazine* deleted the description of the Oread's budded bosom (though rather unaccountably retaining Helen's breasts and the poised sword).[13]

If the School-Miss Laureate could not get all his bosom passages past the censorship of *Macmillan's Magazine* in 1868, the boldness of Materfamilias Browning's emphasis on female breasts in *Aurora Leigh* a dozen years earlier seemed doubly unsettling, situated textually not in the disturbed dreams of a sex-crazed man safely displaced to the geographical and chronological remoteness of classical antiquity, but reverberating in the monologue of a Victorian maiden who had consumed no extenuating aphrodisiac. A reference to breasts in *The Princess* had been cited by one reviewer as an example of the "heterogeneous combination" that spoils the poem in details as well as conception. J. W. Marston in *The Athenaeum* objected to the passage describing the Lady Psyche's yearning for her child: "half / The sacred mother's bosom, panting, burst / The laces toward her babe" (6:131–33).[14] Tennyson's passage seems quaint when juxtaposed against Barrett Browning's recurring references to the female breast. From her detailed fascination with the breasts of Lady Waldemar (5:618–27) to her bizarre description of the modern age as a heaving bosom suckling a future generation (5:216–21), Barrett Browning's Aurora seems obsessed with nursing breasts as the most resonant metonymy for womanhood.[15]

This attention to breasts is one manifestation of both poems' emphasis on female sexuality, an aspect of *The Princess* and *Aurora Leigh* that has been viewed by some readers as part of their ideological conservatism, in the sense that both poems endorse the importance of motherhood, the role idealized by nineteenth-century culture partly to keep women satisfied within the home by persuading them of its sanctity. But both Tennyson and Barrett Browning go beyond the celebration of motherhood in Mrs. Ellis's multiple conduct books and Sarah Lewis's *Woman's Mission* and the comparable ideology of Ruskin's *Of Queen's Gardens* and Patmore's *Angel in the House* to affirm the healthy eroticism of female sexuality, with maternity as its fullest expression. While acknowledging that both Tennyson and Barrett Browning may have sentimentalized mothers and infants, I would also observe the obvious, that by intro-

ducing babies into texts poets could represent what they could not narrate: even "pure" women physically consummated relationships. Moreover, both Tennyson and Barrett Browning imply that women will be able to fulfill themselves intellectually and professionally only when they accept their full identities, including their sexual natures. In both *The Princess* and *Aurora Leigh* woman's acknowledging her sexuality empowers her poetic voice. We can properly appreciate the revolutionary quality of these assertions only by recalling the vigorous controversies of the mid-nineteenth century over whether women in fact experienced sexual feelings at all,[16] whether women's sexual feelings (granting that they had any) were healthy or manifested moral pollution if not insanity, and whether women could exercise their brains in serious educational pursuits or in literary composition without seriously compromising their biological functions.

*D*espite its comic uncertainties *The Princess* suggests the need for women to acknowledge their physical identities as they strive for intellectual and professional equality with men. The poem opens in the Victorian era with a conflict between several college men and a passionate young proto-feminist, Lilia. Rebelling against their patronizing attitudes, Lilia wishes she "were / Some mighty poetess" who could "shame" the patriarchal men who "love to keep [women] children!" (Prologue, 131–33) by writing the story of a truly heroic woman. In response, the men tell Princess Ida's tale. But by monopolizing the storytelling and adopting a mock-heroic style, the males partially subvert Lilia's desire to celebrate heroic womanhood. In sections that Tennyson added after the poem's initial publication, the college men admit Lilia and other women in their party to the margins of the storytelling by inviting them to punctuate the tale with lyric poems, most of which sentimentalize and perpetuate stereotyped masculine and feminine roles.

Tennyson partially resolves the surface dichotomy of male and female attitudes among the storytellers by having a male narrator later record and harmonize the various portions of the tale told seriatim by the college men. Like the Prince in the narrative and Tennyson himself, this narrator mingles views both sympathetic to and critical of women's demands for equality and autonomy as he treats such subjects as whether women's anatomy limits their educability; whether higher education will threaten women's childbearing role; whether women's studying science is physically, socially, or morally appropriate; and whether women can participate in public dialogue as poets.

The comic story line formulated by the college men essentially articulates views prevailing in Victorian society—exaggerated fears that bluestockings threatened the status quo, especially the fabric of family life, by inciting strife between the sexes and rejecting women's biological and social functions as

mothers. But the poem also conveys feminists' critique of the patriarchal
system through metaphors and imagery chosen by a male narrator who sym-
pathizes with the women's cause. Through a cluster of interrelated images the
narrator expresses and counters Victorian misgivings about women studying
science, writing poems, and expressing their sexuality.

A brief review of the story may be useful. Princess Ida, fleeing the patriar-
chy that excludes women from its resources of knowledge and power, estab-
lishes a female university marked by its own competing isolationism. Her
regime rivals the old order in its sterile exclusion of the opposite sex—even
of male animals. Despite the threat of death to male intruders, her betrothed
prince and two cronies infiltrate the school disguised as women. The Prince
initially invades the women's sphere to insinuate his claims to marriage.
Once inside, however, his female garb allows him a privileged perception of
women's craving for the knowledge and power society has traditionally
reserved for men. He comes to appreciate the shared capacities and the
complementary differences of the sexes, and at the end of the poem he
proposes a harmonious organic union between the two. But that ultimate
resolution follows a demonstration of the patriarchy's ability to overpower
with raw force Ida's feminist ambitions. When one of the Prince's compan-
ions betrays their masculinity by singing a bawdy song, pandemonium
erupts. Then Ida's scheme for independence collapses as men settle the issue
of her marriage. After the father of the Prince threatens warfare, the broth-
ers of the Princess annul the betrothal by defeating the Prince in a tourna-
ment. But at this juncture Ida, shaken by the serious injury of the Prince,
opens her female sanctuary to the wounded men as a hospital. As the Prince
recovers, Ida's resistance to matrimony crumbles. Although this conclusion
appears to undercut Ida's claims for independence and equality, the poem
essentially endorses her vision except insofar as she fears and rejects her own
sexuality.

In relating female sexuality to women's bid for education, the poem ad-
dresses Victorian physicians' and educators' claims that women were biologi-
cally unsuited to schooling or even to serious thought. Excessive study was
considered harmful to adolescent girls because it would expend energy "re-
quired by the constitution to work out nature's ends" and might even check
the "critical" menstrual flow. Such claims were not easily quashed. Almost
thirty years after *The Princess* appeared, the physician Henry Maudsley in-
sisted that intellectual activity diverted blood to the brain which should have
"succoured the productive organs" and maintained that higher education for
women ultimately threatened to produce "a puny, enfeebled and sickly
race."[17] Similar medical warnings against advanced education for women
continued to the end of the century, when in 1895 another physician,
J. Compton Burnett, in *Delicate, Backward, Puny, and Stunted Children* reiter-

ated the existence of an ineluctable competition for the body's resources to fuel either brain power or "pelvic power."

These arguments stating that study strained the female organs did not go unchallenged by feminists. An 1869 review of *The Church and the World,* for example, considered it "an impeachment of its Maker's power or of His Wisdom" to imagine that a creature "endowed with both a womb and a brain" was not intended to use both.[18] Physicians such as George Drysdale, Elizabeth Blackwell, and Elizabeth Garrett Anderson more vigorously defended the naturalness of female sexuality, asserting that higher education threatened neither the health of the female student nor the welfare of future generations. But opponents of education for women persistently claimed that inadequacies in the female brain, as well as the demands of the reproductive system, impeded scholarly pursuits. One physician, who wrote *On Mental and Nervous Disorders* seven years after the initial publication of *The Princess,* ridiculed the prospectuses of female academies for announcing they could teach women "the arts, the classics, the sciences." Such demanding material, he insisted, could hardly be "crammed into one small head."[19]

The Princess addresses this notion that the female brain is simply too small for higher education, a view articulated in Herbert Spencer's influential publications and succinctly conveyed in George C. Romanes's phrase "the missing five ounces."[20] Ida's friend, the Lady Psyche, lecturing on the historical suppression of women, proclaims the new opportunity offered by university education. She warns her female students not to fear that their learning capacity is inferior to men's, even though "some said their heads were less," for "often fineness compensated size." But she immediately undercuts this emphasis on quality rather than quantity: "Besides the brain was like the hand, and grew / With using" (2:131–35). This inappropriate anatomical comparison—especially ludicrous coming from a teacher whose name means *mind*—points up one conspicuous deficiency in the curriculum conceived by Princess Ida. Although her college teaches theories of evolution, geology, and astronomy, it exlcudes anatomy. Ida explains that feminine delicacy influenced her avoidance of anatomy: she could not bear to think that her "maids" would imitate "those monstrous males" who dissect living dogs, "Or in the dark dissolving human heart / And holy secrets of this microcosm, / Dabbling a shameless hand with shameful jest, / Encarnalize their spirits" (3:292–98). Her suggestion that women would become encarnalized and shameful by anatomizing the heart and the euphemistic "holy secrets of this microcosm," the body, reveals her fear of confronting sexual realities.[21] Sexual embarassment has prompted her to study medicine in order to prevent the need of summoning male physicians. In her female community Ida will never have to treat a male patient or, presumably, problems relating to sexual activity and

childbirth. Moreover, though Ida likes children, she wishes that "they grew /
Like field-flowers everywhere" (234–35).[22]

Opponents to higher education for women particularly objected to their
studying science because of the unavoidable danger of confronting sexual
facts, and much of the conduct literature specifically counseled restraining
women's scientific interests. Sarah Ellis's 1843 *Daughters of England* asserted
that girls should study science only to become better listeners to men. Read-
ing science for its own sake would "damage" "feminine delicacy." In 1834 a
writer in *Tait's Edinburgh Magazine* who supported colleges for women dif-
fered from Ellis's view by proposing that women occupy professorships in
poetry and science but implicitly acknowledged the sexual danger of teaching
science by stipulating that these female professors should teach only female
students and that the professors be only "women whom early widowhood, or
other causes, consign to celibacy."[23]

At the end of the eighteenth century Richard Polwhele had raised the
specter of feminine modesty endangered even by the study of botany. His
poem *The Unsex'd Females,* attacking Mary Wollstonecraft's proposals for
female education, envisions the horror of girls, their bosoms heaving "with
bliss botanic," dissecting the sex organs of plants. Princess Ida's naive wish
that children could spring up like field flowers may indicate a common avoid-
ance or ignorance of sexual realities. As late as 1911 Marie Stopes, who had
placed second in her class in zoology at University College, London, and had
conducted postdoctoral research in botany for seven years, had to consult
materials in the British Museum to discover that the "something" she intu-
itively felt to be lacking in her six-month-old marriage was, in fact, its sexual
consummation.[24]

More than sixty years before this botanist remained puzzled about human
sexuality, Tennyson's Princess Ida recognizes her own sexual attraction to the
Prince through a literary experience assisted by images of flowers, insects,
birds, and stars—all items she had studied while avoiding human anatomy. As
the Princess sits by the bed of the wounded prince, she reads one of Tenny-
son's loveliest lyrics, "Now Sleeps the Crimson Petal, Now the White." The
poem in unmistakably sexual undertones invites its audience to union. The
lyric represents botanical, zoological, and astronomical entities poised in an-
ticipation, then penetrating or enveloping complementary forms. After read-
ing a second invitation poem in which a shepherd calls a maid down "from
yonder mountain height," for "Love is of the valley" (7:177, 183), Ida yields
to the Prince's suit. But their union should not necessarily be viewed as the
defeat of Ida's feminist aspirations. Rather, she acquires a partner in her
enterprises, along with love that can temper the sterility of her exclusively
female world.

To declare his support of Ida's vision of woman's potential equality with

man in all human endeavors, the Prince first uses a botanical metaphor: "We two will serve . . . both [sexes] in aiding her— / Will clear away the parasitic forms / That seem to keep her up but drag her down / Will leave her space to burgeon" (252–55). Although his objective is worthy—to help woman "make herself her own / To give or keep, to live and learn and be" (256–57)—the image of woman as a shrub infested by parasitic growths falls rather flat at the serious romantic and philosophical resolution of the poem. Only when the Prince draws an analogy from anatomy does his metaphor satisfy the narrative's amatory and thematic requirements.

He describes each sex as insufficient unto itself: "either sex alone / Is half itself, and in true marriage lies / Nor equal, nor unequal: each fulfils / Defect in each" (283–86). And he concludes by prophesying a perfect spiritual and physical partnership, articulated in a resonant procreative image: "always thought in thought, / Purpose in purpose, will in will, they grow / The single pure and perfect animal, / The two-celled heart beating, with one full stroke, / Life" (286–90). Although Ida has refused, as she said earlier, to probe "the dark dissolving human heart" or the euphemistic "holy secrets" of the body that might "encarnalize" her spirit, the Prince at this point assumes that she will comprehend his biological illustration of the equal and reciprocal roles of man and woman no less than his botanical image—a botanical image strangely inept because it lacks the throbbing pulse of the "one full stroke, / Life."

Ida's receptiveness to the biological language has presumably been heightened by her medical ministrations to the Prince's body—a detail comically underscored by the fact that so many of her students have paired off romantically with the men they have nursed to recovery. But more immediately Ida has been readied for the Prince's figurative argument of the genderless unit that man and woman together can create by her reading of "Now Sleeps the Crimson Petal":

'Now sleeps the crimson petal, now the white;
Nor waves the cypress in the palace walk;
Nor winks the gold fin in the porphyry font:
The fire-fly wakens: waken thou with me.

Now droops the milkwhite peacock like a ghost,
And like a ghost she glimmers on to me.

Now lies the Earth all Danaë to the stars,
And all thy heart lies open unto me.

Now slides the silent meteor on, and leaves
A shining furrow, as thy thoughts in me.

Now folds the lily all her sweetness up,
And slips into the bosom of the lake:
So fold thyself, my dearest, thou, and slip
Into my bosom and be lost in me.'

(161–74)

The lyric anticipates the union of sexes by allowing the sex of speaker and listener, or lover and beloved, to blur and shift. Although the second couplet, for example, equates the auditor with the female earth, both playing the role of Danaë, who welcomed Zeus as lover, the imagery of penetration in the third couplet, a sky being furrowed by a meteor, implies a female speaker. And whereas the final quatrain suggests the protective male inviting the female to submit her chaste beauty to his power, the proposed movement into the bosom counters that sense. Moreover, in the insistent reiteration of invitation at the end of each quatrain and couplet—"with me," "on to me," "unto me," "in me," "in me"—the progression of prepositions suggests, in terms of sexual engagement, a female appealing to the male.

The authorship of the poem does not fix its speaker's gender. The narrative reveals only that the lyric was wrought by a poet of Ida's land. In the modern introduction to Ida's tale the feminist Lilia complains that all the poets are men. But within the tale itself we learn that Ida is a poet of "lyrics, prophesying change" (1:141), an apt description of the double gender love plea "Now Sleeps the Crimson Petal." Ida's poetry becomes the comic butt of her father's puns—he declares that she writes "awful odes" and "masterpieces: / They mastered *me*" (137, 144–45). Though her father trivializes her verse, Tennyson revised his work to emphasize Ida's role as a poet. After three editions he altered a description of her as a "strange maiden" to identify her as a "strange Poet-princess" (3:256). Presumably Ida did not write this lyric, but the sex of the poet of her land remains uncertain. In her paternal home in the South poets are male, but in her own domain women are teachers and scientists— and, like herself, poets. In any event, Ida, as reader of the poem, may be taken as either its speaker or its audience. Thus the song inviting a beloved to sexual fulfillment, through its fluid gender images, patterned prepositions, and uncertain authorship, represents either a man or a woman calling a lover to union. "Now Sleeps the Crimson Petal, Now the White" thus prepares Ida for the Prince's potent biological image of equal and complementary relationships, men and women together creating new life with one full stroke.[25]

While registering Victorian society's fears regarding changing gender roles, *The Princess* also eludes and subverts Victorian gender stereotypes. Ida's twentieth-century sisters have often concluded that the poem records her defeat, for men invade her female university, manipulate her future, and relegate her to the conventional roles of nurse and wife.[26] But the poem also undercuts

frequent claims of Victorian physicians, educators, and journalists that women were biologically unsuited to study and could not be both scholars and mothers. The poem also submits that women must prepare themselves for full partnership in education, authorship, and marriage by confronting that dimension of themselves so often proclaimed either nonexistent or aberrant—their sexuality. Tennyson's comedy, rather than discrediting the rights of women, allowed him to champion an unpopular cause without stridency. Moreover, his suggesting both the justice of Ida's resistance to male domination and her extremism enabled him to discredit male sexism while at the same time showing the dangers inherent in Ida's excluding men from her world.[27]

The conclusion is troubling in part because the text denies Ida the opportunity to speak for herself at the end of her story. Within the fiction the Prince recounts the events retrospectively, and the frame assigns the narrative to male speakers who obviously patronize Lilia by turning to comic effect the celebration of heroic womanhood that she craved. And all is finally recorded by a male narrator. But in one sense Tennyson has avoided the most presumptuous gesture possible to him, as the male writer behind all the fictive voices—recording Ida's response to the Prince's final vision of their redefinition of male-female relationships. From one point of view the Prince's final words, "Lay thy sweet hands in mine and trust to me" (7:345), reiterate the seductive, coercive patriarchal promise to Victorian woman, recuperating the erring Princess to the domestic ideal. But unless we discredit him entirely as a lying betrayer, his words swear fidelity to a new vision of partnership. Having established the Prince's respect and love for a woman who has deviated widely from his mother, his idealized Angel in the House, the poet narrator and Tennyson do not presume to answer for her.

Instead, we return to the modern frame where Walter, who earlier had affectionately—and patronizingly—patted Lilia's head, exclaims, "I wish she had not yielded!" (Conclusion, 5). The Conclusion also suggests that the fear of French radicalism associated with free love and higher education for women proposed by the Saint Simonians is the reaction of the conservative sons of conservative fathers, "the Tory member's elder son" (50). Tennyson represents an embodiment of patriarchal England in Sir Walter Vivian surrounded by six boys:

> No little lily-handed Baronet he,
> A great broad-shouldered genial Englishman,
> A lord of fat prize-oxen and of sheep,
> A raiser of huge melons and of pine,
> A patron of some thirty charities,
> A pamphleteer on guano and on grain
> (84–89)

No poet, this incarnation of John Bull writes on utilizing bird dung in agriculture. But the strange diagonal of Tennyson's narrative does not leave us contemplating the patriarch's disquisitions on guano; it returns us to a thoughtful silence prevailing among the college men who have obviously been touched by the closure of Ida's story: "we sat / But spoke not, rapt in nameless reverie, / Perchance upon the future man" (107–9). Their meditation has been partly generated by the women's poems and by their silence:

> and perhaps they [the women] felt their power,
> For something in the ballads which they sang,
> Or in their silent influence as they sat,
> Had ever seemed to wrestle with burlesque,
> And drove us, last, to quite a solemn close—
> (13–17)

The last "word" is given to Lilia, who silently divests the statue of Sir Ralph of his "rich silks," the colorful scarf by which she had created the illusion for herself that a heroic woman could be fashioned by dressing a heroic man in female garb, and the illusion for the men that a tale of heroic woman must be "mock-heroic gigantesque." Tennyson in the Victorian closure, as in the medieval tale, has not formulated the female rejoinder— perhaps his most appropriate response to Lilia's complaint that all the poets have been men. Within the medieval tale Ida has scathingly remarked that men's conventional praise of women is "barren verbiage," "Light coin, the tinsel clink of compliment" (2:40–41). Although she scorns praise of women as sweethearts, wives, and mothers, she learns that by excluding men, wishing children grew like field flowers, and avoiding her own sexuality, she in her own odes and statements of equality has produced barren verbiage as well.

*I*n *Aurora Leigh* Barrett Browning conflates images of barren verbiage, of denied female sexuality and frustrated poetic voice, to focus more intently Tennyson's implication that recognition of her own sexuality empowers woman's poetry. While Barrett Browning follows her early plan to take her novel-poem into Victorian drawing rooms rather than into medieval castles and discusses rape, illegitimacy, oppression of seamstresses, and class schism, she frequently employs classical myth to express her theme of connections between sexuality and writing. Like Ida, Aurora Leigh finally accepts a marriage, arranged by fathers, that originally appeared to threaten her autonomy and professional ambitions and to consign her to the role of inferior helpmate. Aurora finally sees marriage to Romney Leigh, who like Tennyson's Prince has undergone transforming experiences, not as capitulating to male

dominance but as entering a new form of partnership in which stereotypes break down and each sex assists and learns from the other. More fully than does Ida, Aurora achieves this recognition by embracing her own sexual nature. For Aurora, as for Ida, this process depends on acquaintance with the maternal role (Marian Erle's infant paralleling Psyche's baby in facilitating this understanding). And as with Ida's reading love lyrics, Aurora's conversion hinges on literary experience, here inscribed in her own changing representations of herself as a poet.

Aurora initially depicts the poetic craft as a male activity expressed through masculine figurations and the classical myths derived from her father's books. In reading these tomes bequeathed to her by the father, Aurora attempts to appropriate traditionally masculine education. Unlike Princess Ida and her colleagues at the female university, Aurora does not revise male histories and select myths to focus on female contributions to culture or to define woman's situation from woman's viewpoint. Instead, having found only confusion in the ambiguous portrait[28] and the silence of her dead mother, Aurora tries to adopt unchanged the language of the male-dominated literary tradition. An early passage distinguishes between the communicative silence of her then-living mother and the language of the father: women "know a simple, merry, tender knack / Of tying sashes, fitting baby-shoes, / And stringing pretty words that make no sense, / And kissing full sense into empty words," thus teaching children love (1:49–52), whereas "Fathers love as well . . . but still with heavier brains" (60–61).[29] The comment on fathers' "heavier brains" recalls references in *The Princess* to woman's smaller brain as well as Victorian "scientific" discourse on the subject and here specifically links the linguistic impoverishment of women to the "missing five ounces."

In addition to the mother's "empty words" (made sensible only by her physical expressions of love) and the father's "more consciously responsible" (62), wiser language, a third type of discourse figures among the young Aurora's options—the coercive language spoken by her aunt, who has internalized the separate spheres ideology and upholds the conventional domination of intellectual men over emotional women. She attempts to deprive Aurora of the speech of her dead mother, who could kiss meaning into empty words, by withholding maternal affection and by prohibiting the girl's using her mother's native Italian. The aunt also tries to put Aurora's dead father's discourse—the books he bequeathed to Aurora—beyond reach by storing them in the garret. Instead of allowing her to use these inherited forms of speech, the aunt mandates a conventional "lady's" curriculum of smatterings and polite accomplishments that will equip the maiden for the marriage market, a curriculum Barrett Browning scathingly satirizes (1:392–449).

Aurora relates the traditionally masculine education she derives from her father's books in terms of a classical myth of transgressing gender boundaries

in childhood education. In doing so she reverses the traditional mythological
reversal, identifying herself as male by comparing herself to Achilles, who in
his youth was nurtured as a female:

> Thus, my father gave;
> And thus, as did the women formerly
> By young Achilles, when they pinned a veil
> Across the boy's audacious front, . . .
> He wrapt his little daughter in his large
> Man's doublet, careless did it fit or no.
>
> (722–28)

When Romney proposes, he disparagingly notes that Aurora's Greek is
"lady's Greek / Without the accents" (2:76–77). Nevertheless, from her base
of "masculine" education Aurora constructs an image of herself as a poet that
is frequently male and derived from classical myth. As an artist she figures
herself as Jove, Pygmalion, and Ganymede.[30] But as a woman who has denied
the appeal of love and rejected marriage and motherhood for art's sake,
Aurora denies her sexual being, and the mythological representations become
linked to imagery of sexual barrenness.

Barrett Browning connects Aurora's artistry and denial of her own sexual-
ity in an extended passage that departs from Aurora's typical representation of
the artist as male and that instead depicts the artist as a female deriving
inspiration from male divinity. Considering two sketches described by the
artist Vincent Carrington of Danaë awaiting Jove, Aurora reads, or inscribes,
their meaning as idealizing abstractions—"Two states of the recipient artist-
soul" (3:139). She entirely overlooks their obvious erotic aspects, which are
emphasized by the fact that Vincent's own love for his fiancée has strongly
influenced his images. Carrington accentuates the sensuous in his epistolary
descriptions of both sketches:

> A tiptoe Danae, overbold and hot,
> Both arms a-flame to meet her wishing Jove
> Halfway, and burn him faster down; the face
> And breasts upturned and straining, the loose locks
> All glowing with the anticipated gold.
> Or here's another on the self-same theme.
> She lies here—flat upon her prison-floor,
> The long hair swathed about her to the heel
> Like wet seaweed. You dimly see her through
> The glittering haze of that prodigious rain,
> Half bottled out of nature by a love
> As heavy as fate.
>
> (122–33)

Focusing on only the abstract, Aurora misses what she has missed in life—the carnal—and refuses to see that sexual passion may be related to artistic inspiration.[31]

Although Vincent judges that the second sketch "indicates / More passion" (134–35), Aurora sees it only as a heightened image of the artist inspired by divinity: "Self is put away, / And calm with abdication. She is Jove, / And no more Danae—greater thus" (135–37). By remaining blind to the erotic aspects of the image, Aurora avoids confronting its direct links to her own fear of marriage. When Romney first proposed, she had believed that as a woman and an artist she would be "half blotted out" if he became her economic support and the father of her children. The connections to Jove's blotting out Danaë as he inseminates her in a shower of gold would seem inescapable to anyone but Aurora, who so firmly divorces her conception of Danaë the artist from Danaë the woman.[32]

The application to Aurora of this image of Danaë is underscored by the detail of Danaë's hair engulfing her figure like seaweed, for earlier, as a dependent suffering under her aunt's domineering expectations, Aurora had envisioned herself as seaweed:

> I only thought
> Of lying quiet there where I was thrown
> Like sea-weed on the rocks, and suffering her
> To prick me to a pattern with her pin,
> Fibre from fibre, delicate leaf from leaf,
> And dry out from my drowned anatomy
> The last sea-salt left in me.
>
> (1:378–84)

Her aunt's penetrating financial and psychological tyranny anticipates the overtly sexual domination of Jove blotting out Danaë. Just after Romney proposed, Aurora had expressed her fears of financial dependency and resulting loss of self if she married him in imagery later amplified by the Jove-Danaë myth: "He might cut / My body into coins to give away / Among his other paupers; change my sons / While I stood dumb" (2:790–93).[33] Aurora thus associates conception of children with the invasive dependency and sexual obligation she fears in conventional marriage.

Almost immediately after she resists seeing the conjunction of sexual fulfillment and artistic inspiration in the image of Danaë, Aurora describes her solitary working life in London with imagery that accentuates the physical infertility of her own existence. The self-referential implications of her description of the London sun resonate in the mythological associations of her own name with dawn[34]:

> Serene and unafraid of solitude,
> I worked the short days out,—and watched the sun
> On lurid morns or monstrous afternoons
> (Like some Druidic idol's fiery brass
> With fixed unflickering outline of dead heat,
> From which the blood of wretches pent inside
> Seems oozing forth to incarnadine the air).
>
> (3:169–75)

This comparison of the sun to a brass enclosure that functions as a grotesque antithesis of a life-giving womb inverts the myth of Danaë impregnated by gold and giving birth within a brazen tower and implies the barrenness of Aurora's solitary work.

When Aurora soon afterward expresses dissatisfaction with her poetry as barren verbiage, she assumes that she merely echoes the male critic Romney in thinking her work a parody of masculine achievement: "I played at art, made thrusts with a toy-sword" (240). Becoming a genuine (that is, masculine) critic if she cannot be a genuine (masculine) poet, she rips her verses with no toy blade but a (masculine) rapier and discovers her inability as a woman-poet to breed life:

> I ripped my verses up,
> And found no blood upon the rapier's point;
> The heart in them was just an embryo's heart
> Which never yet had beat, that it should die;
> Just gasps of make-believe galvanic life.
>
> (245–49)

Her mythological allusions continue to suggest that the principal weakness in her poetry is her failure to identify with her sex and, more specifically, with her own sexual nature. She feels herself capable of creating inspired art: "And yet I felt it [my poetry] in me where it burnt, / Like those hot fire-seeds of creation held / In Jove's clenched palm before the worlds were sown,— / But I—I was not Juno even!" (251–54). Still blind to the erotic component of the image of Danaë as woman-artist welcoming Jove, Aurora resists thinking of "Jove's hot fire-seeds of creation" in sexual terms. She describes her inability to bear living verse as a failure of the writing hand, but the description of convulsions too weak to bring the Jovian "hot fire-seeds of creation" to fruition betrays the appropriateness of substituting *womb* for *hand:*

> my hand
> Was shut in weak convulsion, woman's ill,
> And when I yearned to loose a finger—lo,

> The nerve revolted. 'Tis the same even now:
> This hand may never, haply, open large,
> Before the spark is quenched. . . .
> (254–59)

When Romney unsuccessfully proposed and offended Aurora's artistic aspirations, he was comparably naive about what would distinguish the voice of a genuine woman-poet from that of the trite poetesses he disparaged. To suggest the narrowness of women's vision of the world and consequently of their poetic scope, he employed sexually charged language potentially unsettling to the young virgin he addressed in its violent and unsavory evocations of conception and childbirth:

> Your quick-breathed hearts,
> So sympathetic to the personal pang,
> Close on each separate knife-stroke, yielding up
> A whole life at each wound, incapable
> Of deepening, widening a large lap of life
> To hold the world-full woe. . . .
> . . . All's yours and you,
> All, coloured with your blood, or otherwise
> Just nothing to you.
> (2:184–98)

Similar undertones covertly threaten Aurora in Romney's earlier description of writing poetry as a sexual defilement: "even dreaming of the stone and bronze / Brings headaches . . . and defiles / The clean white morning dresses" (94–96). And he argues that if she accepts his financial assistance, eliminating her need to write for a livelihood, she can walk the road with clean silken shoes and "sweep [her] ample skirts of womanhood" with impunity (1023–24, 1042).

Oddly, and naively, Romney dissociates sexual threat from his marriage suit by formulating his proposal in pallid botanical imagery, and like Ida's Prince he discovers its ineffectiveness: "Place your fecund heart / In mine, and let us blossom for the world / That wants love's colour in the grey of time" (375–77). Eventually both Aurora and Romney learn through evidence of sexual and social violence the inadequacy of their earlier views of life, love, and poetry. Aurora's recognition that "The spiritual significance burn[s] through / The hieroglyphic of material shows" (7:860–61) leads directly to her blunt avowal: "The end of woman (or of man, I think) / Is not a book. . . . / And Love strikes higher with his lambent flame / Than Art can pile the faggots" (883–84, 893–94). But even when she recognizes a congruence of passional and artistic creativity, she represents herself as poet through analogy

to a mythological male. During her frustrating experience in London, aware
that despite popular acclaim she is writing barren verbiage, she interrogates
her sources of inspiration and her poetic practice:

> Shall I hope
> To speak my poems in mysterious tune
> . . . with the lava-lymph
> That trickles from successive galaxies
> Still drop by drop adown the finger of God
> · · ·
> · · · —with all that strain
> Of sexual passion, which devours the flesh
> In a sacrament of souls? with mother's breasts
> Which, round the new-made creatures hanging there,
> Throb luminous and harmonious like pure spheres?—
> (5:1–5, 14–18)

At this point Aurora remains incapable of viewing her art in harmony with
her womanhood. Not seeing herself as an embodied Danaë welcoming Zeus
the lover as well as the inspiring god, she cannot yet accept herself as a writer
with "mother's breasts" nourishing life. Though recognizing the place of love
in the creative process, she still conceives of the artist in masculine terms,
choosing the myth of Pygmalion to express her desire to incorporate love into
art (5:399–413) and lamenting her consequent barrenness: "I called the artist
but a greatened man. / He may be childless also, like a man. / I laboured on
alone" (419–21).

Elsewhere considerations of the relationship of love to art return her
thoughts to myth, but her figuration of the interpenetration of the divine and
the human is no longer Danaë, whom Aurora had earlier perceived as an artist
exalted by divine inspiration that animates her most intensely when she be-
comes most still ("when indeed our Joves come down, / We all turn stiller
than we have ever been," "She is Jove / And no more Danae–greater thus";
3:142–43, 136–37). Now Aurora's image of Jove's beloved is an unglamor-
ous emblem for suffering womanhood, Io turned into a cow to conceal Jove's
adulterous passion: "When Jove's hand meets us with composing touch, /
And when at last we are hushed and satisfied, / Then Io does not call it truth,
but love?" (7:895–97).[35] In raising the question of how mortals would
evaluate penetration of the divine into their lives (as inspiration or insemina-
tion), Aurora opens a new and uncertain perspective on her earlier vision of
Danaë as sanctified artist and thus calls for a reexamination of woman's fleshly
experience. Identifying herself with Io (whose suffering is central to Aeschy-
lus's *Prometheus Bound*, twice translated by Barrett Browning, the first version
published in 1833 and a second prepared in 1845), Aurora satirizes her own

philosophical anxiety over the relationship between art and love, and her present regret for having rejected love for art, by describing the plight of a cow that has aspired inappropriately, pursued the wrong path, and now hungers: "The occidental flats / Had fed us fatter, therefore? we have climbed / Where herbage ends? we want the beast's part now / And tire of the angel's?" (1003–6).

Romney's later metaphor for the suffering society he still longs to help, despite his phalanstery's collapse in flames, connects Aurora's bovine image of woman's hunger for love with the generative vitality of Danaë through several layers of metaphor and myth. Romney compares the victims of social ills to the victims whom the tyrant Phalarias imprisoned in a torture chamber of polished brass molded to bovine form:

> I was . . .
> . . . distracted with the cries
> Of tortured prisoners in the polished brass
> Of that Phalarian bull, society,
> Which seems to bellow bravely like ten bulls,
> But, if you listen, moans and cries instead
> Despairingly, like victims tossed and gored
> And trampled by their hoofs.
>
> (8:385–92)

This reference to life being extinguished in a brass image recalls Aurora's description of her lonely days of writing in a London steeped in the light of a sun like the polished brass of a druidic idol oozing the blood of its dying victims. This doubled image of brass enclosures in which painful convulsions bring forth death rather than life inverts while recalling the myth of Danaë producing life from insemination by gold in a tower of brass. Together all these images link Aurora's sexuality, her poetry, and the sufferings of society, suggesting that the woman-poet's labors yield living poetry only when they infuse with Jovian "hot fire-seeds" of artistic and physical passion not only the ecstasies of Danaë but also the struggle for survival of mute Io and the anguish of individuals composing the tormented social body.

By the end of the poem Aurora recognizes no split between her identity as a poet and as a woman. She revises her early error that to write she cannot be a woman, that to write she must reject love, marriage, and motherhood. The existence of the poem, *Aurora Leigh,* written after the events it records, demonstrates that her projected marriage to Romney does not silence her as a poet or reduce her to the status of dependent and helpmate she had so much feared initially; instead, their union engenders richer, more complex, and more satisfying verse. Significantly, Barrett Browning never includes in the

narrative any specimens of the poetry by which Aurora established her artistic reputation and persuaded Romney that she was a great poet who through art could work the universal good he failed to accomplish. Instead, the poetry by Aurora that we do read is *Aurora Leigh* itself, the poem that relates the social turmoil of the Victorian period to the interior life of individual woman. This ability to explore in art such issues as the clash of utopian idealism with crass economic exploitation or the discrepancies between the ideal of the Angel in the House and the bitter experience of working-class women and the horror of rape, all in relationship to the personal life of the heroine, depends on Aurora's forging a new aesthetic, an aesthetic represented by her replacing Danaë with Io to exemplify the woman artist. Instead of celebrating Danaë as a female artist whose physical identity is virtually obliterated in the haze of divine—male—inspiration, Aurora hymns Io, who though silent "speaks" eloquently of human pain through her beast's body. Aurora's new aesthetic thus combines the intellectual and spiritual with the passionate and physical, and manifests itself in a new poetry, this text in which she articulates the Victorian world through her own life, her own body. The poem fulfills the aspiration she partially formulates when she drops to the pavement in an Italian church and prays God "would stop His ears to what I said, / And only listen to the run and beat / Of this poor, passionate, helpless blood—And then / I lay, and spoke not: but He heard in heaven" (7:1269–72). This episode reverses the thrust of Aurora's earlier interpretation of the drawings of Danaë, her body effaced by divine messages. Aurora now represents the poet-woman's utterance as the body that speaks to God, through its throbbing pulse inscribing woman's experience.

At this point, with Aurora conceiving of herself as a woman-poet rather than one of the alternatives she earlier imagined—a man-poet or a woman-wife—she is readied for Romney's return. In a closure that recalls Tennyson's *Princess,* Barrett Browning challenges his precedent by giving the last word not to Romney but to Aurora. Tennyson's Prince, while encouraging each sex to acquire strengths from the example of the other, had nonetheless preserved gender distinctions especially relevant to Ida's aspirations as a poet by urging Ida to "set herself to man, / Like perfect music unto noble words" (7:269–70). Once Barrett Browning's Aurora has affirmed her identity as a woman-poet who communicates from the pulsations of her blood and rejects images of the poet derived from male-centered myths (Pygmalion, Danaë obliterated as she is inspired by Zeus), Romney encourages her to "press the clarion on thy woman's lip / . . . And breathe thy fine keen breath along the brass, / And blow all class-walls level as Jericho's" (9:929–32).[36] The full-voiced Aurora originates both the "perfect music" and "noble words" that Tennyson's Prince allocated to different genders. Her revolutionary utterance is not merely the final passage of Barrett Browning's poem, which echoes a male text, St. John's

vision of the millenium (*Rev.* 21.18–20), but is the entire poem, represented from the opening lines as her poetic endeavor to speak her self for herself and her intimates, to "write my story for my better self, / As when you paint your portrait for a friend" (1:4–5). For an authentic portrait of the artist she replaces Vincent Carrington's sketches of Danaë with the self-portrait of a woman who has turned into poetry not only traditionally masculine education and poetic inspiration but also the fullness of woman's passional life.

Aurora comes to see marriage, sexual relations, and motherhood not in their traditional formulation as a conduit of patriarchal wealth—the "coins" into which the young virgin feared Romney would cut her body in order to disperse their male offspring while she remained mute (2:790–93). Instead, marriage opens the channel through which her poetry achieves life. By writing her story Aurora thus becomes a literary "grandmother" of future generations—in fiction a female progenitor of female poems that Barrett Browning herself had vainly sought in the English literary tradition, which she characterized as the legacy of "grandfathers" alone.[37]

Rather than recuperating the heroine of its romance to the domestic sphere under male protection, reinscribing the division between male and female power, public and private domains, which Nancy Armstrong describes as the cultural project of courtship fictions from the late eighteenth century into the Victorian period,[38] *Aurora Leigh* in a sense dismantles these divisions. The marriage closure returns us chronologically to the beginning, to the writing of the poem itself. By focusing attention on such issues as the inequities of female dependency, exploitation of seamstresses in sweat shops, and middle-class hypocrisy and brutality to the fallen woman—as well as on her personal love story—Aurora claims in full her woman's identity. She also claims both romance and the marketplace as the material of poetic grandmothers.

NOTES

1. 30 January 1846, in *Letters of Robert Browning and Elizabeth Barrett Barrett, 1845–1846,* ed. Elvan Kintner (Cambridge: Belknap Press of Harvard University Press, 1969), 1:427; and 31 January 1846, 1:429 (hereafter cited in the notes as *RB/EBB*).

2. 27 February 1845, *RB/EBB*, 1:31; see also *The Letters of Elizabeth Barrett Browning*, ed. Frederic G. Kenyon, 2 vols. (London: Macmillan, 1897), 1:204 (hereafter cited as *Letters*); and *Letters of Elizabeth Barrett Browning to Mary Russell Mitford, 1836–1854,* ed. Meredith B. Raymond and Mary Rose Sullivan, 3 vols. (Armstrong Browning Library of Baylor University, The Browning Institute, Wedgestone Press, and Wellesley College, 1983), 3:49 (hereafter cited in the notes as *EBB/MRM*).

3. Marjorie Stone assesses Barrett Browning's uses and inversions of patterns of *The Princess* in "Genre Subversion and Gender Inversion: *The Princess* and *Aurora Leigh,*" *Victorian Poetry* 25 (1987): 101–27.

4. See, for example, Cora Kaplan's introduction to her edition of *Aurora Leigh* (London: Women's Press, 1978), 26–28; and Deirdre David, *Intellectual Women and Victorian Patriarchy: Harriet Martineau, Elizabeth Barrett Browning, George Eliot* (Ithaca: Cornell University Press, 1987), 156–57. David judges that the conclusion of *Aurora Leigh* reveals an "appropriation of Aurora's art and sexuality by male power" (152) and that in the poem "we hear a woman's voice speaking patriarchal discourse— boldly, passionately, and without rancour" (157).

5. See, for example, Carol Christ, "Victorian Masculinity and the Angel in the House," in *A Widening Sphere: Changing Roles of Victorian Women*, ed. Martha Vicinus (Bloomington: Indiana University Press, 1977), 146–62. Among recent biographers, Robert B. Martin, in *Tennyson: The Unquiet Heart* (Oxford: Clarendon; London: Faber & Faber, 1980), consistently remarks a paucity of sexual interest in Tennyson's work and his life. In contrast, Elaine Jordan, in *Alfred Tennyson* (Cambridge: Cambridge University Press, 1988), argues that Tennyson "wrote the best erotic verse since that of the seventeenth century" and praises his ability in *The Princess* to "acknowledge equally active sexual feeling in a woman" (107).

6. Edward Bulwer-Lytton, *The New Timon* (1846); unsigned review of Grenville Mellen's *The Martyr's Triumph, Buried Valley, and Other Poems*, in the New York *American Monthly Magazine* 4 (October 1833): 325–26, cited in John Olin Eidson, *Tennyson in America: His Reputation and Influence from 1827 to 1858* (Athens: University of Georgia Press, 1943), 12–13.

7. *The Letters of Emily Lady Tennyson*, ed. James O. Hoge (University Park: Pennsylvania State University Press, 1974), 6, 8.

8. Wendell Stacy Johnson, *Sex and Marriage in Victorian Poetry* (Ithaca: Cornell University Press, 1975), cites Tennyson as one of the best exemplars of the "intensely Victorian" madonna-harlot syndrome (34–35).

9. Letter of 3 December 1875, in *Dante Gabriel Rossetti: His Family-Letters, with a Memoir*, ed. William Michael Rossetti, 2 vols. (London: Ellis, 1895), 2:323.

10. "*Aurora Leigh*," *Dublin University Magazine* 49 (1857): 470; *Letters*, 2:255, 252.

11. *Letters*, 2:445.

12. Ann C. Colley, *Tennyson and Madness* (Athens: University of Georgia Press, 1983), 91.

13. Tennyson instructed an editor at *Macmillan's Magazine*, George Grove, to delete the offending passage but to retain it in the version sent to America for publication, remarking, "They are not so squeamish as we are"; *Letters of Alfred Lord Tennyson*, ed. Cecil Y. Lang and Edgar F. Shannon, Jr. (Cambridge: Belknap Press of Harvard University Press, 1987), 2:483. See also pp. 476, 476n, 481n, and Shannon, "The Publication of Tennyson's 'Lucretius,'" *Studies in Bibliography* 34 (1981): 146–86. Tennyson recorded that his final arbiter in matters of taste, his wife Emily, did not think the poem would shock readers; *Letters*, 2:480.

14. J. W. Marston, review in *The Athenaeum* 21 (1 January 1848): 8. All quotations from *The Princess* follow *The Poems of Tennyson*, ed. Christopher Ricks, 2d ed., 3 vols. (Avon: Longman, 1987), 2:185–296, and are identified in the text by part and line number.

15. All citations from *Aurora Leigh* follow *The Complete Works of Elizabeth Barrett Browning,* ed. Charlotte Porter and Helen A. Clarke (New York: Thomas Y. Crowell, 1900; repr. New York: AMS, 1973), vols. 4–5, and are identified in parentheses by book and line numbers. The mammocentric imagery has been discussed by Sandra Donaldson, " 'Motherhood's Advent in Power': Elizabeth Barrett Browning's Poems About Motherhood," *Victorian Poetry* 18 (1980): 51–60; Barbara Charlesworth Gelpi, *"Aurora Leigh:* The Vocation of the Woman Poet," *Victorian Poetry* 19 (1981): 35–48; Virginia V. Steinmetz, "Images of 'Mother-Want' in Elizabeth Barrett Browning's *Aurora Leigh,"* *Victorian Poetry* 21 (1983): 351–67; and Deirdre David, " 'Art's a Service': Social Wound, Sexual Politics, and *Aurora Leigh,"* *Browning Institute Studies* 13 (1985): esp. 121–22. Barrett Browning's using pervasive breast imagery in *Aurora Leigh* marks an evolution in her own sense of poetic decorum, for when she first read Robert Browning's *Pippa Passes* in 1841 (before she met him, married, and bore her own child—for whom, by the way, she employed a wet nurse), she admired it as a work of genius but objected to its "coarseness," presumably its mention of prostitutes and its sexual imagery—including the naive Pippa's references to nipples (Introduction, 89); see *EBB/MRM,* 1:236.

16. On the rise of the idea of female passionlessness, see Nancy F. Cott, "Passionlessness: An Interpretation of Victorian Sexual Ideology, 1790–1850," *Signs* 4, 2 (1978), and Françoise Basch, *Relative Creatures: Victorian Women in Society and the Novel, 1837–67* (London: Allen Lane, 1974). Pat Caplan observes that by the second half of the nineteenth century medical opinion characterized women "as having sexual anesthesia" (Introduction, *The Cultural Construction of Sexuality,* ed. Caplan [London and New York: Routledge, 1987], 3).

17. Edward John Tilt, *The Elements of Health, and Principles of Female Hygiene* (London: Henry G. Bohn, 1852), 209; Henry Maudsley, *Responsibility in Mental Disease* (New York: D. Appleton, 1874), 471–72.

18. "Reviews of Books," *The Englishwoman's Review* 10 (1869): 128–29.

19. Alfred Beaumont Maddock, *Practical Observations on Mental and Nervous Disorders* (1854), cited in Vida Skultans, *Madness and Morals: Ideas on Insanity in the Nineteenth Century* (London: Routledge & Kegan Paul, 1975), 227–28.

20. George G. Romanes, *Mental Differences Between Men and Women* (1887), reprinted in *The Education Papers: Women's Quest for Equality in Britain, 1850–1912,* ed. Dale Spender (London: Routledge & Kegan Paul, 1987), 10–31.

21. Naïveté about their physical natures among young women of the nineteenth century is proverbial; when a Dr. Strut in 1854 published *Female Physiology* to educate young women about their bodies, a review, in *Lancet* 2 (1854): 39, damned it as "offensive." *Lancet* similarly opposed virtually any attempt to inform women about their bodies.

22. *Lancet* systematically opposed women's entering medicine, citing such reasons as the indelicacy of their studying anatomy with male students—or for that matter studying anatomy at all—and of treating male patients. *Lancet* opposed the admission of Jessie Meriton White to study medicine at the University of London on "grounds of decency" (2 [1857]: 95) and repeatedly attacked the early physician Elizabeth Garrett Anderson, who was not "one of the *ladies* of England nor does she

represent them," for ladies would not (the *Lancet* quotes Tennyson's Princess Ida) "encarnalise their spirits" by studying medicine (1862, 2.657).

23. M. L. G. (probably Mary Leman Grimstone), in *Tait's Edinburgh Magazine*, n.s. 1 (March 1834): 101.

24. Richard Polwhele, *The Unsex'd Females: A Poem* (1798), cited in Sandra M. Gilbert and Susan Gubar, *The Madwoman in the Attic: The Woman Writer and the Nineteenth-Century Literary Imagination* (New Haven: Yale University Press, 1979), 693n66. On Marie Stopes, see Fraser Harrison, *The Dark Angel: Aspects of Victorian Sexuality* (New York: Universe Books, 1978), 50–51. After the 1916 dissolution of her marriage, on the grounds of nonconsummation, Stopes campaigned for sex education and birth control, believing that by reducing women's fears of conception, contraception would increase their sexual fulfillment.

25. For a complementary discussion of "Now Sleeps the Crimson Petal," see Marjorie Stone, "Genre Subversion and Gender Inversion," p. 109. Although Elaine Jordan twice declares the speaker of "Now Sleeps the Crimson Petal" to be male (pp. 107–8), her reading also complements mine: "both lovers change as he is furrowed by her thoughts and becomes the lake into which she slips. Genital pleasure, passivity and activity, penetration and infolding, are mixed and doubled" (p. 107).

26. Despite her avowed respect for Florence Nightingale, Elizabeth Barrett Browning elevated thinking over nursing as an activity for women: "Since the siege of Troy and earlier, we have had princesses binding wounds with their hands; it's strictly the woman's part. . . . Every man is on his knees before ladies carrying lint, calling them 'angelic she's,' whereas, if they stir an inch as thinkers or artists from the beaten line (involving more good to general humanity than is involved in lint), the very same men would curse the impudence of the very same women and stop there. . . . I do not consider the best use to which we can put a gifted and accomplished woman is to *make her a hospital nurse*" (24 February 1855, *Letters*, 2:189).

27. Coming to conclusions different from mine, Terry Eagleton, in "Tennyson: Politics & Sexuality in 'The Princess' and 'In Memoriam,'" in *1848: The Sociology of Literature: Proceedings of the Essex Conference on the Sociology of Literature, July 1977*, ed. Francis Barker, et al. (University of Essex, 1978), 97–106, offers a fascinating reading of *The Princess:* he links the sexual uncertainties of the Prince to Victorian problems in asserting masculine hegemony, concluding that the poem refashions the symbolic order by desexualizing woman and expropriating her learning and poetic practice back to male domination.

28. On the significance of the mother's portrait, see Gilbert and Gubar, *The Madwoman in the Attic*, 18–19; and Gelpi, "*Aurora Leigh*," 36–38.

29. On women's nonsymbolic language and mother-daughter language, see Margaret Homans, *Bearing the Word* (Chicago: University of Chicago Press, 1986), chapter 1.

30. When Aurora compares herself as an artist to a female character from myth, she emphasizes the failure of her art, as when she allusively identifies with Niobe because all her poems/offspring are dead (5:413–18). On women writers' revisions of myth, see Alicia Ostriker, "The Thieves of Language: Women Poets and Revisionist Mythmaking," in *The New Feminist Criticism: Essays on Women, Literature, and Theory,*

ed. Elaine Showalter (New York: Pantheon, 1985), esp. 315–17; and Rachel Blau DuPlessis, *Writing Beyond the Ending: Narrative Strategies of Twentieth-Century Women Writers* (Bloomington: Indiana University Press, 1985), esp. 106–7.

31. In light of her experience with her own father, Barrett Browning must have found richly multivalent the myth of Danaë, whose father (to protect himself) locked her in a tower away from sexual passion, then set her adrift in a casket when he learned that a lover had penetrated her prison. For a discussion of the conflation of artistic creativity with biological creativity and of inspiration as "an infusion from a male master" (p. 303), a terrifying sexual experience, see Susan Gubar, " 'The Blank Page' and the Issues of Female Creativity," in *The New Feminist Criticism,* esp. 302–3.

32. In *Jane Eyre* (1847), which reviewers suggested provided the idea for Romney's blinding, Jane refuses to be a Danaë showered with gold when she rejects Rochester's material gifts. Aurora comparably resists the urging of both Romney and her aunt that marriage to him represents material security. Joyce Zonana called to my attention this reference to Danaë in *Jane Eyre.*

33. Narrating her conception of a child by rape, Marian Erle describes her baby as a "coin of price" embedded in her flesh by "the extremity of the shock" when she was beaten into a ditch "[b]y hoofs of maddened oxen" (6:676–81).

34. The name Aurora is significant to Barrett Browning's concern with female sexuality in another way as well, for it doubtless memorializes her regard for George Sand, Aurore Dudevant. A reviewer, in *Blackwood's Edinburgh Magazine* 81 (1857): 33, finding aspects of *Aurora Leigh* unsavory and unfeminine, judged that the heroine "is made to resemble too closely some of the female portraits of George Sand, which never were to our liking." On the importance of Sand to Barrett Browning, see Patricia Thomson, *George Sand and the Victorians: Her Influence and Reputation in Nineteenth-Century England* (New York: Columbia University Press, 1977), 43–60.

35. On the significance of references to Danaë and Io see Joyce Zonana, "The Embodied Muse: Elizabeth Barrett Browning's *Aurora Leigh* and Feminist Poetics," *Tulsa Studies in Women's Literature* 8 (1989): 241–62. See also Dorothy Mermin, *Elizabeth Barrett Browning: The Origins of a New Poetry* (Chicago: Chicago University Press, 1989), 210–11.

36. Gilbert and Gubar, *The Madwoman in the Attic,* 579, see this passage as too revolutionary to be spoken by a woman and therefore "discreetly transferred from female to male lips."

37. In January 1845, the month before she described her plan for *Aurora Leigh,* Barrett Browning analyzed the dearth of serious women poets in England: "I look everywhere for grandmothers and see none. It is not in the filial spirit I am deficient . . . witness my reverent love of the grandfathers!" (*Letters,* 1:232). On women writers' consciousness of lacking female precursors, see Annette Kolodny, "A Map for Rereading: Gender and the Interpretation of Literary Texts," *The New Feminist Criticism,* 46–62.

38. Nancy Armstrong, *Desire and Domestic Fiction: A Political History of the Novel* (New York and Oxford: Oxford University Press, 1987).

MARY ELLIS GIBSON

DIALOGUE
ON THE DARKLING PLAIN

Genre, Gender, and Audience
in Matthew Arnold's Lyrics

Matthew Arnold's lyrics, though much praised, have always been something of an enigma. They exhibit technical virtuosity and lapses in technique, and a voice by turns intimate and aloof. Charles Altieri has argued that Arnold's poetry exemplifies an "acute tension between personal cries and a distanced public language."[1] These remarkable inconsistencies make the voices of Arnold's poems among the most anxious of his time. It is possible to refer Arnold's anxieties immediately to the economic and social stresses in British capitalism of the 1840s or to focus on Arnold's dilemma as the first son of a famous father. But the problem of Arnold's lyrics has yet another dimension, and his lyrics themselves directly present a significant source of anxiety. I argue here that Arnold's search for the poet's cultural centrality was a response to his anxiety about audience, particularly as women were an increasingly important part of the growing audience for elite literature.

A measure of Arnold's struggle toward the authoritative voice can be seen in the roles women play as audience for, subjects of, or silent presences in his poetry. The manifest uneasiness about women in Arnold's lyrics is not interesting primarily as an expression of the poet's attitudes; it is an index to the larger problems of the male lyric poet who occupied an ambiguous place within the gendered boundaries of Victorian public and private life.[2]

By focusing on the problem of gender we can see the connections among a

number of formal and thematic dichotomies in Arnold's lyrics: the central voice of authority versus the voices of the outsider or other; monologue versus dialogue; the closed form of classical genres versus the open form of the novel or novelized poem; the Olympian perspective versus the eddying existence of the darkling plain. To explore these dichotomies I begin by establishing the contours of Arnold's problem with audience and his related anxiety about female authorship. Examining a number of Arnold's lyrics in some detail, I suggest several ways the poet strove to create a powerful lyric presence in the face of these anxieties. I argue, first, that Arnold strove to achieve a voice of cultural centrality, but at a cost. He was compelled to represent dialogue—dialogue with women and what he decried as dialogue of the mind with itself.[3] At the same time, he reduced dialogue to what I call pseudodialogue in a struggle for Olympian detachment. A related strategy for coping with the anxiety of audience was Arnold's presentation of the poet as representative man. As with the Olympian posture in Arnold's poems, the voice of the representative man is unstable. Finally, I will turn to Arnold's encounter with women in his elegiac poetry. For a poet who would articulate the conflicts and losses in his culture, an appropriate mode is elegy, and indeed many critics have argued that Arnold is essentially an elegiac poet. I will focus on two elegies, "Haworth Churchyard" and "A Southern Night," to discuss the implications of gender and audience in poems where Arnold's speaker abandons both pseudodialogue and the posture of representative man. These poems, along with Arnold's other important lyrics, do articulate—as Arnold said they did—a main current of Victorian culture. With an irony Arnold might appreciate, we may take his lyrics to represent in their quest for centrism the very impossibility of such achievement.

THE PROBLEM OF GENDER AND AUDIENCE

In his letters to his family and particularly in his letters to Arthur Hugh Clough, we can see Arnold attempting to define for himself the proper relationship of poet and audience. The most significant and immediate of Arnold's audiences were his family and the group he characterized as his "set," loosely consisting of men associated with his university days. As he defined his work against their various presumptions and expectations, these two groups came to represent Arnold's problem of audience. Was he writing for a small circle of educated men or for ordinary middle-class women and men? Was his purpose to give pleasure to those who might appreciate the nuances of classical allusion, or was he to provide a vision of spiritual and moral completeness evolved amidst the concerns of everyday life? How might lyric expressions of emotion represent larger cultural and social matters?

It was not, of course, that Arnold had simply to choose to write for

Clough or for the women in his family. Clearly both Clough and Arnold's mother and sisters represented to him Thomas Arnold's emphasis on learning and public service. But Clough himself had great difficulty in determining how one might be at once a poet, a man of letters, and a morally responsible man, and thus the correspondence between Arnold and Clough is even more revealing than Arnold's letters to his sisters. Arnold's sense of possible isolation from family values was countered in part by the common education and common interests of Arnold's Oxford set and their associates. In examining Arnold's correspondence with his family, we see his ambivalence toward the Arnold women's critical judgments; in examining his correspondence with his Oxford friends, we see an emerging pattern of mysogyny.

Arnold's difficulties about the audience for and purpose of poetry are first visible in his ambivalent relationship with his mother. Mary Arnold, unsurprisingly, often sought in her sons the qualities of their father. For her, despite the fact that she occasionally wrote poems herself, poetry was never to be thought of as a young man's principal occupation, particularly as in her view this vocation might be antithetical to obligations to society.[4] Yet at the outset of his career, as in his Oxford days, Arnold sought her sympathy for the sense of isolation he expressed in his poetry and at the same time sought to impress her with his worldliness and sophistication. Park Honan argues persuasively that Arnold's mother and sister were at once contributing cause and audience for the ambivalences of his early poetry.

While Arnold's mother was a central source of his ambivalence about the relationship between art and social duty, this tension is most clearly articulated in his correspondence with his sister Jane. In an important letter about his first volume of poetry, Arnold does not yet describe a conflict between personal poetry and social concerns, but he contrasts his fragmentary self and fragmentary poetry with a "person who has any inward completeness."[5] In a letter of 1851 he seems to apply this distinction to his mother and sisters at Fox How, this time describing his dilemma as a conflict between worldliness and morality. Arnold understands his relationship to his family in precisely the same terms his contemporaries used to discuss the separation of male and female spheres. Of his relationship to the Arnold women Matthew writes:

> I feel this in my own case, and in no respect more strongly than in my relations to all of you. I am by nature so very different from you, the worldly element enters so much more largely into my composition, that as I become *formed* there seems to grow a gulf between us, which tends to widen till we can hadly [sic] hold any intercourse across it. . . . So I intend not to give myself the rein in following my natural tendency, but to make war against it till it ceases to isolate me from you,

and leaves me with the power to discern and adopt the good which you have, and I have not.[6]

Jane and his mother present to Arnold a sympathetic audience, but one from whom he may be isolated by following his "natural tendency." With Jane, as Park Honan notes, this sense of possible isolation decreased, until in his forties Arnold viewed his older sister as the "keeper of his conscience." But the crux of the matter in Arnold's early poetry was the criticism by the Arnold women, expressed obliquely in Arnold's "Resignation," that Matthew's "ideas about life had no pertinence to ordinary men and women."[7]

While the dominant motif of Arnold's internal conflict was the Arnold family tradition of social service, his dilemma must also be understood as a problem of audience. For in a sense Arnold could realistically be worried that his poetry meant little to "ordinary men and women" or even to the women who constituted his Fox How family. Although Arnold's Oxford friends were sometimes explicitly critical of his poetry, one can still observe in Arnold's correspondence the sense that his primary audience (for poetry, not prose) was defined as educated men rather than as ordinary men and women. If Jane Arnold was a valued—and valuable—audience for Matthew, she represented the voice from outside the classroom, the audience that did not fully share the education of the public school and the university. Indeed, the worldliness that Arnold says isolates him from Jane is not the materialism of the people Arnold would later call Philistines but the world of Oxford and of London in which the intelligentsia and the aristocracy met.

In 1866, when his career as a poet was largely at an end, Arnold wrote to his friend J. C. Shairp on the publication of "Thyrsis," "[T]he voices I do turn to are the voices of our old set, now so scattered, who, at the critical moment of opening life, were among the same influences and (more or less) sought the same things as I did myself." Although this recollection omits the mixed reaction Arnold's friends actually accorded his first volume of poetry and glosses over Arnold's own aloofness, it speaks significantly to that sense of shared community and values that Arnold found at Rugby and at Oxford and that was imperiled when he considered his relationship to a wider audience.[8] A sense of "our set," the substance of its assumptions about and arguments over poetry, could not preclude sometimes serious disagreement. But however Arnold and his friends might quarrel about poetry, beauty, and conscience, they assumed that poetry deeply mattered.

First among Arnold's Oxford friends was, of course, Arthur Hugh Clough, and it is in his correspondence with Clough that a pattern of anxiety about audience and a pattern of misogyny converge. Arnold obviously feels anxiety about his relationship to his audience if he wishes to be taken seriously. He

counsels Clough, for instance, to choose the duodecimo rather than the oc-
tavo format for his first volume of poetry, because the octavo "seems to imply
a large sale and among the people."⁹ If a "large sale" is not to be wished, still
Arnold is not entirely comfortable with a narrower audience—for the women
in even that audience may not have the ready appreciation of the classics and
classical subjects that he can expect among men. About his own first book,
Arnold tells Clough that his Oxford friends had mixed reactions: "Goldwin
Smith likes the classical ones: but they hinder females from liking the book:
and Shairp urges me to speak more from myself: which I less and less have the
inclination to do: or even the power." Despite their difficulty for the "fe-
males," Arnold lists classical subjects for Clough in suggesting literary employ-
ment for him; he proposes an "edition of the Greek lyric poets" in Greek and
English to be done "as if you were writing a book for educated persons
interested in poetry, *and knowing Greek,* to read."¹⁰ Indeed, Clough's view of
Arnold and Arnold's view of suitable literary employment for Clough coin-
cide in their appropriateness as the undertakings of a scholar and a gentleman.
 Arnold's ambivalence toward his audience is also reflected in Clough's
reaction to Arnold's work. In his review of Arnold's first two books, Clough
writes: "[The poems] are, it would seem, the productions . . . of a scholar and
a gentleman; a man who has received a refined education, seen refined 'soci-
ety', and been more, we dare say, in the world, which is called the world, than
in all likelihood has a Glasgow mechanic [i.e., Alexander Smith]. More re-
fined, therefore, and more highly educated sensibilities,—too delicate, are
they, for common service?"¹¹ Clough's praise is surely double-edged (and not
without implications for Clough himself). The scholar and gentleman is
praised for the refinement of soul and intellect—but as for these "too delicate
sensibilities," are they a kind of cultural effeminacy in Clough's view?
 Arnold's compulsion to defend poetry as central to culture even while
serious poetry on classical subjects evidently cannot be popular is intimately
linked with what Howard Foster Lowry rather politely calls Arnold's "dream
of distressing women."¹² Two passages in the letters to Clough so clearly
illustrate this congruence of anxiety and misogyny that they are worth quot-
ing at length. In the first, Arnold writes Clough from Switzerland, 29 Septem-
ber 1848, and he moves without break or comment from a discussion of
poetry and its audience to an invective against women. Even allowing for the
posturing and playfulness of this letter, the congruence is striking:

> I have with me only Beranger and Epictetus: the latter tho: familiar to me, yet be-
> ing Greek, when tired I am, is not much read by me: of the former I am getting tired.
> Horace whom he resembles had to write only for a circle of highly cultivated des-
> illusionés roués, in a sceptical age: we have the sceptical age, but a far different and
> wider audience: violà pourquoi, with all his genius, there is something 'fade' about

Beranger's Epicureanism. Perhaps you don't see the pourquoi, but I think my love does and the paper draws to an end. In the reste, I am glad to be tired of an author: one link in the immense series of cognoscenda et indagenda despatched. More particulary is this my feeling with regard to (I hate the word) women. We know beforehand all they can teach us: yet we are obliged to learn it directly from them.[13]

Arnold concludes this letter with a poem asking about young women, "shall I chuse / Thy little moment life of loveliness / Betwixt blank nothing and abhorred decay / To glue my fruitless gaze on."

Five years after this letter Arnold writes Clough in America a résumé of the British literary climate. He begins by asking Clough what he thinks of that "brazen female" Margaret Fuller:

> I incline to think that the meeting with her would have made me return all the contents of my spiritual stomach but through the screen of a book I willingly look at her and allow her her exquisite intelligence and fineness of aperçus. But my G–d what rot did she and the other female dogs of Boston talk about the Greek mythology! The absence of men of any culture in America . . . must have made her run riot so wildly, and for many years made her insufferable.
>
> Miss [Charlotte] Bronte has written a hideous undelightful convulsed constricted novel [*Villette*]—what does Thackeray say to it. It is one of the most utterly disagreeable books I ever read—and having seen her makes it more so. She is so entirely—what Margaret Fuller was partially—a fire without aliment—one of the most distressing barren sights one can witness. . . .
>
> Thackeray's Esmond you know everyone here calls a failure—but I do not think so. it [sic] is one of the most readable books I ever met—and Thackeray is certainly a first rate journeyman though not a great artist: It gives you an insight into the *heaven born* character of Waverley and Indiana and such like when you read the undeniably powerful but most un-heaven-born productions of the present people—Thackeray—the woman Stowe etc. The woman Stowe by her picture must be a Gorgon—I can quite believe all you tell me of her—a strong Dissenter–religious middle-class person—she will never go far I think.[14]

The most sympathetic woman in the letter, after George Sand, whom Arnold does not mention by name, is Margaret Fuller, who is mercifully not a novelist—and even she can only be seen without nausea through the "screen" of a book. Even she has suffered from the lack of "men of any culture." Margaret Fuller seems to be a Medusa figure; Brontë a consuming fire; and Stowe a Gorgon.[15] The classical tradition is mined for metaphors of female violence. In this letter, which follows an exchange examining the near rupture of the Arnold/Clough friendship, Arnold attempts to establish solidarity with Clough against religious middle-class sorts of persons generally and women writers in particular.

Arnold's anxiety about audience, about women writers, and about the novel as a popular form seems to have succeeded only partially in evoking a

positive response from Clough, for in the review already quoted, which was published four months after this letter, Clough obliquely criticized Arnold's work while praising the novel. Clough argues,

> Poems after classical models, poems from Oriental sources, and the like, have undoubtedly a great literary value. Yet there is no question, it is plain and patent enough, that people much prefer Vanity Fair and Bleak House. Why so? Is it simply because we have grown prudent and prosaic, and should not welcome, as our fathers did, the Marmions and the Rokebys, the Childe Harolds, and the Corsairs? Or is it, that to be widely popular, to gain the ear of multitudes, to shake the hearts of men, poetry should deal more than at present it usually does, with general wants, ordinary feelings, the obvious rather than the rare facts of human nature?[16]

Even Clough, however, will admit that novels telling a plain tale may be read today and thrown away tomorrow.

Despite his advice about being taken seriously and despite Clough's criticism, Arnold was not willing entirely to sulk and leave the world to novelists. He remained distressed about the problem of audience. He wrote to his sister, for example, on the publication of "Merope," a text scarcely calculated to win popular praise: "Indeed, if the opinion of the general public about my poems were the same as that of the leading literary men, I should make more money by them than I do. But, more than this, I should gain the stimulus necessary to enable me to produce my best—all that I have in me, whatever that may be,—to produce which is no light matter with an existence so hampered as mine is."[17]

In this comment on "Merope," as in his correspondence generally, Arnold shows himself to be anxious about audience. Arnold's letters suggest that he wrote poetry despite a sense of divided audience and purposes. We can see in his letters three parallel divisions: the division between classically educated readers and literate, even literary, readers uninitiated to the mysteries of Greek; the division commonly articulated in Victorian society between men's and women's spheres; and the division between the cultural needs of a "worldly" elite and the moral reforming tendencies of ordinary women and men. While the prose to which Arnold increasingly turned was designed to form the taste and the conscience of a wide middle-class audience, his lyrics reflect the anxiety about audience that we see in his letters.

SPEAKING TO WOMEN: OLYMPIAN DETACHMENT
AND PSEUDODIALOGUE

In the face of these anxieties, Arnold defended the centrality of the classically educated poet's perspective. He desired, especially in his early poetry, a

kind of Olympian detachment that he believed would allow him to articulate a coherent cultural vision. In Arnold's poetry we see a man who, wishing to write poetry from a culture's center, had to create an ideology of a center as well as the poetry itself. It is perverse in some ways to speak of *creating* an ideology, especially an ideology of a center, since by definition a dominant ideology is the cultural expression of centrism. But in defending poetry Arnold was embarking on a perverse course, a course that at least apparently ran counter to economic and social realities of his time while ultimately leaving intact the centrality of institutions such as the public school. Arnold's stance was replete with contradictions, for it combined the familial tradition of social criticism and the critical distance that it seemed to require with a sense of a common bond among his set of classically educated men and with his position as his father's son, born into the center of British culture. Arnold's problem then was that of an insider who needed to understand himself both as an outsider and as one offering a new understanding of a cultural ideal.[18] The voice of centrality, of authority, could be conceived as one that necessarily expressed the poet's social duty; yet it did so by suppressing internal questioning that could be potentially decentering. The posture of defending culture muted the most serious attempts at dialogue in Arnold's poetry, especially as this dialgoue took the form of dialgoue with women.[19]

A productive way to understand the problem of Arnold's quest for centrality and its consequences is suggested in Mikhail Bakhtin's definitions of epic and novel, for Arnold's imagined center is strikingly like the world of epic as Bakhtin defines it. In Bakhtin's view the epic refers to an "absolute past"—a time that is not available to new perspectives and that is a "peak" time as defined by a hierarchy of value. The epic is then written by the descendents of this time, and this "idealization of the past in the high genres has something of an official air."[20] The epic thus is a "closed" genre, resistant to experimentation, and the language of epic is ultimately monological rather than dialogical. The novel, in contrast, is an open form, infecting other forms, even in the nineteenth century influencing poetry, and is dialogical. Leaving aside the obvious fact that Arnold never wrote a complete epic—only "epic" episodes—let us turn to a close reading of several of his lyrics in light of Bakhtin's definition of epic and in light of Arnold's anxiety about the novel and its audience.

In several of the relatively early poems, and especially in "Resignation," one can see Arnold working toward an understanding of poetry that would free the poet from contingency. He seeks the Olympian detachment toward the matter of poetry that also is characteristic of the epic poet's approach to the absolute past of the epic subject. Arnold characterizes this stance—when taken toward the present time—as detachment, resignation, stoic self-restraint. As Dwight Culler puts it, Arnold figures the artist as sage, quietist, or strayed reveler who is "imaged by the still point, the moment of stasis, far above and yet plumbing

far below the world's surface."[21] Arnold's poetry is filled with images of descent and ascent, from the Alps of the Obermann and Marguerite poems, to the "Palladium," to the signal elm of "Thyrsis," to the mountains of "Rugby Chapel," and, more pervasively in the early poems, to the fixed stars. From the perspective of the Palladium or of the stars the poet can engage in monologue, the single-voiced response to or depiction of the world; but such a perspective is more to be wished than to be achieved. And the poetry of the failed Olympian is not monologue but pseudodialogue or, more interestingly, suppressed dialogue. In Charles Altieri's memorable phrase, it is the "monologue of the mind with itself."[22]

Arnold's "Resignation" is itself an interesting case in point. Here the poet is imagined scanning "[n]ot his own course, but that of man."[23] He looks down from a godlike height upon historical rulers, beautiful women, and everyday life. He can regard all these as if they were an "eternal mundane spectacle." At the same time, "Resignation" is structured as a pseudodialogue between "Fausta" (Arnold's sister Jane) and the poet. Fausta is given only ten of the poem's 278 lines, and thereafter her thoughts are interpreted by the poet; they seem like the eddying foam she watches, to grow out of no fully imagined differing experience. The structure of the dialogue, and the poem as a whole, tells us very little about Jane Arnold's own experiences, which we can conjecture at this time to have been painful enough.[24] Instead the pseudodialogue allows the poet to express his own doubts and to resolve them through virtually hectoring his supposed interlocutor. He would establish a "we" to include himself and Fausta, but the tone is self-defensive and the verse syntactically and rhythmically tortured:

> Yet they, believe me, who await
> No gifts from chance, have conquered fate.
> They, winning room to see and hear,
> And to men's business not too near,
> Through clouds of individual strife
> Draw homeward to the general life.
> Like leaves by suns not yet uncurled;
> To the wise, foolish; to the world,
> Weak; yet not weak, I might reply,
> Not foolish, Fausta, in His eye,
> To whom each moment in its race,
> Crowd as we will its neutral space,
> Is but a quiet watershed
> Whence, equally, the seas of life and death are fed.
> (247–60)

The god's eye view here is the final self-defense. At the same time it provides a stance for defending poetry.[25]

The self-defensive posture of "Resignation" becomes, if anything, more marked in Arnold's sequence "Switzerland," where the Olympian resolution seems more clearly a resolution of sexual conflict. The poems reveal not only the speaker's problematic relationship to the woman he calls "Marguerite" but also his difficulty with definitions of sexual roles (his statement that we "school our manners, act our parts" seems to bespeak a pained recognition that even sexual identity may involve role-playing). In "A Farewell," the speaker imputes to Marguerite a desire that a man be characterized by "[s]tern strength and promise of control," and then he rebukes her for this ideal, which he confesses himself to have shared. He lectures her, again with a problematic "we," as he imagines some future life in which "we shall not then call hardness force, / Nor lightness wisdom any more." Unity with Marguerite is conceivable to the speaker only in an unearthly atmosphere; they will greet across infinity. And in infinitude Marguerite will be transformed into a sister:

> How sweet, unreached by earthly jars,
> My sister! to maintain with thee
> The hush among the shining stars,
> The calm upon the moonlit sea!
> (77–80)

Of the "Switzerland" sequence, only "To Marguerite—Continued" avoids the difficulties involved in the poet's attempt to speak for the other person and from the Olympian perspective; here Arnold avoids the pseudodialogue by shifting from the first person to the third person and transforming "mortal millions" into hauntingly animate islands.

A number of Arnold's other poems also involve the pseudodialogue. In two of the most interesting of these, "Self-Dependence" and "A Summer Night," the pseudodialogue is used, as it is in "Resignation," to explore the posture of Olympian poise and detachment. The explicit emotional premise of "Self-Dependence" is the suppression of interior dialogue; the speaker confesses he is "Weary of myself, and sick of asking, / What I am, and what ought to be" (1–2). The poet passionately asks to become vast like the stars and waters he sees from the prow of his emblematic vessel. The "clear, star-sown vault of heaven" replies by counseling self-dependence. The stars live "self-poised"

> nor pine with noting
> All the fever of some differing soul.

> 'Bounded by themselves, and unregardful
> In what state God's other works may be,

In their own tasks all their powers pouring,
These attain the mighty life you see.'
(23–28)

This definition of self-dependence as isolation from the fevers of differing
souls, combined with the admiration of Olympian detachment, leads to the
substitution of pseudodialogue for the dialogue with self or others. The
pseudodialogue allows the poet to take on the voice of authority while the
poem covertly acknowledges that this authority has dubious foundation.

In "A Summer Night," a better poem than "Self-Dependence," this aspira-
tion toward the Olympian perspective and this movement toward monologue
cause the technical unevenness that characterizes many of Arnold's poems. "A
Summer Night" takes up the central emblems of "Self-Dependence"—the
night sea journey, the calm detachment of the heavens. The poet describes his
own restless striving and the heaven's reply, though here the reply is presented
more persuasively than in "Self-Dependence" as a feature of the poet's own
consciousness. The moon questions the poet, and the poet replies in perplex-
ity that either most men live in a brazen prison or the few like Titans embark
on night voyages to destruction. Arnold's description is enormously powerful
in its borrowing from Wordsworth, Byron, and Shelley, in its diction and
versification, and in its simple paratactic joining of grammatical elements:

And the pale master on his spar-strewn deck
With anguished face and flying hair
Grasping the rudder hard,
Still bent to make some port he knows not where,
Still standing for some false, impossible shore.
And sterner comes the roar
Of sea and wind, and through the deepening gloom
Fainter and fainter wreck and helmsman loom,
And he too disappears, and comes no more.
(65–73)

Here Arnold does allow himself to imagine concretely "the fever of some
differing soul," yet as the poem draws to a conclusion it moves back toward
Olympian detachment and, paradoxically, loses its rhythmic and acoustic com-
plexity. The speaker addresses the clear and stainless heavens:

I will not say that your mild deeps retain
A tinge, it may be, of their silent pain
Who have longed deeply once, and longed in vain—
But I will rather say that you remain
A world above man's head, to let him see

How boundless might his soul's horizons be,
How vast, yet of what clear transparency!
How it were good to abide there, and breathe free,
How fair a lot to fill
Is left to each man still!

 (83–92)

The conclusion is a concatenation of riding rhyme tacked on to a somewhat awkward iambic pentameter and dotted with exclamation points. Gone is the flexible free verse and imagistic complexity of the middle sections. In "A Summer Night" the price of evoking Olympian detachment is clearly a diminution of poetic power.

From "Resignation" to "A Summer Night," then, the position of Olympian detachment is achieved only through pseudodialogue that suppresses the possibility of genuine dialogue with a female interlocutor or with the other aspect of the self. In these strangled dialogues and pseudodialogues we can see the difficulty of Arnold's struggle toward a voice of centrality and cultural authority.

SPEAKING FOR WOMEN: POET AS REPRESENTATIVE MAN

Arnold succeeds more completely when, instead of so directly attempting the Olympian view, he presents himself as representative man, often beginning with his own experience and modulating into a strain in which his experience is held out as typical. This self-presentation allows the poet to put forward his own struggle as central. Both "The Buried Life" and "Dover Beach" succeed in this way. Yet even these fine poems cannot admit a dialogue with women.

"The Buried Life" is particularly powerful in presenting the obstacles to a true mutuality between friends or lovers. But as Sandra Gilbert and Susan Gubar have pointed out, the process of discovering the buried life is the process of the speaker seeing himself reflected in his companion's eyes—not precisely the same thing as attempting to see oneself through the eyes of another.[26] The dialogue of the mind with itself is resolved, momentarily, but only because the words of a dialogue with another are first dismissed as light mockery and then turned into wordless music: "When our world-deafened ear / Is by the tones of a loved voice caressed / A bolt is shot back somewhere in our breast, / And a lost pulse of feeling stirs again." The effort at generality, the plural "we" of the representative man, results in incongruous images; two persons would appear to hear with single "world-deafened ear." The plural "we" also comports oddly with the conclusion of the strophe and with the sexual connotations of

Arnold's imagery. The picture of mutuality, in which each lover experiences a respite from isolation, is both created and compromised:

> The eye sinks inward, and the heart lies plain,
> And what we mean, we say, and what we would, we know.
> A man becomes aware of his life's flow,
> And hears its winding murmur; and he sees
> The meadow where it glides, the sun, the breeze.
>
> (86–90)

The last strophe of "The Buried Life" recreates the scene of "Resignation"— the calm view from above of the "quiet watershed" where the streams of life and death equally are fed. Though the mutual "we" resolves itself to the masculine third person, the poet is no longer, as in "Resignation," lecturing the woman whom he addresses; he is representative of suffering men. There is no dialogue in "The Buried Life," and the speaker only claims that this representative man "thinks he knows / The hills where his life rose, / And the sea where it goes."

Another claim for representativeness comes in "Dover Beach." Here the poet speaks in the voice of the representative we: "[W]e / Find also in the sound [of the sea] a thought." Yet the manuscript shows that Arnold vacillated between the inclusive plural and the singular in claiming "now I only hear" the melancholy withdrawing roar of the Sea of Faith. And whether or not both the poet and his auditor have heard this withdrawing roar, both are said to inhabit the "darkling plain." Their shared perspective is by implication the shared perspective of Victorian culture. Ironically, though, the descent to the darkling plain creates a kind of Olympus manqué. "Dover Beach" relocates the geography of "Resignation" without substituting dialogue for monologue. As Anthony Hecht's parody makes clear, only one person speaks in the isolation of the darkling plain, and the woman who, Hecht quips, "had read / Sophocles in a fairly good translation" need not reply.[27]

In "Stanzas from the Grand Chartreuse," a poem thematically and biographically close to "The Buried Life" and "Dover Beach," Arnold gradually abandons any pretense of an auditor, while he retains the location of the speaker as representative of his culture. Seeking, again, to speak from the center of culture and to articulate the alienation of the man so placed, Arnold is driven to the periphery, not to the shore of England but to an Alpine monastery. The difficulties of seeking centrality away from the center are apparent in the instabilities of the pronouns in "Stanzas from the Grand Chartreuse." At the poem's beginning "we" and "our" apparently refer to Arnold and his new wife, who accompanied him to the monastery's guest house. We know that Fanny Lucy necessarily remained in the outer precincts

while Matthew entered the cloister.[28] As he enters the abbey's interior, the speaker shifts to the direct, first person question: "And what am I, that I am here?" (66). Next he identifies himself with a nameless and forlorn Greek, and finally with the Carthusians themselves. The speaker and the monks apparently are separated from the "sons of the world" outside the monastery. But this, it turns out, is a false identification, for the poet is himself a son of the world (and of England, as is made clear in "Heine's Grave"), to which he must return. Though the speaker expresses less firm solidarity with the Carthusians than with the woman addressed in "Dover Beach" and "The Buried Life," the cloister and the private life figure for each other in Arnold's poetic economy. Both serve as temporary refuges from the world, even though both would seem to provide security at a price.

As "Stanzas from the Grand Chartreuse" concludes, the plural "we" becomes increasingly problematic. Who is the "we" who "grieve," whose poetic and biographical fathers watered with tears "the sea of time"? Are the silent "kings of modern thought" the representatives of culture for whom the poet, paradoxically, speaks? Is modern European culture then as obsolete as the Carthusians' faith? Must the poet watch industrialization and empire triumph from the outside? So it would appear. Arnold's "end symbol," however, compromises this overly neat dichotomy. "We are like children reared in shade," Arnold's conclusion begins. These children with whom the poet identifies in the plural "we" are soon shown to be separate from, not incorporate with, him. Their reply separates them from him. They have been called to the world too late; they cannot flower in "foreign air."[29] Here again, as in "Dover Beach," Arnold's second thoughts are revealing, for while the children conclude in 1855, "[L]eave our forest to its peace," in 1867 they plead, "[L]eave our desert to its peace" (209–210). Kenneth Allott sees this revision as symptomatic of Arnold's progressive rejection of the "race of them who grieve" and of his increasing allegiance to the sons of the world; I would argue in addition that the unstable identification of the plural first person reveals Arnold's difficulty even at the poem's conception in placing himself as a representative man. The "family" of the monastery with its monk children and its godlike but dead father provides no more satisfactory alternative to the world than an isolated Olympus or the sanctuary of the private life.

SPEAKING ABOUT WOMEN: ELEGY AND NOVEL

Arnold occupies a precarious position as an artist who lacks the audience he needs and as a "son of the world" who is uneasy about both the elite and middle-class values of his culture. As audience, subjects, and writers, women become an important focus of Arnold's dilemma. They figure importantly not only in the poems of pseudodialogue and in those where Arnold presents

himself as representative man but also in two of his most interesting elegies. "Haworth Churchyard" and "A Southern Night" reveal how difficult it could be for a poet striving for cultural centrality to speak about women as artists or to find a female image through which to criticize cultural failures.

In "Haworth Churchyard," his poem on the Brontës and Harriet Martineau, Arnold virtually abandons both the Olympian perspective and the posture of the representative man. These two favorite stances appropriately enough disappear in the only poem we know Arnold wrote about women writers. He observes the scenery from level ground and speaks directly of his own reaction to Emily Brontë's "too bold dying song." In the poem's "Epilogue" the muse takes the poet's harp and interrupts and silences him with a storm. The usual Arnoldian muting of dialogue is reversed, for the poet himself must be silent. The strength of the final version of "Haworth Churchyard" and this conclusion itself were produced by extensive cutting and revising. Between its first publication in 1855 and its second publication in 1877, Arnold removed sixty-five lines and added the fourteen-line epilogue.

The canceled passages reveal an uneasiness about gender (one deleted passage awkwardly presented the artist as male) coupled with a more general concern about the artist's role in society. By contrasting Martineau and Brontë, Arnold makes room for a contrast between the young artist who demands "only to live by the heart" and the mature artist for whom private affections have "run their circle " and left room for "thoughts of the general weal." Yet in 1877 Arnold canceled the passage resting on this dichotomy, leaving the tribute to the Brontës undiluted by the suggestion that such passions as theirs were too limited.

The complexities of Arnold's revisions to "Haworth Churchyard" suggest his anxiety about the artist's role in society and hark back to his anxiety about audience and genre. Park Honan tells us that Arnold's wife and later his daughters attempted to educate him regarding the contemporary novel, a form with which he had little apparent sympathy, despite all the praise in the final version of "Haworth Churchyard." His temperamental aversion to the novel is best summed up in his own remark that "no Arnold could ever write a novel."[30] "Haworth Churchyard" is interesting as it exemplifies Arnold's encounter with the novel and with women novelists (and with Emily Brontë's strongly unconventional poetry). The multiplicity of voices and the complex ironies of the conclusion to *Wuthering Heights* are not to be found even in the final version of "Haworth Churchyard." From this perspective, Arnold's most intriguing failures as well as his successes are not truly dialogical or multi-voiced in the Bakhtinian sense. Though Bakhtin suggests that the poem in the nineteenth century became "novelized" as it became an open form, one can characterize Arnold's work as largely resisting these possibilities.[31]

That these difficulties in Arnold's lyrics are not problems of form divorced

from larger cultural considerations is clear in a poem that in some ways resembles "Haworth Churchyard." In "A Southern Night," which I will examine briefly in conclusion, Arnold again writes an elegiac lyric, but this time the occasion of elegy is both closer to home and more deeply connected to the position of England as Arnold saw it than were the deaths of the Brontës. "A Southern Night" is remarkable in its exploration of what death might mean as understood from the metropolitan center of empire. It raises questions about the adequacy of British culture as measured by the standards of other cultures. And yet in its function as a double elegy for Arnold's brother and his brother's wife, its tone is revealingly inconsistent. At the poem's center is the speaker's belief that his brother and his sister-in-law, who died in the Indian service, should more appropriately be buried in the city than in the rural peace of Gibralter and Dharmsala. He observes regretfully:

> In cities should we English lie,
> Where cries are rising ever new,
> And men's incessant stream goes by—
> We who pursue
>
> Our business with unslackening stride,
> Traverse in troops, with care-filled breast,
> The soft Mediterannean side,
> The Nile, the East.
>
> (61–68)

An Indian "sage," a grey crusading knight, or a youthful troubadour might better repose in rural peace than William Delafield and Fanny Arnold, the poet says. Then, thinking of the double subject of his elegy, he adds to this list, "some girl, who here . . . by moonlight came / To meet her pirate-lover's ship . . . and pined away" (101–10). As Kenneth Allott observes, this Byronic "vignette" was outmoded by 1859;[32] more crucial, though, is the fact that Arnold is driven to Byronism in order to construct a female symbol to hold in nostalgic contrast to "dusty" lives of the "jaded English." While William Delafield Arnold is indirectly flattered by comparison to sage or knight, his wife is diminished by being compared to so fictional and stereotypical a heroine. When these comparisons are checked by the "midnight breeze" and the poet turns to praise the dead directly and to admit that peaceful graves are their due, he can only characterize Fanny Arnold by her silence: "I think of her, whose gentle tongue / All plaint in her own cause controlled" (121–22). The Indian sage and the figures from the European past are in "A Southern Night" effectively silenced into a nostalgic song; the woman is silent in the elegiac present. The brother retains his "bearing free" and "cordial hand" as the poet sees him. At the end of "A Southern Night"

the dead are gathered into the serenity, even the divinity, of nature, but the poem's curious inconsistencies of tone remain as echo to suggest that the "strange irony of fate" is not his brother's alone but the poet's as well. From a perspective lodged in the urban center that Arnold's very poem criticizes, all deaths are not created equal. Only the imagined voice of nature, as in the conclusion of "Haworth Churchyard," can lend both Fanny and William Delafield Arnold serenity and peace.

In "A Southern Night," as in many other lyrics, Arnold pursued from the periphery an ideology of the center and attempted to create a central position from within his culture from which a poet could speak. Arnold sought the voice of authority, even the Olympian view, despite what he saw as the Philistine center of British values, despite the rising popularity of the novel, despite a diversely educated reading public, and despite the formal constraints of the romantic lyric. The attempted rehabilitation of already closed forms in "Sohrab and Rustum," "Balder Dead," and "Merope" is one logical result of this search for cultural authority. So too is Arnold's difficulty in presenting the speaker of the lyric. The pseudodialogue, the suppression of dialogue, and the posture of the representative man were all part of Arnold's attempt to articulate within the lyric form a position central to culture that was at the same time critical of that culture. It is a strange irony that the other voice, often the female voice, in Arnold's lyrics can rarely engage in genuine dialogue. That voice, like Arnold's poetry itself, was prematurely silenced.

NOTES

1. Charles Altieri, "Arnold and Tennyson: The Plight of Victorian Lyricism as Context of Modernism," *Criticism* 20 (1978): 288. Altieri's study is particularly helpful in discussing the problem of authority and the conflict of discourses in Arnold's poetry.

2. Arnold forcefully expresses his view that his culture is inhospitable to art in a letter to Clough, 14 December 1852, *The Letters of Matthew Arnold to Arthur Hugh Clough,* ed. Howard Foster Lowry (London: Oxford University Press, 1932), 126. Hereafter cited as *Letters to Clough.*

3. Matthew Arnold, "Preface to First Edition of *Poems* (1853)," in *The Prose Works of Matthew Arnold,* ed. R. H. Super, 11 vols. (Ann Arbor: University of Michigan Press, 1960), 1:1.

4. Park Honan, *Matthew Arnold: A Life* (New York: McGraw-Hill, 1981), 172–73. Honan's discussion of the young Arnold's relationships with women generally has suggested the direction of my analysis.

5. Arnold to Jane Arnold Forster, 1853[?], *Unpublished Letters of Matthew Arnold,* ed. Arnold Whitridge (New Haven: Yale University Press, 1923), 18.

6. Arnold to Jane Arnold Forster, 25 January 1853, *Letters of Matthew Arnold,*

1848–1888, ed. George W. E. Russell (New York: Macmillan, 1900), 17. Hereafter cited as *Letters.*

7. Honan, *Matthew Arnold,* 177.

8. Arnold to Shairp, 12 April 1866, *Letters,* 380. A. Dwight Culler emphasizes the conflicts, especially the religious conflicts among students and faculty at Oxford during Arnold's years there, but I think the feeling of community in this struggle vis à vis the larger culture is also significant. See Culler's *Imaginative Reason: The Poetry of Matthew Arnold* (New Haven: Yale University Press, 1966; repr. Westport: Greenwood Press, 1976), chapter 3.

9. Arnold to Clough, 4 March 1848, *Letters to Clough,* 70. For further discussion of Arnold and popular versus elite audiences see Carl Dawson, Introduction to *Matthew Arnold: The Poetry,* The Critical Heritage Series (London: Routledge and Kegan Paul, 1973), 1–39. In his study of Arnold and Clough, James Bertram discusses how Clough's friend Thomas Burbidge, with whom he published *Ambarvalia* in 1849, subsequently published his verses in inexpensive paperback, hoping that the series would eventually be bound and that this format would make his poetry available to a popular audience. Clough rephrases a number of Burbidge's notions in his review of Arnold's first two volumes. See James Bertram, "Arnold and Clough," in *Writers and their Background: Matthew Arnold,* ed. Kenneth Allott (Athens: Ohio University Press, 1976), 190–91.

10. Arnold to Clough, March 1849, *Letters to Clough,* 104; 22 April 1852, *Letters to Clough,* 121 (my italics).

11. Arthur Hugh Clough, "Recent English Poetry," *North American Review,* 77 (1853): 12.

12. *Letters to Clough,* 133n.

13. Arnold to Clough, *Letters to Clough,* 92–93.

14. Arnold to Clough, 21 March 1853, *Letters to Clough,* 132–33.

15. Arnold was markedly more moderate when he wrote about Fuller or Brontë to his mother and sister. See Arnold to Jane Arnold Forster, 14 April 1853, *Letters,* 33–34; and Arnold to Mary Arnold, 1853, *Letters,* 35–36.

16. Clough, "Recent English Poetry," 2–3.

17. Arnold to Jane Arnold Foster, 6 August 1858, *Letters,* 71–72.

18. Altieri, in "Arnold and Tennyson," 289, observes of "The Scholar Gypsy" that it makes ironic use of "the final irony, that culture itself can only be preserved as an ideal or a metaphor, and hence will always paralyze or exile those seduced by its nobility."

19. Numerous critics follow Arnold's own discussion of the "dialogue of the mind with itself" to discuss his poems as metaphorically or thematically engaging in dialogue; see, for example, James A. Berlin, "Arnold's Two Poets: The Critical Context," *Studies in English Literature* 23 (1983): 615–31; R. Peter Burnham, " 'Empedocles on Etna' and Matthew Arnold's Argument with History," *The Arnoldian* 11 (1984): 1–21; Warren Johnson, "The Three Voices of Poetry in 'The Scholar Gipsy,' " *Victorian Poetry* 23 (1985): 379–90.

20. Mikhail Bakhtin, "Epic and Novel," in *The Dialogic Imagination,* ed. Michael Holquist and trans. Holquist and Caryl Emerson, University of Texas Press

Slavic Series (Austin: University of Texas Press, 1981), 18, 20. For a feminist critique of Bakhtin that contributed to my own use of Bakhtin's criticism, see Wayne C. Booth, "Freedom of Interpretation: Bakhtin and the Challenge of Feminist Criticism," in *Bakhtin: Essays and Dialogues on His Work,* ed. Gary Saul Morson (Chicago: University of Chicago Press, 1986), 145–79.

21. Culler, *Imaginative Reason,* 15; on Thucydides and the heights of Epipolae as echoed in "Dover Beach," see p. 41. My use of the term *Olympian* is general rather than a specific argument about Arnold's classicism; for detailed and sympathetic treatment of Arnold and the Olympian muses, see Joyce Zonana, "Matthew Arnold and the Muse: The Limits of the Olympian Ideal," *Victorian Poetry* 23 (1985): 59–74. My discussion follows, if critically, that of William A. Madden, who observes, "Even when he goes out of himself in narrative or drama, the egotistical element is there, described by R. H. Hutton as a 'clear, self-contained, thoughtful, heroic egotism', and lends Olympian dignity and grace to poems that are in fact profoundly sad and personal," in "Arnold the Poet," *Writers and Their Background,* 68–69.

22. Altieri, "Arnold and Tennyson," 285.

23. Matthew Arnold, "Resignation," in *The Poems of Matthew Arnold,* ed. Kenneth Allott (London: Longmans, Green, 1965), l. 146. All further references to Arnold's poetry, his manuscript revisions, and his revisions in various editions follow this edition and are identified parenthetically by line number.

24. Allott, in *The Poems of Matthew Arnold,* discusses this poem as counsel for Jane, who had broken her engagement to George Cotton, assistant master at Rugby; Jane's depression and the family quarrel about the engagement may have been predisposing causes of Thomas Arnold's death a few weeks later.

25. For a more sympathetic reading, see Dorothy Mermin, *The Audience in the Poem* (New Brunswick: Rutgers University Press, 1983), 88–91.

26. Sandra M. Gilbert and Susan Gubar, *The Madwoman in the Attic* (New Haven: Yale University Press, 1979), 401–2. Gilbert and Gubar also discuss "Haworth Churchyard" and Arnold's reaction to Brontë's *Villette,* although they quote the milder version of Arnold's criticism of *Villette.*

27. Anthony Hecht, "The Dover Bitch: A Criticism of Life," in *Matthew Arnold: A Collection of Critical Essays,* ed. David J. DeLaura (Englewood Cliffs: Prentice-Hall, 1973), 54.

28. Honan, *Matthew Arnold,* 239.

29. Roger B. Wilkenfeld also discusses Arnold's ambivalence toward the Carthusians in "Arnold's Way in 'Stanzas from the Grande Chartreuse,'" *Victorian Poetry* 23 (1985): 416–17.

30. Culler, *Imaginative Reason,* 120.

31. Mermin, *The Audience in the Poem,* points out that the ending of "Dover Beach" involves the same retreat to domesticity that often characterized the conclusion of a Victorian novel; her discussion as a whole makes clear how much more likely than Arnold were Clough, Meredith, Browning, and Tennyson to employ novelistic devices. See Mermin's third chapter, pp. 83–108, especially pp. 83–84, 106–108.

32. Allott, ed., *Poems of Matthew Arnold,* 461.

D E B O R A H A . H O O K E R

AMBIGUOUS BODIES

Keats and the Problem of Resurrection in Tennyson's "Demeter and Persephone"

If "something maternal" happens to bear upon the uncertainty that I call abjection, it illuminates the literary scription of the essential struggle that a writer (man or woman) has to engage in with what he calls demonic only to call attention to it as the inseparable obverse of his very being, of the other (sex) that torments and possesses him. Does one write under any other condition than being possessed by abjection, in an indefinite catharsis? . . . none will accuse of being a usurper the artist who, even if he does not know it, is an undoer of narcissism and of all imaginary identity as well, sexual included.
 —Julia Kristeva, *The Powers of Horror: An Essay on Abjection*

When a text openly proclaims its dependence on a mythic model, an insistence on repetition inevitably dominates analysis. Consequently, many readings of Tennyson's "Demeter and Persephone" illumine his faithfulness to the themes of circularity and regeneration and to the imagistic parameters suggested by his sources.[1] James Kissane, for example, locates the thematic center of the poem in its imagery of opposites—light/dark, winter/spring, life/death—and in the poem's "susceptibility to an inverse interpretation" of these dichotomies: "not death in life but life in death." Highlighting the gender-marked nature of the struggle evinced in both the myth and the poem, Christine Gallant promotes the resultant acceptance of cyclicity as a "typically feminine attitude towards existence."[2]

In a more recent reading that takes us beyond such thematic touchstones, Donald Hair expands this reconciliation of opposites into a new concept of the heroic. He anchors it, significantly, within the "domestic affections of the household," the preserve, as Victorian domestic ideology would testify, of quintessentially feminine attitudes. According to Hair, Tennyson invested domestic harmony with an evolutionary significance, for upon it "the order of civilization depended; and out of [it] came the children who were the visible link between [Tennyson's] own generation and the 'crowning race' envisioned at the end of *In Memoriam*"[3]

The strongest domestic relationship figured in "Demeter and Persephone" is, obviously, that between mother and daughter, a pointed rerouting of the traditional pathways along which signifiers of lineage are usually conveyed. Father Zeus remains resolutely in the shadows of Tennyson's poem, subject to the same brief and abstract characterization accorded all the masculine figures except for Hermes. Though relegated offstage, however, the "Bright one in the highest" and "the Dark one in the lowest" (father and uncle, Zeus and Aidoneus, 93–94) function, in line with tradition, as coconspirators. From the shadows they collaborate on the mechanism of Persephone's abduction and ultimately bring the anguished narrative of the mother into being.

At this point it would be quite easy to reduce the myth itself, in light of Lacanian psychoanalysis, to a narrative of signification: the disruption of the mother/child dyad is achieved by the intercession of the Imaginary Father; this intercession is achieved by a kind of double reflex on the part of the emerging subject in response to the mother's desires. On the one hand, the child identifies *with* the mother's desire, as that which completes her—the Imaginary Father. On the other hand, this identification contains an equal and opposite reflex, which is the recognition that the mother desires *at all*; she lacks, and, therefore, the child is not all to her. The gap or difference thus installed between the place of the Imaginary Father and that of the emerging subject inaugurates the possibility of signification and subjectivity. The emerging's subject's confrontation with the difference-from-the-mother that inaugurates the possibility of signification is suggested, too, by the literal "gap" scarring the landscape of Persephone's abduction.

However, given this similarity between the myth and that psychoanalytic model, Tennyson's text intrigues precisely because this psychic configuration plays itself out with most consequence in the domain of the mother. "Demeter and Persephone" foregrounds the mother as the subject of language, as she generates her narrative in and about the absence of its referent—her daughter—who, following the dictates of psychoanalytic theory, comes to occupy the fantasized position of the lost mother. With crucial consequences for the poem's concern with a specific sort of lineage, "Demeter" complicates the easy assignment of position and affect usually conveyed by reading

through such paradigms. After all, it is Demeter who is awestruck by the sight of her resurrected daughter's "imperial disimpassioned eyes" (23); and it is Demeter who is excluded from the realm of sexuality per se, much as a child is denied access to the realm of parental desire. If this is a narrative of signification found, then it is the mother's and not the child's.

But unlike the child, banished forever from the lost "object" of that relationship with the mother, "Demeter" dramatizes, from the maternal perspective, the resurrection and partial restoration of precisely that. The trope of resurrection within this context of signification thus suggests some recuperation of what symbolization negates: "The symbol manifests itself first of all as the murder of the real thing, and this death constitutes in the subject the eternalization of his desire."[4] The myth, with its emphasis on this partial recuperability within the scheme of symbolic loss, subsequently proposes itself as a narrative of the poetic process and of what Julia Kristeva has most completely theorized as the semiotic property of language—the rhythmic, musical, unsignifiable underside of the symbolic that arises from and in connection with the mother's bodily interactions with her child. Poetic language, as Kristeva asserts, "would then be, contrary to murder and the univocity of verbal message, a reconciliation with what murder as well as names were separated from. It would be an attempt to symbolize the 'beginning,' an attempt to name the other facet of taboo: pleasure, pain."[5]

Tennyson's particular deployment of the mother/daughter configuration in "Demeter and Persephone" through the trope of resurrection, I want to argue, enables him to explore a notion of poetic lineage and tradition markedly different from the agonistic, Bloomian paradigm constructed along masculine, oedipalized imaginings.[6] By redirecting the scene of signification away from the child's subjectivity and ostensibly toward the mother's, and by problematizing fixed familial positions through what the allusive body of the resurrected daughter exposes, Tennyson schematizes the central preoccupation of his poem—an acceptance of the recursive character of poetic creation and of poetic voice as interminably dialogic. The mother/daughter trope allows Tennyson to figure poetic tradition and lineage in terms of an eternal musicality, one that is linked inextricably to the maternal sphere. This musicality underwrites poetic language, signifying both the mother's loss and the partial recuperability of her presence within poetry's continued acts of song.

It is Demeter's reclamation of her violated daughter that signals the concern with poetic voice and lineage. As Patricia Joplin reminds us, what "resounds most loudly" through the trope of sexual violence enacted upon the female body is "often the poet's struggle with words." Sexual violence or its suggestion, the act that certainly generates Demeter's narrative, figures as a conscious reenactment upon the woman's body of the poet's linguistic birth, that later violence reinscribing "the anxious memory of an original moment

of rupture," the violence of coming into symbolic being.[7] Though aestheti-
cally transfigured in Demeter's account, her entire narrative issues from the
site of violation and insists upon the poem's preoccupation with poetic subjec-
tivity. Spoken from the "black blur of earth / Left by that closing chasm" of
the uncle's theft (37–38), Demeter's language barely cloaks the images of
sexual assault: the appearance of Aïdoneus (Greek for "phallus"), his car
"rising" to "rapt [Persephone] hence" (38–39), intimates the unspoken rape.
A traditional trope, the identification of female sexuality with flowers and
deflowering, affirms as well the forceful obliteration of Persephone's virgin-
ity: as the "team of Hell . . . pierce[s] the glad and songful air" and "Jet[s]
upward through the mid-day blossom" (44–45, 47), Persephone's "hand let
fall [her] gathered flower" (9). Demeter reclaims Persephone on the site of
her trauma in images that reconstruct the painful mechanisms of her sexual
undoing.

Reading that process psychoanalytically, David Shaw correlates Demeter's
aesthetically blurred attempts to "break thro' " Persephone's "clouded memo-
ries" and reclaim her "lost self" (10–11) with the practices of cathartic ther-
apy.[8] But given the concern with poetic voice here, who or what is resurrected,
and who or what is cathartically laid to rest? The clues lie with the speechless
daughter and the fact that, though reclaimed, Persephone never speaks directly
to us. She is accorded, instead, one ventriloquized word, the elemental cry—
"Mother!"—around whose fantasized body this text will unfold.

Implicitly, Persephone's silence provides yet another version of the trope of
Philomela, the silenced female, her tongue ripped out to ensure her complic-
ity with the violence to which she has been subjected. But given that Deme-
ter's narrative pointedly confesses to that violence as compelling her own
voice, how do we read her invocation of that trope within Joplin's hypothesis
that sexual violence in a poetic text represents both an allusion to poetic birth
and the anxiety of voice in general? In other words, whose voice is at risk here
in the displaced reiteration of the process that shattered Persephone's "glad
and songful air"?

I would suggest that the terms by which the resurrection is enacted in-
scribe the necessary Other within Tennyson's recursive poetics. For whether
or not we accept Demeter's voice as the poet's own, the fact remains that the
voice with whom Tennyson's persona dialogues, the voice his text summons
through Persephone's silence and through the contextualization of her resur-
rection is Tennyson's Other, the imago of Keats, his most problematic precur-
sor and according to standard Freudian paradigms his poetic "Father."
Persephone's silence, like the analyst's, supplies the negative upon which is
etched and exposed the imago of the Other to whom Demeter's discourse is
ultimately directed, "this presence to whom the patient insists upon speaking,
in spite of the listener's silence."[9] To extend substantially the conclusion of

Kissane's reading here, each voice and position in this domestic topos oper-
ates unreservedly within a "susceptibility to an inverse [and asymmetrical]
interpretation."[10]

In effect, then, the text offers two seemingly discordant tropes whose
coexistence disrupts the usual analogues that could be drawn between familial
lines and poetic lineage; it offers, at best, a confusion of bodies: who precedes
whom, and whose voice authorizes or enables whose representations? The
mother/daughter configuration operates as the text's elegiac narrative of recla-
mation wherein the daughter literally and figuratively depends upon the
mother for her embodiment; yet, as both instigator and product of that
reclamation, the silenced woman and her allusive body expose Tennyson's
precursory "father" and open this surface narrative to illuminate the deeper
textual struggles involved in resurrecting a voice inevitably not one's own.

In her analysis of the place of the daughter in the genesis of standard Freud-
ian paradigms, Sarah Steinberg notes that the daughter provided the agency,
the "symptomatic evidence of repressed desire that authorized [Freud's]
representation of the unconscious." Her hysterical symptoms, unyielding to
"local diagnosis," catalyzed his postulate of a "contradictory state of con-
sciousness." Shoshana Felman spells out the radical consequences of that
postulate:

> What Freud reads in the hysteric is not his own resemblance but, rather, his own
> difference from himself; the reading necessarily passes through the Other, and in the
> Other, reads not identity (Other or same), but difference and self-difference. . . . The
> reading is revolutionary in that it is essentially, constitutively dialogic. It is grounded
> in a division; it cannot be synthesized, summed up in a monologue.[11]

So Demeter's monologue is rendered dialogic, radically other, through the
presence of her silenced daughter arising at the site of trauma and loss, which
is alternately the site of reclamation. The ensuing dialogue coalesces around
various echoes of Keats that resurrect, through the allusive body of the daugh-
ter, the troublesome issues of poetic voice and questions about its genesis, its
originality, and its value—anxieties that appear so readily in Keat's own
works. But the traditional father/son topos that constructs its meaning and
value along lines of struggle and mastery is refigured here by an agency whose
effects Victorian readers would have surely associated with the stereotypically
maternal. Rather than attempting to correct or to supplant, as in the oedi-
palized models, this maternal configuration invokes and attempts to complete
the desires of the precursor, to comfort the anxieties voiced in his poems, and
in so doing constructs poetic tradition within traditionally female parameters.

However, even in this context, the trope of resurrection clearly poses the
risk of self-effacement for Tennyson. Christopher Ricks and others have

pointed out, for example, the distinctly imitative aspects of "Demeter," the not-so-subtle borrowings from Keats's second "Hyperion" and "Ode to Autumn." These repetitions undoubtedly signify Tennyson's indebtedness to Keats; however, the character of these contextualizations, couched ultimately in terms of the daughter's dependence upon the mother's generous solicitude, suggests any precursor's ultimate reliance upon those who come afterward to confirm, extend, and more fully "embody" his/her words and influence within the whole of poetic tradition. What is more, these allusions, appearing in the poem's final stanzas, retroactively confirm the more covert invocation of Keats in the poem's opening lines and in so doing amplify its thematics of recursion.

In the opening simile of the poem, the tentativeness of Demeter's voice and the feasibility of her own narrative are invoked in terms uniting their fragility to that of the figure who comes more and more to embody Tennyson's predecessor: "Faint as a climate-changing bird that flies / All night across the darkness, and at dawn / Falls on the threshold of her native land" (1–3), the daughter is "Led upward . . . dazed and dumb" (5–6). Positioned on this site of vocal and visual tentativeness, this silent figure of the resurrected daughter is linked immediately to the phantom of Keats precisely through the trope of threshold, "With passing through at once from state to state" (7).

As Geoffrey Hartman and others have remarked, all of Keats's odes, with the arguable exception of his final "Ode to Autumn," are threshold poems. The persona stands always on the border of transformation, of crossing over into the luminous realm where imaginative identification heightens experience to such a degree that subject and object status are obliterated. Most of the odes, Hartman reminds us, "are feverish quests to enter into the life of the pictured scene, to be totally where the imagination is."[12]

In this opening simile, Tennyson not only offers an innocent description of the resurrected Persephone coming into focus but also announces the arrival of the precursor's voice, which though now "dazed and dumb" will, in the poem's final stanzas, attain an unmistakable clarity. What is more, however, Tennyson situates the phantom of his precursor precisely in a position that Keats could never, in all the "feverish quests" of the odes, attain—at the fulfillment of his desire, in the "life of [the] pictured scene." The daughter's representation and ultimately her voice, as well as Demeter's, falling on the "threshold of her native land," are summoned to inhabit what Keats would have found most desirable and always most elusive in terms of his own anxiety about precursory texts—the verdant and suggestive landscape of Greek mythology.

But the stereotypically maternal agency of the poem transforms this potentially hierarchizing act—of completing what the predecessor could not—into

a confession of shared poetic anxiety. Demeter's attempts to refurbish the site of "blank earth-baldness" with the absent Persephone's flowers recall Keats's own refurbishing attempts in "Endymion," his "frustrated response," according to Martin Aske, to an idealized antiquity, a position that Keats had subsequently come to occupy for Tennyson:

> Keats's declared intent toward "Endymion"—to "make 4000 lines of one bare circumstance and fill them with poetry"—confesses to an inability to do other than *redress* the wilderness of his modernity with literal flowers of speech, in [his] errant and endless search for a pure representation of that beautiful Greece with its beautiful tales.[13]

It is by using the virginal flowers that fell with Persephone's "lost self" that "Demeter's" landscape "clothes itself afresh." And it is through the agency of the daughter and the pressure of her silent presence that the landscape attains a prior brilliance: "as thy footstep falls, / All flowers . . . brighten," Demeter confesses, setting "The field of Enna . . . once more ablaze" (36–37, 35). Thus, Tennyson's persona openly admits to a certain lack of facility, to redressing the landscape with someone else's "lost," or here appropriated, flowers of speech. But by situating the specter of his precursor in the very locus of his belatedness—the Greek landscape—Tennyson parlays certain indebtedness into a confession of shared circumscription: both poets bear the same blessed stigmata, the wound of belatedness. Through positioning the imago of Keats in the "life of [the] pictured scene," Tennyson does more than answer his precursor's desire and provide the first acknowledgment of poetic lineage in terms of shared anxiety; he invokes the central problematic of his poem: the impossible originality, the nonsingularity of the imagination. Through the cathartic resurrection of the Persephone figure (and the precursor that she comes to embody), he hints as well at a reconciliation to the idea that completion, the full embodiment of poetic voice, lies always in the future, to be enacted within the continued songs of future poets or readings by future readers.

Tennyson reaffirms both the precursor's presence and his place within a poetics of recursion through the agency that punctuates Persephone's successful resurrection. In an act of homage that itself becomes here, and elsewhere in the poem, synonymous with all song, a "sudden nightingale / Saw [her], and flashed into a frolic of song / And welcome" (11–13). This image of the nightingale, following fast on the invocation of his precursor's most famed trope of threshold, clearly suggests a thematic kinship with Keats's most famous ode, itself an admission of problematized voice. This bare invocation of the nightingale, an emblem of pure song, seals a connection with Keats's ode and links that text to Tennyson's by means of a particular mother/

daughter dynamic. This dynamic refigures poetic tradition in terms of the mother/child dyad and of song as evidence of its always only partial or fantasized completion.

Keats's "Ode to a Nightingale" offers a precursory mother/daughter configuration but, in contradistinction to "Demeter," depicts the absent and longed-for figure as the mother. Recalling the poignant image of the biblical Ruth separated from her adopted mother Naomi, Keats links this loss of, and desire for, the maternal figure directly to the presence of song, to the purely evocative character and impetus behind the lyric voice itself. Nearly entranced by the melody of the bird that has elicited this image of Ruth alone in the landscape, Keats's persona openly speculates about the eternal efficacy of the bird's song to evoke the anguish of human absence, the loss and lost of history. Perhaps, he speculates, the voice he hears "this passing night" has been heard before and heard eternally. Perhaps it is "the self-same song that found a path / Through the sad heart of Ruth, when, sick for home, / She stood in tears among the alien corn" (63, 65–67).[14]

As Tennyson's nightingale welcomes Persephone into Demeter's narrative, it simultaneously draws the "sad heart" of Keats's ode into the sad heart of Demeter's lament. By drawing the image of the daughter Ruth and the absent mother Naomi into his poem as parallel, though reversed, subject and object of the desire that engendered Demeter's "childless cry," Tennyson reinvokes the paradigm by which Keats explored the genesis of lyric voice. When Tennyson poses an object—the mother Demeter—occupying a position capable of completing the desire of the anguished daughter in the precursor poem (just as Keats's Ruth poses a similar completion for Demeter), he metaphorizes the tradition of lyric voice in terms of the always only partial recuperation of the mother/child relationship. What is more, this anchoring of the thematics of lyric voice within the mother/child configuration reaffirms Tennyson's kinship with Keats within such a tradition. The mother/daughter configuration, which poses each poet's voice as the *potential* fulfillment of the lack that engendered the other's song, acknowledges precursory influence but asserts, too, in that condition of potentiality, its necessary shortfall. The feminine couples operating within and between these two poems necessarily represent figures of potential completion or partial restoration of the mother/child relationship because, as the ode has suggested, it is precisely the "absence" of that fulfilled relationship that gives impetus to, and is most nearly identifiable with, the lyric voice. Thus the relationship between the precursor and the ephebe comes to be signified through the potentially reciprocating figures of the mother/daughter dyad, figures that equalize rather than hierarchize lack.

Moreover, Tennyson's deployment of Demeter as mother to the precursory figure evoked in Persephone certainly eclipses the logic of temporal

orderings, and in this fluid blurring of maternally inflected boundaries and positions posits a certain semiotic foundation for poetry. Diane Hunter outlines the salient characteristics of this presymbolic world: "Before we enter the grammatical order of language, we exist in a dyadic, semiotic world of pure sound and body rhythms" wherein we encounter "the immediacy of semiotic and corporeal rapport" (98–99). The "matter" of semiotics, according to Kristeva, is "irreducible to . . . intelligible verbal translation: it is musical, anterior to judgment" and to the propositional capacities of language that harness and utilize semiotic effects in and through the later workings of syntax. Indeed, Kristeva ultimately characterizes the operation of poetic language in terms of rebirth or resurrection. In her elaboration of the poetic text as a site consciously "exporting semiotic motility across the border on which the symbolic is established," the artist, she maintains, "sketches out a kind of second birth."[15]

Tennyson's reliance upon the feminine nexus within the trope of resurrection repeatedly affirms and recognizes recursion, the return of what symbolization represses; by so doing, he affirms poetic lineage as that "history" of the affective, semiotic heritage of sound arising from the unsignifiable maternal sphere, in-mixing with and underwriting the propositional capabilities of language. What is more, this conflation of bodies in "Demeter," this fluid mirage of the poetic family and the members' fantasized but forestalled completion in one another, attempts to transform the very structure that would silence song—the anxiety of belatedness. Originality, the crux of the anxiety of influence syndrome, is revealed as a radically dialogic phenomenon—necessarily passing through an Other, simultaneously upheld, healed, and threatened by it.

Within the alien and ruined landscape of the second part of "Demeter," the healing property of the word is directly thematized. More overtly now than before, Tennyson reclaims Keats, most prominently through allusions to his second "Hyperion" with its identical question about poetry's redemptive capabilities and its attendant anxieties over the weight of poetic tradition. The force of Tennyson's reply to "Hyperion," the manner in which he addresses the anxieties of his precursor, relies upon a pointedly humanized Demeter whose maternality substantiates this poem's revisioning of poetic tradition as a model of reciprocity.

The figural and thematic similarities between Keats's second "Hyperion" and Tennyson's "Demeter" are explicit: the persona of "Hyperion," like Persephone, is a resurrected figure who has "felt / What 'tis to die and live again before / [His] fated hour" (1:141–43); the masculine gods of the old order await, in both texts, the birth of some new hierarchy that promises either to supplant or to endorse them. Whereas Tennyson's persona confronts a "dazed and dumb" daughter, the questing poet of "Hyperion" confronts the "Half-closed, and visionless" eyes of Moneta that "saw [him] not, / But in

blank splendour, beam'd like the mild moon" (1:267–69), a visage not unlike Persephone's own "imperial disimpassioned" countenance.

Behind Moneta, as behind Ruth, lies yet another mother figure. Keats's persona, according to Geoffrey Hartman, "confronts a High Priestess who is at once the ghost of his dead mother and the conscience of all the great poets before him who had wished for a role equal in importance to that of healing the sick."[16] But Keats only goes so far as to pose the issue of poetry's value and its redemptive capabilities in his text. His pivotal female figure only comments ambiguously on those questions and gestures, even more ambiguously, toward the conditions that might ensure the worth of poetic livelihood.

In "Hyperion" the possibility of healing or redemption through poetry explicitly dissipates as the poem sweeps through the decaying figures of old ideals gone to ruin. The lassitude of both the displaced and impotent Saturn and the insecure Hyperion bespeaks the enervation, for Keats's poetry, of these recursions into figures of epic and idealized grandeur. The precariousness of future direction is figured in the vision of endless change supplied by Moneta. In short, Keats's questions about the nature or worth of the poetic endeavor embody other anxieties of a more personal nature: what topos can one embrace in order to resuscitate one's own work; what topos will revivify the crucial link between past and present? In the vision beyond Moneta, Keats's persona confronts the negative implications of his dependence upon the tropes of antiquity; according to Hartman, he faces the "alienated, silenced faces . . . the death masks of the gods," "sculpture builded-up upon the grave / Of their own power." Hartman raises the question about how we are to read this response. We see only Moneta's visage, rapidly and eternally changing, a face about to dissolve, maintaining the barest semblance of humanity.[17]

Arguably, Tennyson's "Demeter" brings this maternal visage, and thus an answer to Keats's questions, back into focus along resolutely human, as opposed to Olympian, lines. For the poem traces Demeter's assumption of distinctly human limitations and figures, and in that assumption is a means of rethinking tradition and its potentiality for healing others and revitalizing itself. By drawing in the image of the precursory mother (Moneta) through the figure of Persephone, Tennyson again attempts to answer the "sad heart" of "Hyperion," to address the precursor anxiety of Keats, and, by extension, to allay his own thralldom to the idealized antiquity that Keats had come to represent for him.

While Keats's anxiety, voiced in "Hyperion," over whether poetry can exert a redemptive force, is patently reiterated in Demeter's plea for "younger kindlier Gods to bear us down," healing gods who would "stay / Not spread the plague, the famine" (129, 131–32), her response to the loss of an ideal

world through the loss of her daughter is to embrace and to humanize the landscape by positing a future transformation of humanity into gods. Hers is not an idealization, like "Hyperion's," imposed from above, from the masks of the idealized past, of "sculptures builded up upon the grave"; instead, Demeter's ideals are generated, appropriately, from the ground up. Her recourse is to the "souls of men, who grew beyond their race / And made themselves as Gods against the fear / Of Death and Hell" (138–40). Indeed, as Daniel Albright argues, "[T]he whole thrust of the poem is to humanize the gods," to throw off the death mask of antiquity, a pointed rejoinder to the lament for the fallen gods of the precursor poem.[18]

Tennyson elevates this evolutionary potential of humanity to a principle determining poetic perspective and offers Demeter's maternality, grown recognizably human in both its desire and limitations, as the metaphor by which a sustaining and healing narrative can be envisioned. Maternality becomes, here, synonymous with a predilection for the concrete and particular, the present embodiment of the human condition as opposed to the shadowed, abstract, masked beings of Olympus. In a sense, the non-Olympian nature of Demeter's maternality echoes Moneta's admonition to Keats's persona in "Hyperion" to give up his thralldom to the mask of antiquity: "Thou art a dreaming thing," Moneta accuses him, "A fever of thyself. Think of the Earth" (1:168–69). Demeter's maternality, solidifying her affinity with beasts and humans, marks her opposition to and disdain for Olympian powers.

> Child, when thou wert gone,
> I envied human wives, and nested birds,
> Yea, the cubbed lioness; went in search of thee
> Through many a palace, many a cot, and gave
> Thy breast to ailing infants in the night,
> And set the mother waking in amaze
> To find her sick one whole.
>
> (52–57)

Significantly, in marked distinction to the nourishment she offers the human figures in the landscape, Demeter rejects the food that nourishes the gods: their "nectar smacked of hemlock on the lips, / Their rich ambrosia tasted aconite" (102–3). This refusal of Olympian sustenance and the "hard Eternities" it sustains echoes the anxiety of tradition that introduces Keats's second "Hyperion"; but, more importantly, the substitution of a key signifier of Demeter's maternity for that burden suggests a way to reenvision that Olympian weight.

The Keatsian persona fully attests to the power of the precursor, to "the domineering potion" (54):

> I took,
> And, pledging all the mortals of the world,
> And all the dead whose names are in our lips,
> Drank. That full draught is parent of my theme.
> (1:43–46)

As "parent of his theme," this hereditary condition of language ultimately posits words, voice, as constant resurrection of "all the dead," much as modern psycholinguistic theory has.

But Tennyson modifies the Olympian weight of the precursor suggested by Keats's "domineering potion" and the burden of a language that always speaks of a certain mark missed in its articulation of desire, by refiguring poetic tradition in terms of the necessary sustenance offered by a maternal body. He transfigures the isolate and intimidating cup of tradition grasped by Keats's persona into the fluid of the maternal body that literally sustains generations. "The full draught" in "Demeter" is the fluid of the maternal body, the breast offered by the humanized goddess to ailing infants to "make a sick one whole."

If we allow the shadow of Keats to reside in Persephone's resurrected image, then Tennyson's ambiguous "thy," indicating possession of the breast, again clouds the issue of poetic precedence: whose potion is it that heals here? Who nurtures whom in this figurative exposition of poetic lineage? The breast rightfully belongs to Persephone, for her use; it is, however, the mother's, of the maternal body. Again, as if in a deliberate attempt to resituate Keats beyond his interminable struggle with antiquity and to dramatize his own similar struggle, Tennyson substitutes the maternal breast for the "domineering potion" of tradition and invokes in the mother/daughter dyad the very image of reciprocity. As a literal depiction of the transubstantiated body and a metaphor for the precursory text, the breast is an object whose potency resides precisely in its use: its emptying out by the child, the ephebe, categorically ensures its replenishment.

Answering the anxieties of "Hyperion," Tennyson refigures tradition in terms of a maternality that connects all levels of existence and offers a model of poetic reciprocity that mitigates the burden of idealized precursors. It metaphorically asserts for poetry a place of necessity equal to that of bodily sustenance. However, these gestures in no way address the issue of poetic distinctiveness. One cannot merely mirror or "drink in" tradition and hope to distinguish oneself. Situated within the larger tradition of poetics as the impetus to song, that distinction would have to be, and is, figured here as loss. In "Demeter" the loss of the "daughter," and thus the precursor, finds its most heightened expression in the poem's central stanzas, which, ironically, focus on the element by which critics have

frequently allied the two poets, that is, the pictorial similarities of their landscapes.

In the central stanzas of the poem (51–120), Demeter recounts her relentless scouring of the landscape for signs of her lost child. As earth-mother, her consciousness had enjoyed a privileged in-mixing with that of the anthropomorphized elements; but the voices that answer her from that landscape now are devoid of knowledge about Persephone. In view of those answers, which certify her new-found limitations, the mother debunks her own divinity and derisively dismisses as fiction her status as phallic mother:

> . . . I stared from every eagle-peak,
> I thridded the black heart of all the woods,
> I peered through tomb and cave, and in the storms
> Of Autumn swept across the city, and heard
> The murmur of their temples chanting me,
> Me, me, the desolate Mother!
>
> . . . but trace of thee,
> I saw not;
>
> (67–80)

The homage paid her—they chanted "me / Me, me, the desolate Mother!"— ironically reveals the fallacy of a mythologized and idealized status that would have guaranteed her immunity to pain and loss. Reduced to the status of her human counterparts, Demeter is now herself the "mother waking in a maze" of a landscape that she, in effect, can no longer read or through which she can no longer ascertain a path toward her lost child. This is not a landscape that will reveal either the daughter or the precursor summoned through her; it is a landscape that reads as the absence of both.

However, in the frustrating culmination of her search across this mythologized landscape, Tennyson's persona passes a canny judgment upon all the idealized topoi of antiquity and all the influence of predecessors. In her punning summation of the answer given back to her from the landscape— "Nothing knew"—she responds not only to the poet's necessary dependence upon all precursory topoi but also to the obvious limitations implicit in them; they are, by definition, "nothing new." And, as if to respond, both figuratively and literally, to the critics who would link him most inextricably with Keats, Tennyson's persona loses the resurrected image of the precursor precisely on those "grounds" that should have most strongly attested to their similarity.

Ironically, commentators often point to the renderings of landscape as the faculty that demonstrates the "all important kinship of spirit between the two

poets." George Ford notes that the "cult of beauty as practiced by Keats and Tennyson . . . involved an emphasis on the pictorial beauties of the past or of landscape."[19] In the narrative of the mother's loss, the pointed opacity of Tennyson's landscape recalls the ambivalent topographies of "Hyperion," wherein no conclusive answer was given to the questions posed there and which reflect, in the death poses of the antiquated gods there, nothing new. However, Tennyson's landscape resurrects, in a way that the opacity of "Hyperion" cannot, the positive risk of originality and difference. It both recalls and extends Keats's text, postulating difference as the property that, by its very nature, will distinguish itself from tradition by failing to find its reflection or answer there. And it is in this full assumption of difference that song itself is most radically enabled and threatened. As the poem attests, voice is poised here on the threshold of its ability to sing. "The abject is lined with the sublime. . . . the same subject and speech brings them into being."[20] At the height of her loss, Demeter's childless "ravings," she admits, momentarily "hushed / The bird" (106–7).

But close on the heels of this thematization of difference, this parting of the ways that signifies poetic distinction, Tennyson holds the poem open for Keats to speak unreservedly. Recalling the agency of another resurrected figure, Hermes, who provides Demeter with a dream vision of Persephone to begin her reclamation, Tennyson draws from Keats "the likeness of [himself] / Without [his] knowledge," and Keats's shadow, like Persephone's, surely passes "Before [us] crying . . ." (91–93). Here is resurrection, not of image but of voice, of song. After a litany of images recounting human desolation and abjection, a landscape of loss and unrecognizability that figures poetic distinction, the images through which Tennyson celebrates the daughter's presence undeniably derive from Keats, and his voice emerges most strongly and clearly here.

Tennyson's "reaper in the gleam of dawn" (121) will come upon that figure of Autumn previously invoked by Keats in his final ode. The portrayal of Demeter "Blessing [the] field, or seated in the dusk / Of even, by the lonely threshing-floor, / Rejoicing in the harvest and the grange" (123–25) directly invokes the harvest deity in the third stanza of "To Autumn":

> Who hath not seen thee oft amid thy store?
> Sometimes whoever seeks abroad may find
> Thee sitting careless on a granary floor,
> Thy hair soft-lifted by the winnowing wind.
> (12–15)

This critical apotheosis of a voice, perceived aurally and visually in the poem's opening stanzas "faint as a climate-changing bird," now erupts and dominates Demeter's narrative. As if in answer to her prophetic plea for

"younger kindlier Gods to bear us down, / As we bore down the Gods before us / . . . To quench, not hurl the thunderbolt, to stay / Not spread the plague" (129–32), Tennyson's decision to frame Demeter's solution in Keatsian terms again clouds all notions of strict, temporal progression. As if in anticipation of a Keats yet to come, yet to be perceived, he reaches back to his predecessor to move the narrative forward into all the prophetic fullness it will achieve.

The sentences, momentarily loaded with infinitives invoking Gods "to bear," "to quench," "to stay," "to send," echo Keats's "Autumn" ode again. And though Tennyson's efforts are not, at this point, as sublime as Keats's, this catalog of infinitives imitates the dead poet's common technique for braking the rush of his imagery. The infinitives themselves rock slowly from the first word to the second, instantiating the semiotic rhythm of a child's being lulled to sleep in the arms of a guardian. If we had not heard or seen Keats before, Tennyson holds his own poem open in an interlude that suggests an intimate moment between mother and child so that we may fully and unmistakably recognize the resurrected presence enfolded in the poem. Ironically, in undisguisedly raising Keats's voice, Tennyson lays anxiety to rest, for the lines from the ode remind us of Keats's own anticipated death and mark in a visual and vocal way his passing. This act of taking up the precursor's voice again subverts hierarchical authority and notions of precedence, for by couching it within the rhythmical suggestion of protection and guardianship, it suggests the predecessor's ultimate dependence upon those who come after to confirm his continuing presence within, and pressure upon, the forging of new songs.

From this moment on, the poem attempts to negate all notion of precursory or authorizing hierarchy. It has distinctly called forth the voice and image of the precursor. But now Tennyson situates Demeter and Persephone, whose resurrection has drawn Keats into the poem, as equal figures in the landscape. Tennyson gathers up Keats as Demeter gathers up Persephone, in one invigorating invitation to song:

> . . . reap with me,
> Earth-mother, in the harvest hymns of Earth
> The worship which is Love, and see no more
> The stone, the Wheel, the dimly-glimmering lawns
> Of that Elysium. . . .
>
> (145–49)

In the proffered invitation to "reap," Tennyson patently rewrites and reenvisions the terms of the violation that engendered the mother's narrative and offers it as the optimistic first moment of Demeter's prophecy. We are again at a site of rupture and differentiation: to reap is surely to cut, to sever, and this harvesting is contextualized as voice, in the "harvest hymns of Earth"; but this

severance differs from the sexual violence, and thus the anxiety of voice, that set the original narrative of reclamation into place. To reap is "to cut and to gather" in its transitive form; in its intransitive mode it implies "reception," "reward," and most significantly "return." The tenor of this "cut," denoting also a literal return, anagramatically transforms "rape" into "reap," and the loss that implicitly began this narrative is rewritten as Tennyson rewrites Keats, with Demeter inviting Persephone into the "worship which is Love" (147). In this conflation of bodies, Tennyson's text demonstrates that poetic closure, which is completion, lies, as Hartman supposes, in neither the paternal nor the maternal sphere. The anagrammatical rewriting of violation, separation, and identification with the father is incorporated into a return, a sense of poetic recursion anchored in images of the maternal body and in a silenced daughter, a "silent yet speaking image . . . that constitute[s] the matter of semiotics, and which cannot resolve [itself] entirely into unambivalent, unvoiced images."[21] Tennyson's poem undertakes a final unification of precursor and ephebe in this verb taken in both its active and reflexive senses, acknowledging the living poet and the dead in an unending circle of reciprocity, endlessly giving and taking from one another, endlessly burying, resurrecting, and receiving voices. "Reap," in this context, serves as the synecdoche that integrates all the disparate and confused bodies of the text.

Tennyson thus resurrects in the silence of Persephone the image of Keats, his poetic father, according to traditional interpretive paradigms. But through its many fantasized and forestalled figures of completion, "Demeter and Persephone" plays havoc with fixed notions of hierarchy, procedure, and authority. By employing the mother/daughter topoi, mirroring mothers and daughters who are in "actuality" gendered poetic fathers and sons, Tennyson transforms an anxiety of influence into a recognition of the recursion at the heart of all poetic endeavor—the perpetuation of song in-mixing with and surviving the anxiety of belatedness. Ultimately, Tennyson celebrates here the always unfinished song as his lineage.

Indeed, the poem does not achieve closure. Persephone's resurrection is only partially realized; the fulfillment of Demeter's prophecy remains uncertain, and, in terms of the poetic "theory" enacted in Tennyson's poem, its affirmation remains appropriately poised for the future to complete. The poem does attain, however, the quiet sublimity of a lullaby; it serves as a temporary respite from the interminable struggle with predecessors, from the anxiety of belatedness and of death. The "mother's" voice offers to the "daughter" a locus of rest that is both homage to a predecessor and an expression of Tennyson's need to answer the anxieties of his dead precursor because he had come to recognize those as his own. Through "Demeter and Persephone" Tennyson suggests a lineage in the fashioning of song—language as music, language in its purely evocative sense. The sublimity and the abjection of the

poem suggest his reconciliation to the mirage-like craft of poetry and to a poetic lineage tending always toward the same end, one recognized by Keats's persona in the "Nightingale" ode: to find "a path / Through the sad heart" always "amid the alien" landscape of the written word.

NOTES

1. According to Hallam Tennyson, the primary sources for his father's "Demeter and Persephone" are the Homeric "Hymn to Demeter," Ovid's *Metamorphoses,* 5:341–571, and *Fasti,* 4:419–618. See the introductory gloss on the poem by Christopher Ricks in *The Poems of Tennyson,* ed. Ricks, 2d ed., 3 vols. (Berkeley: University of California Press, 1987), 3:163–64, for summaries of other readings that propose sources other than those noted by the poet's son. All references to Tennyson's poetry follow Ricks's *The Poems of Tennyson* and are identified parenthetically by line number.

2. James Kissane, "Victorian Mythology," *Victorian Studies* 6 (1962): 22. Christine Gallant, "Tennyson's Use of the Nature Goddess in 'The Hesperides,' 'Tithonus,' and 'Demeter and Persephone,' " *Victorian Poetry* 14 (1976): 158.

3. Donald Hair's reading departs usefully from past thematic interpretations precisely because he highlights the members of the domestic topoi and the issue of lineage invoked through them. What is more, in his examination of other idyllic poems by Tennyson, including *The Princess,* "The Day Dream," and *Idylls of the King,* Hair notes Tennyson's development of more psychologically complex and realistic responses from his characters, a tendency that deemphasizes the elements of the idyllic setting itself. See *Domestic and Heroic in Tennyson's Poetry* (Toronto: University of Toronto Press, 1981), 52.

4. Jacques Lacan, *Ecrits: A Selection,* trans. Alan Sheridan (New York: W. W. Norton, 1977), 319.

5. Julia Kristeva, *Powers of Horror: An Essay on Abjection,* trans. Leon S. Roudiez (New York: Columbia University Press, 1984), 61–62.

6. In a brief deconstructive reading of Bloom's anxiety of influence paradigm, Christine Brooke-Rose finds Bloom a less "generous" reader than Derrida and de Man because the latter acknowledge the "mythologies of mastery" that underlie all interpretation. Bloom's appeal to tradition as absolute center of his paradigm and his formulation of tropes via a highly literalized reading of Freud represent, for Brooke-Rose, an unexamined surrender to the logocentric repression within the Freudian hypotheses themselves. See her "Id is, is Id," in *Discourse in Psychoanalysis and Literature,* ed. Shlomith Rimmon-Kenan (London: Metheun, 1978), 19–37. See also Paul A. Bové, *Deconstructive Poetics: Heidegger and Modern American Poetry* (New York: Columbia University Press, 1980).

7. Patricia Joplin, "The Voice of the Shuttle is Ours," *Stanford Literary Review* 1 (1984): 30, 31.

8. W. David Shaw, *Tennyson's Style* (Ithaca: Cornell University Press, 1976), 278.

9. Bice Benvenuto and Roger Kennedy, *The Works of Jacques Lacan: An Introduction* (New York: St. Martin's Press, 1986), 72.

10. In the configuration I have proposed, no position in the family topos is ever secure or ever only singularly occupied by either the precursor or the ephebe. The instability of these positions ought, perhaps, to be signaled by enclosing "mother," "father," "son," or "daughter" in quotation marks. However, rather than repeatedly calling attention to that instability by constantly punctuating my text with quotation marks, I will let this note stand as acknowledgment of the erasure under which all perceptions of familial position lie within this family topos.

11. Sarah Steinberg, "The Master Tropes of Dreaming: Rhetoric as a Family Affair," *American Journal of Semiotics* 4 (1986): 42–43; Shoshana Felman, *Literature and Psychoanalysis: The Question of Reading Otherwise* (Baltimore: Johns Hopkins University Press, 1977), 23.

12. Geoffrey Hartman, "Poem and Ideology: A Study of Keats's 'To Autumn,'" in *The Fate of Reading and Other Essays* (Chicago: University of Chicago Press, 1975), 92.

13. Martin Aske, *Keats and Hellenism: An Essay* (Cambridge: Cambridge University Press, 1985), 60–61 (my italics).

14. All references to Keats's poetry follow the texts in *The Poems of John Keats,* ed. Miriam Allott (London: Longman, 1970), and are identified parenthetically by line numbers.

15. Julia Kristeva, *Revolution in Poetic Language,* trans. Margaret Waller (New York: Columbia University Press, 1984), 29, 70. Though I am not here primarily concerned with Kristeva's elucidation of the abject per se, I am interested in her elaboration of the Freudian and Lacanian concepts of the Imaginary Father. In her hypothesis of the abject as that which is turned away from in the formation of the subject and thus what comes to serve as one of the motivations for the incest dread, Kristeva implies a "confrontation with the feminine"; the fantasy content of the maternal body, an effect of symbolic being, though partially jettisoned, exerts a potential for disrupting and overwhelming the symbolic order. The Imaginary Father with which the child can identify and which identification enables signification is a function of the mother's desire away from the child. What precedes and, in effect, motivates this event of primary narcissism is an encounter with "a 'something' that I do not recognize as a thing. A weight of meaninglessness." The Imaginary Father or the Lacanian phallus suffers always a kind of encroachment from this unsignifiable pressure of the maternal presence, which "draws [one] towards the place where meaning collapses." Kristeva, *Powers of Horror,* 2.

16. Geoffrey Hartman, *Saving the Text: Literature/Derrida/Philosophy* (Baltimore: Johns Hopkins University Press, 1981), 118.

17. Hartman, *Saving the Text,* 152.

18. Daniel Albright, *Tennyson: The Muses' Tug of War* (Charlottesville: University Press of Virginia, 1986), 148.

19. George H. Ford, *Keats and the Victorians: A Study of His Influence and Rise to Fame, 1821–1895* (Hamden: Archon, 1962), 33–34.

20. Kristeva, *Powers of Horror,* 11.

21. Hartman, *Saving the Text,* 153.

"EQUAL BEFORE GOD"

Christina Rossetti and the Fallen Women of Highgate Penitentiary

By August 1860 Christina Rossetti had begun her moral welfare work at St. Mary Magdalene's on Highgate Hill in London, one of many homes founded during the mid-century for the redemption of fallen women. All Rossetti's biographers mention her mission among fallen women, and biographical criticism associates Rossetti's poems that employ the figure of the fallen woman, including "Goblin Market," with this time spent at Highgate.[1] However, none of these sources provide much detailed information about her activities there. All simply rely on the three references to the institution made by Rossetti's brother William Michael, who informed Mackenzie Bell, Rossetti's first biographer, that "at one time (1860–'70) [Rossetti] used pretty often to go to an Institution at Highgate for redeeming 'Fallen Women'—It seems to me at one time they wanted to make her a sort of superintendent but she declined." As editor of his sister's poetry, William Michael also included an endnote in which he quotes a section of a letter from Mrs. William Bell Scott, an acquaintance of the Rossetti family, that tells of seeing Christina at Highgate: "Christina is now an associate, and wore the dress—which is very simple, elegant even."[2]

In editing his sister's letters, William Michael included a second explanatory note: "The statement, 'I have promised to go to Highgate,' [appearing in a letter dated 25 October 1861] relates to an institution at Highgate for the reclamation and protection of women leading a vicious life; Christina stayed there from time to time, but not for lengthy periods together, taking part in

the work."[3] In no reference does William Michael Rossetti describe what this "taking part in the work" involved. Nor does he describe the institution itself or the penitents. Thus we are left with several questions: Who were these women? How were they treated by the "unfallen" women running the home, and what led Rossetti to associate herself with them? Once we have answered these questions, we can better assess the connection between Rossetti's fallen woman poems and the time she spent at Highgate.

In 1853 George Nugee, an Anglican clergyman, gave a large sum of money to the diocese of London for, as the deed reads, "the establishment and maintenance within the diocese of the Bishop of London of penitentiaries and houses of refuge for the reception and reformation of penitent fallen women with a view to their ultimate establishment in some respectable calling." In January 1854 an article appeared in the *Times* announcing plans to establish such a penitentiary and urging women to "give help and comfort to a few of their fallen sisters" by participating in the running of the home. By the end of 1855, a large building known as Park House, large enough to accommodate at least 60 penitents, was purchased, and during 1856 the name St. Mary Magdalene was chosen. (Throughout the nineteenth century, the institution was also referred to as the London Diocesan Penitentiary.)[4] According to the first annual report, Park House on Highgate Hill was purchased because of the "healthy and retired position" and the "surrounding 16 acres of garden and meadowsland." Those involved in penitentiary work felt that it was best to place such institutions in countrylike settings where penitents were "not only separated from their past evil life, but brought into a new and pure atmosphere." Several years later, the London Diocesan Penitentiary Council, a group of men appointed by the bishop to oversee the management of St. Mary Magdalene's, opened a house of refuge where a "poor daughter of sin" was to be admitted at any hour "so long as it ha[d] a bed unoccupied."[5]

As this distinction between refuge and penitentiary suggests, moral welfare workers tended to classify fallen women into categories. Although no classification system was employed in the first stages of the Church Penitentiary Movement, one was soon called for. As early as 1857 many felt that separate homes should be established for the "superior" class of fallen women: "Grant that hard manual work and stern discipline may be tests for fallen women of coarse tastes and habits, surely another kind of occupation and a gentler treatment would be more suitable for those whose minds are more refined, and who have lived, as many of them have, at least for some years, lives of luxury."[6]

St. Mary Magdalene's seems to have been open to all classes of women and women in all stages of the fall from purity. The annual reports indicate, however, that most women were from the lower classes, for only one report

mentions that some "inmates of the higher class as regards birth and education" were admitted.[7] Furthermore, the domestic training offered inmates suggests most were from the servant classes: they could receive training in cooking, washing, and needlework. In fact, St. Mary Magdalene's ran a laundry, and, according to the reminiscences of one of the residents of the area, the inmates did "trousseaux for the local ladies."[8] After a stay of not more than two years, the penitents left the home and usually went into domestic service. In some cases, penitents did leave to marry, and often the records report that women left to be "kindly received" by their families.

From these annual reports (from 1856–1870), we can first assume that Rossetti was working primarily with lower-class women but was quite aware that "ladies also fell." Second, we can conclude that these women were not all prostitutes. Some may well have been young women who willingly took a lover and then were later deserted, and others were likely to have been what we would now consider the victims of sexual abuse and exploitation: a lengthy article appearing in the *Westminster Review* in 1850 speaks of the "tender age [10–12 years old] at which thousands of these poor creatures are seduced."[9] In 1876, when arguing for a classification system, one advocate for reform made clear that there were different types of fallen women: "A girl who, in an unguarded moment, has gone astray through her affections, or one who has been a victim of deceit or violence—a girl who has never lived an immoral life . . . we throw . . . with the vilest and most degraded of her sex."[10] Clearly, a woman did not have to be the "vilest of her sex" to be considered fallen. She need only have had sexual intercourse outside of marriage. Last, we can assume that since Rossetti was involved in a cause that sought to reform these women, even return them to the family structure, she must have believed a fallen woman need not forever be a social outcast. However, further evidence suggests she would not have considered the process of reformation an easy one, especially the process of spiritual reformation.

Although the inmates were never legally forced into a penitentiary, accounts of the various houses of mercy, as the church penitentiaries were called, show us that those running the institutions would not have considered a woman truly penitent simply because she applied for admittance. In some cases hunger or sickness might bring her to the door, and in other cases, young penitents were sent to such homes by their families or local clergy. As the Reverend Carter, one of the key figures in the early stages of the movement phrased it, "Real penitence and sorrow would have to be produced after the inmates' admission." When a woman arrived at the penitentiary, those caring for the inmates definitely would have assumed she needed constant watching, and whether she had fallen once or many times would make little difference, since sexual experience outside of marriage, even if occurring only once, was believed by many to transform the woman into a "horrible" specter. One of the first articles

advocating church penitentiaries, "The Church and her Female Penitents," describes the transformation from pure to impure as occurring suddenly and unexpectedly: "In one hour daughter, sister, wife, hath become the thing from which the fondest shrink; the very name of which they dare not utter. It is too horrible to look upon, or to fashion into speech."[11] Sixteen years later the Reverend Burrows, vicar of Christ Church, Albany Street (the church Rossetti attended regularly during these years), describes the decay and deterioration occurring from the moment of "lift[ing] the veil which God's order draws," and he continues, "[w]hen once the sin has been committed, there will always be an increasing weakness of the will" and a "decay of bodily vigour." Not only were the penitents seen as weak-willed and not yet penitent, but fallen women were also seen as physically and mentally impaired: "All the experienced writers on the subject bear witness to the thorough derangement of the nervous system and hence the fitful and fluctuational character of the mind." Thus fallen women were to be watched constantly.[12]

The House of Mercy at Clewer, one of the earliest houses of mercy, saw to it that penitents were never left without a "sister present," one of the unfallen women running the home. This seems to have been the case at St. Mary Magdalene's as well, for according to the records, although each penitent had her own compartment in the dormitory, there was to be "surveillance of a sister whose sleeping chamber [was] so arranged to command it." Further-more, although the records do not include details of the daily life of a peni-tent, another source, Felicia Skene's *Penitentiaries and Reformatories,* provides us with a detailed account of the rigid daily schedule and strict rules of church penitentiaries. The women were to rise at 5:00 A.M., and every hour of the day until retiring after private prayers at 8:15 P.M. was accounted for. Be-tween 12:30 and 1:00 P.M. the women had time for recreation, but they were also to include midday prayers during that half hour. For the most part the entire day was filled with "industrial work," presumably work in the kitchens or laundry, and with prayers. One hour was scheduled for "Bible-Class and Reading." Skene also speaks of a room set aside as a "punishment room with its solitude and its bread and water" and of the tendency of the "ladies in charge" to keep the fallen women "at a distance."[13]

Such regimentation and strictness related directly to the belief that a fallen woman could not save herself, for her "fall" had weakened her both mentally and physically. Even Skene, who believed that such strict discipline was not helpful and that inmates required affection, believed fallen women to have "minds and bodies disorganized by excess and subject to every form of hysteria." A fallen woman needed a pure unfallen sister to save her: Fallen women "need some such sisters to be ever at their side, watching them in weak moments, encouraging them in seasons of overwhelming gloom, checking outbreaks of temper and light words, directing and controlling

their conversations, moving about them like a moral atmosphere."[14] One of the major conclusions the Reverends Armstrong and Carter had come to was that the old system of caring for penitent fallen women, with paid matrons and a few visiting ladies, was not working. A new system was needed in which a special type of self-sacrificing, pure woman played the central role. Armstrong was convinced that "no real good could be effected except through the instrumentality of self-devoted and unpaid ladies, working upon sound Church principles." Armstrong's views were accepted by the Church Penitentiary Association, an organization founded in 1852 to assist in the founding and maintaining of refuges and penitentiaries. This association aided only those penitentiaries "which [were] superintended by self-devoted women," women of "patient and unswerving faith." Fallen women were "so absolutely lost, so cast out of [God's] sight, so abandoned to the bitterness of their own tormented soul" that only the "purity and tender love" of a good woman could save them.[15]

It seems, rather ironically, that fallen women were considered the "best" sinners to save because they were so lost, so in need of saving. The Reverend Tuckniss concludes an article on agencies for "the suppression of vice and crime" with the following quotation from an 1861 sermon preached by the Reverend Henry Drury:

> You may ransack the world for objects of compassion. You may scour the earth in search of suffering humanity, on which to exercise your philanthropy; you may roam the countless hospitals and asylums of this vast city . . . but in all the million claims upon your faith . . . you will never fulfill a mission dearer to Christ . . . you will never more surely wake up joy in heaven and force tears into the eyes of sympathizing angels, than when you can bring a Magdalene face to face with her Redeemer.[16]

At St. Mary Magdalene's, Rossetti would have ample reason to see herself involved in the most significant moral welfare work of her day. Indeed, it is not unusual to find articles of the time presenting the redemption of fallen women as central to saving the whole social order.[17] Furthermore, as a woman she would have heard a special call to become involved in such work. When the *Times* announced the establishment of the London Diocesan Penitentiary, it emphasized the contribution unfallen women could make to the cause: "Such disinterested services are precisely those which would be most valuable in such a case, by causing the penitent to feel that she was not without the sympathy of those from whom she had been long taught to expect only aversion and contempt."[18] The records of Highgate mention several pleas made to enlist the services of "self-devoted women." The Reverend Burrows is mentioned as having preached a sermon at Christ Church on

behalf of the London Diocesan Penitentiary in 1859. Perhaps this sermon led to Rossetti's joining the cause.

What work might Rossetti actually have done while among these "ruined" women? In other words, what did it mean to be an "associate," as Mrs. Scott has described her? First, we need to clarify what the Reverend Armstrong meant by "self-devoted." Such women were not merely to be "kind" but also "holy"; they were to be "self-sacrificing daughters of the Church," willing to give not periodically but constantly to the spiritual reformation of the penitents. As Armstrong phrased it, there had to be "constant pure air mixing itself with the impure. . . . Hence the use, hence the absolute necessity, of a Sisterhood." Although he did not go so far as to suggest that volunteers take vows or follow a religious rule, he felt these self-sacrificing women must be unmarried. At first he called for only widows, but later he decided that women never married might also cope effectively with the fallen, without fear of contamination, if a strict rule of silence were imposed; in other words, the fallen were not to speak of their "past sins."[19]

Armstrong was involved in establishing St. Mary Magdalene's, and the deed of the institution clearly indicates that it was to be run primarily by a "self-devoted" sisterhood such as he describes. Although a clergyman of the Church of England was to be appointed as a warden to perform religious services and superintend religious instruction, the system of instruction was to be "conducted by the Sisters of Mercy," as these women were called. Before a woman would be "fully admitted" as a sister, she would undergo a probationary period. And, although "every sister was free to leave her office and the House, . . . upon admittance to probation," she had to "promise to be bound by and observe all the rules and regulations of the Institution."[20]

Although the deed mentions only the two classes of sisters, "sister probationary" and "sister fully admitted," the first annual report includes the following note: "It may also be stated, that in addition to the above [the probationary and the fully admitted sisters], it is found desirable to have a few serving as Assistant Sisters, for management of the laundry, etc.; and some ladies are engaged as 'Associate Sisters,' in promoting interests of the institution in the several spheres of life and society to which they belong."[21]

*T*hus, when Mrs. Scott refers to Rossetti as an "associate" of the institution, we can conclude she is referring to the last category of sisters. An unpublished letter of Rossetti's does suggest that she was involved in "promoting" St. Mary Magdalene's. She speaks of a sort of open house at Highgate that she had encouraged several friends to attend, and she seems quite pleased with the amount of money raised.[22] We can infer that as an associate she was expected to pray for the fallen women; on the inside cover of the

Minute Book of the London Diocesan Penitentiary can be found a copy of a prayer entitled "Prayer for Associates," which reads in part as follows: "O almighty God, we thy unworthy servants beseech Thee to bless us and all those for whom we have undertaken to pray. Turn and soften the wicked; succour the tempted; arouse the careless; restore and preserve the penitent." Since one of Rossetti's own letters indicates that she stayed at Highgate for several days at a time, we can conclude that while there she may well have been involved in the daily religious instruction of the inmates. Exactly what religious instruction involved is not specified in the records; however, at other church penitentiaries it included reading devotional works to the inmates as they did needlework, and setting and hearing religious lessons.[23] The annual reports do indicate when inmates were baptized and confirmed; perhaps Rossetti took part in preparing the penitents for these sacraments. Because of the rule of silence, the rule that forbade the fallen to speak of their past sins, we can be reasonably certain that Rossetti did not listen to confessional tales of personal experience.

Rossetti's direct involvement with St. Mary Magdalene's (Highgate, as she called it) seems to have ended by 1870. Most likely her declining health was the reason. (In 1871 she was diagnosed as having Grave's disease, a serious thyroid condition.) However, her concern with fallen women did not cease, for in 1874 when she published *Annus Domini,* a collection of her own prayers, she included one for fallen women. Noting that the lineage of Christ contains such women as Tamar, Rahab, and Bathsheba, she asks Him to "give to [all fallen women] and to those who have sinned with them, repentance and amendment of life unto salvation." In the 1880s she was still showing an interest in Highgate. The daily diary she kept for her mother from 1881 until 1884 records four visits to the institution.[24]

*R*ossetti's fallen woman poems demonstrate no immediately obvious connection to the social movement to save fallen women.[25] Rossetti does not set any poem in a penitentiary. Neither does she directly address the issue of prostitution. However, she does depict women who have had sexual intercourse outside of marriage and who are thereby isolated from the larger community. The speaker of "Cousin Kate" now "howls in dust"; the female speaker of "Light Love" is "cast down and trampled in the snows"; and the speaker of "An Apple-Gathering" "loiters" in the night while the unfallen sisters hurry home to their mothers. Furthermore, "shamefaced" Margery is seen by her neighbors as having been "cheap," too willing to show her love. And "The Iniquity of Fathers Upon the Children" makes clear that if the community knew of their lady's fall, they would "Make her quail in dust, / Lorn with no comforter."[26] Significantly, Rossetti consistently portrays these outcasts from

their society as deserving the reader's sympathy and even compassion. Although Rossetti does not free the woman from guilt, each fallen woman appears as a victim not only of her own weak nature but also of male deception. In Rossetti's fallen woman poems—"Cousin Kate," "Light Love," "An Apple-Gathering," "Margery," and "The Iniquity of Fathers Upon the Children"— women are portrayed as foolish to have believed in their male lovers. The same may also be said of "Goblin Market," if we see the goblins as male destroyers of female innocence.[27]

Although Rossetti might have first come upon this theme of seduction and betrayal in her mother's commonplace book[28] as well as in Percy's *Reliques of Ancient English Poetry*, a book familiar to the Rossetti children, she would also have found this view of a woman's fall in the articles and sermons on the most discussed "social evil" in Victorian England. Despite the harsh language used to describe the "horrible" sight a woman became once she fell, and despite the belief that she had to undergo a rigorous moral reformation before she was fit to reenter society, those championing the movement to save fallen women did not place all the blame on the female sex. Bishop Manning's sermon tells his readers to "pity" the fallen woman: "None are more sinned against. Even the most abandoned were once purer than the possessed being by whom they were betrayed. They were, perhaps, the weak and shrinking objects of temptation." Carter's sermons portray the same image of initial innocence betrayed: "They may have been the innocent victims before they became the tempters." William Gregg, in his lengthy article on prostitution, considered to be "something of a watershed in the public debate" on the subject, stresses the need to pity these women by suggesting that many of them were the victims of male sexual desire. And finally, although some street missionaries came to conclude that poverty contributed to prostitution more than seduction did, many believed that a "woman is first betrayed, then deserted, and driven to street prostitution."[29]

Rossetti develops this theme of seduction and betrayal in several poems, and her time at Highgate seems not to have altered her handling of the theme. "Light Love," "Cousin Kate," "An Apple-Gathering," and "Goblin Market" were all written before the 1860 date, so one might conclude that the depiction of the woman's fall in those poems was most influenced by literary sources, both ballads and sermons.[30] However, "Margery" and "The Iniquity" were written during the 1860s, by which time we know she was working at Highgate, and we still find her employing the narrative of a seduction and betrayal. Significantly, both these poems firmly condemn male irresponsibility. In "Margery" the speaker concludes by affirming, "Were I the man she's fretting for, / I should my very self abhor" (*PW*, 361). The illegitimate daughter in "Iniquity" sees her father as the cause of her mother's "shame" and her own "forlorn" life (*CP*, 1:174). Moreover, although the mother is portrayed

sympathetically, the father is not. The daughter calls her mother "Friend, servant, almost child" (*CP,* 1:175) and imagines meeting her "in Paradise." By contrast, when she speaks of her father, she "could almost curse" (*CP,* 1:178).

The male figures in the poems written before 1860 are also negatively portrayed. The lord in "Cousin Kate" appears to have used the innocent country girl and is now ready to desert her, despite the fact she has borne his child. He intends to marry her virginal cousin Kate, leaving the speaker to see herself as having been only his "plaything" now to be "changed like a glove" (*CP,* 1:32). In "Apple-Gathering," Willie now helps his new love, Gertrude, carry her basket full of apples while the speaker, having earlier "plucked pink blossoms," is left alone and "mocked" by her neighbors (*CP,* 1:43). In "Light Love," the image of the male lover is especially harsh. His own words depict a cold insensitive man willing to abandon his former lover and their child in order to marry a "ripe-blooming" virgin. He is cruel enough to suggest to the woman he is leaving that she find an old lover to take care of her: "But hast thou ne'er another love / Left from the days of old, / To build thy nest of silk and gold?" (*CP,* 1:137). Finally, the poem suggests that he will marry the new love because she did not succumb to his sexual desires: he assures the woman he is abandoning that he will not discard his new love, for "not like thee: / She leans, but from a guarded tree" (*CP,* 1:137). The poem ends with the fallen woman looking to God for justice and perhaps revenge: "She raised her eyes, not wet / But hard, to Heaven: 'Does God forget?' " (*CP,* 1:138). In these five poems the male lovers are disloyal and self-centered. They seem as guilty as, if not more guilty than, the fallen women. This strong condemnation of the male involved in the woman's fall points to an important distinction between Rossetti's poetry and other literature of the penitentiary movement.

Although the literature on penitentiaries and on prostitution often blames men, typically individual sermons and articles do not focus on the reformation of male behavior, which Rossetti's poems seem to advocate.[31] The women have loved with honest hearts, for they have at least placed human love above worldly gain. As with the speaker of "An Apple-Gathering," they have "counted rosiest apples on the earth / Of far less worth than love" (*CP,* 1:19–20). The males, by contrast, appear as opportunists willing to take advantage of a woman's innocent youth and gullibility. Margery is described as "guileless" and as a "harmless foolish child" (*PW,* 361). In "The Iniquity," the mother was "scarce sixteen" when her illegitimate child was born, and the daughter asks of her father: "Why did he set his snare / To catch at unaware / My mother's foolish youth" (*CP,* 1:178). And now as a grown woman, the mother seems to fear for her daughter's youth. If "any gentleman" comes to stay at the hall, the mother guards her daughter from seduction:

> My Lady seems to fear
> Some down right dreadful evil
> And makes me keep my room
> As closely as she can.
>
> (*CP*, 1:173)

In these poems the woman falls in part because she foolishly believes in a man she loves. All these fallen women trusted in what the speaker of "Light Love" calls "the love that harms" (*CP*, 1:137). Two of these poems suggest that the only way a woman might find peace after her "fall" is to turn from the world and recognize that human love is vain. Margery must realize that she had risked her "heart" for a "slight thing" before she will be able to "smile" (*PW*, 361). The daughter in "Iniquity," bearing the burden of her parents' sin, chooses not to marry and looks to the time after death when God may "save," when all will be "equal before God" (*CP*, 1:178).

This emphasis on the frailty of human love is a major theme in Rossetti's work. A line in her notes on the book of Genesis is particularly revealing. Commenting on Gen. 30.31 ("And there I buried Leah"), she writes, "not Rachel. A text for earthly love as vanity of vanities."[32] Recognizing the major place this theme of the vanity of earthly love occupies in Rossetti's work provides some insight into how she might have viewed the fallen women of Highgate. She may well have seen their particular sexual sin as merely a part of a larger spiritual issue. These women placed too much trust in the things of the earth and not enough in God; in a sense their fall occurred because they placed man before God. Given this view, Rossetti may well have been less preoccupied with the sexual nature of their fall than were many of her contemporaries. Her poems make it quite clear, in any case, that she did not see the issue in the simple terms of virginity versus sexual experience.

In the three poems in which Rossetti includes a female rival, a pure unfallen woman who wins the male in marriage ("Light Love," "Cousin Kate," and "An Apple-Gathering"), the pure woman does not function within the poem as her fallen sister's opposite; in other words, the virginal woman is not set before the reader as an ideal. And, significantly, the marriage she makes does not appear to be an honorable union based on a sincere love. In "Cousin Kate," Kate seems actually to have betrayed love in marrying the lord:

> O cousin Kate, my love was true,
> Your love was writ in sand:
> If he had fooled not me but you,
> If you stood where I stand,
> He'd not have won me with his love
> Nor bought me with his land.
>
> (*CP*, 1:32)

Kate has betrayed family loyalty. Moreover, she seems not to have married for love but to have sold herself to the lord for position and money. We find in these poems that women appear set against each other as they try to win a wedding ring, and the pure women who win the ring are as guilty as the fallen. They have remained sexually pure, "lean[ing] . . . from a guarded tree," only because that purity will enhance their prospects in the marriage market. In "Margery" the speaker comments:

> A foolish girl, to love a man
> And let him know she loves him so!
> She should have tried another plan:
> Have loved but not have let him know:
> Then he perhaps had loved her so.
>
> (*PW*, 360)

Rossetti implies that there is not much difference between the woman who sells herself in marriage, who does not marry for a genuine love, and the woman who has sexual experience before marriage because she is fooled by the promises of human love. Both are guilty of placing the things of the earth before God. In Rossetti's sonnet "A Triad," which describes three women in terms of their experiences in human love, she associates the fallen woman, who "shamed herself in love," with the married woman, "the sluggish wife" who "[grows] gross in soulless love." Both are "short of life" (*CP*, 1:29). Furthermore, the third, who is "blue with famine after love," the virgin who longs hopelessly for human love, is also described as "short of life." Thus, even the pure sister who neither falls nor sells herself in marriage is found wanting, for she cannot renounce her desire for earthly love. All these women need to place God before man in order to find spiritual life. And in "Goblin Market," Rossetti clearly suggests that if one has fallen, if one has become obsessed with the pleasures of the earth, earthly love included among those pleasures, then to overcome that obsession she will need help from a self-sacrificing sister who places sisterhood before worldly pleasures.

This point returns us to consideration of how Rossetti may have viewed the fallen and unfallen sisters of Highgate. As discussed earlier, the Church Penitentiary Movement saw as central to its success the involvement of unfallen Victorian women who were to devote their time to saving the souls of their fallen sisters. Although the penitentiaries did help train women to reenter society as domestic servants, their primary work was spiritual reformation. As Lizzie helps restore Laura to life, to "her innocent old way," in "Goblin Market," the pure unfallen sisters were to "gain spiritual mastery over the erring sisters' minds" and to help form "new gentle child-like heart[s]" within them.[33] Rossetti makes it clear, through the poem's allusions to Jeanie, that if Laura had not had her noble sister Lizzie, she would have

died; most important, the biblical allusion to Laura's "tree of life droop[ing]" suggests a spiritual death. Similarly, without pure sisters who were willing to sacrifice themselves, the fallen women of Victorian England were seen to be spiritually lost as well. The concluding lines of "Goblin Market" ("There's no friend like a sister / . . . / To fetch one if one goes astray") are reminiscent of the Reverend Armstrong's call for pure sisters to be ever at the sides of the fallen, "watching them in weak moments, encouraging them in seasons of overwhelming gloom."[34] We should thus add to the list of sources for "Goblin Market" the literature of the Church Penitentiary Movement. Even if the parallels to the movement to save fallen women were not intentional on Rossetti's part, it is certainly possible that, while she worked on the proofs of her first volume *Goblin Market and Other Poems*,[35] she recognized those parallels. The fully admitted sisters of the London Diocesan Penitentiary were working like Lizzie to save their fallen sisters from the consequences of "goblin fruit." The prayers Rossetti said as an associate sister were for the spiritual redemption of her fallen sisters.

More detailed understanding of the contexts in which they were written makes it clear that Rossetti's fallen woman poems should be read with an awareness of her firm belief that penitence could restore the soul to a state of purity. Fallen women might have been outcasts in society's eyes, but not in God's. After all, as Rossetti herself noted, "Mary Magdalene out of whom went seven devils, stood beside the 'lily among thorns,' the Mother of sorrows" at the Cross.[36] If a fallen woman could renounce goblin fruit—the things of the world, among which was the "love that harms"—she would be saved. As the speaker of "Iniquity" concluded, "all were equal before God." Rossetti's faith in redemption surely underlies the sympathetic portrayal of fallen women in her poems. Most likely it was that same faith that led her to Highgate Hill, ready to accept her fallen sisters as "equal before God."

NOTES

1. See for example, Kathleen Hickok, *Representations of Women in Nineteenth-Century British Women's Poetry* (Westport: Greenwood Press, 1984). Hickok associates "Light Love," "The Iniquity of the Fathers upon the Children," "An Apple-Gathering," "Cousin Kate," "A Triad," and "Sister Maude" with Rossetti's experiences at Highgate.

2. Mackenzie Bell, *Christina Rossetti: A Biographical and Critical Study* (Boston: Roberts Brothers, 1898), 60; William Michael Rossetti, ed., *The Poetical Works of Christina Georgina Rossetti* (London: Macmillan, 1904), 485. Hereafter cited parenthetically in the text as *PW* and by page number.

3. William Michael Rossetti, ed., *The Family Letters of Christina Georgina Rossetti* (London, 1908; repr. New York: Haskell House, 1968), 26.

4. Deed for Establishing the London Diocesan Penitentiary, Guildhall Library, London, MS 18,532; *Times*, 25 January 1854, 8; see John Richardson, *Highgate: Its History since the Fifteenth Century* (New Barnet, Herts: Historical Publications, 1983), 132–33, for a description and brief history of the building. The structure no longer exists, having been demolished in 1946 to make way for new buildings; however, Richardson does include an illustration. Although he gives 1885 as the date for the opening of the penitentiary, he then quotes census records from 1861 indicating that during that year there were "38 penitents age 16–32." Obviously the 1885 date is an error and should read 1855. According to Richardson, the institution was closed in 1940.

Rossetti's critics and biographers often refer to St. Mary Magdalene's as the House of Charity. However, nowhere in the historical records of the institution is that name ever used. For a more detailed discussion of this issue see my article "Christina Rossetti's 'From Sunset to Star Rise': A New Reading," *Victorian Poetry* 27 (1989): 95–100.

George Nugee's donation to found the London Diocesan Penitentiary was just a small part of a much larger movement to deal with fallen women and prostitution (not all fallen women were prostitutes), to grapple with the "social evil" as it came to be called. Archdeacon Manning's sermon "Penitents and Saints," preached on behalf of the Magdalen Hospital, 8 May 1844, and published later that same year is considered to have given "impulse" to the movement. The Reverend John Armstrong is considered the "originator" of the movement. See Thomas Carter, *A Memoir of John Armstrong* (London: G. John Henry and James Parker, 1857), and Hutchings, *The Life and Letters of Thomas Thellusson Carter*. Carter was also active in the cause and founded one of the first such penitentiaries, the House of Mercy at Clewer.

5. Guildhall MS 18,535; W. H. Hutchings, *The Life and Letters of Thomas Thellusson Carter*, (London: Longmans, Green, 1904), 76; Guildhall MS 18,535.

6. *Times*, 6 May 1857, 7. By the end of the century this classification system had become quite elaborate. Some homes were for "penitent young women who ha[d] lately fallen, but ha[d] otherwise good character, whether pregnant or not"; others were for "fallen women who ha[d] been living a life of sin"; and others for "married women and young girls, with first baby." There were even homes that indicated they would accept fallen women who had attempted suicide. See *The Classified List of Reformatory, Preventive, and Child-Saving Institutions* (London: Reformatory and Refuge Union, 1892).

7. Guildhall MS 18,535.

8. Quoted in Richardson, *Highgate*, 132.

9. William Gregg, "Prostitution," *Westminster Review* 53 (1850): 476.

10. *Work Among the Lost* (London: Hatchards, 1876).

11. Carter, *Memoir*, 233. John Armstrong, "The Church and Her Female Penitents," *Christian Remembrancer* (January 1849): 17.

12. Henry W. Burrows, "The Conflict with Impurity," in *The Enduring Conflict of Christ with Sin that Is in the World* (Oxford: John Henry and James Parker, 1865), 87; Armstrong, "The Church and Her Female Penitents," 14. Armstrong came to this conclusion in 1849. Ten years later the connection between a life of female unchastity, prostitution, nervous disorders, and even madness was still being made. See "The

Vices of the Street" in *Meliora* 1 (1858–1859): 70–79. The life of a prostitute was thought to last at the most seven years, at the least four: "Many perish by suicide; many become mad" (76). See also "The Social Evil" in *Meliora* 3 (1860–1861): 145–57: "In the case of the greater number who forsake to any extent the healthful paths of virtue, unless they are reformed within a very few years, nay, it may be said months, reformation is scarcely within their power; while, even if penitent and morally improved, the disordered state of their nervous system, and the great diminution of their muscular power, render them a mere wreck of their former selves" (155).

13. Thomas Carter, *The First Five Years of the House of Mercy, Clewer* (London: Joseph Masters, 1856), 13; Guildhall MS 18,633.

In her book, Felicia Skene does not mention any particular penitentiary by name; however, she makes it clear that she is referring to the church penitentiaries recently established, and she claims that in describing one of these "homes" she is describing all, "for they scarcely differ in even insignificant details" (6). Her purpose in writing is to argue for reforms in these institutions. Although she believes such institutions are the result of the "most important movement of modern benevolence," she feels they are too strict. Skene, *Penitentiaries and Reformatories* (Edinburgh: Edmonston and Douglas, 1865), 7, 12.

14. Skene, *Penitentiaries and Reformatories*, 12; Armstrong, "The Church and Her Female Penitents," 9.

15. Armstrong quoted in Carter, *Memoir*, 28; Armstrong, "The Church and Her Female Penitents," 15, 17; W. J. Butler, "A Short Preface on Sisterhoods," *On Penitentiary Work* (London: H. H. Parker, 1861), iii–x.

16. "The Accepted Penitent," preached 18 April 1861 at St. James Church Picadilly; quoted in William Tuckniss, "The Agencies at Present in Operation within the Metropolis, for the Suppression of Vice and Crime," in *London Labour and the London Poor*, ed. Henry Mayhew, vol. 4 (1861; repr. New York: Dover, 1968), xi.

17. See, for example, Tuckniss, "Agencies," xxxix, where he quotes the following from an article that appeared in *Magdalene's Friend* (2:131): "Who can tell the pestiferous influence exercised on society by one single fallen women? Who can calculate the evils of such a sister? Woman, waylaid, tempted, deceived, becomes the terrible avenger of her sex. Armed with a power which is all but irresistible, and stript of that which can alone restrain and purify her influence, she steps upon the arena of life qualified to act her part in the reorganization of society . . . the dissolution of domestic ties, in the sacrifice of family peace, in the cold desolation of promising homes, but, above all, in the growth of practical Theism, and in the downward tendency of all that is pure and holy in life!" See also a review of Gaskell's *Ruth* published in the *National British Review* 19 (1853): 155, and Thomas Carter, "Sermon I," in *Mercy for the Fallen: Two Sermons in Aid of the House of Mercy* (London: Joseph Masters, 1856), 10.

18. *Times*, 25 January 1854, 8.

19. Armstrong, "The Church and Her Female Penitents," 8, 10. There is a close connection between the sisterhoods formed to care for female penitents and the revival of religious communities within the Anglican Church. In fact, saving fallen women in some cases provided the occasion for establishing a full-fledged religious

sisterhood that took vows and followed a religious rule. For example, under the guidance of the Reverend Thomas Carter, this occurred at Clewer with the founding of the Society of St. John the Baptist. However, such a religious sisterhood seems not to have been associated with the London Diocesan Penitentiary during Rossetti's lifetime. Although Martha Vicinus in her recent book, *Independent Women: Work and Community for Single Women 1850–1920* (Chicago: University of Chicago Press, 1985), 312, writes that All Saints Society was running St. Mary Magdalene's while ~ Rossetti worked there (1860–1870), the present sisters of the order have informed me that they have no record of ever being in charge of St. Mary Magdalene's. The sisters of St. John the Baptist have informed me that they took charge of the institution in 1900. It seems unlikely that they would have taken over from another fully established religious order. Carter, *Memoir*, 222.

20. Carter, *Memoir*, 244; Guildhall MS 18,535.

21. Guildhall MS 18,535.

22. Unpublished letter from Christina Rossetti to Pauline Trevelyan, no date. Newcastle-Upon-Tyne Library, Trevelyan Collection, Newcastle-Upon-Tyne.

23. Guildhall MS 18,536; Rossetti, ed., *Family Letters*, 26; Armstrong, "The Church and Her Female Penitents," 13; Carter, *First Five Years*, 6.

24. Christina Rossetti, *Annus Domini: A Prayer for Each Day of the Year* (London: James Parker, 1874), 141; the diaries of Frances Lavinia Rossetti, 1881–1886, Angeli-Dennis Collection, University of British Columbia Library, Vancouver, British Columbia.

25. I am not including in the category of fallen women poems those in which Rossetti alludes to the "whore" mentioned in Revelation 17:1–18, such poems as "Babylon the Great," and "Standing afar off for fear of her torment." Nor am I including the poem "The World," which employs the image of the "strange woman" mentioned in the book of Proverbs (5:3–5). In those poems she is following a biblical tradition of using the female image to represent the temptations of the world; she is not using the figure to represent a female human being who has committed some sexual sin. For Rossetti's own comment on the symbolic significance of the fallen woman of Revelation see *The Face of the Deep: A Devotional Commentary on the Apocalypse* (London: Society for Promoting Christian Knowledge, 1892), 411.

26. *The Complete Poems of Christina Rossetti: A Variorum Edition*, ed. Rebecca Crump, 3 vols. (Baton Rouge: Louisiana State University Press, 1979–1990), 1:174. Hereafter cited parenthetically in the text by *CP* and by volume and page number.

27. The sensuous imagery of the goblin fruit has led many critics to interpret Laura's fall as a sexual one. D. M. R. Bentley in a recent article, "The Meretricious and the Meritorious in 'Goblin Market': A Conjecture and an Analysis," in *The Achievement of Christina Rossetti*, ed. David Kent (Ithaca: Cornell University Press, 1988), speculates that Laura represents the fallen women of Highgate and Lizzie represents the sisters running the home. Examination of the movement supports this reading. As ~ we shall see, parallels can be made between the poem and the literature of the Church Penitentiary Movement. However, it should also be noted that when we place this poem within the larger context of Rossetti's other work, goblin fruit can be seen as

symbolic of all self-indulgent experience, experience that places man and the things of the world before God.

28. The commonplace book Mrs. Rossetti kept for her children contains two pieces on the subject of prostitution: "Verses for My Tombstone If Ever I Should Have One," a poem copied in full from Edward Creech's *Fugitive Pieces,* verses supposedly written by a "prostitute and a penitent." The speaker describes herself as a "lost love ruin'd female" and "dupe of passion, vanity and man." (This poem is quoted by Gregg in "Prostitution.") The second piece is an untitled thirteen-line poem:

> Such is the fate unhappy women find,
> And such the curse entail'd upon our kind,
> That man, the lawless libertine, may rove
> Free and unquestion'd through the wilds of love;
> While woman, sense and nature's easy fool,
> If poor weak woman swerve from virtue's rule
> If, strongly charm'd she leave the thorny way,
> And in the softer paths of pleasure stay,—
> Ruin ensues, reproach, and endless shame,
> And one false step for ever damns her name.
> In vain with tears, the loss she may deplore—
> In vain look back to what she was before—
> She sets,—like stars that fall—to rise no more.

29. Manning, "Penitents and Saints," 19; Carter, Sermon II, *Mercy,* 13; Gregg, "Prostitution," 459 (for comments on Gregg's article as a watershed discussion, see Keith Nield, "Introduction," *Prostitution in the Victorian Age: Debates on the Issues from 19th-Century Critical Journals* [Westmead, England: Gregg International Publishers, 1973], 14); A. O. Charles, *The Female Mission to the Fallen* (London: John Henry and James Parker, 1860), 13.

30. There is some possibility that Rossetti had more direct experience with the fallen woman issue than just reading and listening to sermons. Henry W. Burrows, in *The Half-Century of Christ Church, St. Pancras, Albany Street* (London: Skeffington, 1887), writes that in 1852 a Mrs. Chambers opened within the parish a "house of refuge for fallen women" (37). Maria Rossetti took part in Mrs. Chambers's Young Women's Friendly Society, a society founded to provide servant girls with "religious recreations" on Sunday afternoons. Lona Mosk Packer, in *Christina Rossetti* (Berkeley: The University of California Press, 1963), conjectures that it was through Mrs. Chambers's Young Women's Friendly Society that Christina Rossetti "found her way up to Highgate Hill" (422n. 3).

31. Some attention was given to the male penitents by those involved in the movement to save fallen women. The Reverend Armstrong expressed some concern about the spiritual well-being of the male penitents. It seems he felt that they could make amends in part by contributing to female penitentiaries (see Carter, *Memoir,* 234). The Reverend Burrows in his sermon "The Conflict with Impurity" also refers to the act of donating money as an act of repentence for the male sinners. Some articles

publicly recognized the unfairness of the double standard: "Yet men are not admonished to rise from their low degraded condition" ("The Social Evil," *Meliora* 3 [1860–61]: 147). This anonymously written article speaks of the need to save the male sinner as well: "In vain shall we attempt to rescue the one sex [female] from evil if the other is to be held scatheless, and permitted to go on drawing the innocent into the vortex" (150). Despite this recognition that men also "fell," no special institution or organized system of penitence was ever proposed for the male sinner. The emphasis remained on fallen women.

32. Quoted from notes (two to three pages in length) privately owned by Mrs. Harold Rossetti, who generously granted permission to publish them. For a detailed study of the theme of renunciation of earthly love in Rossetti's work, see Antony H. Harrison's *Christina Rossetti in Context* (Chapel Hill: University of North Carolina Press, 1988), 89–141.

33. Armstrong, "The Church and Her Female Penitents," 8; Manning, "Penitents and Saints," 24.

34. Armstrong, "The Church and Her Female Penitents," 9.

35. See Rossetti, ed., *Family Letters,* 26.

36. *Face of the Deep,* 310. For a detailed discussion of Rossetti's interest in Mary Magdalene, see my article "Eve, Mary, and Mary Magdalene: Christina Rossetti's Female Triptych," in *The Achievement of Christina Rossetti,* 175–91.

THAÏS E. MORGAN

VIOLENCE, CREATIVITY, AND THE FEMININE

Poetics and Gender Politics in Swinburne and Hopkins

Sandra Gilbert and Susan Gubar's indictment of Western culture for its historical exclusion of women from artistic creativity in *The Madwoman in the Attic* is well known. In a subsequent article entitled " 'The Blank Page' and the Issues of Female Creativity," Gubar observes that "myths of male primacy" dominate our fundamental paradigms for "theological, artistic, and scientific creativity." For example, Christian typology offers two central models: Genesis (the creativity of the divine Word as manifested in the direct act of Creation) and the Annunciation (the creativity of the divine Word as translated into flesh by a woman). Significantly, there is no place allotted to women in the former model of direct creativity, so that only the latter function of mediating an essentially masculine divine creative force remains open to women. As Gubar points out, this dominant Christian model confines the feminine role to that of "vessel" or passive receptacle and eventual conduit of an intelligence and a power that is always figured as masculine. Gubar calls this the "transcendental phallus" paradigm of creativity.[1]

Given the largely Christian grounds of our culture, Gubar further argues that any woman is typically positioned as an "object," whether the context of representation is religious or secular: "If we think in terms of the production of culture, she is an art object: she is . . . an icon or doll, but she is not the sculptor." Consequently, "female sexuality is often identified with textuality."[2]

In the secularized model of creativity, instead of insemination of a female figure by a divine male creator, the male artist or writer appropriates the female body for purposes of expressing his own worldview, ideologically investing or "inscribing" the female body through his own "word" or text. Thus, the body of "Woman" as a masculinist construct becomes a text that is "written" and "read," or doubly inscribed within a masculine economy of power and knowledge.[3] The male writer may carry out such an inscription of the feminine either by placing a female body at the center of his text's descriptive discourse or by adapting a feminine voice to his own voice throughout his text. Even in the best case, though, says Gubar, the feminine position remains that of a "secondary object" produced by the masculine imagination.[4] Femininity as a potentially distinct and coequal mode of creativity is either bracketed or denied. Whether belonging to Muse, Holy Mother, or erotic partner, the female body inscribed in the text thus "bears"—or represents and reproduces—the masculinist paradigm of creative power and authoritative knowledge.

Although critics in Victorian studies have not usually seen Algernon Charles Swinburne and Gerard Manley Hopkins as engaged in similar projects, I would suggest that a feminist critique of the relation between gender and metaphors of creativity in their poetry reveals that both Swinburne and Hopkins strongly link poetics to sexual politics.[5] Through an analysis of the structures of representation in Hopkins's "The Wreck of the Deutschland" (1875–1876) and Swinburne's "On the Cliffs" (1879–1880), I will argue that the foregrounding of violence to the feminine in their poetry is the effect of misogynistic premises in their poetics. At the same time, the focus on violating the feminine in Hopkins and Swinburne serves another purpose, acting as a defensive detour around the dangers of homoerotic desire and the concomitant homophobic fear of the "effeminate."

Hopkins and Swinburne use parallel structures of representation in which to inscribe their politics of gender. Each poem explores the relations among masculinity, represented by a divine figure; femininity, represented by one or several women who die violent deaths due to sexual conflicts; and a third position, for which I will borrow the marked Victorian term "effeminacy," and which is represented by the poetic persona himself as he shifts back and forth between genders.[6] Moreover, in both "The Wreck of the Deutschland" and "On the Cliffs," the poetic speaker passes through three different kinds of relationships to the feminine, which is the gender position most visibly foregrounded by each text. Specifically, the basic representational structure in Hopkins's and Swinburne's poems is constituted by a scene of erotic violence between a heterosexual pair (masculine divinity and feminine figure), which is then redoubled or reenacted by a homosexual pair (masculine divinity and masculine-identified poetic persona). This basic structure can itself be analyzed

as three sequent scenarios that represent three different situations of gender relations. First, erotic violence takes place when a central feminine figure encounters a masculine godhead and "bears" the "word" of prophetic or poetic truth. Second, this exchange of power, desire, and knowledge is closely watched and contemplated by the poetic speaker, who identifies alternately with the active and passive subject positions in the drama. The eventual death of the central feminine figure(s) in each case precipitates a crisis in gender identity for the poetic speaker. In the final scene of each poem, the persona asserts that he recognizes masculinity, not femininity, as the most powerful source of artistic creativity, but this stance is rendered highly ambiguous by the inscription of effeminacy as the most truly productive—and the most dangerous—position for the poet at the moment of writing the text.

Both Hopkins's "The Wreck of the Deutschland" and Swinburne's "On the Cliffs" are poems of vocation in which the poet dramatizes his calling to poetry and questions the sources of his inspiration as an artist. Hopkins and Swinburne each work in the genre of the dramatic monologue, which enables development of psychological subtleties through achronological narrative devices such as flashbacks and adaptation of multiple voices or dramatic selves.[7] At the same time, as dramatic monologues, "The Wreck of the Deutschland" and "On the Cliffs" afford the male writer the opportunity of exploring a double-gendered discourse in which he can feel and speak through the feminine without permanently forfeiting his masculine identity and without incurring any suspicion from Victorian readers, especially male readers, as to his effeminacy.[8]

Hopkins's "The Wreck of the Deutschland" is divided into two parts: in part 1, the speaker dramatically reenacts his initial calling to God and to poetry, stimulated to do so by the news of the heroic behavior of a Franciscan nun during a shipwreck that occurred in 1875; in part 2, the speaker imagines the scene of the nun's martyrdom and then draws back into a prayerful meditation on his own vocation. Significantly, from the very beginning, Hopkins uses metaphors of violent eroticism to express his own experience of conversion and of God's grace.[9] He describes his experience of divine inspiration not only in the past (stanza 2) but also in the present time of writing (stanza 1):

> Thou mastering me
> God! . . .
>
> . . .
>
> Thou hast bound bones and veins in me, fastened me flesh
> And after it almost unmade, what with dread,
> Thy doing: and dost thou touch me afresh? . . .
>
> . . .

I did say yes
O at lightning and lashed rod . . .

. . .

The swoon of a heart that the sweep and the hurl of thee trod
Hard down . . .[10]

The focus here lies on the body of the person who is called by God and on God's absolute power over that body as its Creator. The speaker is helpless, passive, and as if wounded or "almost unmade" by the invasive force of God's Word. God is "adored King" but also fearful "master" whose "rod" is suffered by the poet-priest exactly as it has been suffered by the martyred nun: God is "her master and mine!" (146). In Hopkins's poetics, erotic violence is the precondition for inspiration. Thus, the speaker can even take pleasure in the pain God administers because being "almost unmade" by His "touch" is a sign of grace, both spiritual and artistic. In exchange for poetic power, then, the speaker is willing to inscribe his own body and voice in the "feminine"—a cultural construct, as Gubar points out, that, in theology as well as in art, positions the subject as "object" or "vessel" to mediate the Word/words of a more powerful other.

At the same time, Hopkins's use of the epithet "master" and the poetic speaker's utter submission to God also suggest a sadomasochistic relation of power between worshiper and divinity, who here are both male. The eroticization of grace through Hopkins's metaphors invites a reading of the experience of inspiration as "feminine" in the psychoanalytic sense of masochistic but also implies a homoerotic relation between Christ and the male Christian. In this double reading, the masochistic joy that characterizes the poet-priest's ecstatic cry during his calling to God—"I did say yes / O at lightning and lashed rod"—parallels the nun's acceptance of her "unchancelling" by God—"O Christ, Christ, come quickly!" (191). The action of the divine Word is unmistakably phallic, not to say physically threatening. Before he identifies himself with the martyred nun directly in part 2 of the poem, therefore, Hopkins's speaker has already been feminized in the very act of seeking poetic inspiration from God. Consequently, at several moments in "The Wreck of the Deutschland," Hopkins models the male poet-priest's reception of God's grace—"Thou heardst me truer than tongue confess / Thy terror" (11–12)—after the Annunciation, whose central feminine figure stands in a relation to the masculine deity that depends on the manifestation of divine presence and power in the form of desire and violence. Typologically, because the model of the Annunciation precedes that of the Crucifixion, the model of male martyrdom or the *imitatio Christi* is itself effeminized, as we shall see.[11]

By making the present moment of his religious and creative inspiration

repeat as well as anticipate the nun's erotic and fatal encounter with the godhead, Hopkins sets up a revisionist Christian typology that serves to destabilize the boundaries of sexual difference. The male artist is most creative precisely when he is most feminized. The "swoon" of the speaker's "heart" as he recalls how God "trod / Hard down" on him in the moment of inspiration both prefigures and postfigures the martyred nun's fatal ecstasy in part 2 of the poem. Hopkins emphasizes the concurrence of sadomasochism and homoeroticism involved in the ascetic assumption of a "feminine" role in relation to the deity's powers. Perhaps it is his fear of becoming fully feminine that prompts the poetic speaker to express "dread" as his body is "touch[ed]" by God: "Over again I feel thy finger and find thee" (8). The speaker himself draws our attention to his precarious state: "almost unmade," he has become dangerously like a woman, specifically like the nun whose mystical violation the speaker keeps constantly before his memory during this dramatic mono-logue, and as if dead to himself as a man or "unmade" in the sense of unmanned and effeminized.

In the next section of part 1 of "The Wreck of the Deutschland," Hopkins depicts the disintegration of the speaker's gender identity through images of the softening of his body:

> I am soft sift
> In an hourglass—at the wall
> Fast, but mined with a motion, a drift, . . .
>
> . . .
>
> But roped with, always, all the way down from the tall
> Fells or flanks . . .
>
> (25–27, 30–31)

Within the stereotypes of masculinity and femininity available in Victorian (and our) culture, "hard" encodes the masculine while "soft" evokes the feminine.[12] In a metaphorical fantasy, the speaker's body merges with the nun's body: as the poet-priest is "mined with-a motion" or the "pressure" of divine poetic inspiration, so the nun is martyred by the violent "motion" of the storm and her dead body turned to sand or "soft sift" in the sea. In other words, hard/masculine imagines itself as soft/feminine. The speaker also feels "roped" in by God—a distinctly sadoerotic metaphor for the "bondage" of the soul to its Maker, here represented by the figure of the martyred nun who was "bound" to the deck during the storm and hence "bound" to her death when the Deutschland sank into "soft sift." Through the very intensity of his desire for union with God at any cost, then, the Jesuit priest makes himself interchangeable with the nun as a feminine subject. The crucial boundary of sexual difference, which Hopkins's metaphors seem aimed at blurring, re-

mains, though: the male speaker is effeminized by his passion for "Christ's gift," while the nun's feminine way to salvation remains apart and finally out of his reach, as he himself recognizes in part 2.

The speaker's markedly intimate gesture toward Christ—"I kiss my hand / To the stars . . . / . . . wafting him out of it" (33–35)—at the beginning of stanza 5 carries on the homoerotic subtext of "The Wreck of the Deutschland."[13] It also suggests that a male-to-male relationship based on erotic violence and power, in which the poet-priest seeks and God wields all the creative force, and which for Hopkins is patterned after the unequal sexual difference represented by the Annunciation, is not the only way to the divine. The second half of part 1 of the poem (stanzas 5–10) hints at another kind of male-to-male relationship, a secret understanding that joins the speaker and Christ, a "mystery" shared by Christ and his male disciples. Significantly, this "mystery must be instressed, stressed" (39): the ambiguity of Hopkins's central terms "stress," "instress," and "inscape" has been noticed by other critics, but I would suggest that Hopkins's balance of "instress" and "stress" in the present context may serve as a way of renegotiating the gender of creativity.[14] This negotiation is complicated and is not a matter of simple choice between masculinity or femininity for Hopkins. Thus, on one hand, poetic inspiration must be experienced in the feminine and in the masculine at once, "instressed" as well as "stressed," just as belief in Christ must be. Yet, on the other hand, if he is willing to adopt a femininized posture in order to receive the Word of God and inspiration for his poetry, Hopkins clearly regards this submissiveness as a temporary condition. Accordingly, in stanza 6, the poetic speaker joyfully accedes to a masculinist position of power based on the knowledge of Christ's "mystery" and on the confident possession of His "gift"—poetic inspiration:

> Not out of his bliss
> Springs the stress felt
> Nor first from heaven (and few know this)
> Swings the stroke dealt—
>
> (41–44).

Not from submission to God but from the poet himself does "the stress" of creativity "first" come. Not from the feminine, with its modalities of passive receptivity and suffering, does poetry come but from the masculine, with its privileged modalities of active creativity and self-assertion. The shift of focus in the metaphors from the speaker's physical body to his spiritual and artistic utterance signals this shift in gender alignment from feminine to masculine, and both of these, in turn, mark a shift in poetic principles from "effeminate" dependence on an outside source to "manly" autonomy for one's art. What

Gubar calls the "transcendental phallus" paradigm of creativity thus competes
with Hopkins's tentative construction of an alternative gender model for cre-
ativity. The productivity that the male artist can draw from this very conflict of
gender identities may indeed be the gist of the poet's secret knowledge—"(and
few know this)."

Although largely based on a "feminine" mode of experiencing divine grace,
the poetics established at the end of part 1 of "The Wreck of the Deutschland"
finally excludes women from access to creativity. Artistic inspiration is meta-
phorically defined in terms of acts of sheer power—"the stroke dealt" that
"rides time like riding a river"—tumescence, and orgasmic "discharge":

> The dense and the driven Passion, and frightful sweat;
> Thence the discharge of it, there its swelling to be,
> Though felt before, though in high flood yet—
> (53–55)

Furthermore, through an allusion to Christ's birth, we are reminded that the
nun to be apotheosized in part 2 is, after all, only a woman, whose highest
destiny in the Christian economy is motherhood, the role of holy "vessel,"
but who is herself incapable of generating the divine "stroke" of genius whose
action characterizes both the poet and his Christ:

> Warm-laid grave of a womb-life grey;
> Manger, maiden's knee
> (51–52).

As Hopkins's explanation of his poetics in a letter to R. W. Dixon makes clear,
the "masterly execution" of poetry "is a kind of male gift and especially marks
off men from women."[15] Before she enters the scene, therefore, the nun as the
central female figure in the poem has already been relegated to the traditional
position of the feminine in the Christian symbolic economy: that of mediatrix
for the sacred and secret communication between "brothers in Christ."[16]

Given the strain between genders in part 1 of "The Wreck of the Deutsch-
land," the speaker's identification with the martyred nun in part 2 can only be
problematic. Above all, it is clear that Hopkins, despite his attraction to the
feminine, does not view the feminine as a desirable subject position. Instead,
Hopkins is exploring the homoeroticism latent in Christianity in general and
in his own poetics in particular *through* the central feminine figure in the text.
In stanzas 11 through 17 the speaker recreates the shipwreck of the Deutsch-
land (1875), and in stanzas 17 and 18 he focuses steadily on one of the
Franciscan nuns, whose calling to martyrdom is interpreted as proof of her
access to a knowledge of Christ and a prophetic power akin to those that the
Jesuit poet must achieve in order to realize his own art:

> . . . a lioness arose breasting the babble,
> A prophetess towered in the tumult, a virginal tongue told.
>
> Ah, touched in your bower of bone
> Are you! turned for an exquisite smart,
> Have you! make words break from me here all alone,
> Do you!—. . .
>
> (135–40)

Like the submissive Christian who recognizes his own creativity through the "pressure" of Christ's "mystery" in part 1 of the poem, the nun suffers into greatness, becoming a "prophetess" or mouthpiece of God only through her death. The nun is given the power to utter divine truth, just as the speaker is at the moment of poetic inspiration: the nun's "virginal tongue told" parallels both the speaker's moments of insight and "instress": "Thou heardst me truer than tongue confess / Thy terror, O Christ, O God" (11–12). Nonetheless, the feminine and the masculine modes of grace and creativity remain incommensurate. First, unlike the poet, whose "stress" is "No[t] first from heaven," the nun as a prophetess acts merely as a mediator of God's Word and is not herself an originator of divine truth. Second, as the epithet reminds us, the nun is not the "hero of Calvary" or Christ but a "lioness" who must, despite the heroism of her deeds, take second place to the lion. Third, the nun must die for the divine knowledge and prophetic power that she gains; the speaker himself will not.

As he tries to imagine the actual scene of her martyrdom, the speaker identifies passionately with the nun's physical sensations as well as with her spiritual revelation. God's "touch" is "an exquisite smart" that "turns" or brings her out of herself, just as the speaker had felt God's "finger" in stanza 2. The imagined sight of the play of pain and pleasure across the nun's body as she unites with Christ causes the excited speaker to forget the poetic mastery he claimed for himself in stanza 6 and to ejaculate, "[M]ake words break from me here all alone / Do you!—" (139–40). Interestingly, during this moment, the tables seem to be turned and the power of inspiration falls to the nun, not to the poet: if she must submit to Christ, the speaker must submit to her and, through her, to Christ. But the nun's mediation of Christ's presence again emphasizes her role as *ancilla dei*, and the speaker's ultimate goal is less to reexperience her martyrdom imaginatively than to experience his own union with Christ, in both the erotic and spiritual senses, through the relatively safe medium of the feminine figure represented in his text.

Yet when he asks, "What can it be, this glee? the good you have there of your own?" (144), the speaker's question implies his recognition that sexual

difference still separates the quality of the nun's inspiration from his own. These questions have a double purpose: he wants to know not only what martyrdom is like generally but also what martyrdom in the feminine might be like. Precisely because she is "mastered" by Christ, his own object of desire, the speaker urgently wants to feel, to know, to appropriate the nun's experience of martyrdom. He questions the nun almost as a jealous lover would, suspecting that, as a woman, she retains for herself a form of divine knowledge and prophetic utterance higher than the male speaker can ever obtain. Later, in stanza 25, Hopkins is still worrying this point: "The majesty! what did she mean? / . . . Is it love in her of the being as her lover had been?" (193, 195). Ironically, despite his frantic attempts to cross over into the feminine by inscribing the female body at the center of his text, Hopkins's persona remains excluded from the nun's uniquely female knowledge of Christ, or her *jouissance.*[17] The best that he can do is to masquerade in the feminine at several points throughout the poem by taking up the "feminine" position in relation to Christ: passivity, receptivity, and submission. Hopkins's persona in "The Wreck of the Deutschland" attempts to participate in the nun's glorious martyrdom and in her union with Christ in another way as well—through voyeurism of what he imagines her encounter with Christ must have been like:

> She to the black-about air . . .
> Was calling 'O Christ, Christ, come quickly';
> The cross to her she calls Christ to her. . . .
>
> The majesty! what did she mean? . . .
> Is it love in her of the being as her lover had been?
> Breathe, body of lovely Death.
> (189–92, 194–95)

Because of the differences he has marked between himself and the nun—the difference between the "prophetess" 's receptivity and the poet's creativity, for instance—the speaker's identification with the nun's erotic union with Christ here appears voyeuristic rather than sympathetic. His ventriloquism of her ecstatic cries at the moment of *jouissance*—" 'O Christ, Christ, come quickly' "—is spoken in a falsetto that mocks as much as records her ecstasy, which, pathetically, she has achieved only through her death.

The speaker's fundamentally misogynistic attitude toward the martyred nun in "The Wreck of the Deutschland" emerges even more strikingly in stanza 28 (217–24). Here, his attempted identification with the feminine produces a rape fantasy, in which the central female figure is violently taken by the male divinity while the speaker looks on:

> But how shall I . . . make me room there:
> Reach me a . . . Fancy, come faster—
> Strike you the sight of it? look at it loom there,
> Thing that she . . . There then! the Master . . .
> Do, deal, lord it . . .
> Let him ride, her pride, in his triumph, despatch and have done . . .
> (217–20, 223–24)

The nun's encounter with Christ is modeled after the Annunciation, but as revised through Hopkins's violent eroticism. In his role as holy Bridegroom, Christ enters the nun to make her "bear" the Word. Hopkins's peculiar "Fancy" of this major Christian story entails a triangulation of desire and power in which the divine male "Master" "ride[s]" the nun and, as spectator, the poetic speaker projects himself into both the sadistic/active and masochistic/passive roles of the central pair. On the one hand, the speaker seems to egg Christ on from the sidelines, like a vicarious participant in a gang rape of a woman who got what she was asking for—"Let him ride, her pride . . . despatch and have done." On the other hand, as the metaphorical equivalences posited between the speaker and the nun earlier make clear—"A master, her master and mine!" (46)—the speaker cannot but see his own desire for Christ's "mystery" of "mastery" in the nun's subjection and also in her *jouissance.*

Arguably, the violence against the central feminine figure in "The Wreck of the Deutschland" is all the more intense because the poetic "I" is divided or conflicted, taking on the roles of desired object and desiring subject, or alternating feminine and masculine gender identities throughout the text. Another reason for the connection between misogynistic violence and creativity in Hopkins's poetics must be considered, too. Through a revisionist use of typology, Hopkins in stanzas 20 through 23 shifts the poem's focus from memorialization of the martyred nun to an ecstatic personal vision of "Lovescape crucified" (180), or a palimpsest of the tortured bodies of male martyrs. As a devotional conceit, "Lovescape crucified" calls to mind the way in which Christ's Passion (stanza 22) prefigures St. Francis's stigmata or the *imitatio Christi* (stanza 23). Similarly, this conceit reinforces the typological parallels between the nun, who stands in for her "coifèd sisterhood" or the other four nuns who died with her, "father Francis," and "suffering Christ." On the structural level of the poem, then, the conceit of "Lovescape crucified" works as does the holy number five, through which the speaker moves from admiring the "five" nuns to imagining the "five" wounds of Christ and, after Him, the "five" stigmata of St. Francis.

However, the near identity of Francis's and Christ's martyrdoms contrasts sharply with the manner of the nun's death: her "virginal" body and its "exquisite smart" differ significantly from the "man's make" of Christ's and

St. Francis's bodies. Their special "Mark" differentiates these male martyrs from the female version but also makes them comparable to another splendidly suffering male body—the body of the brave sailor, whose heroic but ultimately futile self-sacrifice, described in stanza 16, ironically prefigures the nun's heroism, depicted in stanzas 17 and 18. If Christ and St. Francis are legitimate objects of devotional contemplation, Hopkins's fantasy about the tragic sailor, "handy and brave," who attempts "to save" the "women-kind below" during the shipwreck, is illicitly homoerotic in the context of religious worship. Furthermore, even in terms of Victorian typology, Hopkins's inclusion of the sailor in the company of canonical male martyrs (Christ and St. Francis) is a daring move.[18] Of course, the sailor represents a traditional heterosexual ideal of male prowess and chivalry; at the same time, though, he represents a Victorian homosexual ideal of the working-class man's beauty, with "all his dreadnought breast and braids of thew" (125).[19] In the actual event, this sailor was decapitated in his struggle to save others, symbolically losing his manhood for Christ—a fate that Hopkins, who confesses himself "almost unmade" by his devotion to God, both desires and fears.

The specularization of three male bodies in suffering—the sailor's, Christ's, and St. Francis's—competes with the specularization of the female body in the nun's martyrdom. Subtly but unmistakably, Hopkins here shifts from an inscription of the feminine to an inscription of the effeminate at the center of his text. Yet, significantly, the violence in this section of "The Wreck of the Deutschland" is directed not only at the nun but also at the male martyrs. Hopkins's fascination with male martyrdom or "Lovescape crucified" is not an untroubled one, and his repetitive focus on the public exhibition or "Stigma, signal, cinquefoil token" (175) of these three men's exemplariness as religious icons borders on the obsessive. For, paradoxically, their holy status depends on Christ's and Francis's willingness, *as* men, to submit to God as a superior masculine force in the way that a woman, like the nun, would—that is, without reserve but with "Joy." Besides its proper Christological meaning, then, the "Mark" of the male martyrs' bodies here may be read as the poet's attempt to inscribe an emergent homosexual identity into his text—one that still represents itself as improperly effeminate and as exceptional in its mediacy between masculinity and femininity, hence exceptionally vulnerable and fearful of a public martyrdom in the form of a homosexual scandal. Considering this complex interplay of genders in Hopkins's poetics, violence to the feminine in "The Wreck of the Deutschland" may thus stem from a combination of internalized homophobia and gynephobia, in which the male poet both envies the feminine and fears the feminine as that Other he himself already has become through his homoerotic desire.

> Away . . .
> On a pastoral forehead of Wales,
> I was under a roof here, I was at rest . . .
>
> No, but it was not these . . .
> Not danger, electrical horror . . .
> The appealing of the Passion is tenderer in prayer apart;
> Other, I gather, in measure her mind's
> Burden . . .
>
> (185–87, 219, 223–26)

In a recoil that is motivated by an outward-directed gynephobia and an inward-directed homophobia, Hopkins's persona insists upon his distance from the central feminine figure in the poem—geographically, temporally, physically, and spiritually. He rejects identification with the algolagniac spectacle of the nun, or the "appealing of the Passion" in the feminine. Instead, he asserts his preference for a less sensual, less threatening, more "manly," and more conventional "measure" of showing his devotion to Christ. He also draws an absolute distinction between his relation to Christ and hers: as a woman, the nun is "Other" and therefore not to be imitated by the male-identified poetic persona. Her grotesque *jouissance* must be set safely in perspective as an example of an extreme, almost grotesque, relation to God. In other words, the central feminine figure in the poem must be suppressed, lest the speaker himself become too feminized or effeminate by imitating a woman's improper way rather than a man's proper way to God.

In the final movement of "The Wreck of the Deutschland" (stanzas 32–35), Hopkins returns to the standard worship of Christ as carried on "between men." Through the body of the nun, the solidarity of the Jesuit community and the larger homosocial community of which it is a part has been assured. Addressing a prayer to Christ—"I admire thee, master of the tides" (249)—the poetic speaker praises His "mercy," a mercy evident in his own case but hardly so in the nun's. From the poet-priest's point of view, Christ is "Kind, but royally reclaiming his own" (271): although she has died heroically for her faith, it is the speaker who lives on to benefit from Woman's sacrifice, which has revealed to him Christ's "mystery" and has granted him a new power to understand the sources of his own inspiration. In effect, by appropriating her direct knowledge of God for his own but rejecting the pathetic vulnerability of her "body of lovely Death" as wholly "Other," the speaker reviolates the nun in order to reassert a masculinist order of power and knowledge—"prayer apart"—over that weaker vessel, the feminine body of desire. The feminine has served Hopkins's poetics as a

mediator for his creativity, but his gender alignment is finally, as always, with the masculine. As Eve Sedgwick suggests, Victorian male writers who explored a range of gender identities "tried to do so without admitting culturally defined 'femininity' into them as a structuring term."[20] Femininity, especially as invested in Christian theology, may enable Hopkins to articulate the fundamental homoeroticism of his religion and his poetics, but this indebtedness to the feminine is transformed, through the poet's own homophobic fear of becoming effeminate, into disdain for and violence to the central feminine figure in his poem.

Like Hopkins's "The Wreck of the Deutschland," Swinburne's "On the Cliffs" is a poem about artistic vocation that explores the gender of creativity. Swinburne extends the dramatic monologue's flexibility in presenting personae and temporal sequencing even more radically than Hopkins does. Thus, first-person speech in "On the Cliffs" alternates with translations of character speeches from several classical Greek dramas and poems, including Aeschylus's *Oresteia* and Sappho's "Hymn to Aphrodite."[21] These intertextual interpolations are strategically chosen, for all the borrowed speaking voices in Swinburne's poem are feminine: in this way, through the very verbal texture of "On the Cliffs," Swinburne multiplies, or rather fragments and disseminates, the gender identity of his poetic persona, who is identified in the poem as a novice male poet seeking inspiration for his art. Furthermore, in terms of his poetics, Swinburne's attempt to speak through the feminine as well as through the masculine here suggests that he envisions the source of poetic creativity as bisexual, so that the true poet should be able to speak as a man and as a woman alternately and equally. However, the feminine voices heard throughout Swinburne's poem are framed by the voice of the male poet whose main purpose for letting them speak becomes increasingly clear as the poem develops: to appropriate their insights as his own. Ultimately, then, the very virtuosity of Swinburne's ability to "do" several feminine voices is suspect; if Hopkins masquerades in a feminine body in "The Wreck of the Deutschland," then Swinburne ventriloquizes several feminine voices in "On the Cliffs." Besides, any positive movement toward a feminine gender identity for the poet is undermined, in Swinburne's as in Hopkins's text, by the violence to the feminine that is centrally inscribed as the precondition for the triumph of the masculine poet's art.

Like "The Wreck of the Deutschland," "On the Cliffs" concerns the speaker's quest for poetic inspiration in the form of divine grace. Significantly, throughout the text, Swinburne alludes to classical Greek myths that focus on sexual violence between men and women. Clearly, poetics and the politics of gender are interdependent for Swinburne. What Gubar calls the "transcendental phallus" model of creativity is immediately in evidence as "On the Cliffs" begins:

A man's live heart might beat
Wherein a God's with mortal blood should meet
And fill its pulse too full to bear the strain
With fear or love or pleasure's twin-born, pain.[22]

The 'meeting' of "a man" and "God" is the fundamental source of artistic inspiration for Swinburne, as it is for Hopkins, but, whereas Hopkins patterns his poetics after Christian myth, Swinburne quite pointedly chooses the Hellenic paradigm, which represents prophetic or poetic inspiration in homoerotic terms.[23] Yet, like Hopkins, who emphasizes the "stress" of Christ's "mystery" and his "dread" at the invasive force of the divine Word, Swinburne locates a certain "strain" in this otherwise desirable union of mortal man with masculine divinity. The encounter with the godhead produces pain-pleasure, or a mixture of "fear" and "love," in the human recipient of supernatural grace. Like Hopkins's convert in "The Wreck of the Deutschland" who faints with pain-pleasure as the Word of God enters him, Swinburne's poetic persona opens himself to the "God," adopting a "feminine" or passive and receptive position in order to invite the god to notice and to inspire him. Despite the difference between Hellenic and Hebraic contexts, therefore, the model for creative inspiration in both Swinburne's and Hopkins's poems is homoerotic from the first: while Hopkins represents ecstatic inspiration through the male mystic cast in the feminine role of Mary at the Annunciation, Swinburne imagines the dangerous pleasure of seeking artistic inspiration for the male poet through the myth of the young Ganymede rapt by the mature male god Zeus. Nevertheless, as the pain-pleasure of the encounter between "God" and man suggests, Swinburne is concerned with the psychic difficulties that such an ambiguous gender identity entails for the poet who is willing, like the speaker in "On the Cliffs," to sacrifice himself, as if he were a woman, to the "God" of art.

The direct addressee of the speaker's prayer for poetic grace in "On the Cliffs" is not a "God" but Sappho, the classical Greek poetess; this is not revealed, though, until halfway through the poem (226), and only the pronoun "she" is used to refer to the divine source of inspiration invoked continually up to that point. This referential doubling makes the gender of the transcendental Power to whom the speaker prays during the monologue undecidable. The poetic speaker does acknowledge a feminine principle, incarnated in Sappho, as the highest divine power to whom he must submit in order to become a true poet: "For some word would she send me . . ." (35). However, this relationship between the poet and a feminine creative source, his sapphic muse, established by stanza 2 of the poem, conflicts with the relationship already introduced as the idea in stanza 1, or that between the poet and a masculine creative source, a "God." As we will see, this "strain"

between masculine and feminine gender identities lies at the core of Swin-
burne's poetics: should the poet allow himself to become effeminized for the
sake of his art?

The metaphors of receptivity persistently used to describe inspiration
throughout "On the Cliffs" suggest that the male poet attains his most cre-
ative moments when he appears to be most completely feminized.[24] Like
Hopkins, Swinburne regards identification with the feminine as a necessary,
albeit risky, step in the artistic process. For instance, in stanza 5 and again in
stanza 14 of "On the Cliffs," the speaker remembers his calling to poetry in
spiritual as well as erotic terms. "In fruitless years of youth," his "soul, /
Sickening, swam weakly with bated breath / In a deep sea like death" (74, 80–
82); he describes his "spirit" as having been "sick," "heavy," and "unmanned
with strife" (88) until he was inspired by Sappho's poetry to write his own. If
the speaker's inner "strife" was due to his feelings of being "unmanned," or to
the fear of the effeminacy entailed in being both a man and a poet, then
Sappho's lesbian poetry has shown him a way of at least partly resolving this
conflict. But how? In stanzas 14 through 16, the speaker hails Sappho as the
savior of his "sick heavy spirit" and the Muse for his poetry: ". . . I have
known thee always who thou art" (220); ". . . thy gods thus be my gods, and
their will / Made my song part of thy song— . . . / . . . And my life like as thy
life to fulfill" (258–59, 261). To aspire to be a disciple of Sappho's art is, for
the Victorian male poet, tantamount to taking a polemical stance in favor of
same-sex love in life and in favor of same-sex desire as a proper topic for
poetry.[25] Sappho thus serves as an inspiration for the poet because her fame as
a poetess proves to Swinburne that same-sex love—not only female-to-female
but also and above all male-to-male—can be the foundation for truly great
poetry, hers in the past and his now.

Yet Swinburne's celebration of Sappho does not mean that he has decided
that femininity, rather than masculinity, is the true source of poetic creativity.
On the contrary, although at first represented as feminine—historically as
"woman," mythically as "goddess," and metaphorically as nightingale or
"bird"—Sappho herself is gradually masculinized in "On the Cliffs." In stanza
23, the lesbian poetess is called a "strange manlike maiden" whose poetry or
"song" attains the divine status of a "godlike note." Paradoxically, although she
champions lesbianism, Sappho is seen as "manlike," implying that a 'real' or
'pure' woman would never participate in same-sex love—presumably, a prac-
tice reserved for men—and also that such a woman writer could never be
canonized unless a superior masculinity were the secret source of her poetic
creativity. Swinburne's masculinization of Sappho is therefore deeply misogy-
nistic. At the same time, Swinburne needs Sappho as a front for his own
homoerotic poetics: he can say through Sappho what he could not say in
propria persona as a male Victorian poet. Finally, Sappho's aberrant gender

identity as a masculinized woman, or lesbian poetess, redeems, as it were, what Swinburne may feel is his own aberrant gender identity as a feminized man, or homoerotic poet. In performing these textual functions, Swinburne's Sappho is not unlike Hopkins's "tall" nun who both translates and transforms the homoeroticism of "Lovescape crucified" in "The Wreck of the Deutschland."

Displacing the scandal of homosexual love on which his poetry and poetics depend, Swinburne addresses Sappho solely in her feminine aspect in the first half of "On the Cliffs." This makes it easy to forget that Sappho was a lesbian poetess and encourages the reader to regard her as just another muse-figure for the male poet:

> " . . . thou, being more than man or man's desire,
> Being bird and God in one,
> With throat of gold and spirit of the sun;
> The sun whom all our souls call sire,
> Whose godhead gave thee, chosen of all our quire . . .
> Life everlasting of eternal fire"
>
> (94–98, 103)

Through metaphor, Swinburne conflates the nightingale heard on the cliffs by the speaker in the poem with both Sappho and "God." The bird's sublime "song" reminds the speaker of Sappho's poems; significantly, though, the origin of these other beautiful songs turns out to be not Sappho herself but "The sun whom all our souls call sire," or Apollo, the classical male "God" of art, poetry, prophecy, and music. Ironically, then, as "bird and God in one," Sappho is in fact "more than man or man's desire," for she/he contains both masculine and feminine genders. Throughout "On the Cliffs," Sappho acts as Apollo's mouthpiece and also as a mask for the poet's homoerotic desire. The sapphic "soul triune" represents not only "woman and god and bird" but simultaneously man and the "God" Apollo and the poet Swinburne. In presenting the "meeting" between a "man's live heart" and "a God's" as the paradigm for poetic creativity, Swinburne is expressing desire for and solidarity with not the feminine as Other (Sappho) but with the masculine as the Same (Apollo). In Hopkins's "The Wreck of the Deutschland," the poet affirms a special bond between himself and Christ transacted across the body and voice of the nun; likewise, in "On the Cliffs," Swinburne signals his membership in "our quire," or the community of male poets who, like himself, have appropriated Sappho's poetry as a convenient way of representing yet concealing their own homoeroticism.[26]

> Sappho—because I have known thee and loved, hast thou
> None other answer now?

As brother and sister were we . . .
Since thy first Lesbian word
Flamed on me, and . . .
This was the song that struck my whole soul through,
Pierced my keen spirit of sense with edge more keen,
Even when I knew not . . .

(226–33)

Just as Hopkins's poetic persona identifies with the prophetic nun, calling her a "sister" in Christ, so Swinburne's persona identifies with Sappho as a "sister" in the service of art. The identification with the feminine in both texts works in the same way: to mediate and also to palliate the threatening implications of effeminacy for the male poet who makes homoeroticism the ground of his art. The speaker in "On the Cliffs" fantasizes a sadomasochistic relationship with Sappho, whose poetry dominates him erotically as well as spiritually. The phallic metaphors describing Sappho's influence masculinize her and consequently evoke a male-to-male relationship rather than the conventional one between female muse and male poet: her lyricism "pierces" the poet's "keen spirit of sense with edge more keen" than that of any other writer he has read. In effect, Sappho as the ninth muse here plays the masculine/active part while the poetic speaker as recipient of her divine grace takes on the feminine/passive part. Moreover, Sappho's poetry "flames" down on the speaker in a consummation that is both painful and pleasurable, recalling the ideal homoerotic encounter between poet and "God" in stanza 1 as well as the bonding between the Apollonian "sire" and his "quire" of young male poets in stanza 6. As these parallel scenarios imply, the source of creativity in Swinburne's poetics is not at all the centrally featured feminine figure of Sappho but rather the hidden masculine figure of Apollo who speaks through her, as does the male poet himself.

The ultimately masculinist alignment of Swinburne's poetics is also detectable in the way that Sappho is surrounded by and sometimes metaphorically conflated with a series of feminine figures—notably heterosexual—each of whom suffers a violent death. As stanzas 17 and 23 emphasize, Sappho was, after all, a "woman," and as such she joins Clytemnestra, Cassandra, and Philomela, all rebellious females who in some way challenge the patriarchy and consequently meet tragic ends. Indeed, the structure of Swinburne's text is almost schizophrenic in its rapid alternation of the masculine speaker's voice and several feminine voices. Although it is tempting to interpret this technique of double-voicing as a move either toward androgyny or toward a radical dissemination of sexual difference itself, the bloody violence perpetrated against each of these classical female intransigents points not toward transcendence or elimination of sexual difference but, instead, toward its

reinforcement through an implicit siding with the masculine character in each sexual conflict. The "rending" of Clytemnestra's "all-maternal heart" (stanza 3), Cassandra's "*sundering with the two-edged spear*" (stanza 10), and the triple violation of Philomela, who is raped, mutilated, and then turned into a bird in the myth (stanza 10) serve as reminders of the physical inferiority of Woman and also as warnings against any similar disruptions to masculinist hegemony. Furthermore, the "strange grace" that Apollo grants to Cassandra, or the "gift" of forever-discredited prophecy, is suspiciously like the concession that Swinburne makes to Sappho as the "strange manlike maiden" whose "gift" of poetry depends on her being more masculine that feminine. Like Cassandra or Clytemnestra, then, Sappho is too "masculine" for a feminine subject and hence is threatening to the poetic persona in "On the Cliffs," who already fears that his own "feminine" tendencies have put his virile identity at risk. For this reason, Sappho in stanza 17 is killed off along with the other tragically "strange" or overly masculine and powerful women in the poem.

The appropriation of the feminine tradition of prophetic or poetic inspiration represented by Sappho and Cassandra, and the tradition of feminine power represented by them and by Clytemnestra and Philomela is completed in stanzas 23 and 24. The speaker has all along strongly identified himself with Sappho as the immediate source of his own creativity (stanzas 7–9, 14–16): "My heart has been as thy heart, and my life / As thy life is, a sleepless hidden thing" (106–7). Yet the work of Swinburne's poem has been to take over the fame of Sappho's poetry as well as her sexually ambiguous identity for his own. Brilliantly, if insidiously, he has rewritten Sappho's lesbian love lyrics—"*I loved thee,*—hark, one tenderer note than all— / *Atthis, of old time, once*—one low long fall" (3222–23)—into a homoerotic, male-addressed poetry of his own by stealing the language of Cassandra, Philomela, and Sappho.

> If thy gods thus be my gods, and their will
> Made my song part of thy song . . .
> What then have our gods given us? Ah, to thee,
> Sister, much more, much happier than to me . . .
> (258–59, 262–63)

Like Hopkins, who addresses the martyred nun in "The Wreck of the Deutschland" almost jealously as he wonders about the special feminine quality of her union with Christ or her *jouissance,* here Swinburne suspects that Sappho enjoys a quality of poetic "grace" that is denied to him. In short, Sappho already has the immortal joy or "fire" of literary fame, and Swinburne does not. Gender rivalry becomes inextricable from poetic rivalry as the speaker in stanzas 17 through 23 begins to undermine the myth of Sappho's immortality—a

myth that, ironically, his own poem has helped to build. Reminding us that Sappho "wast woman" (276), hence vulnerable to men and temporality, Swinburne alludes to Ovid's version of Sappho's life, which represents her as having given up lesbianism for the love of a faithless man and then drowning herself "on the cliffs" in despair.[27] The nightingale heard by the speaker "on the cliffs" in the present poem is now metaphorically equated with Sappho's "one sovereign Lesbian song," which is also her death song: "How in her barren bride-bed, void and vast, / Even thy soul sang itself to sleep at last" (279, 286–87). Swinburne thus subjects Sappho to misogynistic violence twice over: first, by evoking the Ovidian myth, where she presumably crosses over from lesbianism to heterosexuality, only to die tragically; and second, by ventriloquizing her poetry, forcing it to serve the bonding of a male homosocial community to which it was never addressed.

As in Hopkins's "The Wreck of the Deutschland," then, the concluding moment of Swinburne's "On the Cliffs" recovers the position of dominance from the central feminine figure and returns it to the masculine poetic persona. Whereas Hopkins's speaker accomplishes the appropriation of feminine knowledge and power—the nun's gift of prophecy—through an act of sexual voyeurism followed by gynephobic recoil, Swinburne's speaker appropriates Sappho's poetic reputation for himself by praising her genius at the same time that he damns her by association with the series of fatally punished rebellious women depicted earlier in the poem:

> But when thy name was woman, and thy word
> Human,—then haply, surely then meseems
> This thy bird's note was heard on earth of none . . .
> . . . only then,
> When her life's wing of womanhood was furled,
> . . . this cry of thine was heard again,
> As of me now . . .
> (356–58, 385–88)

Like the deaths of Clytemnestra, Cassandra, and Philomela, Sappho's death is necessary to mediate and ensure masculine gender identity and cultural power. Although Swinburne does see the feminine as an active component in creative inspiration, its very potency—epitomized by the "strange manlike" Sappho—is finally seen as threatening to the maintenance of the homosocial literary tradition or Apollonian "quire" to which Aeschylus, Ovid, and, de facto, Swinburne belong: "O soul triune, woman and god and bird, / Man, man at least has heard. / . . . thy cry / The mightiest as the least [poet] beneath the sky / . . . Hath heard or hears,—even Aeschylus as I" (349–51, 355). Unlike Aeschylus and Ovid, however, Swinburne continues to identify closely

with Sappho even while relegating her to the ancillary role of mediatrix of artistic inspiration for the male artist. Sappho remains valuable because, through this central feminine figure from classical literature, Swinburne can safely articulate the homoerotic feelings that inspire his poetry—his own "more than man's desire"—just as Hopkins can articulate the homoeroticism that underlies his devotional poetry through the martyred nun without leaving the enclosure of Christianity. In neither case is the feminine body or subject position valorized for its own sake: desire, power, and knowledge move "between men"—between the Jesuit and his Christ, and between the novice poet and his Apollo; women, even "strong" women like the nun or Sappho, enter in only as mediatrixes or doubles for male-male bonding. Thus, at the end of "On the Cliffs," when his poetic persona claims, "Song, and the secrets of it, and their might, / . . . I know them . . ." (410–11), Swinburne is announcing a victory not only over the commanding feminine figure of Sappho but also over the improper male femininity or effeminacy that constitutes the other problematic Other of his own poetics.

In conclusion, even if Hopkins and Swinburne are willing to explore the feminine as a mode of creativity in their poetry, their commitment remains with the masculinist hegemony in Victorian culture and specifically with the homosocial/homoerotic community. In "The Wreck of the Deutschland" and "On the Cliffs," the boundaries of sexual difference may be blurred, gender roles may be reversed or crossed, but these experiments are only temporary: a choice between gender identities is finally imposed by the writer's own homophobic fear of becoming effeminate through his identification with feminine sources of creativity. Given the focus on conflict between gender identities in Hopkins's "The Wreck of the Deutschland" and Swinburne's "On the Cliffs," moreover, I would suggest that these poems may be interpreted not only as statements on poetics but also as partly autobiographical narratives of homosexual self-discovery. Speaking within the virulently homophobic culture of Victorian England, Hopkins and Swinburne use the multiple voices and fictional frames of the dramatic monologue simultaneously to construct and to deny homosexuality as an alternative gender identity.

Eve Sedgwick argues that "the status of women, and the whole question of arrangements between genders, is deeply and inescapably inscribed in the structure even of relationships that seem to exclude women—even in male homosocial/homosexual relationships."[28] I have argued that both "The Wreck of the Deutschland" and "On the Cliffs" involve a negotiation of desire and power between men—the poetic persona and a male divinity or masculine ideal—that is transacted across the female body and feminine voice as represented within a patriarchal ideology, either Christianity or classical Greek mythology. In Hopkins and Swinburne, the poetic persona, in each case defined primarily as masculine, identifies alternately with masculine and feminine positions, setting

up the sort of triangulation of desire and power "between men" that Sedgwick discusses. At stake, finally, in "The Wreck of the Deutschland" and "On the Cliffs" is the gender of creativity, or the question of whether masculinity, femininity, or some other gender configuration is the true source of a work of art. The perceived connection between the feminine and creativity is simultaneously attractive and unbearable to Hopkins and Swinburne because of their own investments in the construct of male effeminacy and also in its counterconstruct, or homophobic misogyny. The violence to the feminine that occupies center stage in Hopkins's and Swinburne's poetics stems from this conflict between internalized homophobia and the desire for an alternative gender identity that would incorporate at least some "feminine" features. In "The Wreck of the Deutschland" and "On the Cliffs," fear of the feminine Other manifests the male poet's fear of being thought effeminate himself, and this configuration is "oppressive of the so-called feminine in men, but . . . oppressive of women" as well.[29]

NOTES

1. In *The Madwoman in the Attic: The Woman Writer and the Nineteenth-Century Literary Imagination* (New Haven: Yale University Press, 1979), Sandra M. Gilbert and Susan Gubar open their argument on the difficulties of "female creativity" under the dominant "metaphor of literary paternity" by discussing Gerard Manley Hopkins. Gilbert and Gubar suggest that the analogy between the "pen" and the "penis" implicit in Hopkins's writings is "a concept central to . . . Victorian culture" (3–4). Susan Gubar, " 'The Blank Page' and the Issues of Female Creativity," in *The New Feminist Criticism*, ed. Elaine Showalter (New York: Pantheon, 1985), 293. Here Gubar may be combining Derrida's notion of the "transcendental signifier" with Lacan's notion of the Symbolic order of the "phallus." See Jane Gallop, *The Daughter's Seduction: Feminism and Psychoanalysis* (Ithaca: Cornell University Press, 1982).
2. Gubar, " 'The Blank Page,' " 293, 294.
3. Helena Michie examines several aspects of the "inscription" of the feminine in Victorian culture in *The Flesh Made Word: Female Figures and Women's Bodies* (New York: Oxford University Press, 1987).
4. Gubar, " 'The Blank Page,' " 295.
5. An important exception is George P. Landow, who, in *Victorian Types, Victorian Shadows: Biblical Typology in Victorian Literature, Art, and Thought* (Boston: Routledge & Kegan Paul, 1980), compares Swinburne's parodic use of typology to Hopkins's devotional use of an "extravagant conceit" at the end of "The Wreck of the Deutschland" (160–61). I would add that just as Hopkins's use of typology moves toward the Decadent in this poem, so Swinburne's use of classical mythology moves toward the Christian typological in "On the Cliffs."
6. On the term "effeminacy" in Victorian discourse, see, for example, my "Mixed Metaphor, Mixed Gender: Swinburne and the Victorian Critics," *Victorian Newsletter* 73 (1988): 16–19.

7. For an overview of the genre of dramatic monologue, see the special issue of *Victorian Poetry* 22, 2 (Summer 1984).

8. On the circulation of homophobia between male writers and readers in Victorian culture, see Eve Kosofsky Sedgwick, *Between Men: English Literature and Male Homosocial Desire* (New York: Columbia University Press, 1985), esp. chapters 7, 9, and 10.

9. Michael W. Murphy points out that Hopkins often uses sexual metaphors involving mutilation and violent death to describe poetic inspiration in "Violent Imagery in the Poetry of Gerard Manley Hopkins," *Victorian Poetry* 7 (1967): 1–16. He suggests that this kind of imagery "represents a sublimation of a strong sadomasochistic element in Hopkins' personality" (10), and that Hopkins's "training as a Jesuit may have increased . . . his . . . attraction to violence" (13). Murphy concludes, however, by insisting on "the tense, masculine energy of Hopkins' verse" and by emphatically denying anything "weak or pale or effeminate" (16) about Hopkins's writings—a clear instance of homophobia in recent criticism.

For a more helpful discussion of algolagnia and violence in Hopkins's poetry, see Trevor McNeely, "The Blissful Agony of Hopkins: Notes of a Neo-Reactionary," *The Hopkins Quarterly* 12, 3–4 (1985–1986): 97–114.

10. "The Wreck of the Deutschland," in Catherine Phillips's edition entitled *Gerard Manley Hopkins,* The Oxford Authors Series (Oxford: Oxford University Press, 1986), 110–19, ll. 1–2, 5–7, 9–10, 14–15. All further references to this poem are from this edition and are cited parenthetically in the text by line number.

11. Jerome Bump discusses the Marian and Christological aspects of Hopkins's poetry in "Hopkins' Imagery and Medievalist Poetics," *Victorian Poetry* 15 (1977): 99–119. His contrast of Hopkins and Swinburne is particularly interesting.

12. Peter T. Cominos surveys Victorian stereotypes of masculinity and femininity in "Innocent Femina Sensualis in Unconscious Conflict," in *Suffer and Be Still,* ed. Martha Vicinus (Bloomington: Indiana University Press, 1972), 155–72.

13. Phillips, ed., *Gerard Manley Hopkins,* annotates line 33 as "an ancient gesture of 'adoration and salutation,' although in the Bible associated with pagan worship" (337). Since Swinburne had already made the association between "paganism" and homoeroticism clear in 1866, Hopkins's Hellenic allusion cannot be completely innocent.

14. For an interpretation of "inscape" that takes Hopkins's "homosexual feelings" into account, see Wendell Stacy Johnson, "Sexuality and Inscape," *The Hopkins Quarterly* 3, 2 (1976): 59–65.

15. This letter to R. W. Dixon, dated 1886, is quoted in Gilbert and Gubar, *The Madwoman in the Attic,* 3.

16. Julia Kristeva analyzes the Christian "symbolic economy" in relation to the feminine in "Stabat Mater," in *The Female Body in Western Culture: Contemporary Perspectives,* ed. Susan R. Suleiman (Cambridge: Harvard University Press, 1986), 99–118; reprinted in Toril Moi, ed., *A Kristeva Reader* (New York: Columbia University Press, 1986), 160–86. Kristeva's main premise is that Christianity is a masculinist system and "the most sophisticated symbolic construct in which . . . femininity . . . is confined within the limits of the *Maternal*" (99–100).

17. The French term *jouissance* is useful here because it covers the English ideas of joy, ecstasy, and sexual pleasure or orgasm. On the specificity of feminine *jouissance,* see, for example, Hélène Cixous, "The Laugh of the Medusa," trans. Keith and Paula Cohen, *Signs* 1 (1976): 875–99.

18. On the incorporation of ordinary people and daily events into biblical typology in Victorian literature, see Herbert L. Sussman, *Fact into Figure: Typology in Carlyle, Ruskin, and the Pre-Raphaelite Brotherhood* (Columbus: Ohio State University Press, 1979).

19. J. A. Symonds describes the range of Victorian ideals of masculine beauty in his *Memoirs: The Secret Homosexual Life of a Leading Nineteenth-Century Man of Letters,* ed. Phyllis Grosskurth (New York: Random House, 1984).

20. *Between Men,* 207.

21. For a discussion of the classical allusions in "On the Cliffs," see Meredith B. Raymond, "Swinburne Among the Nightingales," *Victorian Poetry* 6 (1968): 125–41. For an excellent interpretation of the place of Sappho's poetry in Swinburne's poetics, see Jerome J. McGann, *Swinburne: An Experiment in Criticism* (Chicago: University of Chicago Press, 1972), 107–16.

For an overview of theories of intertextuality, see my "The Space of Intertextuality," in *Intertextuality and Contemporary American Fiction,* eds. Patrick O'Donnell and Robert Con Davis (Baltimore: Johns Hopkins University Press, 1989), 239–79.

22. "On the Cliffs," in *The Poems of Algernon Charles Swinburne,* 6 vols. (London: Chatto and Windus, 1904), 3:311–25, ll. 5–8. All further references to this poem are from this edition and are cited parenthetically in the text by line number.

23. I have in mind here not only Plato's *Ion* but also the Apollonian cult at Delphi. The main ritual of this cult consisted of purification by fire of a boy impersonating Apollo. In order to receive the god, the male initiate had to adopt a markedly submissive posture: see *The Oxford Classical Dictionary,* eds. N. G. L. Hammond and H. H. Scullard, 2d ed. (Oxford: Clarendon Press, 1970), 81–82. The imagery of fire as a sign of transcendence is worked to great effect by Swinburne in "On the Cliffs," where the Apollonian power of "song" is attributed first to Sappho and eventually transferred to the poetic persona himself: "The sun . . . / Whose godhead gave thee . . . / This gift, this doom . . . / Life everlasting of eternal fire" (97–98, 102–3); "And in thine heart, where love and song make strife, / Fire everlasting of eternal life" (429–30).

On the relation between homosexuality and Apollo in Victorian literature, see Robert L. Peters, "The Cult of the Returned Apollo: Walter Pater's *Renaissance* and *Imaginary Portraits," Journal of Pre-Raphaelite Studies* 2, 1 (1980): 53–69.

24. According to Raymond, "Swinburne Among the Nightingales," in Swinburne's poetics, in order to "release or activate his creative power, the poet must be receptive to a divine *logos.*" Although Raymond observes that "Swinburne's primary assumption [is] that Apollo is the *external* and eternal source of art" (140), she does not notice the role of gender in his poetics as developed in "On the Cliffs."

25. On Swinburne's polemicizing in favor of same-sex love, see my discussion of "Anactoria" (1866) in "Swinburne's Dramatic Monologues: Sex and Ideology,"

Victorian Poetry 22 (1984): 175–95; and see Richard Dellamora, *Masculine Desire: The Sexual Politics of Victorian Aestheticism* (Chapel Hill: University of North Carolina Press, 1990), chapter 4.

26. On male writers' appropriation of female writers' work, and especially Sappho's poetry, through "transvested ventriloquism," see Joan DeJean, "Fictions of Sappho," *Critical Inquiry* 13 (1987): 787–805. Swinburne's "decadent" representation of Sappho is also mentioned in Joan DeJean, *Fictions of Sappho, 1546–1937* (Chicago: University of Chicago Press, 1989).

27. See Joan DeJean's feminist analysis of Ovid's story of Sappho's suicide for love in "Fictions of Sappho" and in "Sappho's Leap: Domesticating the Woman Writer," *L'Esprit créateur* 25, 2 (1985): 14–20. I would argue that Swinburne's allusion to Sappho's death "on the cliffs" signals his masculinist allegiance.

28. *Between Men,* 25.

29. Sedgwick makes this statement in the context of her introduction: "I will . . . be arguing that homophobia directed by men against men is misogynistic, and perhaps transhistorically so. (By 'misogynistic' I mean not only that it is oppressive of the so-called feminine in men, but that it is oppressive of women.)" (*Between Men,* 20).

FICTION

ELIZABETH LANGLAND

THE VOICING OF FEMININE DESIRE IN ANNE BRONTË'S *THE TENANT OF WILDFELL HALL*

Because of its radical and indecorous subject matter—a woman's flight from her abusive husband—Anne Brontë's *The Tenant of Wildfell Hall* shocked contemporary audiences. Yet the very indecorousness of the subject may seem to be undermined by the propriety of the form this narrative takes: the woman's story is enclosed within and authorized by a respectable man's narrative. Within the discourse of traditional analysis we would speak of the "nested" narratives of Anne Brontë's novel, one story enclosed within another. In this case, the woman's story, in the form of a diary, is "nested" within the man's narrative. The critical language we are employing here already suggests certain conclusions about priority and hierarchy. The woman's story must, it seems, be subsumed within the man's account, which is prior and originary. The presentation of her version of events depends upon his re-presentation. Within a traditional narrative analysis, then, Brontë's *Tenant* may tell an untraditional tale of a fallen woman redeemed, but it tells it in such a way that reaffirms the patriarchal status quo of masculine priority and privilege, of women's subordination and dependency. The radical subject is defused by the form. But such a traditional analysis that speaks of nested narratives is already contaminated by the patriarchal ideology of prior and latter and so cannot effectively question what I wish to question here: the transgressive nature of narrative exchange.

Following Roland Barthes I propose that we recognize "[a]t the origin of Narrative, desire," because at the heart of narrative operates an economic system, an exchange. To Barthes, "[t]his is the question raised, perhaps, by every narrative. *What should the narrative be exchanged for? What is the narrative 'worth'?*" In his analysis of "Sarrasine," the exchange is a "night of love for a good story." Thus "the two parts of the text are not detached from one another according to the so-called principle of 'nested narratives.' . . . Narrative is determined not by a desire to narrate but by a desire to exchange: it is a *medium of exchange,* an agent, a currency, a gold standard."[1]

I wish to examine Anne Brontë's *The Tenant of Wildfell Hall* in the light of narrative as exchange—of narrative within a narrative not as hierarchical or detachable parts but as interacting functions within a transgressive economy that allows for the paradoxic voicing of feminine desire. Articulating this process will be the focus of my essay. I also suggest here (to indicate implications of this analysis) that such narrative exchanges are common in Victorian stories of transgression, as in Barthes's example, Balzac's "Sarrasine" (the castrati as man/woman); in Emily Brontë's *Wuthering Heights* (the self as Other—"I am Heathcliff"); in Mary Shelley's *Frankenstein* (the human as monster); and in Joseph Conrad's *Heart of Darkness* (the civilized man as savage).

The ideas of feminine voice and feminine desire in Victorian England were oxymorons, in Roland Barthes's coinage, *paradoxisms,* a joining of two antithetical terms, a "passage through the wall of the Antithesis."[2] The patriarchal discourse of Victorianism coded terms such as masculine/feminine, desire/repletion, speech/silence as opposites, as paradigmatic poles marked by the slash. Thus the feminine view, which was repressed, could have no voice, and passion, or desire, was the province of the masculine, a function of what Barthes calls the symbolic code.

Barthes elaborates, "The antithesis is a wall without a doorway. Leaping this wall is a transgression. . . . Anything that draws these two antipathetic sides together is rightly scandalous (the most blatant scandal: that of form)."[3] Barthes's formulation suggests the immense difficulty confronting the Victorian writer who wished to give voice to feminine desire. This transgressive act at its most blatantly scandalous depends on formal juxtaposition: something that "draws these two antipathetic sides together." I propose that we examine the transgressive possibilities inherent in the symbolic code itself and, further, that we look at the narrative within the narrative as a mode of juxtaposition, both of meanings and of focus.

In Brontë's *The Tenant of Wildfell Hall* the subject is transgression—a woman's illegal flight from her husband.[4] Brontë uses the transgressive possibilities of narrative exchange to *write* her transgressive story, a story of female desire, and she uses the trangressive possibilities of the symbolic code to

rewrite her transgression or "fall" as her triumph. A brief summary of the novel's plot will focus the central issues. A young and idealistic woman marries a man whose character is already in need of reformation. Believing herself called to this task, she begins optimistically only to discover that she is powerless to effect any changes that cannot be wrought by the force of moral suasion. She has no social or legal leverage. Ultimately, finding her son and herself sinking into the corruption generated by her husband, she plans to flee, only to be defeated on a first attempt when her husband, discerning her intention, confiscates all her property. Prompted by her husband's introduction of his mistress into the house as his son's governess, she succeeds at a second attempt, but she must carefully guard her identity from her inquisitive neighbors or she may be betrayed to her husband and forced to return.

These events, at the heart of the novel, are told only retrospectively. The novel is, in fact, doubly retrospective—Helen's narrative is nested within Gilbert's narrative, which is, in turn, a story told to his friend Halford. The novel opens in 1847 when Gilbert commences his correspondence with Halford. He has felt that he owes Halford a return for an earlier confidence and will now make good his "debt" with an "old-world story . . . a full and faithful account of certain circumstances connected with the most important event of my life."[5] Gilbert's narrative itself begins twenty years earlier, in the autumn of 1827, with the arrival of a new tenant at Wildfell Hall. Helen Graham, the mysterious tenant, is that woman who has transgressed Victorian social convention by leaving her husband, and her story—incorporated through her diary—begins on 1 June 1821. Brontë anticipates Barthes by having Gilbert define narrative exchange as economic exchange. He writes to Halford: "If the coin suits you, tell me so, and I'll send you the rest at my leisure: if you would rather remain my creditor than stuff your purse with such ungainly heavy pieces . . . I'll . . . willingly keep the treasure to myself" (44). The monetary metaphors underline the novel's implicit insistence that one does not narrate simply because of a desire to narrate: narration enacts an exchange and a gain or loss.

Traditional literary criticism has faulted Brontë's *Tenant* for its clumsy device of Helen Graham's interpolated diary. George Moore, otherwise ardently enthusiastic over Brontë's talents, instigated criticism of her artistic "breakdown" in the middle of the novel. Moore regretted not the interpolated tale but the manner of exchange. He complained, "You must not let your heroine give her diary to the young farmer . . . your heroine must tell the young farmer her story" to "preserve the atmosphere of a passionate and original love story."[6] This distinction in the mode of exchange, telling versus writing, raises a question Barthes does not discuss, and it encourages further reflection. Were the heroine merely to speak her tale, then one kind of economic exchange would be confirmed: her story for his chivalric allegiance,

something he is struggling to preserve in the face of society's calumny. Such a "telling" would preserve the atmosphere of "a passionate and original love story," as George Moore saw, but that story would be the traditional one of a male subject's reaffirmation of his desire for a woman as object. That is not the story Brontë wanted to write. Helen's diary spans one-half of the novel, and it confirms another kind of economic exchange: her story for the right to fulfill her polymorphous desire—to restore her reputation, to punish with impunity her husband, and to marry a man who consents to be the object of her beneficence and affection.

Gilbert Markham opens his narrative with the arrival of Helen Graham at Wildfell Hall. She is immediately put into circulation as an object of community gossip, speculation, and horror that a "single lady" has let a "place . . . in ruins" (37). The community reads her character through this behavior, concluding she must be a "witch," a decoding that follows from an initial suspicion that she cannot be a "respectable female" (38, 39). Such suspicions unleash a barage of one-way exchanges in the form of "pastoral advice" or "useful advice" (38, 39) as community members seek to circumscribe her within the usual sexual economies, to regulate "the apparent, or non-apparent circumstances, and probable, or improbable history of the mysterious lady" (39). The explicit oppositions in this passage emphasize the binaries that undergird Brontë's story from the outset, the excesses of which disrupt the seemingly simple love story of a young farmer and beautiful stranger. As we have seen in Barthes's formulation, this is a function of antitheses or the symbolic code, which both separates and joins and thus allows for the transgression as well as the conservation of oppositions.

Is Helen Graham a witch-devil or an angel? Is she a wife or a widow, amiable or ill-tempered? Is she pure or corrupt, a saint or a sinner, faithful or fallen? Her identity is made more problematic because her decorous appearance and religious devotion coexist with her claims that she has no use for "such things that every lady ought to be familiar with" and "what every respectable female ought to know" (39). Although civilized in manner, she appears to "wholly disregard the common observances of civilized life" (51).

It is immediately plain that Brontë is not giving us the traditional generic domestic comedy, that is, the story of a woman who focuses on making herself into a desirable object for a suitable man. That story is circumvented at the outset with Helen Graham's ambiguous status as widow/wife, and yet the pressure of that traditional narrative is such, and the cultural expectations for beautiful women are such, that Gilbert's story strives to become that narrative as he falls out of love with Eliza Millward and into love with Helen Graham and begins to write himself into the narrative as the rescuing figure of the maligned and misunderstood lady. Significantly, Gilbert's narrative at first tends to assign similar traits to Eliza and Helen despite their manifest differences. For exam-

ple, Gilbert describes Eliza Millward as a woman whose "chief attraction" (like Helen's) lay in her eyes: "the expression various, and ever changing but always either preternaturally—I had almost said *diabolically*—wicked, or irresistibly bewitching—often both" (42). This assignment of traits aligns Eliza paradigmatically with Helen (she is already syntagmatically aligned since she is another love interest of Gilbert), and the effect is to domesticate Helen and her true strangeness because we rapidly perceive that Eliza is a very ordinary young woman who does desire only to become the object of some man's affection. Thus, at this early point, Gilbert's narrative strives to interpret Helen Graham as it does Eliza Millward—as just another woman whose life could be fulfilled by connection with his.

By initially making Helen Graham an object of Gilbert's narrative and not the subject of her own, the text enacts what it also presents thematically: women's objectification and marginalization within patriarchal culture. Specific comments underscore our perception of this process. Helen Graham is criticized for making a "milksop," not a "man," of her little boy, who is supposed to "learn to be ashamed" of being "always tied to his mother's apron string" (52). Helen's energetic defense insists, "I trust my son will never be ashamed to love his mother," and "I am to send him to school, I suppose, to learn to despise his mother's authority and affection!" (55).

Women are paradigmatically all linked and consequently all marginalized by obsessive attention to men and their needs. Gilbert's sister complains, "I'm told I ought not to think of myself." She quotes her mother's words: "You know, Rose, in all household matters, we have only two things to consider, first, what's proper to be done, and secondly, what's most agreeable to the gentlemen of the house—anything will do for the ladies'" (78). Mrs. Markham sums up the duties of husband and wife: "you must fall each into your proper place. You'll do your business, and she, if she's worthy of you, will do hers; but it's your business to please yourself, and hers to please you" (79).

Gilbert Markham is suddenly and surprisingly enabled to articulate this process and his own benefits: "Perhaps, too, I was a little spoiled by my mother and sister, and some other ladies of my acquaintance" (5). He achieves this unusual self-knowledge partly to prepare for his ceding the position of subject to Helen and thereby crediting her story and the possibility of her desire. He tells his mother, "[W]hen I marry, I shall expect to find more pleasure in making my wife happy and comfortable, than in being made so by her: I would rather give than receive" (79).

We are also prepared for the narrative's change of focus by the extent of Helen Graham's difference from the women around her. A professional painter who supports herself and her son, she "cannot afford to paint for [her] own amusement" (69). She does not allow her painting to be interrupted by casual social calls, objects to Gilbert's "superintendence" of her

progress on a sketch and to being the object of his appreciative gaze, and manifests an "evident desire to be rid of [Gilbert]" (89). A visit he pays her provokes his recognition, "I do not think Mrs. Graham was particularly delighted to see us," an indirect confession of his initial failure to accord primacy to her as desiring subject instead of desired object.

These thematic shifts anticipate and prepare for the narrative exchange that is about to take place as Gilbert cedes the story to Helen. In fact, such shifts proliferate just prior to the commencement of Helen's diary narrative. Gilbert begins to change his orientation toward Helen, focusing less on how she meets his desire and more on how he might meet hers. He confesses that his early behavior toward her made him "the more dissatisfied with myself for having so unfavourably impressed her, and the more desirous to vindicate my character and disposition in her eyes, and if possible, to win her esteem" (85).

Yet at the same time that Gilbert expresses dissatisfaction with his early behavior, he embroils himself in an embarrassing misunderstanding with Mr. Lawrence, whom he imagines to be another would-be lover of Helen because he is blind to the truth that Lawrence is, in fact, her brother. Markham here enacts a charade of the jealous lover—a charade marked by insults and, finally, by a physical assault on Lawrence. It is his nadir, the moment when he privileges the community voices and the "evidence of [his] senses" (145) over Helen's authority to speak her story. Although Gilbert Markham pretends to disregard the storm of rumor surrounding Helen Graham that the community circulates—characterized as "shaky reports," "idle slander," "mysterious reports," "talk," "the poison of detracting tongues," a "spicy piece of scandal," "the calumnies of malicious tongues," "vile constructions," "lying inventions," "babbling fiends" (96, 97, 102, 103, 120, 123, 124)—his behavior reveals that he accords rumor great authority. When he adds what he calls "the evidence of my senses," he feels his position is unassailable just at the point where it is most vulnerable. We, as readers, appreciate the limitation of Gilbert's perspective, the ways he, in focalizing events and other characters, has generated a cloud of misapprehension shaped by his own needs, fears, and desires. At this point his narrative is bankrupt, unable to provide answers to the questions generated by the text's hermeneutic code. Helen's voice intervenes at this point, with greater narrative authority, to silence the other proliferating voices. Her narrative must redeem Gilbert's and provide those answers, the final signifieds of the text's multiplying signifiers: the promise that the classic novel holds out.

I mentioned earlier that narratives of transgression often depend on narrative exchange. Whether we are dealing with the young lady in "Sarrasine," or Lockwood in *Wuthering Heights,* or Victor Frankenstein in *Frankenstein,* or the unnamed fellow in *Heart of Darkness,* or Gilbert in *The Tenant of Wildfell Hall,* the focalizer of events confronts an enigma born of a transgression of

antitheses, and his explanatory power is momentarily exhausted. Answers to the enigma depend on a new viewpoint, a new focus—in this case, a new narrator or focalizer. I use the term "focalizer" deliberately to allow us to distinguish between the one who narrates and the one who sees or focuses the events.[7] But the relationship between the two focalizers is always problematic because they offer competing narratives; each claims authority to tell the story, and the two versions cannot be simply supplementary. The relationship between the two focalizers may also become problematic because one of the narrators may become the focalizer of both narratives, which is what I believe happens in *The Tenant of Wildfell Hall*, and this collapse generates a narrative transgression—a confusion of outside and inside, primary and secondary, subject and object. Although Helen's story is enclosed within Gilbert's story and might seem, therefore, to be part of his, nonetheless, by providing the answers we and Gilbert seek, it subordinates his narrative to hers. Helen's narrative rewrites Gilbert's, stabilizing it within a particular hermeneutic pattern. Thus, it is her story but also his story, a conflation that Brontë plays upon after Helen's diary concludes and Markham resumes; it becomes impossible at times to distinguish which one is the focalizer of events, a process to be examined after we explore the operation of the symbolic code in Helen's story.

Helen's narrative fully focalizes the "paradoxism" of feminine desire. Her diary, first of all, records the story of a young woman's falling in love and concomitant distraction and alienation from her common pursuits and ordered life. That is, hers is an often told tale of a young woman's newly aroused desire for a young man: "All my former occupations seem so tedious and dull. . . . I cannot enjoy my music. . . . I cannot enjoy my walks. . . . I cannot enjoy my books. . . . My drawing suits me best. . . . But then, there is one face I am alway trying to paint or to sketch" (148). Helen's painting becomes an eloquent voice of her desire for Huntingdon because it reveals to him what her words deny. Indeed, Huntingdon pinpoints the connection between images and words, between hasty tracings and postscripts: "I perceive, the backs of young ladies' drawings, like the post-scripts of their letters, are the most important and interesting part of the concern" (172). And, as he reads the message of her desire in her sketch, Helen is mortified: "So then! . . . he despises me, because he knows I love him" (172). This recognition underscores a significant pattern already in place, that a young woman must disguise her physical desire for a man because expression of such desire only kindles contempt within a patriarchy.

Thus, Helen's perception initiates a process, first of dissembling her desire and then, more significantly, of coding a physical urge as a spiritual need. In the first move, the desire becomes a subterranean force, something not openly expressed; in the second move, the desire is no longer recognized or accepted

for what it is. A woman sublimates her physical desire for a man; it becomes a need to reform him spiritually. So, women's physical desires, because illicit, are often encoded in literature as spiritual ones. The legion of female saviors in Victorian fiction testifies to this rewriting. Charlotte Brontë's Jane Eyre is to guide and protect a reformed Rochester; George Eliot's Dorothea Brooke and Mary Garth are to give a social focus to the self-indulgent desires of Will Ladislaw and Fred Vincy. Anne Brontë allows her heroine to be more vocal and articulate about her sublimated desire. In justifying her marriage to Huntingdon, Helen argues, "I will save him from" his evil companions, "I would willingly risk my happiness for the chance of securing his," and, finally, "If he has done amiss, I shall consider my life well spent in saving him from the consequences of his early errors" (167). She sighs, "Oh! if I could but believe that Heaven has designed me for this!" (168). Helen is so indoctrinated by this myth that, when she believes Huntingdon has committed adultery with Annabella Wilmot, she claims, "It is not my loss, nor her triumph that I deplore so greatly as the wreck of my fond hopes for his advantage" (178). The failure of this rosy scenario is anticipated in her aunt's summation: "Do you imagine your merry, thoughtless profligate would allow himself to be guided by a young girl like you?" (165). That, of course, is precisely the Victorian myth and ideology. While Helen quietly gloats, "[A]n inward instinct . . . assures me I am right. There *is* essential goodness in him;—and what delight to unfold it!" (168), we are already apprised of her mistaken apprehension by the retrospective structure of the narrative that testifies to the fiction she is projecting.

What does it mean, then, that Brontë's Helen fails in her efforts at spiritual reform? And not only does she fail, but Huntingdon also succeeds to an extent in corrupting her. Such failure and reversal inevitably shift attention from the spiritual realm back to the physical one, in the traditional antithesis of body and soul. Not surprisingly, reviewers of *Tenant* were outraged because the novel concentrated so heavily on sensual indulgences and abuses. Perhaps more threatening, however, *Tenant* explodes the myth of woman's redemptive spirituality and insight, and it opens the door to the unthinkable transgression, feminine desire. The force of Helen's love is now channeled into hatred; a desire to redeem becomes a desire to punish. Helen admits, "I hate him tenfold more than ever, for having brought me to this! . . . Instead of being humbled and purified by my afflictions, I feel that they are turning my nature into gall" (323).

Again, Barthes's symbolic code helps to articulate the process. The symbolic code represents meaning as difference through antithesis that appears inevitable. And, as we have seen, "every joining of two antithetical terms . . . every passage through the wall of Antithesis . . . constitutes a transgression."[8] Brontë insistently deploys such oppositions as love/hate, redemption/

punishment, saint/sinner, angel/devil, female/male to set up the conditions for transgression. At this point the text works to privilege and to legitimate one binary term over another. But, inevitably, due to the operation of the symbolic code, the text also becomes the site for exposure, multivalence, and reversibility. The pivotal event is Helen's return to nurse her injured husband. Does she return to redeem or to punish? Does she go out of love or out of hatred? Is she a ministering angel or a vengeful devil? Is she a holy saint or a common sinner?

In returning to Huntingdon, Helen passes through the wall of antithesis to transgress and to collapse differences that were seemingly inviolable. Huntingdon ejaculates at her return, "Devil take her," even as Markham extols the man's good fortune to have "such an angel by his side" (428, 444). Huntingdon perceives his returned wife as a "fancy" or "mania" that would "kill" him. Helen insists his mania is the "truth." She asserts she has come "to take care" of him, to "save" him. He answers, "[D]on't torment me now!" He interprets her behavior as "an act of Christian charity, whereby you hope to gain a higher seat in heaven for yourself, and scoop a deeper pit in hell for me." She states she has come to offer him "comfort and assistance," while he accuses her of a desire to overwhelm him "with remorse and confusion" (430). Huntingdon recognizes her act as "sweet revenge," made sweeter because "it's all in the way of duty" (433). He complains that she wants to "scare [him] to death"; she responds that she does not want to "lull [him] to false security" (434). Helen characterizes herself as his "kind nurse," while Huntingdon regrets that he has been abandoned to the "mercy of a harsh, exacting, cold-hearted woman" (439, 445). He is the object of her "solicitude"; she is no longer the object of his cruelty. Save/kill, care for/torment, angel/devil, truth/fancy, duty/revenge, kind/harsh, lull/scare, heaven/hell, higher seat/deeper pit—the signifiers slide, distinctions collapse, meaning erodes. Feminine desire expresses itself in the resulting vacuum of meaning. In the novel's hermeneutic, the fallen woman of Victorian life becomes the paragon, the exemplum, and revenge becomes a fine duty.

At the point that Helen returns to Huntingdon's bedside, Gilbert Markham has resumed the narration, but he has not assumed the authority to focus the bedside events. His narrative contains frequent letters from Helen, and she is as often the focalizer of the events as he is; indeed, it is often impossible to distinguish who is the focalizer. Gilbert's perspectives merge with Helen's as he incorporates her letters into his narrative—sometimes the literal words, sometimes a paraphrase—until the reader cannot distinguish between them. One narrative transgresses the other, distinctions between narrators collapse. For example, in chapter 49 Gilbert Markham writes, "The next [letter] was still more distressing in the tenor of its contents. The sufferer was fast approaching dissolution" (449). Theoretically, he is summarizing. But suddenly, we are in

the midst of a scene between Helen and Huntingdon in which present tense mixes with past to convey immediacy: " 'If I try,' said his afflicted wife, 'to divert him from these things . . . , it is no better'.—'Worse and worse!' he groans. . . . 'And yet he clings to me with unrelenting pertinacity' " (450). We are then immediately immersed in dialogue.

> "Stay with me, Helen. . . . But death *will* come. . . . Oh, if I *could* believe there was nothing after!"
> "Don't try to believe it. . . . If you *sincerely* repent—"
> "I *can't* repent; I only fear."
> "You only regret the past for its consequences to yourself?"
> "Just so—except that I'm sorry to have wronged you, Nell, because you're so good to me." (450)

The "afflicted wife" of Gilbert's narrative merges with the "I" of Helen's reportage and the "you" of the dialogue. The shifting persons stabilize in the "I" of the scene's final sentence, which also stabilizes the meaning: "I have said enough, I think, to convince you that I did well to go to him" (451). The narrative exchange and transgression allow for Helen's behavior here to signify duty instead of willfulness or perversity, to signify her elevation from fallen woman to paragon. Gilbert anticipates this closure: "I see that she was actuated by the best and noblest motives in what she has done" (435). He rejoices: "It was now in my power to clear her name from every foul aspersion. The Millwards and the Wilsons should see, with their own eyes, the bright sun bursting from the cloud—and they should be scorched and dazzled by its beams" (440). His story has, in fact, become her story.

Through the transgressive possibilities of the symbolic code and antithesis, Helen's desire to punish has been enacted as a wish to succor, and, through narrative exchange and transgression, the enigma surrounding her life has been, seemingly, penetrated, and Gilbert's resumed narrative now, seemingly, conveys the "truth." The meaning of Helen's behavior—as triumph rather than fall—is therefore stabilized by Gilbert's narrative. Although it may seem strange to speak of a novel that imbeds a woman's story within a man's as "giving voice" to a woman's desire, we can now appreciate the techniques through which Brontë enacts this process.

Yet a final, difficult aspect of the expression of feminine desire in this text remains unexplored: the representation of courtship and marriage between Gilbert and Helen. As we saw earlier, Gilbert's narrative at first strives to become the traditional story of a male subject's desire for the female as object. That narrative movement is thwarted when Helen becomes the speaking subject of the diary portion of the novel, but it could easily reassert itself as Gilbert regains narrative control in the novel's concluding pages. Indeed,

many critics have been dissatisfied with women's novels that must, it appears, conclude with the traditional wedding bells reaffirming the status quo. To what extent, we must ask, does Brontë elude that resolution in *The Tenant of Wildfell Hall?*

Clearly we hear wedding bells, but the status quo is destabilized by certain subversive tendencies in the narrative. Huntingdon's death, which allows the meaning of Helen's behavior to be stabilized, radically destabilizes the relationship between Helen and Gilbert, which had been, perforce, limited to "friendship." She is now capable of becoming an object of courtship, but Huntingdon's death has altered the relationship in a more significant manner by making her a wealthy widow, as Gilbert realizes: "there was a wide distinction between the rank and circumstances of Mrs Huntingdon, the lady of Grass-dale Manor, and those of Mrs Graham the artist, the tenant of Wildfell Hall" (454). The class distinction supersedes the gender difference and subverts the gender hierarchy. Gilbert becomes silent, submissive, passive, and acquiescent. He resolves to wait several months and then "send her a letter modestly reminding her of her former permission to write to her" (456). Only his receiving news that Helen is about to remarry goads him out of his passivity.

Again, Gilbert enacts the part of an ardent suitor, determined to save Helen from a bad marriage, but, as he takes on this more active role, we are reimmersed in the world of antitheses. He imagines himself in the role of heroic savior even as he recognizes he might pass "for a madman or an impertinent fool" (465). He goes to her, "winged by this hope, and goaded by these fears" (466). When he discovers he has been mistaken in his information, he resolves to find Helen and speak to her. He seeks her at Grass-dale Manor (Huntingdon's estate) and is impressed by the "park as beautiful now, in its wintry garb, as it could be in its summer glory" (472). He discovers that Helen has removed to Staningly, her uncle's estate, and that she has become even more remote from him through inheriting this property as well. He now feels himself to be, indeed, on a madman's or fool's errand and resolves to return home without seeing Helen. Their fortuitous encounter leaves him silent and forces upon her the role of suitor. She must propose to him and so transgress the boundaries of the masculine and feminine. She plucks a winter rose—a paradoxism particularly within a literary economy that metaphorically aligns the rose with youth and innocence, not with age and experience—and says, "This rose is not so fragrant as a summer flower, but it has stood through hardships none of *them* could bear. . . . It is still fresh and blooming as a flower can be, with the cold snow even now on its petals—Will you have it?" (484). The paradoxism of a winter rose, the transgression of customary antithesis, prepares for the paradoxism of the assertive woman expressing feminine desire.

In addition, although Gilbert is narrating, Helen is the focalizer of the scene. Gilbert, here a very diffident suitor, hesitates to understand the meaning of the rose, and Helen snatches it back. Finally she is forced to explain, "The rose I gave you was an emblem of my heart," but he is so backward that he must ask, "Would you give me your hand too, if I asked it?" (485). Though he still worries, "But if you *should* repent!" she utters definitive words, "It would be your fault . . . I never shall, unless you bitterly disappoint me" (486). She has focalized the meaning of this event. Her wishes dominate; he is *subject to* her desire, and he is the *object of* her desire.

At the same time that Helen expresses her desire, she closes off the meaning of this story and proleptically concludes all subsequent ones; if she repents, it will be his fault. Gilbert writes his story as her story. She has been defined—and now predefines herself—as the paragon, an exemplar among women. Whereas the angel could only fall in the previous narrative controlled by Victorian ideology, here only Gilbert can fall. However, a tension underlies this resolution. Because the expression of feminine desire depends on transgression and exchange, the stabilization of the narrative in closure seems simultaneously to close off the space for that expression. Not surprisingly, Brontë destabilizes her conclusion by focusing on exchange: Gilbert exchanges the final installment of his narrative with Halford, and he simultaneously anticipates the exchange of Halford's visit.

It is appropriate in a world of antitheses and in the context of their transgression that the ending of the narrative should be just such an advent. Gilbert writes, "We are just now looking forward to the advent of you and Rose, for the time of your annual visit draws nigh, when you must leave your dusty, smoky, noisy, toiling, striving city for a season of invigorating relaxation and social retirement with us" (490). The implied antithesis of country and city gives way to the explicit paradoxisms of "invigorating relaxation" and "social retirement" in the last line of the novel. And "this passage through the world of Antithesis," by keeping open the possibility for transgression, also keeps open a possible space for feminine desire.[9] If this seems a fragile and tentative resolution—one threatening to reassert the status quo—it is also a radically important one in refusing to postulate an essential female desire existing outside of and independent of the discursive practices that construct women's lives.

NOTES

1. Roland Barthes, *S/Z: An Essay,* trans. Richard Miller (New York: Hill and Wang, 1974), 88, 89, 90.

2. Barthes, *S/Z,* 27.

3. Barthes, *S/Z,* 65.

4. Only recently has Anne Brontë's *The Tenant of Wildfell Hall* begun to receive the attention it deserves. The reasons for the neglect are many. See my *Anne Brontë: The Other One* (London: Macmillan, 1989).

5. Anne Brontë, *The Tenant of Wildfell Hall* (Harmondsworth: Penguin, 1979), 34. All further references are from this edition and are cited parenthetically in the text by page number.

6. George Moore, *Conversations in Ebury Street* (New York: Boni and Liveright, 1924), 254. On the subject of narrative infelicities in Brontë's *Tenant,* Moore is joined by other, later critics, notably Winifred Gérin, "Introduction," *The Tenant of Wildfell Hall,* 14. However, some fine recent articles have attempted to do more justice to the narrative structure of the novel, particularly as it revises Emily's *Wuthering Heights.* See Jan Gordon, "Gossip, Diary, Letter, Text: Anne Brontë's Narrative Tenant and the Problematic of the Gothic Sequel," *ELH* 5 (1984): 719–45; and Naomi Jacobs, "Gender and Layered Narrative in *Wuthering Heights* and *The Tenant of Wildfell Hall,*" *Journal of Narrative Technique* 16 (Autumn 1986): 204–19.

7. Gerard Genette, *Narrative Discourse: An Essay in Method,* trans. Jane E. Lewin (Ithaca: Cornell University Press, 1980), 194–211.

8. Barthes, *S/Z,* 26–27.

9. Barthes, *S/Z,* 27.

DEIRDRE DAVID

CHILDREN OF EMPIRE

Victorian Imperialism and Sexual Politics in Dickens and Kipling

One of the most pervasive images in Dickens's early novels is that of the child trudging along the road to his or her destiny. Fusing the literary tropes of the pilgrimage and the picaresque, Dickens sends his unhappy boy and girl characters out on the road to meet their fictional fates. Oliver Twist, in flight from his somber employment and physical abuse at Mr. Sowerberry's, is collared by the Dodger just outside London and thus positioned for his eventual discovery of family in the Maylies and Mr. Brownlow. David Copperfield, traveling in the opposite direction, flees the London bottle warehouse for the white cliffs of Dover, Betsey Trotwood, and the beginning of his career as a writer. And Little Nell, menaced by Quilp and frightened by her grandfather's helplessness, heads up to Wolverhampton and beyond. All three characters (Oliver, David, and Nell) trudge along penniless, homeless, and without protection, on the road, respectively, to family, profession, and death. What is most notably different, of course, about the three characters is that the two boys, Oliver and David, live and are happy and the girl, Nell, dies a lingering death, having made others happy in the doing so. What is less noticeable about *The Old Curiosity Shop,* however, is that it is not only a "quest" novel about a secular pilgrim on the road to deadly rest, not only the sentimental story of Nell's suffering and apotheosis, but also a novel about the British empire.[1]

To some, the assertion that *The Old Curiosity Shop* is about empire may seem quixotic, even wrong; unlike Dickens's novels more overtly about this

subject, this text depicts no native servants, no blustery majors puffed up with imperial exploits, no city merchants enriched by trading with the East India Company, no characters either resignedly sailing for Australia at the end of the narrative or dramatically returning from that colony in the middle of it. Yet *The Old Curiosity Shop* indeed intimates the growth of empire in the first half of the nineteenth century and displays, in particular, Dickens's participation in an emerging discourse about Africa at the beginning of the Victorian period. As a way of elaborating this claim, I shall contrast *The Old Curiosity Shop* with Kipling's *Kim,* a late Victorian "road" novel produced at the troublesome apex of British imperial power, its subject unambiguously that of imperialism and set not in the dreary English midlands but on the exotic Northwest frontier. As Nell plods out through Middlesex, Kim cavorts along the Grand Trunk Road. I embark consciously on this seemingly perverse yoking of two radically different novels in order to point out deliberately the difference in terms of gender and race politics. Moreover, the differences as elaborated—girl/boy, seemingly not about empire/all about empire, early Victorian/late Victorian—are subsumed under one encompassing similarity that defines both novels as contributing to Victorian colonial/imperial discourse. In *The Old Curiosity Shop* and *Kim,* ideologies of gender work to constitute ideologies of race; and, conversely, ideologies of race work to constitute ideologies of gender. If this essay makes any contribution to theories of colonial/imperial discourse, it will be to show the way gender politics inflect imperialist politics and the way imperialist politics inflect gender politics: in sum, Victorian ideas about gender and race exist in these novels in a relationship of reciprocal constitution. It will be helpful, at the start of this enterprise, to show that nineteenth-century novels do not need exotic settings to characterize their pervasive representation of imperialism's structure and effects.[2]

Imperialism is the unspoken source of English manor-house power in *Mansfield Park,* in the form of Sir Thomas Bertram's Antigua estates; it is the plush provider of London social being for Jos Sedley in *Vanity Fair* and the civil and military protection for St. John Rivers's missionary plans in *Jane Eyre.* Late eighteenth-century British looting of Indian cultural artifacts triggers the Victorian domestic plot in Wilkie Collins's *The Moonstone.* Gabriel Betteredge, retelling the events that seem to have precipitated the disappearance of the priceless moonstone from his mistress's household, causing housemaids to disappear, dinner guests to forget their table manners, and country-house life to unravel, confides to the reader, "[H]ere was our quiet English house suddenly invaded by a devilish Indian Diamond—bringing after it a conspiracy of living rogues, set loose on us by the vengeance of a dead man."[3] Through his amazed description of a quiet English country house being "invaded" by an Indian diamond, Betteredge articulates, altogether

unconsciously, an imaginative expression of Victorian imperialist process. The benefit to Britain's domestic economy ("quiet" English country houses well staffed by loyal servants) that is the consequence of overseas imperial invasion and expansion is accompanied by a counterinvasion of the colonized (a "devilish" diamond accompanied everywhere by "roguish" natives) into the colonizer's domestic space.

Imperialism also provides the stuff of Victorian domestic fantasy. In Dickens's *Our Mutual Friend,* Bella Wilfer conjures Orientalist daydreams about "being married to an Indian Prince, who was a Something-or-Other, and who wore Cashmere shawls all over himself, and diamonds and emeralds blazing in his turban, and was beautifully coffee-coloured and excessively devoted, though a little too jealous."[4] Imperialism, too, is the probable social-parent of that "black-haired" child found "houseless" on the streets of Liverpool by Mr. Earnshaw in *Wuthering Heights,* and it provides the economically emphatic detail of Dickens's social criticism in *Nicholas Nickleby,* where "half-naked shivering figures" on a London street stop "to gaze at Chinese shawls and golden stuffs of India."[5] At the end of the Victorian period, Conrad's *Nostromo* provides the definitive interrogation of imperialism's structure and effects; what was enabling material background in *Mansfield Park* becomes explicit subject of moral, political, and psychological investigation. Just as the Indian diamond "invades" England in *The Moonstone,* the thematic material of empire may be said to make a literary invasion of the English novel during the nineteenth century, thereby revealing the imperialist foundation of Britain's domestic wealth during that extended period of economic growth.

SAVAGE QUILP, SUFFERING NELL

Quilp and Nell customarily get lined up as monster and angel; evil and good; grotesque and graceful; animal vitality and human frailty; inhuman lack of moral sentiment and human overload of pathos and suffering; demonic force surging from the underworld and spiritual power yearning for heavenly rest. At the risk of offering even more evidence for what Abdul JanMohamed terms an inevitable Manichean allegory, whereby European subject-constitution is achieved through the postulation of a native Other,[6] I wish to extend the foregoing by adding another set of binary oppositions. This set does not diminish the interpretive force of the critical pairing of Quilp and Nell as it stands; indeed, this supplementary focus depends upon the established field of oppositions. What we identify as moral/metaphysical difference in *The Old Curiosity Shop* may also be seen as racial. In some sense, this should come as no surprise, for the Other (whether race, class, or gender specific) is conventionally represented in European culture as dark and barbar-

ian, and monstrous savages do not appear on the scene for the first time in the nineteenth century.[7] But they do have a historically specific meaning in *The Old Curiosity Shop*. Congruent with gender-specific tropes in early Victorian writing, Quilp represents the savage/dark/male and Nell the civilized/pale/female. Nell is doomed to death by her mission to replace heathen idolatry with Christian belief, by her enforced journey from "home" through the pagan wilderness suggested by the smoking inferno of the English Midlands, by her vulnerability, sacrifice, and passivity. All of this is heightened by the fact that she is a thirteen-year-old female child. Quilp's savagery is derived from early Victorian myths about native barbarism, and I want to place this colonial paradigm of English female suffering in the face of native male aggression in the context of Dickens's writings about Africa and the "Noble Savage" and also of early nineteenth-century writings about woman's civilizing mission. To locate the affiliative presence of this model in *The Old Curiosity Shop*, we need to look at the physical Quilp, who is, as Mr. Podsnap would say, definitely "Not English!"

With a "head and face . . . large enough for the body of a giant" but possessing the body of a dwarf, Quilp is a dark, tough monster: he has black eyes, a complexion never "clean or wholesome," "discoloured fangs," and "grizzled black" hair.[8] As "watchful as a lynx" (360), Quilp is also designated sharp as a ferret and cunning as a weasel. Panting like a dog, he is called demon, imp, goblin, ogre, and Chinese idol, and, as many critics have observed, he bears some resemblance to Caliban, Richard III, and the generic dwarf of fairy tales.[9] But it is Dickens's likening of him to an "African Chief" squatting on a piece of matting as he devours vast quantities of bread, cheese, and beer (104) that is particularly significant for the purposes of this essay. The resonance of his animalism, his savage dexterity, and his "African" agility (despite his deformity) are enforced by a devouring, biting, engulfing performance throughout the novel. He is, seemingly, a symbolic cannibal, roaming the domestic spaces of early Victorian Britain in search of human food. He bites the air, "with a snarl" threatens to bite his wife (37), and leers at her— adding, "Oh you nice creature!" and smacking his lips "as if this were no figure of speech, and she were actually a sweetmeat" (35). (Mrs. Quilp, incidentally, is a constant victim of his abuse, her arms "seldom free from impressions of his fingers in black and blue colours" [100].) At his most explicitly antisocial and his most unambiguously cannibalistic, Quilp piles his stove high with coals and dines "off a beefsteak, which he cooked himself in somewhat of a savage and cannibal-like manner" (504).

As Patrick Brantlinger and others have noted, cannibalism becomes an important theme in British writing about Africa around the middle of the nineteenth century. Sensational treatments of anthropophagy abounded, and the more Europeans began to penetrate Africa, the more savage and cannibalistic

the Africans came to seem; the myth of the "Dark Continent," Brantlinger explains, developed during transition from the successful campaign against slavery in the early 1830s to the imperialist scramble for Africa in the final quarter of the nineteenth century.[10] *The Old Curiosity Shop* was published at a time when Africa was becoming, in British culture, the dark locus of scientific exploration, of mercantile adventurism, and of missionary conversion. Despite his affectionate description of the Nubbles family's preparation for Kit's journey across London to Finchley, "as if he had been about to penetrate into the interior of Africa" (166), Dickens did not look favorably on mercantile and missionary exploration.

Before Mrs. Jellyby and her program for cultivating coffee "conjointly with the natives" at the settlement of Borrioboola-Gha appeared on the satiric scene in *Bleak House* in the early 1850s, Dickens in 1848 made some choice remarks about the Niger expedition of 1841–1842, a disastrous government-sponsored attempt led by Thomas Fowell Buxton. The Niger expedition aimed to establish Christianity and free trade in the Heart of Darkness, exploring the Niger River, establishing antislavery treaties with the Africans, and setting up trading posts. Some of this was achieved, but a high mortality rate (approximately one-third of the 159-member group composed of members of the African Civilization Society and the Church Missionary Society) clouded any success. For Dickens, the Niger expedition was a tragic farce, a ludicrous failure to recognize that between "the civilized European and the barbarous African there is a great gulf set." To change the customs of "ignorant and savage races," he declared, "requires a stretch of years that dazzles in the looking at."[11] This is not to say, incidentally, that Dickens was indifferent to the slave trade; mounting his attack on "the upholders of slavery in America," he abominates "the atrocities" of the system, declaring, "I shall not write one word for which I have not ample proof and warrant." Scorning the hypocrisy that declaims "against the ignorant peasantry of Ireland" and keeps silent about those "who notch the ears of men and women, cut pleasant posies in the shrinking flesh, learn to write with pens of red-hot iron on the human face," he calls, romantically, for the restoration of "the forest and the Indian village" and the replacement of "streets and squares by wigwams."[12] Just as fiercely, Dickens later demolished the myth of the Noble Savage, although his political imperative seems paradoxically opposite to that calling for a feather fluttering in the breeze in lieu of the stars and stripes.

Appearing in 1853 in *Household Words*, Dickens's essay on the legendary figure of the Noble Savage combines sympathetic condemnation of the exhibition in London of creatures such as the Hottentot Venus (in 1810) and the Bushmen and Kaffir groups from Southern Africa (in the mid-to-late 1840s) with detestation of their sentimental distortion in the popular imagination.[13]

What he detests most of all is "whimpering" over the loss of some putatively heroic existence:

> Think of the Bushmen. . . . Are the majority of persons—who remember the horrid little leader of that party in his festering bundle of hides, with his filth and his antipathy to water, and his straddled legs, and his odious eyes shaded by his brutal hand . . . conscious of an affectionate yearning towards that noble savage, or is it idiosyncratic in me to abhor, detest, abominate, and abjure him?

"If we have anything to learn from the Noble Savage," he concludes, "it is what to avoid. His virtues are a fable; his happiness is a delusion; his nobility, nonsense."[14] Authentic savages, for Dickens, were more like Daniel Quilp than the sentimentally "noble" figures of romantic myth.

In this essay, Dickens fixes his loathing of the exhibition of Bushmen on one figure, the abhorred, detested, abominated, and abjured "horrid little leader" repugnantly straddling his legs and shading his eyes with brutal hands. Descriptions of Daniel Quilp suggest that his repellency anticipates by some ten years that ascribed to the exhibited Bushman and, more importantly for the overall purpose of this argument, that Dickens's characterization of Quilp participates in the production of early Victorian imperial writing. With his festering, filthy neckerchief and his habits of smearing "his countenance with a damp towel of very unwholesome appearance" in lieu of washing, of straddling his legs to frighten his wife, of rolling his odious, inflamed eyes to intimidate Sampson Brass, and of using his brutal hands to batter a totemic representation of his enemy Kit "until the perspiration streamed down his face with the violence of the exercise" (461), Quilp behaves alarmingly like the exhibited Bushman as described by Dickens in 1853.

A sensational drawing card in the exhibition of savages in the 1830s and 1840s was a tableau vivant, usually given over to native war dances, ritualized chanting, and tribal cooking, which inevitably created for the horrified English viewer the prospect of cannibalism. Quilp's comically savage taste for doing "something fantastic and monkey-like" compels him to arrange his own Tableaux Vivants. For example, when waiting in the shop for Nell and her grandfather, he perches on the back of a chair, one leg cocked over the other, and presents so grotesque and vital a picture that Nell utters "a suppressed shriek" when she sees him (72). With no audience but a demented dog, he does a sort of ecstatic demon-dance, "arms a-kimbo"; and he enacts for Sampson Brass a kind of rhythmic native ritual, a chanted "monotonous repetition of one sentence in a very rapid manner, with a long stress upon the last word, which he swelled into a dismal roar" (457): the sentence he repeats is taken from a newspaper story detailing the conviction for stealing of his moral antithesis, Kit Nubbles. For his wife's benefit he plants his hands on his

knees, straddles his legs out very wide, and stoops down and brings his head
between them to ask, "Am I nice to look at?" Receiving a less than enthusias-
tic response, he treats her to a succession of "horrible grimaces. . . . During
the whole of this performance, which was somewhat of the longest, he pre-
served a dead silence, except when, by an unexpected skip or leap, he made his
wife start backward with an irrepressible shriek" (36). (The primary female
response to Quilp always seems to be a shriek.) As the grand breakfast finale
to this night-long performance, in front of an astonished Mrs. Quilp and her
mother, he devours hard eggs "shell and all" and gigantic prawns with the
heads and tails on, chews tobacco and watercresses at the same time, drinks
boiling tea, and bites his fork and spoon—he "in short performed so many
horrifying and uncommon acts that the women were nearly frightened out of
their wits and began to doubt if he were really a human creature" (40). Of
course, Quilp is a human creature and not a savage African chief; he is more
than and different from all the things suggested (he is *comically* monstrous, for
one thing, sexually compelling, for another). The concern in this essay is with
a reading that supplements rather than negates others and that relies on rather
than discards the core meaning of Quilp and Nell as emblems of leering evil
and quivering purity. Quilp is a dark demonic force whose destruction alle-
gorically requires the suffering and death of an English girl, "so small, so
compact, so beautifully modelled, so fair, with such blue veins and such a
transparent skin," as Quilp greedily describes her. In *The Old Curiosity Shop,*
eradication of male barbarism is accompanied by the forfeiture of female life,
or, to reinscribe Victorian ideas of gender in affiliation with Victorian ideas of
race, native savagery can be tamed only by the sacrifice of Englishwomen. I
shall return to this point in more detail after explication of Nell as allegorical
figure of imperial female suffering.

Emerging from Mrs. Jarley's caravan, "amidst an admiring group of chil-
dren," and paraded through the town as an advertisement for the waxworks,
Nell is thought to be "an important item of the curiosities" (211). Hardly
seeming to need nourishment, often "too tired to eat," always giving the
"best fragments" from her basket to her grandfather, "so very calm and unre-
sisting," she epitomizes the sentimental selflessness conventionally attributed
to Victorian women. Just as Quilp's demonic performances symbolize his
meaning as an "uncivilized" racial curiosity, so Nell's shy presence symbolizes
her meaning as "civilized" racial curiosity. She is an immutable physical type
whose genetic inheritance from her grandmother is perceived by her grand-
father's brother, who regards her as the "same sweet girl . . . with a mild blue
eye . . . never growing old or changing . . . the Good Angel of the race" seen
in generic English family portraits (504). In sum, she is an unalterable em-
blem of English sweetness, mildness, and angelic purity. She is, consequently,
more mythological icon than living, breathing female child. While Quilp

takes up demoniacal vital residence in his countinghouse, a performing savage grilling steaks and executing simian acrobatics from his hammock, Nell manages a wasting existence in the solemn, vaulted dwelling where she is to die, a performing angel (albeit an entirely unself-conscious one) exhausted by her journey through the wilderness. She attains a kind of Clarissa-like transparency, having a lie-down on tombstones and drawing curious "parties" to the church. These people, seeing her, "speak to others of the child": eventually she has a throng of daily visitors (again like Clarissa) who praise her pale beauty and moral perfection and pity her decline (410).

Nell's immutable physical and moral type may be found in much Victorian writing about empire; a figure of suffering Englishwomanhood, her type is illustrated well in a painting by Sir Joseph Noel Paton entitled *In Memoriam* that consecrates the heroism of British "ladies" at the time of the Indian Rebellion in 1857. As the reviewer for the *Art Journal* at the time observed, "The spectator is fascinated by the sublimely calm expression of the principal head—hers is more than Roman virtue; her lips are parted in prayer; she holds the Bible in her hand, and that is her strength."[15] Ready to die (or worse) at the hands of sepoy savages, the female representative of an empire superior to that of Rome (a common Victorian trope) is armed only with a Bible. The Englishwoman sacrificed for empire is a common figure in early Victorian writing about imperialism.

In the mid-1830s, for example, the well-known travel-writer Emma Roberts provided for her English readers *Scenes and Characteristics of Hindostan With Sketches of Anglo-Indian Society*. The *Sketches* outline a life of deathly discomfort for women that serves to authorize the disciplinary presence of the British Raj. Englishwomen began to go out to India with some regularity in the last quarter of the eighteenth century (most as the wives of army officers and East India Company officials and a very few as missionaries), but it was not until the 1820s and 1830s that they began to arrive in large numbers. Evangelical influence at home dictated a disinfection of "Nabob" corruption and sexual license, what in the House of Commons in 1833 Macaulay termed "the reconstruction of a decomposed society,"[16] and a developing sense of duty to orderly administration was accompanied by a developing sense of the importance of the Memsahib in this enterprise. As Emma Roberts's evocation implies, life was so dreadful for Englishwomen in India that they could only be there for the good of the natives. One effect of this trope of suffering Englishwoman was to legitimate the military and civil occupation enacted by their husbands, fathers, and brothers. The women suffered the heat, fungus growing on the mattresses, enormous insects, slovenly female servants, the loss of children sent back to England; there existed no music, no picture-galleries, no opera—in short, there existed no English comfort, culture, or convenience. It was not until after 1857 that the increased presence of

Englishwomen as the wives/daughters/sisters of civil officials led to the estab-
lishment of reading circles, dramatic societies, and Surrey-style country clubs
at every civil station, and a large public library in Calcutta.[17]

To this point, I have elaborated Dickens's characterization of Quilp and
Nell as reproducing and producing certain defining aspects of Victorian race
and gender politics. Quilp performs as a kind of exhibited savage-cannibal
and Nell as an emblem of suffering Englishwomanhood. Powerful ideas
about race are thereby reinforced by powerful ideas about gender, and each
set of ideas may be said to exist in a relationship of reciprocal constitution
with the other. As suggested, the ideological negotiations found in much of
early Victorian writing about empire, exemplified by Emma Roberts's *Scenes
and Characteristics* and *Sketches,* follow this circular route of reciprocal consti-
tution: native disorder authorizes colonial discipline; colonialism requires
woman's sacrifice; and woman's sacrifice symbolically transforms a mytholo-
gized native disorder. Excellent evidence of this latter phenomenon is to be
found in a perfectly awful poem by Emma Roberts. Written on the occasion
of the opening of a theater at Cawnpore in 1829, the poem describes a jungle
overrun with towering palms and spreading banyan trees; but "tangled dells"
are cleared to erect a "Doric structure," and the theater is brought into being
by "woman's smile" as she "blesses" the wilderness.[18] We might well ask, at
this point, if Nell is the symbolic racial antithesis of the savage Quilp, why is
she running away from him? Why does she not stay put, Bible in hand, like
the sacrificial female agent of empire depicted in Sir Joseph Noel Paton's
painting of the women at the Well of Cawnpore? Why does she not clear the
metaphorical wilderness of Quilp with a resolute smile?

That Nell is a child of empire in more ways than one signifies, it seems, the
way in which early Victorian race and gender politics work and are defined:
beliefs about race and gender are multiple and contradictory.[19] All at once,
Nell is the English female child whose opposite is the rapacious male savage,
and her destiny would be to "smile" and thereby clear the jungle; but she is
also the suffering female child whose flight from and symbolic death at the
hands of the rapacious savage registers Dickens's unease (at the very least)
with imperialism as it was developing in early Victorian culture. Appropriat-
ing Nell's home, invading her domestic space in much the same way that the
"devilish Indian diamond" (symbol of the colonized) invades the English
country house (home of the colonizer) in Collins's *The Moonstone,* Quilp
sends her on the road. He drives her from the city in search of "some distant
country place remote from towns or even other villages," "a green and fresh
world" where, she says to her grandfather, "we may live in peace." To be sure,
this is the ritualized flight from the infernally secular "City of Dickens" that
Alexander Welsh has so fully articulated, but it is also a journey back in time
to a place that existed *before* missionary interference, scientific exploration,

mercantile imperialism. In that mythical place there are no Quilps, no performing savages brought to the city and taught the tricks of a cash-nexus society. Yet, paradoxically, Dickens also seems to be saying that it is too late to go back to that place, too late to escape Quilp and his symbolically affiliated figure: "A perpetual nightmare to the child," he is imaginatively present at Nell's death, even if his smoking rage has finally been quenched by the dark river. That Nell must die partially signifies Dickens's view that the changes wrought in Victorian culture by mercantile empire-building are inescapable, cannot be eradicated, must be problematically symbolized, and thereby are occluded. The critique of imperialism metaphorically implied in *The Old Curiosity Shop* is more fully explicit and representational in Dickens's last novel of social criticism in the 1840s, *Dombey and Son*.

Briefly, in *Dombey and Son*, British military and mercantile domination of the Indian continent is the literal foundation of Dombey's commercial and domestic power; he is the disciplinary center and the absolute ruler of an office just around the corner from the East India Company. Dominant ideologies of race enable Dombey's wealth, and dominant ideologies of gender authorize his patriarchal despotism. Consciously or not, Dickens shows that exploitation of race (Dombey's business dealings with India) empowers Dombey's gender politics (his attempts at tyrannical control of Florence and Edith); and if one ideology may be said to authorize the other, then, conversely, the destruction of power enabled by exploitation of race facilitates the destruction of power enabled by exploitation of women. In one way or another, *The Old Curiosity Shop* and *Dombey and Son* lament the loss of a sentimental ideal of disinterested rule of native cultures and its replacement by a "money-getting" worldly imperialism.[20] In significant contrast to Dickens's critique of imperialism and nostalgia for a preindustrial, preimperialist world, Rudyard Kipling's *Kim* embraces the imperialist project, just as its boy-hero embraces the vitality and variety of Indian experience. In contrast to a female child of empire on the road to sacrificial death, we have a male child of empire on the road to adult male subjectivity as servant of the British Raj, an institution mythically erased, incidentally, by *Dombey and Son*'s demolition of mercantile wealth derived from East India Company connections.

MOTHER INDIA, ORPHAN KIM

Published in 1901, *Kim* is one of the major literary documents of British imperialism, a splendid story told by a narrator who gains as much delight from describing the riotous life of India as Kim finds in experiencing it. It is also deeply sentimental in its idealization of the British Raj and conventionally Victorian in its presentation of a world in which men do the dangerous

work of mapping subjugated territory and foiling native resistance to the English, *despite* the interference of women. Moreover, as Edward Said has observed in his comprehensive introduction to the Penguin edition, *Kim* is profoundly racist in its reliance on stereotypes, its fabric dotted with "a scattering of editorial asides on the immutable nature of the Oriental world."[21] Abdul JanMohamed also points out that despite Kipling's attempt to find "syncretic solutions to the manichean opposition of the colonizer and the colonized" *Kim* remains a powerful example of the manichean allegory.[22] Race and gender politics work together in *Kim* to form a congruent discourse of imperialism that seeks to shore up the Raj at a time when it was at the very least under political interrogation and at the very worst (from the British government's perspective) under direct attack from the Congress party that was formed in 1880. If the girl-heroine Nell proves too frail to carry the white woman's burden in *The Old Curiosity Shop,* then in *Kim* the eponymous boy-hero is capable of carrying hers *and* his own. And if we find in Dickens the symbolic presence of an expansionist colonialism that was beginning to change Victorian culture, then in Kipling we find the literal presence of an expansionist imperialism that has transformed it. Sydney Haldane, secretary of the Fabian Society and governor of Jamaica from 1907 to 1913, offers this assessment of the idea behind British rule that developed between the writing of *The Old Curiosity Shop* and *Kim:* "Sympathetically conceived, the philosophy invited a programme of administrative and engineering efficiency rather than one of industrial and profiteering exploitation."[23] In Kipling's novel, imperialism is a notably efficient operation, appropriating, for instance, the newly established scientific discipline of ethnography; civil and military precision sharply contrasts with the "happy Asiatic disorder" into which Kim dives and that is a source of horror to the Englishwomen described by Emma Roberts and others earlier in the century.

Diving into "happy Asiatic disorder" implies one is not part of that disorder. Kim possesses a freedom to define himself *positively* against a native Other, however affectionately or sympathetically described. It is significant that critics tend to speak of Kipling's attitude toward India in terms of affection, sympathy, and understanding, sentiments that suggest his privileged distance from the culture he describes and also an analogous relationship to Kim as character. Just as Kipling is the true novelist of empire drawing resourcefully on his deep, enduring love and knowledge, so Kim is the true white child of empire, drawing for his survival on his distance from Indian culture *and* on his passionate bond with "Mother Earth/Mother India" (we will return to this figure at the end of the essay).

Kim's privileged position, given to him by virtue of his gender and his race, is suggested at the beginning of the novel, where he sits in "defiance of municipal orders" astride the gun outside the museum in Lahore, speaking

the clear and fluent vernacular of the West Punjab. When Nell is first described in *The Old Curiosity Shop*, she is lost at night in the Covent Garden area of London, timidly asking directions of the soon-to-disappear narrator; when Kim is first described, he asks no directions but trades insults with the native policemen on guard at the museum. He can get away with it, just as he is fearlessly able to enter the museum, a place thought by his native playmates to be a temple of idolatry. Here, Indian culture becomes imperial curiosity, and trophies of empire are displayed in "friezes of figures in relief, fragments of statues and slabs crowded with figures . . . dug up and labelled, made the pride of the Museum" (54). Kim, his fluid personality suggested by his familiarity with the worlds both outside and inside the museum, whether disguised as Mohamedan horseboy or Eurasian servant or whether dressed in the skimpy outfit of a Hindu streetchild or the saffron-colored robes of a Buddhist disciple, is always able to become again and to remain, if he so wishes, a white boy. When he is captured by his father's regiment and subjected to the European "discipline" he believes he has spent his entire life avoiding, he consoles himself with the idea that "he could escape into great, grey, formless India, beyond tents and padres and colonels. Meantime, if the Sahibs were to be impressed, he would do his best to impress them. He too was a white man" (143). To be a white man at the end of the Victorian period in India was not to suffer for the civilization of the savage and not to endure sacrifice for the elevation of the native to something approximating European culture; rather, to be a white man was to assume one's place in the imperial structure, to be permitted, along the way, the visionary moment on a mountain granted to many male figures in nineteenth-century literature. Toward the end of his journey on the road to perfected white male identity, Kim sits as if "in a swallow's nest under the eaves of the roof of the world" (307) and listens to the tales of Shamlegh's people, coming into full possession of his role as sympathetic sahib.

More than anything else in Kipling's novel, it is Kim's simple statement, "I always desire to see some new things" (130), that distinguishes him from Nell. Handsome, intelligent, boundlessly energetic, eager always to fling himself "whole-heartedly upon the next turn of the wheel," he relishes life, whereas Nell's narrative chronicles her retreat from it. At the end of his adolescent adventures, on the brink of fully achieved subjectivity and a career as spy for the British Raj, confused by multiple loyalties, he becomes that quintessential character in the English novel, someone in search of self. This search forms a significant contrast to Nell's experience, which is not only devoid of a quest for self but is also characterized by suppression of whatever slim shred of self she might have, of whatever tentative move in the direction of subjectivity she might make. The girl's story is one of self-erasure, the boy's of self-inscription. This crucial difference between *The Old Curiosity Shop* and

Kim tells all the difference in terms of gender and race politics between the two novels. Moreover, by virtue of his race and gender, Kim possesses a freedom that can never be Nell's—not just because she is a less than real/more than mortal figure in a very different kind of novel but because Kim's race gives him privilege in the actual world of empire and his gender gives him picaresque resilience. Imagine, for a moment, that Kim were Kate, the orphaned daughter of Irish parents, as pretty as Kipling's Kim is handsome, as quickly intelligent as he is wittily inventive; we would have a very different novel, maybe something by Flora Annie Steel that would see Kate O'Hara taken into the household by two unmarried English sisters living with their civil-servant brother and eventually married to a young color sergeant who would be a better version of her opium-addicted father. Mingling with the natives would be unthinkable for this character, and a Moll Flanders-type endurance would be unimaginable in the late Victorian novel of empire; there is even the possibility that Kate O'Hara would end up in a Calcutta brothel, as many young European women did in the last quarter of the nineteenth century.[24]

Recall that famous passage in *Kim* when "with an almost audible click" Kim feels "the wheels of his being lock up anew on the world without. Things that rode meaningless on the eyeball an instant before slid into proper proportion. Roads were meant to be walked upon, houses to be lived in, cattle to be driven, fields to be tilled, and men and women to be talked to. They were all real and true—solidly planted upon the feet—perfectly comprehensible—clay of his clay, neither more nor less" (331). In an image joltingly reminiscent of Dorothea Ladislaw seeing figures in the landscape, feeling she is "a part of that involuntary, palpitating life" and that she is thus reborn into the world,[25] Kim is reborn into his identity as a sahib. He lives in the great world, plays the Great Game, gathers strength from the opposite sex, and is not destroyed by it (as is Nell). For example, the lusty Woman of Shemlegh guides Kim through mountain passes to safety, and the "withered and undesirable" ruling-class native woman who loves "the bustle and stir of the open road" returns Kim to health at the end of the novel. In *Kim,* the women are real, not emblems, and the road is real, not symbolic. And for Kim that road is "to be walked on" *to* somewhere, not away from menacing savages but forward to the work of spying for the British Raj and thereby improving the lot of all natives under its protection.

The road is most real when Kim feels the seed of all life beneath his toes as he walks on the ground full of "good clean dust"; he pats it with his palms and lies down, and "Mother Earth" (as "faithful" as the native sahiba who has nursed him through his illness) breathes through him "to restore the poise he had lost lying so long on a cot cut off from her good currents. His head lay powerless upon her breast, and his opened hands surrendered to her strength" (332).

Juxtapose this image of the joyful, vital boy lying full length on the ground with that of Nell terrified of the bustle and stir of the open road, thankful when she reaches her conventlike retreat where she can linger among the gravestones. When we contrast *The Old Curiosity Shop* and *Kim*, we see in the former Dickens's flight from the city, from mercantile imperialism, from the metaphorical road of technological progress built by British command of trading routes, the appropriation of native resources, the creation of native markets for British goods. This flight is symbolized in the figure of a female child who is not only forced by patriarchal dereliction and Victorian gender politics to be mother to her grandfather but also rendered incapable of embracing "Mother Earth" by virtue of the weight of female suffering imposed on her frail shoulders. In Kipling's novel, we see an embrace of origins, of empire, of life, of curiosity.

The real road in *Kim* is the one traveled by Englishmen running the Raj, and also by the women under their protection. The regimental march, for example, usually undertaken every three years, was an astonishing event. Emma Roberts recounts that a three-person English family would be attended by a one-hundred-person native train composed of servants and the families of those servants; the native officers belonging to sepoy regiments would have their own zenanas, and the overall march was accompanied by a bazaar to keep it supplied. A tiny group of Europeans, utterly privileged and utterly vulnerable, yet in complete control of the entire operation, would wind its way across the roads of India: a memorable metonym of the early days of empire.[26] Kim travels many paths, from the Grand Trunk Road, through mountain passes, through shortcuts in the back alleys of Simla, to affirmation of life itself: waking one morning on the Grand Trunk Road, with the lama beside him, he feels that "[t]his was seeing the world in real truth; this was life as he would have it—bustling, shouting . . . India was awake, and Kim was in the middle of it, more awake and more excited than anyone" (121). Protected and educated by his benevolent, wise, and unworldly surrogate father, who knows the road through traveling it (unlike the British authorities who know most roads through their representation on a "mighty map"), Kim is enabled to seize the day; in sharp and sad contrast, Nell traverses an awful road through an industrial inferno, drained by the demands of her worldly grandfather rather than protected and educated by him.

By way of conclusion, I would situate Kipling's novel in the politically conservative context of its time, not to treat *Kim* as imperialist propaganda but to show its place in a cultural climate of English dread of feminism, of race degeneration, and of loss of empire. An Anglo/Indian novel published some ten years after *Kim*, Maud Diver's *Awakening* exemplifies these cultural fears. Less about India, in some ways, than about the corruption of a sentimental ideal of English rule, Diver's novel traces the romance of an English

upper-class painter, Nevil Sinclair, and Lilamani, a high-caste seventeen-year-old Hindu (always referred to in Diver's arch style as "She of seventeen summers" or "She of Asia") who has been brought to Europe by Audrey Hammond. Audrey is a character whose occupation and ideals are rooted in late nineteenth-century attitudes toward women and careers: she is a doctor in India and is taunted by Nevil for her "progressive schemes," for her "advanced views on the Woman Question," and for her career in "doctoring zenana ladies." Definitively, Audrey Hammond is a New Woman, of whom the narrator remarks, "It is a question whether girls of her type—products of extreme reaction from mid-Victorian ideals—are not cultivating brain and ego at the expense of the natural emotions; a doubtful gain for themselves and for the race, in an age already over-loaded with intellectuality and all its works."[27] Throughout *Awakening* the noticeable emphasis on type and race implies degeneration from a mythologized ideal: Audrey belongs to a type who may be harming her race; Hebraic Germans are the money-making type; Lilamani's father is the Anglophilic type embodying the myth that natives celebrate benevolent colonial rule, urged by his conservative English friends to speak out before "the whole Empire [comes] crashing about our ears!" (114); and Nevil is the Orientalist painter type. Stereotyping is integral to the ideological force of Diver's novel and may be seen as a shoring up of empire, an elaboration of European racialism that gained force throughout the nineteenth century. *Kim*, too, is rife with stereotyping, but of a more skillful sort than Diver can manage. As Edward Said points out, we hear about "the immemorial commission of Asia," "the huckster instinct of the East," the babu stowing spy papers about his body "as only Orientals can"; enchanted, rightly, by the vivacity of Kipling's novel, we are less alert to racialist mythology than when reading the cruder text. The deployment of types fixes the alien, threatening Other in a controlled position much as, one can say, Emma Roberts's *Scenes and Characteristics,* written some seventy-five years earlier, frames and fixes a native culture in a stereotype of sloth and neglect.

It is important to remember that *Kim,* with its boisterous emphasis on male adventure and its reproduction of gender and race politics that reward male control of women and of natives, was produced at a time of considerable cultural interrogation of the place of women and the meaning of empire. Diver's novel makes crudely explicit what is disguised by *Kim*'s charming vitality: threats to the hegemony of the British Raj are best dealt with by keeping women and natives in their protected, yet subjugated, place.

The fear of an active transforming sexual politics that we find in *Awakening* is a register of the social change for women that occurred in English life during the Victorian period, during the seventy years since Nell is imaginatively "devoured" by Quilp's cannibalistic evil. This social change is powerfully registered in the stereotyping of Lilamani, who looks at Nevil with "her

dark unfathomable eyes" in a "passion of adoration, such as the modern man rarely looks for in marriage, and still more rarely receives" (130). Lilamani is a dusky version of Nell. In the late Victorian and early twentieth-century English novels of empire, white women are no longer the sacrificial, ancillary, and civilizing figures we find in missionary literature, in travel narratives, in memoirs, and in novels of the 1840s. It is the native woman, Lilamani, who has taken on the unhappy burden of sentimental self-sacrifice and who is, perhaps, the figure behind this pronouncement by Maud Diver, issued in her journalistic study of Anglo/Indian life: "Woman is the lever, the only infallible lever, whereby sunken nations are upraised."[28] Maybe this is what Dickens had in mind in creating Nell, a child of empire who never grows to be a woman because her creator seems overcome with pessimism about the prospect of raising an England sunk in greed and selfishness, in dreams of imperialist money-making, and in hypocritical rescue of the less than noble savage. What Diver seems to have in mind is the subservient "She of Asia" as a monitory figure for women ambitious for a career and natives ambitious for independence.

In the most celebratory of Lilamani's father's speeches about English rule, he affirms "his fervent belief in ultimate accord between 'mother and eldest daughter' " (113)—a common myth and metaphor for the state that is given particular resonance in imperial writing. The great nurturing mother country (England) gives birth to subservient, passive daughters; it is difficult to imagine a metaphor for imperial rule that would invoke an authoritarian fatherland begetting aggressive sons destined to supplant him in their eventually successful struggles for independence. In this sense, both Nell and Kim are children of the same imperial mother. They are joined by a common bond of racial superiority that represents their imaginative contribution to Victorian colonial/imperial discourse; but they are divided by virtue of gender. In accord with conventional Victorian gender ideology and Dickens's nostalgic rejection of imperialism, Nell dies a female death in symbolic exchange for the eradication of the savage/native; in accord with the same gender ideology but certainly not with a rejection of imperialism, Kim lives a male life in imaginative justification of the surveillance and control of that savage/native.

NOTES

1. Steven Marcus, *Dickens: from Pickwick to Dombey* (London: Chatto and Windus, 1965), 73–74, points out that "[t]he pilgrimage has always been one of the grand, universal subjects of literature. . . . When Oliver sets out on his road to London, with nothing but 'a crust of bread, a coarse shirt, and two pairs of stockings,' he is traversing one of history's best-worn paths." Alexander Welsh, *The City of Dickens* (Oxford: Clarendon Press, 1971), 119–21, has perceptively interpreted Little Nell

and her grandfather as "sojourners" from the "earthly city" and also Little Nell as an angelic figure of death. Dickens's deployment, in his depiction of Nell's death-journey, of the emblems that influenced Victorian writing has been carefully explicated by Barry Qualls, *The Secular Pilgrims of Victorian Fiction: The Novel as Book of Life* (Cambridge: Cambridge University Press, 1982).

2. In this essay, I shall make little distinction between the terms "colonialism" and "imperialism." I employ the latter term to mean something more than/earlier than the jingoistic scramble for territory engaged in by European powers in the last quarter of the nineteenth century. Here, I am in agreement with Patrick Brantlinger, who has recently argued that the European colonization of Africa, India, and the West Indies in the early nineteenth century was as thoroughly land-grabbing and as economically driven as anything that went on from the 1870s to the end of the century. See Patrick Brantlinger, *Rule of Darkness: British Literature and Imperialism, 1830–1914* (Ithaca: Cornell University Press, 1988). In 1902, J. A. Hobson provided the first political distinction between British colonialism and imperialism, arguing that the former makes "no drain upon our material and moral resources, because it has made for the creation of free white democracies, a policy of informal federation, of decentralisation, involving no appreciable strain upon the governmental faculties of Great Britain." By contrast, imperialism "is the very antithesis of this free, wholesome colonial connection, making, as it ever does, for greater complications of foreign policy, greater centralisation of power, and a congestion of business which ever threatens to absorb and overtax the capacity of parliamentary government." See J. A. Hobson, *Imperialism: A Study* (London: James Nisbet & Co. Ltd., 1902), 132. Hobson's conservative fantasy of benign colonialism and costly imperialism points, in fact, to the essential project of both enterprises: the invasion of foreign territory by British civil and military power for the purposes of appropriating land and subjugating native peoples.

3. Wilkie Collins, *The Moonstone* (1868; Harmondsworth, Middlesex: Penguin Books, 1966), 67.

4. Charles Dickens, *Our Mutual Friend* (1864–1865; London: Oxford University Press, 1952), 319.

5. Charles Dickens, *The Life and Adventures of Nicholas Nickleby* (1838–1839; London: Oxford University Press, 1950), 409.

6. Abdul R. JanMohamed, *Manichean Aesthetics: The Politics of Literature in Colonial Africa* (Amherst: The University of Massachusetts Press, 1983), 4–5.

7. For a persuasive analysis of the presence of this figure in Renaissance writing and in *The Tempest* in particular, see Paul Brown's essay " 'This thing of darkness I acknowledge mine': *The Tempest* and the Discourse of Colonialism," in *Political Shakespeare: New Essays in Cultural Materialism*, eds. Jonathan Dollimore and Alan Sinfield (Ithaca: Cornell University Press, 1985), 48–71.

8. Charles Dickens, *The Old Curiosity Shop* (1840–41; London: Oxford University Press, 1951), 22. All further references are from this edition and are cited parenthetically in the text by page number.

9. Michael Hollington interprets Dickens's characterization of Quilp as expressing his critique of an industrial age: unnatural social systems produce unnatural monstrosities. See *Dickens and the Grotesque* (Totowa: Barnes and Noble Books,

1984), 91. For a complete guide to critical readings of Quilp from his first monstrous appearance in 1840 to recent interpretations, see Priscilla Schlicke and Paul Schlicke, *The Old Curiosity Shop: An Annotated Bibliography* (New York: Garland Publishing, Inc., 1988).

10. See Brantlinger, *Rule of Darkness*, 173–97.

11. Brantlinger, *Rule of Darkness*, 178.

12. Charles Dickens, "Slavery," *American Notes and Pictures from Italy* (1842–1846; London: Oxford University Press, 1957), 228, 242, 243.

13. As Richard Altick has splendidly shown, in Victorian Britain the exhibition of imperial curiosities (often human) accompanied imperial expansion, a phenomenon that crested at the grandest imperial show of all: the Great Exhibition at the Crystal Palace in 1851. See Richard D. Altick, *The Shows of London* (Cambridge: Belknap Press of Harvard University Press, 1978), esp. 269–87.

14. Charles Dickens, "The Noble Savage," *Household Words* 7 (11 June 1853): 337–39.

15. Cited by Linda Nochlin in *Women, Art, and Power and Other Essays* (New York: Harper and Row, 1988), 50. Of the *Art Journal's* remarks, Nochlin observes, "The heroism of British ladies would seem to have consisted of kneeling down and allowing themselves and their children to be atrociously raped and murdered, dressed in the most unsuitably fashionable but flattering clothes possible, without lifting a finger to defend themselves" (50).

16. *Macaulay: Prose and Poetry*, selected by G. M. Young (Cambridge: Harvard University Press, 1967), 703.

17. Emma Roberts, *Scenes and Characteristics of Hindostan with Sketches of Anglo-Indian Society*, 3 vols. (London: Wm. H. Allen & Co., 1835), 3:35; 79.

18. Roberts, *Scenes and Characteristics*, 3:202–4.

19. I am using the term *ideology* in a loosely Althusserian sense: ideology as a conception of the world made manifest through culture and society, ideology as that terrain on which a dominant social group gains hegemony over other social groups to secure cohesion and social order. See Louis Althusser, "Ideology and the Ideological State Apparatuses," in *Lenin and Philosophy and Other Essays* (London: New Left Books, 1971), for theoretical analysis of how institutions such as schools, the church, the family, the law, the media, and culture contribute to the production and reproduction of ideology.

20. A less well-known novel of the 1840s, *Oakfield*, by William Arnold (Matthew's brother), depicts the East India Company as driven by "beaver tendencies" and Anglo/Indian society tainted by "the evils of a money-getting earthly mind." W. D. Arnold, Lieut. 58th Regiment B.N.I., *Oakfield; or, Fellowship in the East*, 2 vols. (London: Longman, Brown, Green and Longmans, 1845), 2:223.

21. Edward W. Said, Introduction to Rudyard Kipling, *Kim* (Harmondsworth, Middlesex: Penguin Books, 1987), 28. All further references are from this edition and are cited parenthetically in the text by page number.

22. Abdul JanMohamed, "The Economy of Manichean Allegory: The Function of Racial Difference in Colonialist Literature," in *'Race,' Writing, and Difference*, ed. Henry Louis Gates, Jr. (Chicago: The University of Chicago Press, 1985–1986), 95.

23. Sydney Haldane, *White Capital and Coloured Labour,* selection reprinted in *Imperialism,* ed. Philip D. Curtin (New York: Walker and Company, 1971), 107.

24. For informed documentation of European prostitution in India at the end of the Victorian period, see Kenneth Ballhatchet, *Race, Sex and Class under the Raj: Imperial Attitudes and Policies and their Critics 1793–1905* (New York: St. Martin's Press, 1980), 129.

25. George Eliot, *Middlemarch,* ed. Gordon S. Haight (1871–1872; Boston: Houghton Mifflin Co., 1956), 578.

26. Roberts, *Scenes and Characteristics,* 13:138.

27. Maud Diver, *Awakening* (London: Hutchinson and Company, 1911), 52. All further references are from this edition and are cited parenthetically in the text by page number.

28. Maud Diver, *The Englishwoman in India* (London: William Blackwood and Sons, 1909), 100.

ALISON BOOTH

NOT ALL MEN
ARE SELFISH AND CRUEL

Felix Holt *as a Feminist Novel*

Once George Eliot had established herself as a great woman of letters in such works as the unpopular but authoritative *Romola,* she found herself in a difficult position. The stakes were higher perhaps even than they had been when she vindicated the fallen, strong-minded woman, Marian Evans "Lewes," in the wise reminiscences of the clerical George Eliot. That gentleman had now been promoted to the position of Victorian sage, which could easily take the fun out of the novelist's job. Yet while she was expected to teach, she was still expected to dazzle; overt preaching was taboo in the Victorian almost as much as in the modern aesthetic code. Further, her now public womanhood burdened her; the suspicion cast on any woman not minding her domestic business could poison a political novel by a woman, not to mention a novel recklessly broaching the "woman question." In *Felix Holt, the Radical,* Eliot veers close to feminist special pleading, yet the novel has always appeared to be political only in the traditional sense (and her traditional politics have irritated many); she can "pass" as a male historical novelist of a superior order, experimenting in artful form and allusion, avoiding Scott's anachronism, elevating her readers' understanding and taste. Yet it is important to see, behind the mask of the great novelist, a writer politically situated, one who recognized the interdependence of the public and private spheres and who, perhaps more than she realized, indicted the injustices of patriarchy in a drama of class and gender in a small Midlands town in the Reform Era.

In *Felix Holt* (1866) Eliot disguised her arguments about gender and class in an apparently impartial history of everyday life; she in effect responded to an immediate political threat, the second Reform Bill, by advocating gradual amelioration of private life and, above all, of women's lot. Like her friends and associates who campaigned in the 1850s and 1860s for such things as women's higher education and the right for married women to own property, she adhered to an ideology of influence, a belief in women's vocation for sympathy as a basis for social reform.[1] She hoped to foster feminine influence but entertained no political ambitions of remaking woman in man's image— and still less of eliminating class along with sexual differences.[2] Eliot mistrusted partisan politics as a kind of institutionalization of unfeminine egocentrism and competition, and while she, like so many of her contemporaries, perceived an affinity between women and oppressed classes and peoples, the bonds of the common life as she portrays them are uneasy at best. In particular, she suggests an ingrained antagonism between imperious men and all "others," redefining "radical" to mean, one who repudiates *his* ties to the past, to family life, and to the feminine.

Eliot's evident constraints in dealing with the electoral conflicts compressed in the subtitle "the Radical" become more intelligible and even excusable when seen in light of her feminist politics, which affirm what the self-promoting vote-mongers would like to leave behind. In the epigraph to chapter 21, an unidentified opportunist (perhaps lawyer Jermyn or his informer Christian) complains, " 'Tis grievous, that with all amplification of travel both by sea and land, a man can never separate himself from his past history."[3] Eliot might simply be echoing the platitude that there are no shortcuts in moral life and illustrating it with alarming scenes of social upheaval, but she is applying these conservative brakes because men who desire mobility have generally stored their women at home as too heavy to carry along. Thus Mrs. Transome's lover, Jermyn, has left her behind in his own career of reputable villainy, like Jason believing that he is "not at all obliged to" his Medea, only to face the vengeance of consequences (512–13). Eliot's consequential world, in which there can be no revolutions or magical escapes from the past, also gives voice to Medea's rage, a disturbance of the peace more truly radical, in the usual sense, than any riot on election day.

The feminism of *Felix Holt* for the most part is sealed off from the public political action of committees or votes, while its ladies are perceived as under siege not only by patriarchs but also by the masses. Eliot begs her social questions: Which misogynist "radical" is Esther Lyon to marry? Which fate is better for the workers in the short run, brute subjection or brute rebellion? But she seeks to appease the classes and the sexes within the tradition of the novel of manners, through a slightly eccentric marriage in which the heiress marries the poor man (forfeiting her wealth) and seems prepared to help him

run a kind of workers' institute.[4] Uneasy about pressing too political a message in her novel, she preferred to publish a more explicit statement about class and electoral politics (but *not* the "woman question") as a nonfictional appendix: "Address to Working Men, by Felix Holt" (1867). *Felix Holt* may be seen as an attempt to subsume the agitation for women's suffrage in the 1860s under scenes of "masculine" political life from the 1830s, in the locale and period of Eliot's youth, working within literary and social traditions.[5] Perhaps it is no wonder, given the complexity of its aims, that this is one of the least read of Eliot's novels.

In outline these aims are very much those of *Middlemarch,* another study of the English Midlands in the 1830s with interwoven masculine and feminine histories. Although the two novels differ enormously in power and design, many of the elements of the acknowledged masterpiece appear in the preceding work, with an almost inverted emphasis. Such inversion makes *Felix Holt* the more revealing articulation of a hushed politics. Eliot's earlier novel leaves the political issues of class and gender surprisingly exposed and unresolved, whereas the "greater" novel marginalizes scenes of political life and feminist protest as minor episodes or as hints in the prelude and finale. Is it partly the dictum that great art is not political that has devalued *Felix Holt* and that hampered Eliot as she wrote it?[6] *Felix Holt,* almost in spite of Eliot, seems an *overtly* radical text, even as it repudiates masculine "radicalism." The bitter protests of Mrs. Transome in particular arrest our attention (and readers from the beginning have found her the most compelling feature of the novel). That ailing woman, before being put to bed and "soothe[d] . . . with a daughter's tendance" by Esther, says, "Men are selfish . . . and cruel. What they care for is their own pleasure and their own pride." "Not all," is Esther's rather inadequate response to these "painful" words (597).

In *Felix Holt,* Eliot appears to reconcile interdependent spheres, the private and the public, much as though she would justify patriarchal society as the natural order modeled on the family, yet she alters the scale of values: the private, associated with women, the powerless, and personal relations, becomes the predominant factor in human history. Thus the novel implies that social progress relies on some form of fellow-feeling and on the sympathy that women are conditioned to extend rather than on practical measures or on the active pursuit of change usually reserved for young men. Eliot's narrator declares, "[T]his history is chiefly concerned with the private lot of a few men and women; but there is no private life which has not been determined by a wider public life" (129). By implication, one cannot understand public life without reading the history of private lots.

Most critics of the novel address a perceived strain between these political and "personal" strands, some accounting for it in terms of conflicting generic intentions. During composition, Eliot does seem to have been doubly

concerned with the accuracy of a historical-political novel on the Reform Era and with the effectiveness of a tragedy in novel form.[7] According to Fred C. Thomson, Eliot's notebooks indicate that *Felix Holt* originated in Eliot's study of classical tragedy as she worked on *The Spanish Gypsy* and that the interest in electioneering politics was worked up later.[8] Like the tendency to suppress "the Radical," the subtitle on the original title page, this view that the story of the Transomes takes precedence over the depiction of changing social conditions is suspect (part of a bias toward timeless, apolitical art?), but it is hard to deny that the circumstances of the election, the legal machinery that conveys Esther to Transome Court, and the reconciliation and marriage of Esther and Felix lack Mrs. Transome's fire.[9] Arnold Kettle, reversing Thomson's ordering, claims that the original study of two kinds of radical was deflected by Eliot's interest in "the position of woman" and "moral responsibility" (106).[10] Whatever Eliot's process of creation, it seems that critics resist the idea that the plots centering on Mrs. Transome, Esther, Felix, and Harold might be more than incidentally related; in other words, they presume that the plots centering on men's politics and on women's relationships are disparate if not rivalrous, that private and public spheres remain alien to each other. In spite of the manifest analogies in the novel between the politics of the drawing room and of the hustings, the accounts of Eliot's having been distracted from one sphere into the other persist. Even in light of these analogies, it is impossible to make a fully coherent novel out of *Felix Holt*. There is, especially, a surplus of feminist protest—surplus because narrator, characters, and plot largely ignore it.

The tragedy of Mrs. Transome is that of a woman who is unable to renounce her personal desires and who finds no wider calling; she is a pettier prototype of the Alcharisi, the dark double of the great woman of letters. Female ambition without voluntary self-sacrifice is always a disturbing force in Eliot's work. As though to contain this force, the novel shows a more dispassionate interest in things as they were: the history of the Reform Era as it opened and quickly closed the possibility of extending political rights to workers and women.[11] In addition to tragic form and historical accuracy, Eliot juggled the conventions of plot and plausibility, consulting the Comtean lawyer Frederic Harrison on the legal details of her plot.[12] Harrison's and John Blackwood's praise of the "politics" of the first two volumes dispelled Eliot's "depression as to [the novel's] practical effectiveness," though she remained "in that state of utter distrust and anxiety about my work which is usually the painful accompaniment of authorship with me."[13] She was not, of course, discouraged from attempting a similar synthesis of diverse elements again: Eliot assured Harrison that she would "keep the great possibility (or impossibility)" of creating an effective microcosm of social relations "perpetually in my mind," and we may speculate that *Middlemarch* developed as a

result. Eliot acknowledged the risk she had taken in attempting political art. After the publication of *Felix Holt*, she noted "the severe effort of trying to make certain ideas thoroughly incarnate"; "aesthetic teaching," she now maintained, would necessarily become offensive when "it lapses . . . from the picture to the diagram."[14] The artful world of *Felix Holt* at times seems reduced to a two-dimensional tract, but it does not disintegrate into unrelated private and public narratives.[15]

The conservative tenor of this novel may be primarily attributed to a *resistance* to such disintegration of the gendered spheres. *Felix Holt* offers radical insight into the correspondence between the lots of English ladies and the fate of all citizens of the Empire, between historical events and moments in the domestic interior; and the insight is occluded by the enfranchised actors in the drama. Mrs. Transome's battle with her son is more than coincidentally linked with the battle between ancient right and the rioting rabble on election day. In addition, while the novel dramatizes the possibility of gradual progress in obscure lives—in a realistic historical framework—it also invokes a spiritual counterhistory, cyclical rather than teleological, perpetuating hidden conflicts in gender relations. Mrs. Transome's and Esther's complementary stories have a mythical quality, as though like Demeter and Persephone they enact the recurring seasons, while Mrs. Transome recognizes that home is a Dantesque hell. The complex structure of the novel—shifting between plots, households, times, points of view—draws analogies between the private choices of women and men and the transitional epochs in which they live, implying, for instance, that there is more promise in Esther's growing awareness than in any extension of the franchise or triumph of a politically enlightened faction.

The power of *Felix Holt* derives from irreconcilable differences between men and women and their respective fields of power and influence in English society. What cannot be put asunder, according to the outlook of this novel, also cannot be joined without masking the rough margins. Familiar forms have been twisted out of shape; emphasis falls unexpectedly. There are dark family secrets, musty wills, lovers' lockets, but nothing more sensational arises than an anticlimactic riot. To most readers, Mrs. Transome and Matthew Jermyn broadcast their secret affair long before their son Harold knows of it, while the dispute between the Transomes, Durfeys, and Bycliffes—all the legal matter of base fees and remainder-men that Frederic Harrison supplied—remains hardly more than it appears to Esther, a muddle of prerogatives magically invoked to change lives.[16] Even the title raises doubts, not only as to the sense in which "Radical" applies to a man who opposes what would become the Chartist program (395–403) but also as to the centrality of the fortunate and faithupholding Felix Holt to the moral drama of the novel. Happy is he who holds on by the roots, the title seems to say, yet Felix must undo his father's errors and

resist his mother, while Esther must escape her inheritance.[17] The patriarch is rather shabbily represented on the one hand by imbecile Mr. Transome and dotty Mr. Lyon, who fail in biological fathering, and on the other by devious Lawyer Jermyn and his illegitimate son, Harold, who marries a slave.

If the male line of succession is doubtful, the novel seems reluctant to let matriarchy stand in its stead. E. S. Dallas observed in 1866 that a male author would have named the book after Esther.[18] Indeed, most of the novel centers on the metamorphoses of the heroine, whose namesakes, Dickens's Esther Summerson and Queen Esther, are likewise poor foster daughters who find favor with powerful men. Eliot's Esther earns her moral crown by refusing a luxurious place as chief concubine, but she uses her influence to help her lover and her father, just as Queen Esther saves her cousin and adoptive father, Mordecai. The tragic Vashti, a famous actress in *Villette* (1853), in this novel has become the defeated Mrs. Transome, almost as though Eliot, like another King Ahasuerus, wished to make an example of the rebellious woman.[19] Precedent and tradition are subtly modified, but without overt challenge to patriarchal order.

For all her strong didactic aim, the woman of letters seems more than usually reluctant to commit herself to any particular doctrine; the mono-logues of the eccentric Rufus Lyon suggest that the preacher must be a kind of outsider. Political activity is shown to be corrupt, idealistic, ineffectual, or irrelevant. Only Felix, manly and dignified, is allowed to seize the author's podium for a time, but he is jailed for his part in civil disorder, while his misguided enthusiasm seems subordinate to the question of his education in the femininity he initially despised. The treatment of class conflict is even more unsatisfactory; the human animals of the Sproxton mines are noted but are offered no real help: only a future relief through the evolutionary enlight-enment of the race. Given these evasions, in what sense does Eliot integrate the private with the public life?

To answer this question, we must concentrate on the "woman question" in nineteenth-century England. It seems to have been impossible to cover up the gap between the historic lot of Englishwomen and their potential. Eliot shows how women are denied their due influence, but any protest is rigidly controlled, primarily as the bitter censured outcry of a sinning woman. In the process of writing this novel, I would suggest, Eliot tempered her feminist argument, deflecting attention from female characters onto male and deploy-ing impersonal descriptive passages and a title that subordinated the perspec-tive of the women. Mrs. Transome and Transome Court are only part of the story of 1832, and a less timely part; Esther, similarly, remains outside public life, more like Maggie Tulliver than Romola. The struggles of Harold, Jermyn, Rufus, and Felix, in contrast, appear almost identical with the histori-cal crisis of the novel. It is as though the implied author concurs with at least

the first part of Harold's sweeping exclusion of women from historical mobility: "women keep to the notions in which they have been brought up. It doesn't signify what they think—they are not called upon to judge or act" (117). In Eliot's world of course it *does* signify what ladies think and how they judge and act, but they scarcely show signs of the times. In response to the grand political turmoil of the Reform Era, Eliot offers two private pacifications: Harold, a Byronic colonialist, misogynist, and cynic, is finally swayed by Esther and reconciled with his mother, while Esther adapts herself to (and begins to influence) her romantic hero of the working classes.

These pacifications obey the central principle of *Felix Holt:* that "we" are each one among many, parts of a general pattern of interdependent private and public lives that foil our egotistical plans; hence the impersonal overview of the narrator, particularly in the "Author's Introduction" and in the epigraphs to each chapter, added late to the manuscript. A close look at the way we are conducted into the novel and at the subtle politics of certain unobtrusive scenes will help us uncover the unacknowledged propaganda in the work. A tendency to universalize a Victorian, masculine norm is tempered by a critique of particular manly egotists and radicals of all walks of life.

Eliot's narrator is kin to DeQuincey ("The English Mail-Coach"), Thackeray's showman (chapter 7 in *Vanity Fair*) and the future Theophrastus Such: "Five-and-thirty years ago the glory had not yet departed from the old coach roads," he begins in a comradely tone, savoring a lost era of conservative immobility (75–76). The departed glory must be seen through ever-receding frames of nostalgic retrospect, since elderly gentlemen of 1831 resent the coach itself as an innovation going beyond "packhorses" (20). Then, on a narrated coach ride through the Midlands that is also a chronological history, the traveler "passed rapidly from one phase of English life to another," from pastoral harmony to market towns to manufacturing districts where miners and weavers turn day to night (76–79). Our narrator, like the coachman another "Virgil," will lead us into the Dantesque inferno of untold "human histories," such as the hereditary tragedies lurking on estates like Transome Court that try to resist social change (81–84). Thus we pass through changing social conditions to enter Mrs. Transome's hell in chapter 1—from the public and diachronic to the private and perpetual. At once we focus on a particular yet typical scene, a woman restlessly waiting in her drawing room for a man to return from his affairs in the world outside and to fulfill *her* ambitions. Mrs. Transome will bitterly learn that her son means to rule at home as he did abroad. The novel, then, opens with a wide-circling bird's-eye view, only to perch in a gilded cage with sexual and social politics coming home to roost. Two chapters later the novel reverses this move and examines surrounding conditions, so-called men's affairs of business and politics, in light of such domestic tragedy.

The action of *Felix Holt* is compressed into a brief period of gestation, the nine months from Harold's arrival to Esther's wedding, as though mimicking dramatic unities.[20] This compression, while it implausibly hastens Esther's metamorphosis from a creature of Byronic sensibility to one of Words-worthian duty, calls attention to the formal design of the work. Each of the main characters undergoes a crisis essential to Eliot's view of tragedy and of society: an "irreparable collision between the individual and the general," that is, between "our individual needs" and "the dire necessities of our lot."[21] Such tragic unity as Eliot might have found in the Transome story alone is subordinate to an inclusive study of society; all the varied lots meet their necessity and discover their interdependence. When we turn in chapter 3 to the humorous history of Treby Magna as though on a layover on another introductory coach ride, or when we abandon Mrs. Transome or Felix for long passages until Esther comes to them in their prisons, we should perceive the pattern in a larger web than the fate of one hero or heroine. Just before Felix, Mrs. Holt, and Rufus Lyon are introduced as analogues to Harold, Mrs. Transome, and Matthew Jermyn, we are asked to attend to the process of the common life:

> And the lives we are about to look back upon . . . are rooted in the common earth, having to endure all the ordinary chances of past and present weather. As to the weather of 1832, the Zadkiel of that time had predicted . . . unusual perturbations in organic existence . . . that mutual influence of dissimilar destinies which we shall see unfolding itself. (129)

Social history evolves naturally and, as a rule, unpredictably, this suggests, regardless of individual will or perspective. Such a vision may make the "universal custom" of the "subjection of women to men" appear "natural" rather than merely customary, as John Stuart Mill observed in *The Subjection of Women* (1869), a work that like *Felix Holt* elaborated a response to the 1867 Reform Bill.[22] But Eliot's emphasis on organically interdependent social development is aimed not at mystifying class and gender hierarchies—these are exposed as awkward customs in *Felix Holt*—but rather at chastening the egotism of the individual who does not acknowledge "mutual influence" and who denies his subjection to a collective historical plan. Women, the novel shows, may be egotists, "selfish and cruel," but they perforce acknowledge mutual influence.

As the novel unfolds, however, the law of consequences that the novel enforces against the male radicals, upstarts and opportunists like Harold or Jermyn and their various hired guns, seems to lose its power. Social life may be metaphorically an organism "rooted in the common earth," or it may be as random as stormy weather; disparate elements of the social microcosm and of the narrative that creates it are uprooted and blown out of place. Many of the

episodes seem to lack clear relevance; the pretext of a revelatory plot, with its punitive consequences, is often inadequate to account for the amplitude of Eliot's history. At times it seems that Eliot's historical curiosity about the detail of English common life undermines her respect for the public priorities of traditional political history. Perhaps the novel is designed to "denature" the customary and to displace the scene of political progress from the market square to the home.

In the domestic interior it is perhaps easier—and less regressive—to dramatize the ethical imperative of memory, of fidelity to the past, because historically the women's sphere has been forgotten. In Eliot's own conscientious, public-spirited act of memory, she precisely records the detail of past domestic life in order to retrieve evidence of women's experience. She perpetuates the tradition of the apparently apolitical novel that offers a realistic social history, including indisputably political events. Simply to note the trivial matters of lives of the obscure can be, of course, a form of protest. If women have been consigned to lives of repetitive domestic detail, it is time the history of such detail were related. No details of women's lives should be dismissed as "small airs and small notions," as Felix calls them. On the contrary, the key to the history of nineteenth-century parliamentary reform was kept in the work-baskets of mothers, daughters, wives. Yet the novelist saw no solution in women's rivaling men: Mrs. Transome's cold lust for power seems a sign of the self-wounding that comes of angry confrontation with men, as well as a forerunner of hostile images of suffragettes and women's-libbers. Eliot's narrator remains more sympathetic than hostile, of course, in keeping with her unbiased humanist persona. The novel suggests that the sexes will be reconciled only if men and women are able to change, but they must not fruitlessly resist inevitable sexual differences. These differences, for Eliot, have some positive value in the exclusion of women from power and ownership, which are sources of violence and exploitation. The influence of Esther is presented as the feminine alternative to the corruption of masculine power. Indicting the treatment of women, the novel then, in the forgiving form of Esther, softens the judgment when the case comes to trial. Men are brought to acknowledge women's claims on them. As Harold must accept his dependence on others, Felix must accommodate his idealism to the fact of a wife.

To highlight the false division between the domestic circle and the outside world, women are depicted indoors, looking out; home becomes sanctuary or prison, while life outside beckons as well as threatens. At Transome Court, Esther opens the blinds to see the river and the trees: "She wanted the largeness of the world to help her thought." To Mrs. Transome, the same vista only reflects "boundary" and "line," "the loneliness and monotony of her life" (590, 596). (Compare Dorothea's view from the boudoir at Lowick in *Middlemarch*.) In the end, Esther rejects "a silken bondage" as a lady at the manor in

favor of "the dim life of the back street, the contact with sordid vulgarity" (591–92). It appears that the social order itself is founded on the clear demarcation of domestic interior and public exterior, and on the liminal status of women who must pay if they cross the boundary.

In 1832, ladies depend on gentlemen's protection; during the riot, Felix reassures Esther in her home before he tries to lead the mob, only to find himself swept along in its rampage toward Treby Manor. There, as earlier in an inn, his knightly impulse is to rescue the women, but ironically he is forced to pose as the aggressor, brandishing his "sabre" in a lighted window before "a group of women clinging together in terror," frightened as much by him as by the pillagers he is preoccupied in turning away. The soldiers shoot him as though he were the leader of the rabble, wounding "the shoulder of the arm that held the naked weapon which shone in the light of the window." The phallic image of the man who has entered the women's interior remains indelible evidence against him at the trial, in spite of his chivalrous intentions (432). He appears to be another literary martyr to the cause of humbling and reforming men, like Rochester in *Jane Eyre* and Romney in *Aurora Leigh*.

Eliot's political analysis of separate spheres takes the form not only of showing what happens when the threshold is violated but also of examining the significance of domestic details; female characters are represented in relation to household trappings. Esther is first introduced as the minister's daughter who objects to the smell of ale and tallow candles. Her fastidiousness sets her apart from the vulgar, "weak sisters" who pester their minister Rufus (133), yet she herself threatens her father's and Felix's vocations. Felix sneers at Esther's indulgence in wax candles: "I thank Heaven I am not a mouse to have a nose that takes note of wax or tallow" (140). Catherine Gallagher points out here the conflict of Felix's contempt for such material "signs" and the narrator's realistic method;[23] misogyny and contempt for detail coincide in Felix with an egotistical denial of humanity's common interdependence. Female sensibility is animal-like to Felix: "A fine lady is a squirrel-headed thing, with small airs and small notions, about as applicable to the business of life as a pair of tweezers to the clearing of a forest" (153). He will have to refine his sense of scale in order to learn how the sexes might collaborate in domestic and public life, while Esther will learn that wax candles may come at the price of a woman's freedom.

As though her self-indulgent wish for refinement were granted, Esther is invited to choose a new home that has all the amenities lacking in Malthouse Yard. Transome Court seems like "Paradise" until she recognizes the role of the woman in it; it is "haunted by an Eve gone grey with bitter memories of an Adam who had complained, 'The woman . . . she gave me of the tree, and I did eat' " (585). In contrast with Felix, Harold prefers the decoration to the life, asking Esther to pose in finery like one of the Transome portraits. She

refuses, however, to adopt a fixed, false image (498). The portrait of Mrs. Transome in young and hopeful days seems to admonish her to "put out the wax lights that she might get rid of the oppressive urgency of walls and upholstery," and thus to reject her first vanity for a higher vision (47, 586). She is not to be the "doll-Madonna in her shrine" that Eliot criticized in "Margaret Fuller and Mary Wollstonecraft," an essay in which the heroic feminists, certainly not doll-like, are praised for retaining domestic loyalties as well as for not overvaluing women who have been degraded by decorous captivity.[24]

Although like so many heroines Esther faces a choice personified by two lovers, she more clearly dreads two kinds of disempowerment. Both the man who sneers at domestic detail and the man who wants to pile it up around his women are dangerous suitors for a woman who likes self-definition, just as they are distressing sons to their willful mothers.[25] Harold, like Felix, eagerly repudiates female claims on him. Harold's "busy thoughts were imperiously determined by habits which had no reference to any woman's feeling," and he is incapable either of imagining "what his mother's feeling was" or of swaying from his own imperious purpose (93). The radical who repudiates the past, the man who cannot be domesticated, is the man trying to his mother's will; thus Mrs. Holt and Mrs. Transome, "women who appear ... to have a masculine decisiveness ... and force of mind," have "come into severe collision with sons arrived at the masterful stage" (535). Whereas Felix is a kind of hippie (his mother grieves that he wears no stock), Harold is no genuine radical but a composite of all the prejudices of the privileged European male: he is imperialist, racist, classist, and sexist. As Esther senses, "to Harold Transome, Felix Holt was one of the common people who could come into question in no other than a public light. She had a native capability for discerning that the sense of ranks and degrees has its repulsions corresponding to the repulsions dependent on difference of race and colour" (522–23). Thus, accepting the power of prejudice, Esther shrinks from telling Harold that she has been intimate with Felix. Yet her repulsion when she hears that Harold's first wife "had been a slave—was bought, in fact" (541) is more than dread of vicarious contact with the alien; it is also dread of the sexually abusive master. Esther's "native" discernment has everything to do with her having been socialized as a woman; she may play along with ranks and degrees, but she begins to find them repulsive in themselves, since race and gender remain, like class, the registers on which the patriarch marks his supremacy.

Somewhat like Gwendolen in *Daniel Deronda*, Esther resists the surrender implied in accepting a man: "The homage of a man may be delightful until he asks straight for love, by which a woman renders homage." Harold's love "seemed to threaten her with a stifling oppression," almost as though she

intuits the opinion he declared when he first returned from Smyrna as a widower: "I hate English wives; they want to give their opinion about everything" (94). Perhaps less ominously, after having kissed Felix, "she felt as if she had vowed herself away, as if memory lay on her lips like a seal of possession" (592); he at least has taken the trouble to argue with her opinions. Crudely, she must choose between the radical who sees women as useless delights and the radical who sees women as temptations unless useful. With more conscience and foresight than Mrs. Transome, Esther chooses duty rather than pleasure (524), the man who scolds rather than the man who flatters her.

In outline, Eliot's novel promises little for women. While Esther seemingly must submit to Felix in the end, for her adultery Mrs. Transome must endure a living hell, dependent on Harold's belated understanding. Yet, as to the necessity for such sacrifices, the narrator offers contradictory commentary, generated especially by the figure of Mrs. Transome. Having married an imbecile, chosen a lover, and with him managed her failing estate, Mrs. Transome is now told she must become "grandmama on satin cushions" (95). Her power has not gained her love, and her illicit affair has rendered her powerless. The narrator can only advise resigned silence: "half the sorrows of women would be averted if they could repress the speech they know to be useless; nay, the speech they have resolved not to utter" (117). It is advice that Eliot herself, in the powerful voice of the narrator, does not follow. Observing Harold's bulldozing egotism, the narrator offers this rebuke:

> It is a fact kept a little too much in the background, that mothers have a self larger than their maternity, and that when their sons have become taller than themselves, and are gone from them to college or into the world, there are wide spaces of their time which are not filled with praying for their boys, reading old letters, and envying yet blessing those who are attending to their shirt-buttons. Mrs. Transome was certainly not one of those bland, adoring, and gently tearful women. (198)

It may make us uneasy to be told that there are such bland women, but they seem to be relegated to the world of unrealistic fiction. Esther, too, is certainly not one of the quiescent type, but lacking power she can only hope for the less demeaning love that recognizes her as a "woman whose mind was as noble as her face was beautiful." She complains of the injustice to Felix: "It is difficult for a woman ever to try to be anything good . . . when it is always supposed that she must be contemptible." Men may choose "hard" and "great" lots, but women, apart from the rare "Saint Theresas," "must take meaner things, because only meaner things are within [their] reach" (364–67). Esther's growing humility and desire for a truly great lot in life excuse this complaint. She will grow to embody some of a saint's grand calling, but

she is a woman, not a saint—that is, she is not destined, as George Eliot was, to join in the vanguard of public historical movements.

For some time it seems likely that Esther will take Harold, a meaner thing within her reach. Mrs. Transome predicts Esther's sacrifice to Harold with the bitterness of one of the damned:

> "This girl has a fine spirit—plenty of fire and pride and wit. Men like such captives, as they like horses that champ the bit. . . . What is the use of a woman's will?—if she tries she doesn't get it, and she ceases to be loved. God was cruel when he made women." (488)

The narrator understands such bitterness without forgiving it or offering women any recourse. In complaints or reproaches, "poor women, whose power lies solely in their influence, make themselves like music out of tune, and only move men to run away" (437). Pointing out the selfish, cowardly response of men, however, is not the surest way to recommend women's submission. Though the sexes mirror each other unflatteringly, ultimately women appear less base than men. Mrs. Transome's servant Denner comically declares: "I shouldn't like to be a man—to cough so loud, and stand straddling about on a wet day, and be so wasteful with meat and drink. They're a coarse lot, I think" (488). Mrs. Transome tells Jermyn, "I would not lose the misery of being a woman, now I see what can be the baseness of a man" (519).

To all appearances, Harold is the opposite of coarse, but the narrator, like Mrs. Transome and eventually Esther, detects the flaws of egotism beneath his veneer:

> "A woman ought never to have any trouble. There should always be a man to guard her from it." (Harold Transome was masculine and fallible; he had incautiously sat down this morning to pay his addresses by talk about nothing in particular; and, clever experienced man that he was, he fell into nonsense.) (500)

The corollary of Harold's gallantry is that women should protect men from wounded vanity, much as the narrator does by this backhanded parenthetical excuse. In practice, Victorian gender ideology depends on mutual blindness; thus Harold is uneasy when he suspects that Esther has a mind as well as a beautiful face:

> She was clearly a woman that could be governed. . . . Yet there was a lightning that shot out of her now and then, which seemed the sign of a dangerous judgment; as if she inwardly saw something more admirable than Harold Transome. Now, to be perfectly charming, a woman should not see this. (525)

The final caustic comment belongs to the wise and, in spite of the counsel of resignation, feminist narrator (the voice seems that of the unguarded Jane Austen in *Northanger Abbey*).

There are signs that the narrator realizes the unsatisfactory compromise in the romantic ending supposedly so devoutly to be wished. Really, Esther cannot do better than to marry, the narrator, in Shakespearean guise, maintains: "she was intensely of the feminine type, verging neither towards the saint nor the angel. She was 'a fair divided excellence, whose fulness of perfection' must be in marriage" (551).[26] Characteristically, Eliot presents feminine independence as the exception to the common order, a possibility for rare spirits like St. Theresa or Romola. Yet an inert and ignorant Angel in the House will spread a curse as much as any demonic Mrs. Transome. Esther must retain her will and aspiration. At her great moment, she assumes the role of a heroine of history:

> When a woman feels purely and nobly, that ardour which breaks through formulas too rigorously urged on men by daily practical needs, makes one of her most precious influences. . . . Her inspired ignorance gives a sublimity to actions . . . that otherwise . . . would make men smile. Some of that ardour which has . . . illuminated all poetry and history was burning to-day in the bosom of sweet Esther Lyon. In this, at least, her woman's lot was perfect: that the man she loved was her hero; that her woman's passion and her reverence for rarest goodness rushed together in an undivided current. (571)

The "divided excellence" finds a rare undivided opportunity to act. There could hardly be a more explicit image of the compensations of influence, yet Esther does not consume her life in obeisance to her manly hero. Like another Elizabeth Bennet, she could only be happy with a man "greater and nobler than I am," but she reserves a little of her wealth and, playfully, of her power: "You don't know how clever I am. I mean to go on teaching a great many things"—including Felix—"and you will not attribute stupid thoughts to me before I've uttered them." She will enjoy the "retribution" of demanding that he be worthy of her sacrifice (602–3).[27]

Eliot has captured perfectly the strange balance of power in the ideology of influence; she would later present a more convincing portrait of such a relationship in that of Mary Garth and Fred Vincy, where the man learns virtue by living up to the woman's standard for him. Felix must play the part of Esther's mentor, but it is a role she creates and makes him worthy of. Significantly, the union is cleansed of any hint of sexual mastery. Felix and Esther unite rather as though Maggie and Tom Tulliver were able to prolong their last moment outside of gender difference, like children or angels:

> He smiled, and took her two hands between his, pressed together as children hold them up in prayer. Both of them felt too solemnly to be bashful. They looked straight into each other's eyes, as angels do when they tell some truth. (556)

Male and female lots have been shown to be separate though tensely intertwined; the fusion at the end belies the instructive disunity of the novel. Felix and Esther leap out of history and out of gendered sexuality in order to unite as novelistic closure demands.

The comments on women's lot in *Felix Holt* are remarkably outspoken, more so than in *Middlemarch* or *Daniel Deronda*. Here lovers and mothers and sons openly negotiate power and ownership, and, in spite of the plot of reconciliation, the sexes seem to glare at each other unappeased. Eliot's drama of 1832 remains a puzzle in which the pieces of private and public life seem to fit and yet do not. Social divisions are exposed along the fault lines of class as well as gender. As in *Romola*, Eliot represents the common people as both the medium of continuity and as a volatile force for change; common people and upper-class women are implicitly linked in their shared exclusion from corrupt modes of power. As before, the novel exalts less the crowd or the suffering masses than individual, uncommon, but obscure beings such as Felix Holt and Rufus Lyon who are willing instruments of progress; the radicalism of their visions is tempered by fellow-feeling, love of tradition, and domestic sentiments. Their influence may be narrow and unsteady, but it is the ingredient heretofore missing from public life, where all men do appear selfish and cruel. Ladies at times are able to collaborate with such decent meliorists as Felix and Rufus, as when Esther rises in court in defense of Felix, "break[ing] through" the rigid systems of men (571). Felix holds an article of faith that "there's some dignity and happiness for a man other than changing his station" (557), but the spirit of the age is against him (as well as his own rejection of vulgar parents). The challenge to inherited station during the Reform Era jarred the Treby Magnas of England out of an apparent slumber of centuries. Eliot appears to dramatize the crisis of her times primarily in terms of class politics, but public events are upstaged by the skirmishes between men and women, which the novel suggests more profoundly determine the course of human history.

In a commentary on the disjunction between those interlocked spheres, private and public life, Eliot's narrator analyzes a society ostensibly governed by men whose public personae deceive everyone, including themselves—though perhaps not the women who know them in private life. "Under the stimulus of small many-mixed motives . . . a great deal of business has been done in the world by well-clad, and, in 1833, clean-shaven men, whose names are on charity-lists, and who do not know that they are base" (471–72). Certainly, young men who learn to integrate public forms and private relations offer some hope for change. Felix refuses to join the fashionable parade of self-deceiving educated men, but he must also learn to value the trivia of domestic life and to respect as a fellow human being what he mistook for "a squirrel-headed thing." Influential young women such as Esther were beginning in the

1830s to step out of the house and not only to put their own names on the charity lists but also to organize widespread reforms aimed at reconciling public and private morality. The novelist herself was such a reformer, urging that the business of the world be conducted in a less deceptive, impersonal manner, so that signs of authority—upper-class English manhood—could not be mistaken for signs of virtue or merit. The feminist political message is certainly muted, especially by Mrs. Transome's heartlessness and the forced concluding marriage. But such muting, like the moderation of Victorian feminism in general, enabled the very real advances that women like Eliot were able to make. The disjunctions of *Felix Holt* can be attributed largely to the strains on a writer sustaining the position of a great woman of letters, wishing to affirm a continuous tradition yet to integrate the different voices that had been silenced, wishing to narrate a political history of pre-Victorian society that incorporated the private experience of middle-class women, and finally wishing to expose bias and false consciousness while herself appearing impartially human and omniscient. These diverse wishes are impossible to fulfill entirely, of course. Whatever the "many-mixed motives" of the author herself, however, her text makes the most of these contradictions by not resolving them, exposing an unassimilated feminist argument.

NOTES

Adapted from Alison Booth, *Greatness Engendered: George Eliot and Virginia Woolf.* Copyright 1992 by Cornell University. Used by permission of the publisher, Cornell University Press.

1. Suzanne Graver, *George Eliot and Community* (Berkeley: University of California Press, 1984), 176–78. Eliot offers a good example of what Naomi Black calls "social feminism." See *Social Feminism* (Ithaca: Cornell University Press, 1989), 1–3.

2. See, for example, *The George Eliot Letters,* ed. Gordon Haight, 9 vols. (New Haven: Yale University Press, 1954–1978), 4:364–65, 467–68.

3. George Eliot, *Felix Holt: The Radical,* ed. Peter Coveney (Harmondsworth: Penguin, 1972), 310. Hereafter cited parenthetically in the text by page number. We are reminded of the warning in the "Author's Introduction" that progress has its price as well as its benefits: "Posterity may be shot, like a bullet through a tube, by atmospheric pressure from Winchester to Newcastle: that is a fine result to have among our hopes; but the slow old-fashioned way of getting from one end of our country to the other is the better thing to have in the memory" (75).

4. Esther Lyon, like Emma Woodhouse, is the spoiled darling of a widower, but she learns to reject the lord of the manor for the yeoman, the Robert Martin figure, Felix Holt. Ellen Moers has pointed out Eliot's alteration of Austen's class scale. See *Literary Women: The Great Writers* (1976; repr. New York: Oxford University Press, 1985), 50.

5. Bonnie Zimmerman, "*Felix Holt* and the True Power of Womanhood," *English Literary History* 46 (1979): 432–37.

6. Obviously, many "great" novels have political themes, and many even stage battle or election scenes (*War and Peace, The Red and the Black, Waverley, Vanity Fair,* and *Middlemarch* come to mind). But it seems that the arbiters of the canon prefer not to be reminded that the implied author is also politically situated and that the novel, much like the tract, takes sides.

7. Early critics of *Felix Holt,* while generally admiring, laid out two lines of attack: against the political novel of the Reform era and against the moral drama of the Transomes, Lyons, and Holts. See David Carroll, *George Eliot: The Critical Heritage* (London: Routledge and Kegan Paul, 1971), 251–70; and Florence Sandler, "The Unity of *Felix Holt,*" in *George Eliot: A Centenary Tribute,* ed. Gordon S. Haight and Rosemary T. VanArsdel (London: Macmillan, 1982), 137. *Felix Holt* was more a critical than popular success (Gordon Haight, *George Eliot: A Biography* [New York: Oxford University Press, 1968], 387). Though it appears to belong in the company of political novels such as Disraeli's *Sybil* or of multiplot social-problem novels such as *Bleak House,* it defies generic expectation. See Raymond Williams, *Culture and Society, 1780–1950* (New York: Columbia University Press, 1958), 103.

8. Fred C. Thomson, "*Felix Holt* as Classic Tragedy," *Nineteenth-Century Fiction* 16 (1961): 47; "The Genesis of *Felix Holt,*" *PMLA* 74 (1959): 576.

9. Norman Vance, "Law, Religion, and the Unity of *Felix Holt,*" in *George Eliot: Centenary Essays and an Unpublished Fragment,* ed. Anne Smith (London: Vision, 1980), 103–20.

10. " '*Felix Holt* the Radical,' " *Critical Essays on George Eliot,* ed. Barbara Hardy (New York: Barnes & Noble, 1970), 106. David Carroll diagrams the novel's "spheres of politics, religion, and love" as deliberately interrelated, yet he claims that Esther has "usurped Felix's central position" ("*Felix Holt:* Society as Protagonist," in *George Eliot: A Collection of Critical Essays,* ed. George R. Creeger [Englewood Cliffs, N.J.: Prentice-Hall, 1970], 134, 140). See also Michael Edwards, "George Eliot and Negative Form," *Critical Quarterly* 17 (1975): 171; and Joseph Wiesenfarth, "Felix qui non potuit," in *George Eliot's Mythmaking* (Heidelberg: Carl Winter, 1977), 170–85.

11. Eliot's journal and notebooks record extensive research on the economic and political contexts of 1832 in the *Times,* the *Annual Register,* the House of Commons's *Report from the Select Committee on Bribery at Elections* (1835), Mill's *Principles of Political Economy,* Samuel Bamford's *Passages From the Life of a Radical,* and Daniel Neals's *History of the Puritans,* among other sources. See Haight, *George Eliot,* 381; and Thomson, "The Genesis of *Felix Holt,*" 577–83, and the introduction to his edition of *Felix Holt* (Oxford: Clarendon, 1980), xiii–xlii.

12. His suggestion for the statement by the attorney-general was inserted in chapter 35. See Appendix B, 629–37, in Coveney's edition of *Felix Holt,* and the introduction, xxii–xxv, to Thomson's edition. The collaboration was unusual for her (*George Eliot Letters* 4:214–302).

13. *George Eliot Letters,* 4:258.

14. *George Eliot Letters,* 4:300–301.

15. Catherine Gallagher sees *Felix Holt* as a crisis in Eliot's "inductive" method of "metonymic realism," when the social tension of the 1860s made "the discontinuity between facts and values" impossible to ignore (*The Industrial Reformation of English Fiction* [Chicago: University of Chicago Press, 1985], 237–43). The righteous eponymous hero, generally seen as "too good to be true," tries to deny his affiliation with domestic life (see Laurence Lerner, *The Truthtellers* [New York: Schocken, 1967], 49). He has been condemned as a spokesman for Eliot's dread of public upheaval, in line with Arnold's response to the Hyde Park Riots in *Culture and Anarchy* (1869), but he is also the common man "feminized" and elevated by fellow-feeling. Williams, *Culture and Society,* 109, reproaches Eliot for excluding the common people from her vision of the interdependence of public and private life. See W. F. T. Myers, "Politics and Personality in *Felix Holt,*" *Renaissance and Modern Studies* 10 (1966): 27; David Craig, "Fiction and the Rising Industrial Classes," *Essays in Criticism* 17 (1967): 64–74; and Linda Bamber, "Self-Defeating Politics in George Eliot's *Felix Holt,*" *Victorian Studies* 18 (1975): 419–35.

16. The Lyons receive the news of Esther's inheritance as "magic"; Felix says her fitness for ladyship gives "chance sanction to that musty law . . . the appropriate conditions are come at last" (557).

17. Wiesenfarth, "Felix qui non potuit," 177–78.

18. Carroll, *Critical Heritage,* 267. Compare *Little Dorrit,* in which Arthur Clennam undergoes a more dramatic development than the eponymous guiding light; a woman might have named it *Arthur Clennam.*

19. The Book of Esther sets the context of *Felix Holt,* but the heroine's role as political savior of her people has been privatized. Lawyer Jermyn is Haman the villainous minister; Felix, like Mordecai, is an unruly outsider yet a guide for Esther inside the palace. See Zimmerman, "*Felix Holt,*" 441n.11. Charlotte Brontë's "Vashti" is judged as a woman rather than as an artist, suggesting a precedent for Eliot's defiant Alcharisi in *Daniel Deronda.*

20. Thomson, "*Felix Holt* as Classic Tragedy," 54.

21. Eliot, "Notes on 'The Spanish Gypsy,' " *George Eliot's Life as Related in Her Letters and Journals,* ed. John W. Cross, 3 vols. (New York: Harper & Brothers, n.d.), 31–32.

22. John Stuart Mill, *The Subjection of Women* (New York: D. Appleton, 1870), 22–23.

23. Gallagher, *Industrial Reformation,* 237–43.

24. "Margaret Fuller and Mary Wollstonecraft," *Essays of George Eliot,* ed. Thomas Pinney (London: Routledge & Kegan Paul, 1963), 201–5.

25. Felix rejects the dishonest occupation of his dead, mountebank father, thus distressing his mother; Harold repudiates his Tory lineage, neglects his imbecile "father," and almost kills Jermyn, his real father, all in a contest of wills with his mother.

26. The quotation is from *King John* 2:1.

27. Coveney points out that Esther's "laugh as sweet as the morning thrush" in this concluding scene echoes the scene in prison when Esther, "like a thrush . . . a messenger of darkness," warns Felix of failure (chapter 45, n. 1; chapter 51, n. 2).

WILLIAM W. MORGAN

GENDER AND SILENCE
IN THOMAS HARDY'S TEXTS

There is a loquacity that tells nothing . . . , and there is a silence
which says much.

—Far From the Madding Crowd

Thomas Hardy's work, more than that of any other major Victorian
writer, has historically provided a site on which views about some of the most
difficult political and aesthetic issues of gender could and should be con-
tested. And the contestation extends not only over time—from almost the
first reviews of his first novels to very recently—but also over an enormous
range of political, aesthetic, and moral positions. Some of the better-known
early readers whose response to his work proceeded from a position about
gender issues are Margaret Oliphant, Kate Chopin, and Havelock Ellis—all
of whom read *Jude the Obscure* (1896) in terms of their own consciously or
unconsciously worked-out ideas of the "truth" of gender, a term they under-
stood variously as a biological, psychological, or social datum in the structure
of human identity and social organization. D. H. Lawrence's *A Study of
Thomas Hardy* (1936) continued the critical investment in the problem,
which was taken up by Albert Guerard and Evelyn Hardy in the late 1940s
and early 1950s. This work, in turn, has been significantly reformulated but is
still very much alive in recent critical analysis such as Penny Boumelha's
Thomas Hardy and Women (1982), Ruth Milberg-Kaye's *Thomas Hardy:
Myths of Sexuality* (1983), Declan Kiberd's *Men and Feminism in Modern
Literature* (1985), Rosemarie Morgan's *Women and Sexuality in the Novels of
Thomas Hardy* (1989) as well as several dozen more recent articles and essays
by feminist, psychoanalytic, and cultural critics. Some recent readers find

Hardy the eternal adolescent, absorbed in and blinded by his own egoistic sexual desires and fantasies; others find an admirable advocate for social reform to be carried out along the lines of a feminist agenda. Readers studying Hardy's novels and poems in the past have found a contemptible and ignorant cynicism about women's capacity to love, blind and unintegrated anger at his own situation as a man, reckless and self-indulgent aggression against marriage as an institution, crass denial of the spiritual value of love and sex, a pseudobiological defense of male social and intellectual privilege, or, conversely, profound insight into mythic and eternal truths about the male and female psyches, advocacy for the social and sexual liberation of women, strongly felt if ultimately powerless compassion for women as victims of oppression, and deep insight into sex as ("after all," or "surely" it would be said) a straightforward human compulsion merely dressed up in spiritual robes by a puritan Christian culture.[1]

The literary discourse of gender is "surely" an overdetermined linguistic location—a language arena whose ideological atmosphere is so thickly populated with the desires of its speakers and hearers that whatever words are spoken are instantly aligned and sorted into a preexisting arrangement of possible positions, where they serve the ends of those holding the positions and where whatever desire for signification a speaker might have had is absorbed, swallowed up in the mass. In large part, the Victorians were the originators of this situation, since it appears that on every level and in every dimension of Victorian culture the ideas of sex and gender were overdetermined in a similar way. Small wonder, then, that Victorian texts seem to evidence a desire that their language should be strongly positioned about issues of gender and sex—it was the only way to be heard. Small wonder, likewise, that the inherited critical discourse of Hardy studies is similarly crowded with ready-made possibilities for signification about such issues, since Hardy's early readers were reading *from* an overdetermined cultural position and were seeing his works as part of a tradition of strongly positioned texts. Such tension is not only our inheritance as Hardy readers but also a part of our ambient environment, since of course *all* reading—even (perhaps especially) that of the most sophisticated writers and critics—is in a sense the construction of a text's possibilities according to our desires as readers and since, furthermore, our own culture is not exactly even-handed about sex or innocent of gender overdetermination. But even these explanations, powerful as they are, do not seem to me to account adequately for the persistent and extraordinarily various sexual readings of Hardy's work; there must be, I reason, something about the texts themselves that first invites and then betrays a reader's wish for political and aesthetic clarity.

In this essay I wish to propose three related theses: that Hardy's texts are significantly *under*determined—even indeterminate—at critical moments in

their presentation of sexual politics; that this indeterminacy most frequently "appears" in the texts as a form of silence; and that these silences mark the absence of an adequate language base, a body of linguistic custom and usage, from which a male writer of Hardy's era might speak on issues of gender—if he wished to do anything other than simply to enter the discourse of mastery that the biological determinism of the period authorized him to inhabit. The point of presenting these theses is not to attack or to defend Hardy or even to articulate some new and truer position about his fitness as a guide through the politics of gender; nor is it altogether to account for the persistence and variety of the sexual readings of his texts that I have mentioned (though I have some hope that I may in part account for this feature of Hardy's reputation). The point, for me, is to discover, to practice, and to propose strategies of reading—reading Hardy's texts, reading Victorian culture, even reading our own lives—that are at once textually specific and ethically responsible. While Hardy's texts often raise just the right questions about gender and while the governed rhetoric of those texts sometimes is close to being right about how to answer those questions, on the whole, Hardy's work does not provide an adequate guide to issues of sociosexual justice—it is instead confused and sometimes self-indulgent. But this fact does not mean that the work is not valuable; indeed, it is precisely in the ways in which Hardy's texts at times come close to being "right" and therefore challenge through their inadequacies that a good measure of their aesthetic and political value exists. I propose, therefore, that reading the gendered silences of Hardy's texts—that is, trying to locate and identify them and to find out what might be signified by those silences and what might plausibly be inserted into them—may be of more interest and of more use than reading those texts' declared content on gender issues. And if *even one* of my three theses turns out to be convincing, then I will feel that I shall have done Hardy readers a service: the full rendering of his texts as documents in a cultural debate about gender will have been restored to readers as a matter they can consciously negotiate with the texts—and will not then be something taken away from them by an overstrained and therefore intellectually impoverished argumentative arena.

SILENCE AND MASTERY: THE POEMS OF THE 1860s

In one of its purer forms, what I have called the discourse of mastery that Victorian thought authorized men to use appears in the following short Hardy poem:

> When the maiden leaves off teasing,
> Then the man may leave off pleasing:
> Yea, 'tis sign,

Wet or fine,
She will love him without ceasing
With a love there's no appeasing.
Is it so?
Ha-ha. Ho!²

In the larger movement of its rhetoric and argument, this is an unsavory bit of
bravado that brings the mnemonic authority of rhyming verse into the service
of a self-assured thesis about sex, gender, and power: a woman's erotic power
("teasing"), says the poem, is contingent and requires male cooperation
("pleasing") for its fulfillment, whereas a man's power is essential and final,
still in place and serving his needs when the woman's power is spent and all
she has left is unending ("without ceasing") powerlessness ("a love there's no
appeasing"). The voice of the poem seems content with such an arrangement
and content to present it as a given, a continuously true ("wet or fine")
description of the state of things. I have suppressed evidence in order to arrive
at this uncluttered reading: the poem was written in November 1868 (when
Hardy was a twenty-eight-year-old architect living in London) and published
posthumously in October 1928 in *Winter Words* with a note that read, "Nov.
1868. / From an old notebook." In one manuscript version it was titled
"Dandy's Song," and in all published versions it is titled "Gallant's Song."
Readers of one sort would perhaps use such ambient evidence this way:
"Well, then, it's a youthful poem, so one needs to make some allowance, and
besides it's a dramatic utterance—the Gallant (or Dandy) is making these
unpleasant arguments, not the poet. Hardy must have meant us to see the
poem as a critique of its speaker, something that ridicules itself by its very
overstatement." And other kinds of readers might say, "No, the dramatic title
is a transparent dodge, and so is the half-apologetic note placing the poem
well back in time; this is very likely the young Hardy's view, and even if it's
not, he still has to take responsibility for writing the poem and publishing
it—it was the presence of similar feelings in his mind that allowed him to hear
and give form to that voice of masculine power (his youth is no excuse), and
it was he who presented that voice to the world, even if he waited 60 years to
do it. There is a kind of endorsement in the very act of re-presenting such a
structure of values, and the choice to publish is yet another kind of endorse-
ment, one that brings the cultural authority of the printed word and that of
the (by then) distinguished poet's canon into line with the poem's argument."
 Clearly these arguments derive from 'readings' of the "white space" sur-
rounding the poem, what might be called its unenclosed, extratextual si-
lences; such responses are efforts to supply information that will anchor the
poem somewhere so that its relation to a recognized debate will be legible.
That such responses are necessary is evidence to support the idea of un-

derdetermination in Hardy's texts. But there are signifying silences within the poem as well as those surrounding it. How does one account for line 7, "Is it so?" What features of the narrator's consciousness can explain that question, coming so abruptly as it does after six lines of confident assertion? Is it perhaps an ungoverned authorial intervention, the *poet's* doubt finding its way into and qualifying the confidence of the dramatized speaker? Is it the speaker's own doubt? And are we to see that doubt as suppressed or validated by the last line, "Ha-ha. Ho!"? What kind of rhetorical direction is the laugh supposed to offer us? Is it a denial of the intervening question and a return to confidence, or is it an extension of someone's (whose?) nervous uncertainty about the poem's argument? What happens, in other words, in the *enclosed* white space that is shaped by the poem's formal rigor—the space between phrases, clauses, and lines? If we read backward from the ambiguity of the closing laugh, through the unsettling question, "Is it so?," to the last phrase of line 6, "no appeasing," we begin to sense a frightening and unarticulated emotional shadow alongside the poem's confident assertion: a love that cannot be appeased is a black hole that exercises continuous and tyrannical power over *both* parties "without ceasing," "Wet or fine," once the terrifying "sign"—silence and cessation—comes into position. When both "leave off" the teasing and pleasing activities that structure their relations, they are left with, quite literally, nothing that can be affirmed. The female is reduced to a single term of insatiable need, and the male becomes her prisoner, singing (desperately?) of his pride in conquest and the privileges of his hollow liberty. There is one further silence of note after the title and before the poem's first word, "When." When *does* the maiden leave off teasing—what is the referent in this construction? We must supply it, since the poem does not. Does she cease teasing when she believes she has secured his love? When she is convinced she cannot? When there is sexual consummation? The poem, silent on this as well as other issues, grants unquestioned status only to the culturally approved mode of heterosexual interaction, teasing and pleasing; as that falls away over the progress of the poem, there is nothing left but cocksure bravado, masking significant anxiety. These enclosed or "mapped" silences in the poem suggest that textual indeterminacy in Hardy takes the form of a silence marking the absence of a language community from which he might be able to speak other than in a discourse of mastery. The poem may be seen as "saying" that it "cannot say" the dangers of its governed statement.

In several other poems from the same period, Hardy structures in a particular kind of male silence—a silence that the poems point to and declare to have significance as silence. In the four "She, to Him" sonnets (1866) and a few other female-narrated poems such as "Her Confession" (1865–1867), "From Her in the Country" (1866), and "Her Reproach" (1867), the female narrators are imagined as speaking to a present but silent male hearer. From one

point of view, this rhetorical situation, formally constraining the male audi-
tors to silence, may be seen as an evenhanded and perhaps generous way of
giving the female speakers plenty of room in which to have their say. But
room in which to speak is not enough to assure political clarity, especially if
that space is specifically designated as one surrounded by a silence signifying a
powerful male hearer's nonresponsive presence. The "She, to Him" sonnets as
a group constitute a kind of narrative, a sequence of moments in the con-
sciousness of a female lover who is being left behind. She moves from asking
for her silent lover's friendship, even if she must forfeit his love ("She, to Him
I"), to anger at the way his decision has trivialized her ("She, to Him II"), to
self-destructive affirmation of loyalty to him in spite of his rejection ("She, to
Him III"), to, finally, a deep and resentful anger at his having taken a new
lover (She, to Him IV):

> This love puts all humanity from me;
> I can but maledict her, pray her dead,
> For giving love and getting love of thee—
> Feeding a heart that else mine own had fed!
>
> How much I love I know not, life not known,
> Save as one unit I would add love by;
> But this I know, my being is but thine own—
> Fused from its separateness by ecstasy.
>
> And thus I grasp thy amplitudes, of her
> Ungrasped, though helped by nigh-regarding eyes;
> Canst thou then hate me as an envier
> Who see unrecked what I so dearly prize?
> Believe me, Lost One, Love is lovelier
> The more it shapes its moan in selfish-wise.
>
> (1:20–21)

This sonnet is, of course, a representation of emotional extremity—maledic-
tion, denial of selfhood, and redefinition of love as selfishness—and such
extreme states of mind have been present in the three earlier poems as well.
But it seems even more important to note that the poem is also a representa-
tion of confrontation: the extremity, however "true" it may be, is also func-
tioning as rhetoric, since it is pointedly directed at the silent "Him." Because
of that rhetorical pointing, the poems present not just a psychological por-
trait of a spurned lover but also a violently asymmetrical confrontation
between her extremity and his silence. The poems' governed statements do
not, it seems, even try to make sense of their asymmetry; rather, they insist
that the reader do so, since only a crippled reading of the poems is possible
without somehow filling that silence. And how does one begin? What words

can serve to fill the hearer's silence? The voice of mastery might say, "There, there; you're upset; it's not so bad as all that!" or, perhaps, "Control yourself; you're behaving like a madwoman!" Another nameless voice might say, "I'm sorry I've hurt you." There are no doubt other possibilities, but Hardy provides no clue, and the absence of a clue is itself an eloquent marker, since it makes the asymmetry of the exchange one of the points of the poems.

Another semantic dimension of the surrounding silence is made clear in "She, to Him II" and in "Her Reproach," a poem which in many ways is at one with the "She, to Him" sonnets. In "She, to Him II," the narrator speculates that the departing lover will perhaps someday remember her and think, " 'Poor jade!' " (line 5) without realizing

> That your thin thought, in two small words conveyed,
> Was no such fleeting phantom-thought to me,
> But the Whole Life wherein my part was played;
>
> (1:19, 10–12)

What is most grating to her, it seems, is the small space she can hope to occupy in his life: indeed, her "Whole Life" can be reduced to "two small words" within his. Likewise, the narrator of "Her Reproach" seems to resent her lover's literary ambitions because they reduce her stature within his life, and she attempts to persuade him to adopt a set of values that would give greater space to love:

HER REPROACH

> Con the dead page as 'twere live love: press on!
> Cold wisdom's words will ease thy track for thee;
> Aye, go; cast off sweet ways, and leave me wan
> To biting blasts that are intent on me.
>
> But if thy object Fame's far summits be,
> Whose inclines many a skeleton overlies
> That missed both dream and substance, stop and see
> How absence wears these cheeks and dims these eyes!
>
> It surely is far sweeter and more wise
> To water love, than toil to leave anon
> A name whose glory-gleam will but advise
> Invidious minds to eclipse it with their own,
>
> And over which the kindliest will not stay
> A moment; musing, 'He, too, had his day!'
>
> (1:173)

The "larger," or at least different, scale on which the silent male's life is organized is not so much the enemy here as is its corollary: the small place that the speaker and what she represents—that is, romantic love—can have as a consequence. This larger asymmetry, in which the male psyche is presumed to move through and beyond love, as well as within it, while the female psyche is virtually identified with love, is also articulated through silence. While the female speaker talks of "resign[ing] her all to [him]" ("She, to Him II") and represents herself as frozen in place, "Numb as a vane that cankers on its point, / True to the wind that kissed ere canker came" ("She, to Him III"), the male listener is not only silent for his own part but, in a curious kind of ventriloquism, has even taken over her voice: he has become the poet whose larger frame of reference and literary ambitions have positioned him so that he can absorb her anger and place her within the epistemological frame constituted by his silence, a frame in which she has no existence outside her love for him. Whereas his silence in the immediate human terms of the love debate may be seen as an inability to speak because there are no adequate words, his silence in this larger-scale asymmetry may be seen as indicating that there is no need for him to speak, since the culture speaks for him when it authorizes him to "speak" as the silent male poet representing both the love obsessions of the female and his own separateness from those obsessions. In an indirect and perverse way, his silence has merged with the voice of mastery in "Gallant's Song"; just as that voice was riddled with anxiety, so this silence, for all its participation in the construction of the discourse of mastery, is a cover for the—literally—unspeakable ethical gap between the parties to the debate.

GAPS AND ARTICULATED SILENCES IN
HARDY'S FICTION

Not surprisingly, Hardy's fiction has moments small and large in which the issues and strategies mentioned above are transposed into the different problematic of a prose narrative. The fictional conventions within which Hardy worked for virtually his entire career included the expectation that a novelist would provide an *adequate* narrator—that is, a narrative voice whose management of action would also provide a management of wisdom and value—who could and would guide readers toward some kind of assessment of the issues raised by character and event. The voice that speaks in a work of nineteenth-century third-person realistic fiction is, by convention, expected to be wise enough—or at least knowing enough—to appraise the fictional situation and to make it morally and philosophically coherent to the readers, even if the characters and events of the novel mount a forthright challenge to the values and habits of those same readers. Hardy seems to have accepted this convention in his earliest novels and to have worked to establish for his narrators an

almost seamless authority that would allow them to leave little if anything unaccounted for. A world in which everything is accounted for and in its place is not a world in which an articulated narrative silence (such as that surrounding the "She, to Him" sonnets) can be allowed much weight: such silences must be filled by the narrator's adequacy or coherence is threatened. Nonetheless, the earliest novels, despite their allegience to the conventions of adequacy and coherence, exhibit at least two kinds of signifying silences when they deal with issues of gender; and those silences are again, it seems, textual locations at which indeterminacy is manifest.

The first and by far more common version of silence is paradoxically the other side of hyperconfident assertion. Consider the following examples:

> The love affair which had been Ambrose Graye's disheartening blow was precisely of that nature which lads take little account of, but girls ponder in their hearts.

> It was Miss Aldclyffe's turn to start now; and the remark she made was an instance of that sudden change of tone from high-flown invective to the pettiness of curiosity which so often makes women's quarrels ridiculous.

> She seemed to be completely won out of herself by close contact with a young woman whose modesty was absolutely unimpaired, and whose artlessness was as perfect as was compatible with the complexity necessary to produce the due charm of womanhood.

> Springrove had long since passed that peculiar line which lies across the course of falling in love—if, indeed it may not be called the initial itself of the complete passion—a longing to cherish; when the woman is shifted in a man's mind from the region of mere admiration to the region of warm friendship.[3]

> 'It was not exactly the fault of the hut,' she observed in a tone which showed her to be that novelty among women—one who finished a thought before beginning the sentence which was to convey it.

> Theirs was that substantial affection which arises (if any arises at all) when the two who are thrown together begin first by knowing the rougher sides of each other's character, and not the best till further on, the romance growing up in the interstices of a mass of hard prosaic reality. (*Far From the Madding Crowd*, 58, 419)

The syntactic formula in the first three examples is almost identical and is deployed, without explanation or gloss, as a means of establishing narrator-reader solidarity by making a claim on shared knowledge: it is a gesture of supreme confidence—"that nature," "that sudden change of tone," and "the due charm of womanhood" are expressions claiming the assent of readers by placing us within the community of generally accepted information that the

knowing narrator presides over and that he pays us the compliment of assuming we share. But the expressions are deeply duplicitous since the confidence and clarity they claim is but the mask of a silence: What *is* the due charm of womanhood? What sudden change of tone makes women's quarrels ridiculous? What kind of love affair has such differing effects on boys and girls? The rhetoric of the passages urges us to assume we know the answers to such questions, that our answers are the same as the narrator's, and that, accordingly, we should move comfortably along to the next moment in the narrative. But since the narrator is silent about his own answers, the expressions function as mere placeholders, hollow signifiers waiting to be filled with a reader's conceptions of gender difference. The second three examples, however, would seem to put the same syntactic structure to a more forthright kind of use: "that novelty among women" and "that substantial affection" are glossed for us, so that the grounds of our compliance with the narrator's view appear to be made clear, and we are invited to think of ourselves as agreeing with something fairly directly stated. But, as almost always seems to be the case when Hardy's fictional texts address gender issues at the same time they seek out reader assent, there is a margin of silence here as well, and the silence makes a claim about the degree of commonness with which the phenomena occur. Is a woman who finishes her thought before beginning her sentence a novelty? Is the affection that may arise under the stated conditions an unusually substantial one? Are these commonly observable phenomena of the world of gender, phenomena to whose commonness we will give our witness without pause, as we are asked to do? If we do assent, we must do so on terms that the text withholds—and therefore on terms that we must supply.

Such passages in which narrative confidence seems a mask of indeterminacy are in one sense an indication of Hardy's skillful management of the convention of narrative adequacy. The gesture of referring to this or that "well-known phenomenon" empowers the narrator by making the reader into a colleague. But the same passages may be seen as the texts' ways of gesturing toward the unknown and unknowable, then quickly moving to bring the rebel element under the control of a nominal solidarity between narrator and reader. The fact that the passages *do* gesture toward that which might threaten the narrator's authority is as interesting as the fact that they mask the gesture. Hardy's fictional texts are, in such moments, registering a kind of "consciousness" of what they cannot speak through the persons of their narrators, but those same texts occasionally allow that consciousness to speak through their representations of female characters, though always in such a way that there remains a huge gap between the ethical positions that are available to the narrators and to the female characters, respectively. This kind of silence, an open and unverbalized space between the ethical world of narrator and female character, more directly challenges the authority of the adequate narrator: the

female character without explanation, rebuke, or correction from the presiding voice of the novel challenges the foundations of the narrator's authority, and the novel grounds that challenge on gender. Consider the following:

> At these times a woman does not faint, or weep, or scream, as she will in the moment of sudden shocks. When lanced by a mental agony of such refined and special torture that it is indescribable by men's words, she moves among her acquaintances much as before, and contrives so to cast her actions in the old moulds that she is only considered to be rather duller than usual. (*Desperate Remedies*, 278)

> "Do you like me, or do you respect me?"
> "I don't know—at least, I cannot tell you. It is difficult for a woman to define her feelings in language which is chiefly made by men to express theirs. . . .' (*Far From the Madding Crowd*, 376)

Although in the first example Cytherea does not speak in her own voice, the passage makes clear that the absence of her voice is exactly the point; that voice is simply beyond the resources of language "made by men" and can only be indicated by its absence and the shadowy corollary of that absence, the narrator's deference to her otherness. Likewise, Bathsheba's feelings about Boldwood are unstable "in language which is chiefly made by men to express theirs" and must remain unspoken; her feelings must remain, indeed, an anomaly, a signifying silence in a fictional world governed by the authority of a male narrator who, in another, more nearly characteristic moment is willing to say:

> She might have looked her thanks to Gabriel on a minute scale, but she did not speak them; more probably she felt none, for in gaining her a passage he had lost her her point, and we know how women take a favour of that kind. (*Far From the Madding Crowd*, 45)

How does one account for the verbal and ethical space between such passages? A narrator who is provisionally uncertain about his female character's feelings ("might have" and "more probably") but who declares that, like himself, we "know how women take a favour of that kind" is claiming our partnership in a substantial knowledge of women's feelings in general; but what authority can the claim have if we also credit the other position, that women's feelings are inaccessible—either to men or to women—in language "made by men"? On a few occasions, the same problem of male language adequacy surfaces in another form, when a female character resists or rejects a male character's attempt to name or to explain her feelings:

'I didn't understand your meaning till it was too late.'

'That's what every woman says.'

'How can you dare to use such words!' she cried. . . . 'My God! I could knock you out of the gig! Did it never strike your mind that what every woman says some women may feel?' (*Tess of the d'Urbervilles*, 112)

' . . . How it carries one back, doesn't it! I could examine it for hours. . . . '

'Your cousin is so terribly clever that she criticizes it unmercifully,' said Phillotson, with good-humoured satire. 'She is quite sceptical as to its correctness.'

'No, Mr Phillotson, I am not—altogether! I hate to be what is called a clever girl—there are too many of that sort now!' answered Sue sensitively. "I only meant—I don't know what I meant—except that it was what you don't understand!' (*Jude the Obscure*, 127)

Or consider these two passages, in which the issue is not the adequacy of male naming but in which the feelings and beliefs of a female character sort awkwardly with the statements of the novel's narrator:

' . . . A woman jilted him, they say.'

'People always say that—and we know very well women scarcely ever jilt men; 'tis the men who jilt us.'

Women are never tired of bewailing man's fickleness in love, but they only seem to snub his constancy. (*Far From the Madding Crowd*, 127, 191)

According to Bathsheba, then, women are maligned by public opinion that makes them out to be fickle: men, she says, are statistically less faithful than women. But, according to the narrator, the problem starts with women's inconsistency: they don't value faithful men and prefer to complain about the unfaithful ones. How does one evaluate the competing claims of such diverging positions if one is reading within the conventions of third-person realism? This is a problem that readers confront every time they take up a Hardy novel; since the novels continue to be read, readers of every stripe must be filling in the gap in some way.

The dominant epistemological position of Hardy's fiction is a patriarchal one that participates in a tradition of male linguistic privilege as old as Adam's right to name the animals in Eden. Such a privilege manifests itself in the texts' presentation of a lengthy procession of signifying systems, all of which register sexual difference and male privilege—verbal language, erotic behavior, the conceptualization of the body, the emotional structure of pairings and communities, the organization of work, and the distribution of decisive social power, to name a few examples. That privilege functions at every semantic level of the texts and is consistently invoked as an axiological framework for

an array of narrative moments astonishing in their range of tones and functions. But even when Hardy's fictional texts seem to be at their most complacently sexist, they are so in a way that is often fundamentally unstable—either because the language of the text redefines the male privilege it enacts (so as to suggest that the privilege is accompanied by a profound uncertainty) or, more commonly, because the text is silent about one or more of the values upon which it depends for its rhetoric.

> Smart jogged along, and Dick jogged, and the helpless Fancy necessarily jogged too; and she felt that she was in a measure captured and made a prisoner.
> 'I am so much obliged to you for your company, Miss Day,' he observed. . . .
> To Miss Day, crediting him with the same consciousness of mastery—a consciousness of which he was perfectly innocent—this remark sounded like a mangnanimous intention to soothe her, the captive.
> 'I didn't come for the pleasure of obliging you with my company,' she said.
> The answer had an unexpected manner of incivility in it that must have been rather surprising to young Dewy. At the same time it may be observed that when a young woman returns a rude answer to a young man's civil remark her heart is in a state which argues rather hopefully for his case than otherwise. (*Under the Greenwood Tree*, 132)

With that last sentence, the narrator abruptly withdraws his provisional sympathy with Fancy's position as captive, takes away her verbal victory, and restores Dick to a position of advantage in the readers' eyes by reminding us that he's going to get the girl after all—her very incivility is evidence of the fact. It is as though the initially sympathetic insight into her awkward situation cannot be allowed to stand without a counterweight. The summary sentence rights the "balance" between the parties by noting that Dick's remark is "civil" (but not that it is insensitive) and then buries Fancy's uneasiness under the narrator's relentless participation in the logic of the heterosexual love-world. Each of the shifts of position in this passage—from sympathy with Fancy, to sympathy with Dick, to rib-nudging collegiality with the reader—leaves a silence in its wake. Consider the following passage:

> Rays of male vision seem to have a tickling effect upon virgin faces in rural districts; she brushed hers with her hand, as if Gabriel had been irritating its pink surface by actual touch, and the free air of her previous movements was reduced at the same time to a chastened phase of itself. Yet it was the man who blushed, the maid not at all.
> 'I found a hat,' said Oak. (*Far From the Madding Crowd*, 55)

Though Gabriel as the male *has* the power to subdue the female with a glance, and in spite of the fact that his glance has an effect he cannot control, he does

not experience himself as a locus of power; rather, if he experiences the power implicit in the situation at all, he feels it as something that brings about an awkward misstatement of his intentions. If in the first passage the narrator moves to restore the logic of heterosexual determinism and to reassure readers that all will be well, in the second he makes a rhetorical gesture that complicates the same determinism by suggesting that, whatever its material effect on the woman, this system of power does not necessarily accord with the wishes of the man. These two passages mark the two most characteristic kinds of unstable moments in Hardy's management of male privilege in his texts.

Such moments are very common. A casual count of the markings in my copies of Hardy's novels suggests that I could produce something like 150–200 narrative moments in which the values at work are grounded in ideas of sexual difference and male privilege. Consider another example:

> The throw was the idea of a man conjoined with the execution of a woman. No man who had ever seen bird, rabbit, or squirrel in his childhood, could possibly have thrown with such utter imbecility as was shown here. (*Far From the Madding Crowd*, 120)

Perhaps the art of throwing is appropriately judged by a male standard, but is it necessary that the critique of Fanny Robin's athleticism be couched in such violent language as "utter imbecility"? What kind of anger and urge for dominance lie unspoken behind that phrase? Indeed, why does her throwing need to be critiqued at all, since the point of the scene seems to be her poverty and vulnerability?

> She chafed to and fro in rebelliousness, like a caged leopard; her whole soul was in arms, and the blood fired her face. Until she had met Troy, Bathsheba had been proud of her position as a woman; it had been a glory to her to know that her lips had been touched by no man's on earth—that her waist had never been encircled by a lover's arm. . . . That she had never, by look, word, or sign, encouraged a man to approach her—that she had felt herself sufficient to herself, and had in the independence of her girlish heart fancied there was a certain degradation in re-nouncing the simplicity of a maiden existence to become the humbler half of an indifferent matrimonial whole—were facts now bitterly remembered. (*Far From the Madding Crowd*, 303)

This is a powerful evocation of Bathsheba's pride and spirit—two of her most engaging characteristics—but do not the narrator's two words, "girlish" and "fancied," modify significantly our response to her strength? In my view, these two words are enough to reshape the last sentence and suggest that the grounds of her now vanished sense of self-confidence were, after all, mere petty illusions, peculiar to young women without experience in the "real"

world of love (which the narrator quietly claims to understand)—all this while silently declining to declare what the nature of that real love-world is?

> Cleverer, greater than herself, one outside her mental orbit, as she considered him, he seemed to be her ruler rather than her equal, protector, and dear familiar friend. (*The Woodlanders*, 196)

What are we to make of the contrast here? Is it that Grace, the narrator, and/or the good reader ought to wish that Fitzpiers were, or *believe* that he should be, her equal, protector, and dear familiar friend instead of what he is? We are invited to participate in a gender-based tension here, but on what terms?

> 'Then may I inquire why you came?'
> 'A man brought me. Women are always carried about like corks upon the waves of masculine desires. . . .' (*The Woodlanders*, 219–20)

Says who? Felice Charmond, of course. But what relation does her declaration bear to the sociosexual values inscribed in the novel? "She," as character, "says" these words, but how does the text-world ask us to evaluate the unstated premises from which the words proceed? Are we to see this statement as critiqued on the grounds that it proceeds from some corrupt lack of will? Or are we, perhaps, to attribute to it a kind of worldly wisdom that the other characters lack? This passage, like the previous one, seems stranded without an interpretive context.

> 'But I don't want anybody to kiss me, sir!' she implored. . . .
> He was inexorable, and she sat still, and d'Urberville gave the kiss of mastery. . . . (*Tess of the d'Urbervilles*, 85)

What is the kiss of mastery? This question can be answered in any of a dozen ways, but the point is that the reader *must* fill in the answer—since, in this instance as in later, more crucial moments in its presentation of sex and power, Hardy's text does not.

> . . . by reason of the charm which is acquired by woman when she becomes part and parcel of outdoor nature, and is not merely an object set down therein as at ordinary times. A field-man is a personality afield; a field-woman is a portion of the field; she has somehow lost her own margin, imbibed the essence of her surrounding, and assimilated herself with it. (*Tess of the d'Urbervilles*, 123)

"Somehow" lost her margin? How? In whose eyes? I find myself arguing with the text in a manner something like this: If you would, as it appears, solicit my

agreement to this proposition, then you would have me accept, uncritically, the idea that female ego-boundaries are less distinct than male ones—but you don't seem willing to say so, even while you invite me to believe that it is (mysteriously) the case. I don't find in your presentation the grounds for the assent you ask.

> Izz . . . could not be—no woman with a heart bigger than a hazel-nut could be—antagonistic to Tess in her presence, the influence which she exercised over those of her own sex being of a warmth and strength [Why not stop here—what is gained (or lost) by going on as you do? I find myself asking. Why go on to call that warmth and strength] quite unusual, curiously overpowering the less worthy feminine feelings of spite and rivalry. (*Tess of the d'Urbervilles*, 342)

> If he had been a woman he must have screamed under the nervous tension which he was now undergoing. But that relief being denied to his virility, [Why not *start* here?—the gender distinction seems gratuitous.] he clenched his teeth in misery, bringing lines about his mouth like those in the Laocoon, and corrugations between his brows. (*Jude the Obscure*, 144)

> It was distracting to Jude, and his heart would have ached less had she appeared anyhow but as she did appear; essentially large-minded and generous on reflection, despite a previous exercise of [There you go again!—look at the next few words! Think of what you are asking me to agree to!] those narrow womanly humours on impulse that were necessary to give her sex. (*Jude the Obscure*, 187)

> 'What I can't understand in you is your extraordinary blindness now to your old logic.'

So says Jude to Sue when she is trying to defend her decision to return to Phillotson—understandably enough; but notice how the next two sentences modulate out of the immediate situation of the characters and into something quite different:

> Is it peculiar to you, or is it common to woman? Is a woman a thinking unit at all, or a fraction always wanting its integer?' (*Jude the Obscure*, 371)

I would be willing to venture that at this moment in the novel, the novelist-character distinction has collapsed and that what we witness is barely fiction at all; indeed, this is Thomas Hardy in dialogue with himself about an issue that is obsessively present in his texts.

The same claim might be made about all the passages cited above. Each might be said to be evidence of Hardy's own psychic dissonance, his inability to resolve the tension between his desire, on the one hand, for the possibility

of mutually respectful, emotionally enriching union between women and men (real and fictional) and, on the other hand, an ungovernable compulsion to return to a kind of intrapsychic order that is available to him only in a form that forbids the possibility of his having what he desires. But it seems something of an evasion to posit a "Hardy psyche" outside his texts. Such a putative psyche, interesting as it can be to those of us who want to come to terms with what we read in as many ways as we can find, can matter to us, finally, only as it is manifest in marks on a page, marks whose ability to point to presence and absence at once can make a claim on us and on the literary culture in which we live. Most often, as in the narrative moments cited, that claim is a double one—and one that stretches our moral attention across a textual contradiction that cannot itself be articulated because it participates in two mutually exclusive bodies of language—one that honors, however tentatively, the human reality and human value of femaleness, and another that subordinates female value to male. When it is more or less fully voiced, the second kind of language sounds like this:

> Half-an-hour later they all lay in their cubicles, their tender feminine faces upturned to the flaring gas-jets which at intervals stretched down the long dormitories, every face bearing the legend 'The Weaker' upon it, as the penalty of the sex wherein they were moulded, which by no possible exertion of their willing hearts and abilities could be made strong while the inexorable laws of nature remain what they are. They formed a pretty, suggestive, pathetic sight, of whose pathos and beauty they were themselves unconscious, and would not discover till, amid the storms and strains of after-years, with their injustice, loneliness, child-bearing, and bereavement, their minds would revert to this experience as to something which had been allowed to slip past them insufficiently regarded. (*Jude the Obscure*, 160–61)

Such a position, of course, settles all disputes by simultaneously claiming and acting out a hierarchy of competing discourses: if gender conditions are accurately described here, there need be no mystery about Cytherea's or Bathsheba's inability to give voice to complex feelings—that inability is simply a congenital incompetence that must be borne; Bathsheba's virgin pride is charming but naive; Sue's and Tess's reluctance to be named by male language is hyperfastidious affectation. As the second half of the passage makes clear, love, affection, even simple well-wishing that proceeds from this position will more nearly resemble the anxious love of a parent for a young child than that of lover for lover, since the ground of knowledge that informs its vision of the other also includes a presumption of wider knowledge, more reliable experience, and greater fortitude on the part of him who can speak these words. In other words, this position, while it offers the coherence and clarity missing in the other passages cited, achieves its closure by removing all moral and

aesthetic tension from the act of reading and by seeking to bring readers into complicity with its attitude of clear but sentimental repose. Such moments are, fortunately, rare.

Perhaps the most crucial gendered silence in all of Hardy's fiction is the one with which the narrator of *Tess* surrounds a critical moment in the events in The Chase on an evening in September when Tess Durbeyfield is seventeen:

> ... Roaming up and down, round and round, he at length heard a slight movement of the horse close at hand; and the sleeve of his overcoat unexpectedly caught his foot.
>
> 'Tess!' said d'Urberville.
>
> There was no answer. The obscurity was now so great that he could see absolutely nothing but a pale nebulousness at his feet, which represented the white muslin figure he had left upon the dead leaves. Everything else was blackness alike. D'Urberville stooped; and heard a gentle regular breathing. He knelt and bent lower, till her breath warmed his face, and in a moment his cheek was in contact with hers. She was sleeping soundly, and upon her eyelashes there lingered tears.
>
> Darkness and silence ruled everywhere around. Above them rose the primeval yews and oaks of The Chase, in which were poised gentle roosting birds in their last nap; and about them stole the hopping rabbits and hares. [What happens *here*? What do you, as reader, insert retroactively into this silence once you have begun the next sentence, which asks you to assume that something undesirable has happened?] But, some might say, where was Tess's guardian angel? where was the providence of her simple faith? Perhaps, like that other god of whom the ironical Tishbite spoke, he was talking, or he was pursuing, or he was in a journey, or he was sleeping and not to be awaked. (*Tess of the d'Urbervilles,* 107)

This silence is preceded by multiple images of Tess's pursuit and violation, by scenes in which Alec and others subject her to physical and psychological coercion, and by insistent references to her vulnerability; it is also followed by suggestions that possibly before, possibly during, and certainly *after* that narrative silence, Tess experiences a confused kind of sexual attraction to Alec. What name, then, can we give to the sexual act that is pointedly *not* narrated in that silence, that figures so largely in a reader's imagined history of Tess Durbeyfield but that is missing from the text of *Tess of the d'Urbervilles?* I would suggest that, insofar as we are attending to the feelings and behavior of Alec, we are given more than adequate grounds to name it rape, but insofar as we are attending to the feelings and behavior of Tess, we are offered no adequate name for what happened in that silence or afterward. In the text of the novel, in other words, Alec rapes Tess, but Tess may not have been raped.[4] In the mind of readers as they "complete" that text, however, a collection of widely dispersed words and images have to sort themselves with the readers' feelings and politics to form some kind of conclusion about that silence, or the rest of the novel is a muddle.[5]

THE TRANSFORMATIONS OF RETICENCE IN THE LATER POEMS

The kind of division I am trying to point to in the narration of *Tess* is a symptom of what I take to be a fundamental contradiction running through Hardy's texts at large, and, in this particular moment, forcibly intersected by a pressure inherent in the genre in which he is working—to make good on the conventional contract that calls for narrative adequacy. The contradiction itself consists, on the one hand, of a pressure from within the narrator/writer's own desires and affections to voice an intuition about the dignity and value of femaleness—its ontological status as something humanly valuable both in itself and in its relation to maleness—and, on the other hand, his participation in a male-centered discourse that makes that intuition inaccessible on any terms on which its value can be maintained. By the time of *Tess* and especially *Jude,* the psychic/textual contradiction itself seems to have become a foreground subject of the novels, and that fact, along with the pressure of the demand for narrative adequacy, may well have been enough to force a crisis— and, perhaps, enough to push the problem of narration itself to the surface and to create one of the very few metafictional moments in all of Hardy's novels: "The purpose of a chronicler of moods and deeds does not require him to express his personal views upon the grave controversy above given" (*Jude the Obscure,* 308). This narrative moment, it might be noted, defines the purpose of such a "chronicler" in terms of reticence and selective silence. It is not implausible that such a crisis may even have figured in Hardy's decision to leave the novel and return to poetry, since in poetry he was authorized by tradition to present fragments of experience: verbal moments whose ultimate coherence was understood to be the collaborative work of poet, text, and reader.

About the point at which Hardy began his second career (around the mid to late 1890s), a new paradigm entered his writing about gender and figured in his texts for the next thirty years—from the first published poems, through the famous elegies for his wife, the "Poems of 1912–13," until the end of his life. In the new paradigm, female selfhood "speaks" only through physical sexuality or mute absence (and progressively more often through the latter), and male response to physical sexuality is an experience of disorientation and disablement and to mute absence, a fumbling, often self-confessed verbal inadequacy—a kind of filling up of silence with verbal possibilities, none of which is adequate. Both within the "Poems of 1912–13" and outside them, there are occasions on which Hardy's texts make an effort to recover the physical intimacy of voice and ear. "The Haunter," "His Visitor," and "The Spell of the Rose," for example, are spoken entirely in the voice of an imagined Emma; that voice also holds a place in portions of "Your Last Drive" and

"Without Ceremony," as well as in other pieces such as "Lost Love," "An Upbraiding," and "My Spirit Will Not Haunt the Mound," probably written during the same period but not included in the sequence. These and other poems written in the last fifteen to twenty years of Hardy's life have their moments in which the absent woman—Emma or another—becomes vocal in the poet's imagination. But such occasions are residual and relatively rare. The more characteristic voicing of gender in the closing years of Hardy's career is something fundamentally different from either the voice of mastery with which he began or the later acts of ventriloquism that attempt to compensate for loss: instead of locating his gendered textual moments at some highly charged and awkward intersection of female value and male language, Hardy seems, after the death of his wife and after the tumult of the Great War, to have settled into gender difference as a way of knowing instead of viewing it as a problem. And instead of surrounding or intruding into the poem, silence in these later poems is more commonly a given, the corollary of a confessed ignorance or incapacity. The difference can be best noted in a comparison of "The Shadow on the Stone" (1913/1916),[6] one of Hardy's most eloquent evocations of female absence, and "Concerning Agnes" (ca. 1926–1927), one of Hardy's last poems. In the first, an active tension of desire prevails between the male perceiver and the presence that the dead female seems to offer; in the second, an unmistakable note of acceptance of the fact that the narrator and the dead woman occupy irreconcilably different orders of reality resonates. In the first, female silence is an unacceptable condition that must be contradicted, even at the cost of appropriating the psyche of the dead one; in the second, female silence is accepted as something integral to the condition of the freedom within which the speaker has his being.

CONCERNING AGNES

I am stopped from hoping what I have hoped before—
 Yes, many a time!—
To dance with that fair woman yet once more
 As in the prime
Of August, when the wide-faced moon looked through
The boughs at the faery lamps of the Larmer Avenue.

I could not, though I should wish, have over again
 That old romance,
And sit apart in the shade as we sat then
 After the dance
The while I held her hand, and, to the booms
Of contrabassos, feet still pulsed from the distant rooms.

I could not. And you do not ask me why.
 Hence you infer
That what may chance to the fairest under the sky
 Has chanced to her.
Yes. She lies white, straight, features marble-keen,
Unapproachable, mute, in a nook I have never seen.

There she may rest like some vague goddess, shaped
 As out of snow;
Say Aphrodite sleeping; or bedraped
 Like Kalupso;
Or Amphitrite stretched on the Mid-sea swell,
Or one of the Nine grown stiff from thought. I cannot tell!

 (3:215)

In "Concerning Agnes," the speaker specifically refuses to appropriate the dead woman; indeed, separateness has become an assumption rather than a problem, and, as such, it makes possible a position from which other matters may be seen more clearly and from which certain kinds of ignorance are, like other deprivations, both necessary and tolerable. The narrator may not "have over again / That old romance" (lines 7–8) because she is dead and he is alive, and he cannot see or even visualize her in death, since she is "Unapproachable, mute, in a nook [he has] never seen" (line 18). But paradoxically, the enforced separation seems to free the erotic and the mythic and allow them to function, respectively, within memory and speculation in the poem. The poem, by its unambiguous statement of what the narrator cannot have and cannot know, becomes a very rich and sensuous statement about what he has had and what he does know: possession is denied, ignorance is accepted, and the result is a vibrant eroticism ("The while I held her hand, and, to the booms / Of contra-bassos, feet still pulsed from the distant rooms") that yields in turn to mythic detachment and speculative image-making ("Say Aphrodite sleeping; or bedraped / Like Kalupso; / Or Amphitrite stretched on the Mid-sea swell, / Or one of the Nine grown stiff from thought"). Following as it does just after the image of a thought-stiffened muse, the closing clause, "I cannot tell!," is a particularly brilliant integration of the relationship of knowing and speaking; it may of course mean "I cannot discern" or "I cannot express," or, most appropriately, both. The gesture toward myth in the closing section of the poem is "about" the speaker's need for psychic order and not about the dead woman at all, and the poem's last three words reinforce that fact.

This suggests that in the poem death is to be understood figuratively as well as literally, that recognition and acceptance of unalterable difference are imaged here as death. In other words, the literal inaccessibility of the dead Agnes provides an occasion for a meditation on the inaccessibility of femaleness to

the speaker's language. In this view, the poem's last clause, "I cannot tell!," is a dignified admission of that inaccessibility and a forthright integration of necessary silence into the governed statement of the poem—a position that silence has not generally held in Hardy's texts. The admission of inaccessibility is also an open declaration of female otherness in relation to male discourse, and, in its concern with this issue, "Concerning Agnes" differs from other Hardy texts only in its forthrightness. Surely it has been the problem of female otherness all along that has kept Hardy's texts dancing around the moral and political issues of gender—the *problem* of otherness being the fact that, once declared "other," a being cannot be known or controlled, and the being that escapes knowledge and control is a threat to the coherence of the world and of the text.

*W*hatever the obsessive consistency, whatever the sameness of Hardy's texts when they address such issues, there is nonetheless a kind of change or repositioning that occurs over time. These changes are fairly subtle ones that are visible only if one looks at large blocks of Hardy's writing life, but silence is the critical element in the voicing of gender issues in all of Hardy's texts. Furthermore, the *position* of silence—whose silence it is, what voicing it enables, and what it requires of a reader—may be seen as the marker that indicates both the main periods in the history of Hardy's attempts to deal with female otherness and the kinds of strategic solutions he may be seen to propose. For roughly the first half of his writing life (ca. 1865–1895), the silence that figures most prominently in the texts is a male silence undertaken in the interest of giving voice to (a representation of) female consciousness. In the early poems, that silence seems primarily a kind of structural deference, an ultimately futile attempt to get the presiding male consciousness out of the way. In other instances, silence is a raw form of the claim to superior understanding that I have called the discourse of mastery. The choice of deference or mastery as it is applied to fiction becomes, in effect, a dialogue between the two instead of a choice; and the narrative moments in Hardy's fiction in which gender is most self-consciously present are also moments in which the competing demands for honoring female consciousness and for "placing" and explaining it within the known parameters of male-authored narration are simultaneously at work. With few exceptions, such moments are resolved when the male narrative voice, after temporarily imposing a silence upon itself, resumes its place and speaks with an authority that, in effect, smothers the voice of femaleness.

Sometime around the mid-1890s Hardy's texts begin to exhibit a very different strategy and tone.[7] As if abandoning the project of representing female verbal consciousness, or as if reflecting a recognition that the only voice he could truly represent is a male one, Hardy, instead of using male

silence as a device for giving voice to female consciousness, seems to have begun a process of silencing female consciousness altogether—at least insofar as female consciousness may be understood to represent itself in verbal language. Femaleness is curiously mute in the last few novels, and, progressively, from about 1890 to 1912, it is represented less by its own language at all and more by a kind of erotically engaging presence, a physical sexuality that, while it cannot speak, nonetheless elicits speech from male narrators both in fiction and in poetry. And, finally, from about 1912 until the end of his life, Hardy's texts are obsessively interested in female silence in its most absolute forms, absence and death. In the last half of Hardy's career, the half in which women are mostly silent, his work seems to proceed from a kind of recognition that the only language it can speak is one that registers male consciousness—and therefore one in which femaleness is not subject but object, one in which female consciousness is, because it must be, silent. For a reader of Hardy, these various positionings of silence are an indication of the range of Hardy's engagement over a long period of time with issues of gender, language, and power. As such, they can offer access to a wide range of understanding of his work. The various silences and their positions may also open the way for readers to recognize the kinds of political and aesthetic acts they must undertake in "completing" Hardy's texts. And, finally, these silences may be just as profitably read for what they can offer in the way of old-fashioned human wisdom; they may be read, that is, as a series of proposals about where it may be possible to stand in the act of reading or speaking about gender, whether one is Hardy writing or me or you reading, and whether one is speaking a novel, a poem, an essay, or a love-letter.

NOTES

1. The critical commentary referred to here is most easily accessible in the following places: Margaret Oliphant, "The Anti-Marriage League," *Blackwoods' Magazine* 159 (January 1896): 135–49, repr. *Thomas Hardy: The Critical Heritage,* ed. R. G. Cox (London: Routledge & Kegan Paul, 1970), 256–62; Kate Chopin, [Untitled review of *Jude the Obscure*], *St. Louis Criterion* (13 March 1897), repr. *The Complete Works of Kate Chopin,* ed. Per Seyersted, 2 vols. (Baton Rouge: Louisiana State University Press, 1969), 2:713–15; Havelock Ellis, "Concerning *Jude the Obscure,*" *Savoy Magazine* 6 (October 1896): 35–49, repr. *Thomas Hardy: The Critical Heritage,* 300–315; D. H. Lawrence, "Study of Thomas Hardy," in *Lawrence on Hardy & Painting,* ed. J. V. Davies (London: Heinemann, 1973), 10–128; Albert Guerard, *Thomas Hardy: The Novels and Stories* (Oxford: Oxford University Press, 1949); Evelyn Hardy, *Thomas Hardy: A Critical Biography* (London: Hogarth, 1954); Penny Boumelha, *Thomas Hardy and Women* (Brighton: Harvester; Totowa: Barnes & Noble, 1982); Ruth Milberg-Kaye, *Thomas Hardy: Myths of Sexuality* (New York: John Jay Press, 1983); Declan Kiberd, "Hardy's Sue: The New Woman as Neurotic," in *Men and*

Feminism in Modern Literature (New York: St. Martin's, 1985), 85–102; and Rose-marie Morgan, *Women and Sexuality in the Novels of Thomas Hardy* (New York: Rout-ledge, Chapman & Hall, 1989).

2. *The Complete Poetical Works of Thomas Hardy,* ed. Samuel Hynes, 3 vols. (Oxford: Oxford University Press, 1982, 1984, 1985), 3:234. All further references to Hardy's poetry are from these editions and are cited parenthetically in the text by volume, page, and line number.

3. *Desperate Remedies,* New Wessex Edition (London: Macmillan, 1974, 1975), 49, 107, 145, 287. All further references to Hardy's novels are from the New Wessex Edition and are cited parenthetically in the text by page number.

4. There is a good deal of intelligent and politically alert commentary on this issue to be found in the criticism: See especially Kristin Brady, "Tess and Alec: Rape or Seduction," *Thomas Hardy Annual,* no. 4, ed. Norman Page (London: Macmillan, 1986), 127–47; and Mary Jacobus, "Tess's Purity," *Essays in Criticism* 26 (October 1976): 318–38.

5. I do not wish to evade the issue or appear to be coy about my own politics here, but I have relegated my reading of the situation to the notes in order that it not intrude on the main line of my argument. In my view, the action in the Chase is most accurately read as rape, no matter which character's subjectivity one is attending to. For Alec, the entire pursuit, including the night in the Chase, is an exercise of power, and for Tess, even if she experiences in the moment and afterward something that might be called desire for him, the experience is one of powerlessness and subjection that, even if it includes sexual desire, is more accurately defined as rape than as consensual sex.

6. *Complete Poetical Works,* 2:280.

7. The most obvious biographical explanation would be the well-known es-trangement between Hardy and Emma that seems to have set in with full force in the mid-1890s and dominated the couple's marital relations until Emma's death in 1912. During this period—when many of his poems present narrators who admire and appreciate female sexuality from a safe distance—Hardy seems also to have been involved in a number of flirtations with women other than Emma. Her death could easily be seen as providing the basis for the obsessive theme of female absence in his poetry from roughly 1912 until his death in 1928.

ANTONY H. HARRISON

SWINBURNE AND THE CRITIQUE OF IDEOLOGY IN *THE AWAKENING*

Kate Chopin, in chapter 30 of *The Awakening*, describes Edna Pontellier's dinner party heralding her removal from her husband's house to a place of her own, the "pigeon house." There she hopes to pursue an integral and free life, unconstrained by responsibilities to her husband and children or by social obligations that her marriage has imposed on her. In the previous chapter Edna's lover, Arobin, has jokingly described her forthcoming party as a coup d'état, a description that Edna does not fully comprehend. The dinner is in fact a ritual repudiating the entire system of values that Edna's husband, Léonce, her children, and her position in society have come to represent. These values are defined throughout the novel as capitalist, materialist, and patriarchal. From the first chapter Léonce is depicted as a living symbol of these values, a virtual incarnation of an ideology.

Gradually, Edna's party deteriorates in tamely hedonistic directions. Mrs. Highcamp, a minor character, whimsically undertakes to alter Victor Lebrun's appearance. She adorns his "conventional evening dress" with a garland of roses for his "black curls" and drapes a white silken scarf across "the boy" in "graceful folds." He is thus "transformed into a vision of Oriental beauty. His cheeks were the color of crushed grapes, and his dusky eyes glowed with a languishing fire." In response to this decadent transmutation, Mr. Gouvernail in hushed tones appropriately quotes two lines from A. C. Swinburne's aesthetically self-conscious sonnet, "A Cameo," the only explicit allusion in *The Awakening* to the often scandalous work of this contemporary English poet:

> " 'There was a graven image of Desire
> Painted with red blood on a ground of gold.' "

Although this citation is unique in the novel, Swinburne's works and the conflicted political, philosophical, and amatory values—that is, the romantic ideology[1]—they propound constitute the most important and pervasive subtext of *The Awakening*.[2] Chopin's work, like so many of Swinburne's poems, presents a critique of capitalist social values, repressive patriarchal mores, and the social as well as the religious institutions that perpetuate both.[3] The impetus for this critique with Chopin, as with Swinburne, is the obstacled quest for total fulfillment of romantic "Desire" (in all its sexual, emotional, psychological, and spiritual manifestations). Traditional, socially accepted outlets for gratifying these fundamental impulses prove inadequate and illusory for Chopin's heroine and, typically, for Swinburne's poetic personae. Nonetheless, these figures embrace the impulses themselves and ultimately transfer them to a wholly fulfilling transcendent mode of experience anticipated in death and symbolized by the sea.[4]

Many lyrics from Swinburne's *Poems and Ballads, First Series* (1866), as well as from later works, fully develop his radical version of the traditional ideology of romantic love, a version that insists on the ultimate value of amatory experience but at the same time renounces as duplicitous all prospects for permanent fulfillment of passions in this life. In such poems as "The Triumph of Time," "The Garden of Proserpine," "Anactoria," and even his famous elegy on the death of Baudelaire, "Ave Atque Vale," such renunciation leads ultimately to suicidal impulses, a quest for death as oblivion—"Only the sleep eternal / In an eternal night." But this concept of death is deliberately undercut in obvious ways throughout these poems. Death is more than "the end of all" and is repeatedly associated with the sea, at once a matriarchal protectress, a primal lover, and a surrogate for the unattainable beloved of this life. In "The Triumph of Time," for instance, the speaker finally determines to

> . . . go back to the great sweet mother,
> Mother and lover of men, the sea.
> I will go down to her, I and no other,
> Close with her, kiss her and mix her with me;
> Cling to her, strive with her, hold her fast:
> O fair white mother, in days long past
> Born without sister, born without brother,
> Set free my soul as thy soul is free.
> *(Poems,* I, 42)

In Swinburne's poems this fantasized resolution to the contradictions inherent in traditional romantic mythologies of love—historically associated with

emerging capitalist society—serves as a critique not of those mythologies but of the constraints and limitations of a social world in which romantic ideals can never by attained. Disappointment or betrayal in love is inevitable for the speakers in his poems, but it is precisely through such losses, paradoxically, that they attain fulfillment. Unlike these speakers, Edna Pontellier ultimately realizes that she has been "a dupe to illusions all [her] life" (110). To free herself from the constraints, demands, and false promises of *her* social world, she commits suicide by drowning in the sea. As in Swinburne's poems, the sea is described as a surrogate lover: "The touch of the sea is sensuous, enfolding the body in its soft, close embrace." Its voice is "seductive, never ceasing, whispering, clamoring, murmuring, inviting the soul to wander in abysses of solitude" (113). In *The Awakening* Chopin thus appropriates values and patterns of behavior common in Swinburne's amatory poetry. But she also extends these to present a particularized critique of a social and economic superstructure that embraces mythologies of romantic love only to manipulate and victimize those who subscribe to them. Her revolutionary Swinburnean novel finally repudiates not only the materialist, patriarchal, and Christian values of America in the Gilded Age but also the illusory romantic ideology her society perpetuates and that Swinburne's poetry fully accepts. But her work is even more radical than this. It presents, as well, an anticapitalist and prospectively matriarchal counterideology while sustaining an artistically structured dialogue among the several ideologies whose conflict it dramatizes.[5]

*K*ate Chopin was an avid reader and often unconventional in her tastes. Critics of her work have traced influences on *The Awakening* from Bourget to Whitman.[6] Yet Swinburne is the only contemporary writer quoted in *The Awakening*, a fact that suggests his powerful influence on Chopin. The patterns of amatory values and behavior, of desire and rebellion, of disillusionment and renunciation, as well as the dominant metaphor of the sea in her novel closely replicate those that pervade Swinburne's poems from *Chastelard* (1860) to "The Lake of Gaube" (1896).

Perhaps the single most influential pre-text for *The Awakening* is "The Triumph of Time" (1866), generally considered the most autobiographical of Swinburne's many poems of lost love.[7] In nearly four hundred lines this impassioned *cri de coeur* circuitously describes a man's response to disappointed love. He is one "whose whole life's love goes down in a day." Compelled to put his "days and dreams out of mind, / Days that are over, dreams that are done," he acknowledges the extent of his devotion to the dream of fulfilled passion and thus to his beloved:

> What I would have done for the least word said.
> I had wrung life dry for your lips to drink,
> Broken it up for your daily bread.
>
> . . .
>
> I had given, and lain down for you, glad and dead.
>
> <div align="right">(Poems, I, 37)</div>

Dreams shattered, he determines first to keep his "soul out of sight," to pursue solitude, then to drown in the sea, the "great sweet mother," in a surrogate act of passion yielding fulfillment:

> O fair green-girdled mother of men,
> Sea, that art clothed with the sun and the rain,
> Thy sweet hard kisses are strong like wine,
> Thy large embraces are keen like pain.
> Save me and hide me with all thy waves,
> Find me one grave of thy thousand graves,
> Those pure cold populous graves of thine
> Wrought without hand in a world without stain.
>
> . . .
>
> This woven raiment of nights and days,
> Were it once cast off and unwound from me,
> Naked and glad would I walk in thy ways,
> Alive and aware of thy ways and thee;
> Clear of the whole world, hidden at home,
> Clothed with the green and crowned with the foam,
> A pulse of the life of thy straits and bays,
> A vein in the heart of the streams of the sea.
>
> <div align="right">(Poems, I, 42–43)</div>

Published thirty-three years before Chopin's novel (which shocked readers almost as powerfully as Swinburne's 1866 poems did),[8] this literary fantasy is reenacted in the last scene of *The Awakening.* Edna Pontellier succumbs to the voice of the sea, "inviting the soul to wander in abysses of solitude," and she does so after casting off her "unpleasant, pricking garments" and standing naked at the shore: "How strange and awful it seemed to stand naked under the sky! how delicious! She felt like some new-born creature, opening its eyes in a familiar world that it had never known" (113).

In "Anactoria"—one of the most decadent and iconoclastic poems in the 1866 volume—the typical Swinburean pattern of disillusionment in love, of world weariness, and of suicide in the sea is repeated, this time by Sappho, who addresses her uncooperative would-be lover, Anactoria. At the end of Chopin's novel Edna, who finds "no one thing in the world that she desires"

(113), echoes Swinburne's Sappho, who is profoundly frustrated by unful-
filled and unfulfillable passions. She begins her monologue weary "Of all
love's fiery nights and all his days, / And all the broken kisses salt as brine"
(*Poems*, I, 58). She expresses a powerful impulse to rebel against the con-
straints that impede her freedom. Unlike those of Edna Pontellier, however,
these constraints have been created for her not by society, a husband, and a
family but by their corollary in the world of this poem, the patriarchal "high
god" who would have "all his will" (*Poems*, I, 65). About to commit suicide,
Sappho perceives the "deep dear sea" as an ally that ultimately will "undo the
bondage of the gods" and

> . . . lay, to slake and satiate me all through,
> Lotus and Lethe on my lips like dew,
> And shed around and over and under me
> Thick darkness and the insuperable sea.
> (*Poems*, I, 66)

Swinburne's "The Lake of Gaube," published just three years before *The
Awakening*, similarly reinforces the truncated romantic ideology that pervades
his poetry and that Chopin appropriates. Here the speaker plunges raptur-
ously into the deep black waters of Gaube:

> Death-dark and delicious as death in the dream of a lover
> and dreamer may be,
> It clasps and encompasses body and soul with delight to
> be living and free:
> Free utterly now, though the freedom endure but the
> space of a perilous breath,
> And living, though girdled about with the darkness and
> coldness and strangeness of death.
> (*Poems*, VI, 285)

The work of both writers thus focuses on impassioned figures who envision
"no greater bliss on earth than possession of the beloved one" (*The Awaken-
ing*, 110). Such possession is, however, prevented by repressive and constrain-
ing forces. In Swinburne's poetry these forces are sometimes amorphous,
always patriarchal, and often associated with the misguided religious values
embraced by society.[9] In Chopin's novel such forces are explicitly social,
marital, and patriarchal. In chapter 13, as Edna's "awakening" begins, they
are also indirectly associated with religion when Edna attends the "quaint
little Gothic church of Our Lady of Lourdes," where "A feeling of oppres-
sion . . . overcame [her] during the service" and "her one thought was to quit
the stifling atmosphere of the church" (36).[10] With both writers, committing

suicide in the sea is at once a negative response to experiences of the failed patriarchal ideology of romantic love and fulfillment of the promises that ideology makes to its adherents. A surrogate for the beloved, the sea is represented as a realm of transvalued existence, a transcendent escape from the constraints and contingencies of the social world. It is a realm where attainment of the ideal of bliss associated with the beloved is assured, a posthumous utopia of fulfilled love.[11]

*B*eyond this point the value systems inscribed in the works of Swinburne and Chopin diverge. Although notoriously iconoclastic and libertarian, Swinburne's poems—unlike Chopin's novel—remain predictably vague about social, political, and religious values he would substitute for the status quo, and his works operate at an ideologically abstract level. "Hertha" (1871), for example, is a poem that repudiates not only Christianity but also all forms of religious orthodoxy and all repressive political systems that embrace it:

> A creed is a rod,
> And a crown is of night;
> But this thing is God,
> To be man with thy might,
> To grow straight in the strength of thy spirit, and live out
> thy life as the light.
>
> *(Poems*, II, 75)

In "To Walt Whitman in America" (1871) Swinburne identifies "the one [true] God and one spirit" as Freedom, which will eventually

> . . . rise and remain and take station
> With the stars of the worlds that rejoice;
> Till the voice of its heart's exultation
> Be as theirs an invariable voice;
> By no discord of evil estranged,
> By no pause, by no breach in it changed,
> By no clash in the chord of its choice.
>
> *(Poems,* II, 125)

Given the highly generalized level of religious, political, and philosophical discourse in his poems, it is perhaps not surprising to find that the values embedded in Swinburne's mythology of passion are conflicted. Much of his work is impelled by a pursuit of traditional, partriarchal ideals of romantic love; yet his love poems most often conclude by acknowledging that such ideals are always unattainable and thus a source of profound frustration that is

not merely sexual but also psychological and spiritual. Instead of exposing the hollowness of amatory ideals, however, he ultimately reinforces their value by metaphorically transvaluing and spiritualizing them, thrusting the only possibility of fulfillment into a transcendental realm usually expressed, as we have seen, in the metaphor of the sea. The ideology of Swinburne's love poetry is therefore only partially subversive. It finally rejects the fraudulent amatory promises of this world in favor of the certainty of fulfillment in a unique afterlife. At the same time, his mythology thereby reinforces the absolute value of romantic love. While insisting on the inevitability of disillusionment and betrayal in love, Swinburne also rejects Christianity as a false system of spiritual values. He repeatedly substitutes for this duplicitous religion his own mythology of idealized amatory values.[12]

In part by appropriating and extending the values, the patterns of action, and the dominant metaphors in Swinburne's poems, Chopin exposes in explicit ways an oppressively capitalist society that sustains itself on the twin illusory ideologies of Christian religion and romantic love. Chopin, unlike her English precursor, however, presents a highly particularized critique of the false value systems that have "duped" her heroine. She also embeds in her novel a counterideology to that dominating Edna Pontellier's social world, along with suggestions of an antithetical, concrete, and attainable utopia whose values contrast strikingly with the soul-eroding materialism of capitalism and the false promises of the traditional ideology of romantic love.

In the course of *The Awakening* readers are presented with three alternate holistic value systems. Each is associated with a particular social class. Each is also represented by a particular character or group of characters crucial in Edna's life and in her gradual awakening to the relations among these systems of value, one of the two awakenings that constitute the main internal action of the novel.[13] (The other is, of course, Edna's awakening to sexual desire.)

All the male characters in the work blindly adhere to the ideology that governs their society. Only Dr. Mandelet is conscious of the fraudulency and the dangers of an ideology that constrains, represses, and victimizes the novel's central female characters in clear ways, employing social mythologies of idealized romantic love and domestic happiness to do so. Unlike Leonce Pontellier, Robert Lebrun, and Alcee Arobin, Mandelet is well aware that "youth is given up to illusions" but that these are not self-generated. He blames nature for the "arbitrary conditions which we create." In "decoy[ing] women] to secure mothers for the race," according to the doctor, "Nature takes no account of moral consequences." Sympathetic as he is in his willingness to talk with Edna of things she has never "dreamt of talking about before," he believes the situation of women is immutable, like the social and moral laws "we feel obliged to maintain at any cost" in order to sustain and enforce the situation of women (109–10).

In all respects the antithesis of Mandalet, Léonce Pontellier embodies and espouses his society's dominant ideology. In him capitalist, patriarchal, and traditional romantic/domestic values converge. Chopin's exclusive focus on Léonce in the novel's first chapter constitutes a structural analogy to the primacy of his ideology in the social world of the novel. Moreover, in this chapter the most important concerns of that ideology are made clear through Léonce's circumstances and behavior. Disturbed by Madame Lebrun's parrot speaking an alien "language which nobody understood," Léonce abandons his chair while maintaining the illusion of his own dominant position: "The parrot and the mocking-bird were the property of Madame Lebrun, and they had the right to make all the noise they wished. Mr. Pontellier had the privilege of quitting their society when they ceased to be entertaining" (3).

Significantly, Pontellier respects the parrot's "rights" only in its capacity as "property." Almost immediately, when he returns to his newspaper, we learn of his priorities: "he was already acquainted with the market reports." A short while later, Léonce instinctively enacts his role as patriarchal representative of a capitalist culture that valorizes—in exclusively material terms—most experiences, as well as most people and their behavior. When Edna and Robert Lebrun appear fresh from an afternoon swim, Léonce exclaims, "What folly! to bathe at such an hour in such heat!" He is concerned about his wife's sunburn, but not for humane reasons. He looks at Edna "as one looks at a valuable piece of personal property which has suffered some damage" (4).

Léonce appears pompous but secure as the exponent of a uniformly capitalist value system and of the conventional modes of behavior that sustain and protect it. Accordingly, as the chapter concludes, Pontellier is far more interested in playing billiards at Klein's hotel than dining with his family: "It all depended upon the company which he found over at Klein's and the size of 'the game'" (5). When he returns at eleven o'clock, Pontellier is "in an excellent humor, in high spirits," presumably because he has accumulated "a fistful of crumpled bank notes and a good deal of silver coin," having parlayed the ten dollars with which he began the evening. As the chapter concludes, Pontellier gives Edna "half the money which he had brought away from Klein's hotel" by way of reparation for the argument he had initiated and the distress he had caused her after his return. We then learn the full extent to which the ideology that Léonce represents is accepted and dominant in his society: "Pontellier was a great favorite" with everyone, "ladies, men, children, even nurses" (9). Having sent Edna a box of exotic foods on his return to New Orleans, Pontellier is "declared . . . the best husband in the world" by everyone. Against such a consensus Edna cannot demur: "Mrs. Pontellier was forced to admit that she knew of none better" (9).

That Pontellier is the perfect extension of a society that worships property and maintains convention "at any cost" is apparent throughout the novel.

Chopin is perhaps most explicit on this score in chapter 17 when describing the Pontelliers' opulent house in New Orleans. A "large, double cottage, with a broad front veranda" and "fluted columns" painted "a dazzling white," it is a mystifying totem of Pontellier's values: "Within doors the appointments were perfect after the conventional type. The softest carpets and rugs covered the floors; rich and tasteful draperies hung at doors and windows. . . . The cut glass, the silver, the heavy damask which daily appeared upon the table were the envy of many women whose husbands were less generous than Mr. Pontellier" (50). Pontellier's "generosity" is, of course, nothing more than materialistic self-indulgence: "Mr. Pontellier was very fond of walking about his house examining its various appointments and details. . . . He greatly valued his possessions, chiefly because they were his, and derived genuine pleasure from contemplating a painting, a statuette, a rare lace curtain—no matter what—after he had bought it and placed it among his household gods" (50). Chopin's sarcasm here deliberately emphasizes the conflation of capitalist, religious, and domestic values in the minds of those like Pontellier who dominate this world from which Edna is eventually compelled to escape.[14] So complete is the hegemony of these values in the society Léonce represents that when Edna begins to rebel against them (by canceling her Tuesday "at-homes") Pontellier wonders "if his wife were not growing a little unbalanced mentally" (57).

As usual, however, Pontellier's apparent concern for his wife's well-being even in moments of crisis gives way to his concern with money and reputation. During his extended business trip to New York, when Léonce learns of "his wife's intention to abandon her home and take up her residence elsewhere," he strongly disapproves and begs her "to consider first, foremost, and above all else, what people would say." Surprisingly, he is not really distressed by the possibility of scandal. Rather, "he was simply thinking of his financial integrity. It might get noised about that the Pontelliers had met with reverses, and were forced to conduct their *ménage* on a humbler scale than heretofore. It might do incalculable mischief to his business prospects" (92). The last reference to Pontellier in the novel completes earlier depictions of him as thoroughly materialistic. His public announcement of extensive renovations to their house suggests increased prosperity rather than financial reverses.

The two other important men in Edna's life, Alcée Arobin and Robert Lebrun, are only slightly more equivocal reflections of capitalist and patriarchal values. Arobin is a playboy and man of leisure with a "dreadful reputation," whose "attentions alone are considered enough to ruin a woman's name," according to Madame Ratignolle (95). Apart from his emotionless exploitation of Edna, his role in the novel reinforces readers' perceptions of the hegemony of capitalist values in her society. During Edna's dinner party, in an interview that would otherwise seem marginal to the novel's central

concerns, Monsieur Ratignolle "inquired of Arobin if he were related to the gentleman of that name who formed one of the firm of Laitner and Arobin, lawyers." Arobin acknowleges that he permits his name "to decorate the firm's letterheads and to appear upon a shingle that graced Perdido Street," a place that is, presumably, truly lost to the system of values Arobin represents. As if to apologize for his co-optation by the ideology upon which he depends for his wealth and leisure and against which he would like to appear to rebel, he explains that "one is really forced as a matter of convenience these days to assume the virtue of an occupation if he has it not" (87).

Beneath both Pontellier and Arobin in the materialist hierarchy of society, Robert Lebrun has some difficulty settling on an occupation. Although he explains to Edna during a moment of passion that what drove him away from New Orleans and drove him back again was his love of her (106), the truth of this assertion is never clear. Initially we learn from the novel's reliable narrator that "Robert spoke of his intention to go to Mexico in the autumn, where fortune awaited him. . . . Meanwhile he held on to his modest position in a mercantile house in New Orleans" (6). In a letter to Mademoiselle Reisz sometime after his departure, he laments that "the financial situation [there] was no improvement over the one he had left in New Orleans, but of course the prospects were vastly better" (61). He expresses this preeminent concern with money to a correspondent from whom he hides nothing, not even his socially unacceptable interest in Edna. And to the woman he supposedly loves, his first explanation of his return home is that "business was as profit- able here as there" (97). The motives behind Lebrun's eventual abandonment of Edna are as ambiguous as the motives for his behavior throughout the novel. "Good-by—because I love you" appears suspect as a sentiment not just because it is trite. With these words Robert capitulates to the conventions of fidelity in marriage—conventions designed initially so that property could be inherited patrilineally only by legitimate children. These conventions Edna has already emphatically repudiated in conversation with him: "I am no longer one of Mr. Pontellier's possessions to dispose of or not. I give myself where I choose" (107). Robert's renunciation of Edna can thus be seen as the self-interested corollary of Pontellier's relentless attempts to dominate her.

The female counterpart of these men who sustain the patriarchal and capitalist values in the novel is Adèle Ratignolle, who fully accepts, embodies, and enacts the "illusions" thrust upon her by a pervasively materialist culture. She is the ideal "mother-woman," primarily a bearer of children who will inherit property and extend the lineage. Just as Pontellier embodies the capi- talist ideology, Adèle is a virtual incarnation of the ideology of romantic love capitalism subsumes and exploits. The "only words to describe her" are "the old ones that have served so often to picture the bygone heroine of romance and the fair lady of our dreams." Thoroughly idealized in Chopin's representa-

tion, Adèle's "beauty was all there, flaming and apparent." She boasts "spun-gold hair," "blue eyes that were like nothing but sapphires," "lips that pouted . . . so red that one could only think of cherries or some other delicious crimson fruit in looking at them" (10). The perfect female of the capitalist-romantic ideology, Adèle is a commodity ripe for consumption. Unlike Edna, who rebels against this ideology, Adèle actively collaborates in her own victimization. As "a faultless Madonna" (12), she is the human nexus of social and religious value systems in *The Awakening*. She is introduced to us as one of "those women who idolized their children, worshiped their husbands, and esteemed it a holy privilege to efface themselves as individuals and grow wings as ministering angels" (10). Even during her labor in chapter 37, "the scene of torture," against which Edna feels a "flaming, outspoken revolt," Adèle protests only mildly because of Mandalet's tardiness. And as Edna leaves the Ratignolle house, "stunned and speechless with emotion," Adèle admonishes selflessly in her exhaustion, "Think of the children, Edna. Oh! think of the children! Remember them!" (109).

Early in chapter 37, Chopin has provided us with a subtle coda for understanding the network of oppressive social, religious, and economic values that are climactically exposed here. During Adèle's labor Chopin presents the sequel to the initial description of her: "her face was drawn and pinched, her sweet blue eyes haggard and unnatural. All her beautiful hair had been drawn back and plaited. It lay in a long braid on the sofa pillow, coiled like a golden serpent" (108). This simile reconstitutes ironically the mythology of original sin for which women are said to be punished by laboring in childbirth. Here the serpent is removed from the garden and implicitly repositioned at the site of childbirth and, through its goldenness, identified with the capitalist marketplace that is the generalized cultural setting for the novel's events. Further, the deployment of this image just before Edna's awakening to an awareness of the "illusions" that repress and victimize women reminds us how ancient and culturally embedded they are.

Edna can escape the power of the ideology these illusions sustain in her society only by committing suicide after the Swinburnean pattern. Chopin does, however, present two spheres of existence on the margins of Edna's quotidian world that embody alternate value systems to those that inhere in the capitalist-romantic culture. These alternate "cultures" are those of Mademoiselle Reisz, the artist, and those of the lower classes—Madame Antoine and the "old *mulatresse*." These women and the spheres of activity they represent become the only genuine sources of consolation, escape, and succor that exist for Edna within her social world. Each lives literally or figuratively on the fringes of the dominant middle-class society of New Orleans, and each suggests the possibility of a mode of existence that is antithetical to that society—distinctively female if not distinctively matriarchal. These alternative

cultures—like the system of values drawn from Swinburne's work—compose a pervasive subtext in *The Awakening*: Mademoiselle Reisz is sporadically Edna's inspiration and companion in the course of her awakenings, and the scenes involving Madame Antoine and the *mulattresse* virtually frame the main action of the novel.

From her introduction early in *The Awakening* Mademoiselle Reisz appears as a social outsider whose music evokes profound, "mystic" internal responses in Edna. It generates "pictures in [Edna's] mind" (26) but further arouses "the very passions themselves . . . within her soul" (27). These are both disturbing and healing. Reisz's music is, other than the sea, the only source of total escape and fulfillment in Edna's life, and it is, from the first, associated with the sea: the passions awakened by it sway and lash her soul "as the waves daily beat upon her splendid body" (27). Like Mademoiselle Reisz's companionship, her music serves momentarily to liberate Edna from the domestic and cultural constraints that impinge upon her, thrusting her into an amorphous condition of transcendence: "The music grew strange and fantastic—turbulent, insistent, plaintive and soft with entreaty. . . . The music filled the room. It floated out upon the night, over the housetops, the crescent of the river, losing itself in the silence of the upper air. Edna was sobbing . . . new voices awoke in her" (64).

As an artist possessing "the courageous soul" (63), Mademoiselle Reisz remains untempted by the values and the rewards that dominate her society. She is, indeed, hostile to its unwitting emissaries. She "had quarreled with almost every one, owing to a temper which was self-assertive and a disposition to trample upon the rights of others" (26). In many respects the stereotypical artist, she lives in semipoverty, ostracized because of her unconventional appearance and behavior. "A homely woman, with a small weazened face and body and eyes that glowed, [s]he had absolutely no taste in dress, and wore a batch of rusty black lace with a bunch of artificial violets pinned to the side of her hair" (26). Her refusal to swim becomes "a theme for much pleasantry. Some . . . thought it was on account of her false hair, or the dread of getting the violets wet, while others attributed it to the natural aversion for water sometimes believed to accompany the artistic temperament" (48). Yet it is to her friend's "shabby, unpretentious little room" that Edna resorts "for a rest, for a refuge," and for discussions of Robert, whom she perceives until the end as her only route of escape from oppression and unfulfillment.

Unlike Mademoiselle Reisz, who exists as an outcast in the midst of New Orleans, Madame Antoine and the old *mulattresse* conduct their lives on the geographical, cultural, and economic fringes of bourgeois society. Both women are associated with satisfying food, with rest, and with garden settings. Their environs on the outskirts of the fallen social world are edenic, and Edna's brief visits to them are, at least temporarily, redemptive.[15]

Edna visits the "cot" of Madame Antoine early in the novel to escape the "stifling atmosphere of the church" she attends with a party from Grand Isle. With Robert she crosses the marsh to "that low, drowsy island," where Edna thinks that "it must always have been God's day" (36). The Acadian boy who revives them with water "cool to her heated face" is suggestive, too, of a reentry into paradise. Madame Antoine, living "at the far end of the village," runs a household that is "immaculately clean" and offers abundant natural foods. There Edna sleeps "long and soundly"—"precisely one hundred years"—and arises with "her eyes . . . bright and wide awake and her face glow[ing]" (38). She eats heartily of Madame Antoine's food, "no mean repast" (39); dallying in the garden, Edna is, for once, satisfied: "it was very pleasant to stay there under the orange trees, while the sun dipped lower and lower, turning the western sky to flaming copper and gold" (39).

The "garden out in the suburbs" where the old *mulattresse* abides presents as stark a contrast to the opulence of Edna's bourgeois house in New Orleans as Madame Antoine's "little gray, weather-beaten" house "nestled peacefully among the orange trees" (36). The *mulattresse,* too, provides a primitive repast, "milk and cream cheese . . . and bread and butter," that exposes as decadent the banquet Edna has recently served at her dinner party. In its simplicity the meal contrasts with the foods associated with Edna's domestic life: the box of exotic *friandises,* "toothsome bits," fine fruits, pâtés, "delicious syrups, and bonbons in abundance" that Leonce Pontellier sent to Edna after his return to New Orleans from Grand Isle. The garden over which the *mulattresse* presides is "too modest to attract the attention of people of fashion, and so quiet as to have escaped the notice of those in search of pleasure and dissipation" (104). Yet "no one . . . could make such excellent coffee or fry a chicken so golden brown" as the *mulattresse,* who, like her cat, "slept her idle hours away." At this idyllic retreat from her world Edna "often stopped" to read or dine.

Both of these lower-class settings in *The Awakening* present miniature utopias that serve as an implicit ideological critique of the fallen society in which Edna finds herself and of which, as we have seen, her husband is an extension. In these fringe worlds, as in the tiny apartment of Mademoiselle Reisz, women preside. The inhabitants remain uncorrupted by the material wealth associated throughout the novel with the patriarchy, and they are for Edna a source of spiritual renewal.

*A*ccording to this analysis, *The Awakening* is, in the most general terms, a novel that deliberately exposes the oppressiveness and spiritual limitations of patriarchal and capitalist American society at the end of the nineteenth century. The work presents a heroine who, in various stages of epiphany,

becomes conscious of her victimization at the hands of her culture's dominant ideology. She reacts in part by seizing opportunities for independent action but primarily by pursuing what she sees as alternate, spiritually and sexually fulfilling modes of feeling and behavior dictated by what she mistakes as an alternate system of values: the ideology of romantic love, especially as that ideology derives from late-nineteenth century romanticism, specifically from Swinburne's poetry. Belatedly, she discovers that this ideology is impracticable in the real social world. In effect, her culture makes use of this mythology of love (which, like Christianity, it has wholly subsumed) to delude and captivate those it must most fully exploit to survive—women. But while Edna Pontellier discovers a complete escape from her entrapment in this social world only through an act of suicide that vaguely promises romantic fulfillment as well as release, the novel itself explicitly presents genuine, ideologically alternate modes of existence that are on the fringes of the dominant social world but are nonetheless "in" reality. These are nonmaterialist, propsectively matriarchal, and spiritually satisfying.

Clearly, escape to one of these fringe worlds for Edna would be impossible for two reasons. First, these worlds are culturally alien and therefore wholly inaccessible to her in the long term. Practically, she is not equipped to function and to survive in them. Even the possibility of attempting to do so appears to be beyond her horizon of imaginable possibilities. The other, clearly related reason that Edna cannot migrate to one of these preferable spheres of existence (as Robert LeBrun attempted to migrate to Mexico) results from her cultural conditioning: the "illusions" that define romantic love as the unique source of ultimate fulfillment in life have, as in the case of Swinburne, attained an inescapable power over her fundamental desires and expectations. She cannot authentically repudiate them, even though she has become aware of her victimization by them and by a culturally pervasive web of values in which romantic love is an integral strand. Despite her "awakening," Edna is unable finally to perceive what Frederic Jameson designates as "some ultimate moment of *cure,* in which the dynamics of the unconscious proper rise to the light of day and of consciousness and are somehow 'integrated' in an active lucidity about ourselves and the determination of our desires and our behavior." But such a "cure" is actually "a myth," a "vision of a moment in which the individual subject would be somehow fully conscious of his or her determination . . . and would be able to square the circle of ideological conditioning by sheer lucidity and the taking of thought."[16]

Unlike her heroine, however, the author who created Edna demonstrates in *The Awakening* a unique ability to distance herself, at least tentatively, from the ideological web that entraps and eventually destroys Edna. And in this lies much of Chopin's great accomplishment with this novel. It is an achievement, nonetheless, to which Chopin's critics have, without exception, been blind,

because they simplistically identify the values authorized by the novel's artistic structure with those that are articulated in Edna's consciousness and that motivate her in the latter half of the work.

In this respect, these critics resemble the early commentators on Dostoyevsky, as they are discussed by Mikhail Bakhtin.[17] Although *The Awakening* does not fit the strict requirements for the dialogical or polyphonic novel as Bakhtin defines them, Chopin's work does operate dialogically to the extent that it portrays the competing discourses of three identifiable social classes, each with an implicit or explicit ideology: that of capitalist and patriarchal Christian society; that of rebellious, solipsistic women (including Edna Pontellier and Mademoiselle Reisz); and that of the lower or suppressed classes on which the dominant class partially depends for existence but which is presented in the novel as largely autonomous and peripheral. Ignoring the dialogue among discourses (either articulate or internal) enacted by representative members of these classes, criticism of *The Awakening* has suffered from the same difficulties that, according to Bakhtin, afflicted early commentators on Dostoyevsky:

> For some . . . Dostoyevsky's voice merges with the voices of one or another of his characters; for others, it is a peculiar synthesis of all these ideological voices; for yet others, his voice is simply drowned out by all those other voices. Characters are polemicized with, learned from; attempts are made to develop their views into finished systems. The character is treated as ideologically authoritative and independent . . . as the author of a fully weighted ideological conception of his own, and not as the object of Dostoyevsky's finalizing artistic vision.[18]

Because readers have most often assumed an identification between the emerging values of Edna Pontellier and Chopin's own, they have been little concerned that *The Awakening* (like all of Dostoyevsky's novels) "is *multi-accented* and contradictory in its values." Indeed, "contradictory accents clash" (15) in the novel's various dialogues among characters, within characters, and among social classes (and individuated types within classes) that hold opposed ideologies.

In this reading *The Awakening* appears as a fully developed dialogical representation of one particularized historical phase of ideological conflict. It is a phase of cultural crisis and transition whose outcome is uncertain. Necessarily, therefore, the novel's dialogues are not closed off in its final chapter. Edna's last thoughts reenact the ideological standoff that culminates with her suicide:

> She thought of Léonce and the children. They were part of her life. But they need not have thought that they could possess her, body and soul. How Mademoiselle

Reisz would have laughed, perhaps sneered, if she knew! "And you call yourself an artist! What pretensions, Madame! The artist must possess the courageous soul that dares and defies." . . . "Good-by—because I love you." [Robert] did not know; he did not understand. He would never understand. Perhaps Doctor Mandalet would have understood if she had seen him. . . . Edna heard her father's voice. . . . She heard the barking of an old dog that was chained to the sycamore tree. The spurs of the cavalry officer clanged as he walked across the porch. (114)

The voices of the patriarchy, the artistic fringe world, and the illusory world of romance speak out here with equal urgency and authority, so that the novel concludes inconclusively in a mode of ideological exploration and inquiry rather than Swinburnean polemic.[19]

In *The Awakening* Chopin has nonetheless appropriated the essential romantic mythology of Swinburne's poetry to fulfill several clear goals. She has presented a critique of capitalist patriarchal society (along with the cultural institutions that support it). She has exposed as an illusory alternative to the dominant values of that society the ideology of romantic love that Swinburne embraces through his poetry. And she has portrayed alternate modes of social existence. In this process she has included among the novel's various dialogues an intertextual dialogue with her English precursor and *his* pre-texts that is at once ideological and formal.

The hybrid form of *The Awakening* has perplexed critics in recent years.[20] Chopin's novel draws attention to its unusual combination of realism, romance, lyricism, and fantasy. One effect of this strategy is to invite formal (as well as thematic) comparisons, especially with the uniquely Swinburnean lyricism of many descriptions in the novel. The pervasiveness of this stylistic mode is eventually foregrounded by Gouvernail's hushed but nonetheless typographically prominent quotation of lines from "A Cameo" in Chapter 30. Chopin thus introduces, among her novel's other dialogues, a dialogue with a precursor in poetic forms, whose work bears significant thematic and metaphorical resemblances to her own and is equally iconoclastic. This subtextual dialogue finally implies opposition as well as appropriation: it insists that, for all his radicalism, Swinburne—like Edna Pontellier—has been a dupe of romantic illusions he has perpetuated throughout his career. It also suggests that Chopin's innovative fiction can, more effectively than Swinburne's amatory poetry, convey a sweeping social critique adequately depicting the realities of ideological conflict within the social structure.

NOTES

1. In this context I use this familiar term, uncapitalized, to designate the tradition of values that stresses love as the unique source of human fulfillment, that

idealizes the beloved, and that insists upon the sacrifice of all other sources of worldly and spiritual satisfaction in deference to passions that are at once carnal and spiritual. The phrase is not to be confused with the Romantic ideology much discussed recently in connection with early nineteenth-century English poetry and first explored at length by Jerome McGann in *The Romantic Ideology* (Chicago: University of Chicago Press, 1983). All citations to Swinburne's poems are taken from *The Poems of Algernon Charles Swinburne,* 6 vols. (London: Chatto and Windus, 1904), and are cited parenthetically by volume and page number.

2. Much discussion of literary sources for *The Awakening* has appeared since a renewal of critical interest in Chopin's novel began in the early 1950s. No thorough analysis of Swinburnean subtexts, however, has been performed. Bernard J. Koloski was the first to identify the passage from "A Cameo" in "The Swinburne Lines in *The Awakening,*" *American Literature* 45 (1974): 608–10. Two years later Margaret Culley argued, "The allusion to the rather brutal Swinburne poem about the insatiety of fleshly desire and the final victory of time and death over passion, foretells the impossibility of such deliverance for Edna" (Margaret Culley, ed., *The Awakening* [New York: Norton, 1976], 228). All further references to *The Awakening* are from this authoritative edition of the novel and are cited parenthetically in the text by page number.

The most extensive discussion to date of the Swinburnean subtexts of the novel is the sporadic commentary in Sandra Gilbert's important article, "The Second Coming of Aphrodite: Kate Chopin's Fantasy of Desire," *The Kenyon Review* 5 (1983): 42–66. Although Gilbert does not pursue the political implications of the Swinburne connection, as I do below, she does discuss Edna Pontellier's gradual repudiation of the "dictations and interdictions of patriarchal culture, especially of patriarchal theology" (51) as loosely derivative of Swinburne, along with other precursors including Flaubert and Whitman (see esp. pp. 60–62).

3. In the introduction to his edition of the *Complete Works of Kate Chopin* Per Seyersted acknowledges as a crucial theme in *The Awakening* "how patriarchal society condemns particularly a freedom-seeking woman who neglects her children" (Baton Rouge: Louisiana State University Press, 1969), p. 28.

4. Perhaps the most extensive among the many discussions of sea symbolism in the novel is that of Lewis Leary, who argues that echoes of Whitman dominate these passages. See *Southern Excursions: Essays on Mark Twain and Others* (Baton Rouge: Louisiana State University Press, 1971), 169–74.

5. In *Tradition and Counter Tradition: Love and the Form of Fiction* (Chicago: The University of Chicago Press, 1987), 1–64, Joseph Allen Boone discusses the historical and cultural backgrounds essential to my commentary. For the most useful recent commentaries on the history and operations of ideological criticism in American literary studies, see *Ideology and Classic American Literature,* ed. Sacvan Bercovitch and Myra Jehlen (Cambridge: Cambridge University Press, 1986). Also see Bercovitch "The Problem of Ideology in American Literary History," *Critical Inquiry* 122 (1986): 631–53.

6. My argument here controverts Daniel Rankin's insistence that Chopin simply "absorbed the atmosphere and the mood of the ending of the century, as that

ending is reflected in Continental European art and literature. . . . She was not . . .
under the sway of any one writer, but the range of her debts is wide." See *Kate Chopin
and Her Creole Stories* (Philadelphia: University of Pennsylvania Press, 1932), 173–
74.

7. See Cecil Y. Lang, "Swinburne's Lost Love," *PMLA* 74 (1959): 123–30.

8. The reviews of *The Awakening*, like those of *Poems and Ballads, First Series*,
were often vitriolic. The Los Angeles *Sunday Times* (25 June 1899) reviewer, for
instance, compared *The Awakening* to "one of Aubrey Beardsley's hideous but haunt-
ing pictures with their disfiguring leer of sensuality. . . . It is unhealthily introspective
and morbid in feeling." In 1866 Swinburne had, even more heatedly, been termed
"the libidinous laureate of a pack of satyrs," his works "depressing and misbegot-
ten . . . utterly revolting." Yale's president, Noah Porter, positioned Swinburne
among the "lecherous priests of Venus." See Clyde K. Hyder, *Swinburne's Literary
Career and Fame* (Durham: Duke University Press, 1933, repr. 1963). Chopin was an
impressionable fifteen-year-old, of course, when Swinburne's highly publicized and
controversial volume burst on the American literary scene with a title—*Laus Veneris
and Other Poems*—that drew attention to one of its most scandalous works. It went
through three American editions in three months.

9. Such is the case most forcefully in *Atalanta in Calydon* (1865), the work
that made Swinburne a (positive) sensation overnight in England. Like later works,
this poem flaunts powerfully iconoclastic passages, including the famous chorus "Who
has given man speech?" which decries "The Supreme evil, God" (ll. 1038ff.).

10. As Seyersted, *Complete Works,* has observed, "that [Chopin] drifted away
from Catholicism did not mean that she became an atheist . . . but only that she
sought God in nature rather than through the Church" (23). Although avowedly an
atheist, Swinburne, like his Romantic precursors, clearly intuited the presence of a
spiritual force presiding over nature and human history. See, for instance, "Hertha,"
"Genesis," and "A Nympholept."

11. Typically, critics have not seen Edna's suicide in these terms. Donald Ringe,
for instance, sees it as a philosophically and psychologically romantic act, but one
having nothing to do with amatory impulses. See "Romantic Imagery in Kate Chopin's
The Awakening" (*American Literature* 43 [1972]; repr. Culley, ed., *The Awakening*, p.
202). Alternately, in a psychoanalytic reading of the novel, Cynthia Wolff does observe
that "Edna's final act of destruction has a quality of uncompromising sensuous fulfill-
ment," but Wolff deemphasizes this aspect of the event. See "Thanatos and Eros: Kate
Chopin's *The Awakening*," *American Quarterly* 25 (1973): 471. Gilbert, "The Second
Coming of Aphrodite," understands Edna's suicide as I do, but she emphasizes the
theological rather than ideological implications of Edna's final act (p. 52).

12. Unlike his contemporary Walter Pater, Swinburne does not see Christianity
and the system of values and behavior associated with romantic love as twin manifesta-
tions of a single ideology. See Pater's 1868 review, "Poems by William Morris," *The
Westminster Review* 90, n.s. 34 ; repr. in James Sambrook, ed., *Pre-Raphaelitism: A
Collection of Critical Essays* (Chicago: University of Chicago Press, 1974), 105–6.

13. Although through most of the novel Chopin elides direct narrative com-
mentary on the importance of socioeconomic issues to Edna's expanding awareness,

the narrator occasionally introduces such issues obtrusively. After Edna moves into her "pigeon-house," for instance, we learn that "there was with her a feeling of having descended in the social scale with a corresponding sense of having risen in the spiritual. . . . She began to look with her own eyes; to see and to apprehend the deeper undercurrents of life" (93). Seyersted, *Complete Works,* has observed that Chopin's "own set of social values . . . [was] often at variance with [that] of the ruthless, money-making Gilded Age" (26). These values clearly underwent significant development during her years (1879–1883) in Natchitoches when "she became intimately acquainted with the Cane River Creoles, Cajuns, and Negroes," that is, when she began to develop a fully comparative perspective on the social classes (see p. 22).

14. For the fullest recent discussion of Léonce "as the immediate oppressor of Edna," see Priscilla Allen, "Old Critics and New: The Treatment of Chopin's *The Awakening,*" in *The Authority of Experience: Essays in Feminist Criticism,* ed. Arlyn Diamond and Lee Edwards (Amherst: University of Massachusetts Press, 1977), 231–34.

15. Gilbert, "The Second Coming of Aphrodite," goes so far as to describe Madame Antoine as a "fat matriarch," at whose feet Edna "received quasireligious instruction in an alternate theology" (54).

16. For Jameson only "a collective unity can achieve this transparency" (*The Political Unconscious* [Ithaca, New York: Cornell University Press, 1981], p. 283).

17. For an extensive Bakhtinian reading of *The Awakening* that complements my own, see Dale M. Bauer, *Feminist Dialogics: A Theory of Failed Community* (Albany, New York: State University of New York Press, 1988), 129–58. Bauer's emphasis diverges from mine in its focus on Edna's difficulty in constructing a genuine self and generating a nonderivative language in which to express her subversive ideas and feelings.

18. *Problems of Dostoyevsky's Poetics* (Minneapolis: University of Minnesota Press, 1984), p. 5.

19. Bauer, *Feminist Dialogics,* 153–54, reads the ending differently.

20. Gilbert, for instance, argues that *The Awakening* is a "shadowy fantasy or fantasy *manqué,*" noting that "a number of [the novel's formal] qualities . . . have puzzled its severe critics as well as its enthusiastic admirers: its odd short chapters, its ambiguous lyricism . . . its editorial restraint, its use of recurrent images and refrains, its implicit or explicit allusions to writers like Whitman, Swinburne, Flaubert, and its air of moral indeterminacy" ("The Second Coming of Aphrodite," 45). Lawrence Thornton is similarly concerned with matters of genre in "*The Awakening:* A Political Romance," *American Literature* 62 (1980): 50–66.

VISUAL

ARTS

"THE NECESSITY OF A NAME"

Portrayals and Betrayals of
Victorian Women Artists

An obscure treatise privately printed for the author Harriet Gouldsmith Arnold in 1839 delicately, almost subliminally, raises the issue of contemporary female artists in England. Arnold's slim volume entitled *A Voice from a Picture By a Female Artist of the Present Day* projects a rather tormented persona into a painting, endowing it with a life and voice to speak passionately of its creation, its ill treatment during display and restoration, and its neglect by English patrons. Although Arnold herself was an artist who exhibited dozens of works at the Royal Academy over a period of several decades (1807–1854, and even after marriage), her assumption throughout this book—with only one brief aside—is that the maker of art is male, and the pronoun and the viewpoint are always masculine. The treatise complains about the prejudice of taste and the doomed impoverishment of the artist yet only once amid these hardships and disappointments mentions the lot of the female artist. In discussing "the necessity of a name" for success as a painter, Arnold recounts an anecdote revealing how "the influence of a 'name' is indeed great, the celebrity of which is still more difficult to attain by a female artist. The authoress of these pages, in one particular instance, heard of the highest praise bestowed upon a picture publicly exhibited, but she had the mortification afterwards to understand the commendation was in great measure retracted, when the picture was understood to be the production of a *female*."[1]

This understated "mortification" is less significant as a sign of Arnold's lacerated dignity than as an emblem of women artists' plight during the

Victorian period. In the past decade some groundbreaking research has helped rediscover and chronicle the careers of numerous Victorian female artists and has raised questions about women's amateur status and achievement of limited fame or commercial success.[2] The lamentable state of art education for women and limited opportunities for public exhibition have also begun to be explored. Moreover, the subject matter favored by English female painters—a wide spectrum of literary heroines as well as themes related to the daily round of middle-class female life such as leisure pursuits, church activities or charitable acts, courtship customs, reverie, and motherhood—has also been suggested as a fertile area for investigation.[3] An increasing focus on women workers after mid-century—on governesses, sempstresses, milliners, and even prostitutes— was evinced by male painters and, to a lesser extent, by their female counter- parts. Thus far, however, little has yet been written about the image of the Victorian woman artist in the eyes and hands of both sexes, though the statisti- cal scarcity of her self-image has been mentioned.[4] Although self-portraiture decreased in the decades from 1850 to 1870, a few paintings by women offered at least some social commentary and criticism on the relationship of the female artist to her work and to society. This iconological phenomenon—embracing both male and female images of the female as artistic bystander, muse, or maker—constitutes the first part of this essay. Moving beyond these often deprecating images, the discussion then considers how a few "lady painters" (in itself a damning term) depicted themselves and other female workers some- times conservatively and occasionally with bitter satire and a hint of rebellious- ness. Their careers and the images they employ help us understand the work of other women artists of the period. Moreover, some of the artistic and iconological stereotypes to be analyzed also appear in later art or cross interna- tional boundaries, and thus the fertile range of Victorian genre subject matter offers insights that may illuminate other cultures as well.

Victorian women artists, with few exceptions, did not challenge and trans- form prevailing canons of imagery, but this should neither surprise nor dis- may students in the late twentieth century. Outside the artistic mainstream, they had no control over how images were forged and reproduced. Their representation of roles and of sexuality in art is thus closely related to their own place in society, and their conservatism—far from being a sign of cowardice—must be understood in part as a byproduct of their inbred servil- ity to male greatness and their insecurity in art schools and the marketplace.

VICTORIAN IMAGES OF ARTISTS, STUDIOS, AND MODELS

Analysis of both male and female artists' portrayals of themselves and their studios proves revealing on many levels. From about mid-century onward the

subject of women artists in England began to be discussed in newspapers, magazines, and contemporary fiction with increasing frequency, with both male and female authors claiming insight into the topic.[5] The novel in particular seized upon the subject of artists with some fervor, and throughout the queen's reign scores of writers of both sexes—including Anthony Trollope, Henry James, George Moore, Theodore Watts-Dunton, George DuMaurier, Averil Beaumont (the pseudonym of Margaret Hunt), George Eliot, Mary Anne Hardy, and Margaret Roberts—focused their attention primarily on the creative male. The effect of this literary phenomenon was to establish recognizable traits of an idealized romantic artist who was bohemian, flamboyant, tormented or struggling, moody or soulful, and often imbued with a Promethean spirit that allied him with the alleged divinity of genius.[6] "Lady painters" were originally novelties, the young ladies in Jane Austen's *Emma* (1815) or Louisa Costello's *Clara Fane* (1848) being either amateurish copyists or hobbyists. Occasionally a more serious form of feminine creativity emerged in the works of Charlotte or Anne Brontë, but mostly the woman artist was perceived as merely graceful and intuitive, capable of representing women and children in domestic settings. Women preferred painting in watercolors, and one character in Beaumont's *Magdalen Wynard: or the Provocations of a Pre-Raphaelite* (1872) actually forbade her daughter to study oils because this was supposedly such a masculine medium. Schooled in subservience, women artists found few chances to express egalitarianism or independence and were unable to compete with male colleagues. When they did try to gain a foothold, they were often mocked; in George Moore's *A Modern Lover* (1883), for example, a male artist derides the new breed of altruistic women painters as parasitic dilettantes who voraciously try to absorb European art but who had "not yet time to thoroughly digest what they have learnt, much less to create anything new."[7] While some of the women artists in contemporary literature behave in an eccentric manner, they rarely compromise their gentility or become threateningly unconventional or libertine. Nor are they shown as visionary geniuses involved in intense relationships with their models or obsessed with their careers.

So-called feminine sensibilities worked against the alleged asset of female intuition and sensitivity even in the realm of connoisseurship. Supposedly high-strung, impressionable, and unable to endure morbid or offensive subjects in art, women were supposed to be shielded from such art either by artists themselves, who were expected to obey the unwritten rules about subject matter, or by their chaperones.

Given prevailing reductive and restrictive attitudes, it is no surprise that most pictorial depictions of artists, studios, patrons, connoisseurs, and the artistic community are entirely masculine. Although these painted artists lack some of the unorthodox attributes of their literary counterparts, they nonetheless

often seem a race apart, distinguished by abnormal clothing, habits, or sur-
roundings. These images include costume fripperies of the eighteenth century
highlighted in the string of connoisseur pictures by John Arthur Lomax or
Edwin Hughes as well as the toga-clad counterpart figures painted by Lawrens
Alma-Tadema, all products of the last quarter of the century. Other artists, such
as Augustus Egg in his 1858 *Self-Portrait as a Poor Author* (Hospitalfield Trust,
Arbroath), reinforce the myth of the unappreciated, isolated male genius strug-
gling for survival in a dingy, depressing garret. There are even notable portray-
als of historic boy artists, including Edward M. Ward's *Benjamin West's First
Effort in Drawing* (1849; Dunedin Art Gallery), John Absolon's *Opie when a
Boy Reproved by his Mother* (1853; private collection), and William Dyce's
Titian Preparing to Make his First Essay in Colouring (1857; Aberdeen Art
Galleries and Museums). Such paintings established a convention to which a
woman artist would comply in a related context, as did Margaret Dicksee in
The Child Handel (1893; Royal Pavilion, Brighton).[8]

Still other painters explored the relationship between female model and
male creator, occasionally in Pygmalionesque terms; invariably in these works
the power of the artist and his control over the sitter is conveyed in a deeply
felt moment of creation.[9] In the realm of nineteenth-century British litera-
ture, the romantic artist-hero is typically a gifted, often egotistic, "prophet"
who dares to defy convention and yet needs the inspiration of a real muse to
personify ideal feminine beauty. He is most frequently the social superior of
his lower-class model, who is often portrayed as a femme fatale who could
either make or break a man's career. An artist's more extreme obsession and
involvement with his model is also sometimes explored, as in Rhoda Brough-
ton's 1892 novel *Mrs. Bligh* where, as one modern scholar has noted, a fatal
ménage à trois develops: "Art became an integral part of the man's love-
making because the artist not only wanted to celebrate his earthly mistress,
but relied on his creative triumphs to secure her admiration and respect."[10] In
some works the model sometimes even gains a power rivaling that of art and
threatens to annihilate the artist's creativity.

While some of these more sinister aspects of the relations between artist
and model are transposed from fiction to the realm of art, usually the visual
imagery is much tamer. Pre-Raphaelite sympathizer Edward Burne-Jones
extended the love of an artist for his work of art into a series of images of
Pygmalion in the years between 1869 and 1879; and in *The Hand Refrains*
(Birmingham City Museums and Art Gallery), the sculptor helps his beloved
creation come alive and descend from her pedestal to reality. In contrast,
William Powell Frith offered numerous contemporary images of the female
model and the artist, among them an 1860 panel and one dated 1867 (figure
1). In the latter a model arrives at the studio and stands before the seated
painter, Frith himself, who significantly does not rise in her presence. Fully

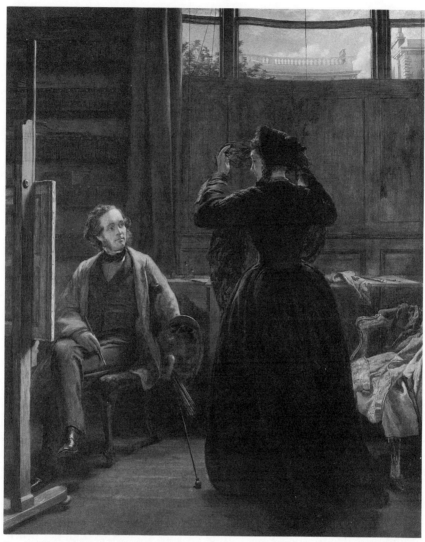

1. William Powell Frith. *Self-Portrait*. 1867. Oil on canvas. 24 × 18¼". National Portrait Gallery, London.

clothed, she symbolically prepares to remove her veil and hat, a sight that seemingly proves to be something of a revelation to the artist, who sits transfixed. Whether or not she will ultimately have a mesmerizing effect upon him is a matter of speculation, but it is important that her forthright glance in his direction differs from that of most pictorial models. Compared with their

literary counterparts, painted models are generally very passive, serving as silent, unmenacing, utilitarian objects and witnesses to the process of male creativity. Frith's sitter here has more presence than is typical, her standing pose alone giving her dominance visually in the composition.

Besides models, women who appear in men's studios either function as useful (if beautiful) props or as adorable, charming, but infantile or girlish trespassers in the profoundly masculine arena. In Edward Matthew Ward's *Hogarth's Studio in 1739* (City Art Gallery, York) from the 1863 Royal Academy, for example, Hogarth and the sitter, Captain Coram, hover behind the painting while various little girls bound for the Foundling Hospital (which Coram himself established) virtually clap their hands in glee in front of the canvas. They bring flowers, sweet innocence, and naïveté to their perception of this masterpiece, but their lack of seriousness is not really amusing, especially when one considers that Ward's own wife, Henrietta, was an accomplished painter who at this point in her career was well established and enjoyed numerous successes at the Royal Academy. Although hindered by the weight of her husband's artistic pedigree and by the demands of a large family, she did not produce solely domestic vignettes. In fact, her reputation as a female historical painter earned her many compliments; unfortunately, however, her works' stylistic and thematic similarity to her husband's historical dramas often made critics describe her art as derivative or imitative. Often she treated female heroines from the past (modern women were typically shown in conventional settings, not as overtly brave or decisive), and her work was much admired by the queen. The honor of being deemed one of the best female artists of her era was tainted by male discrimination; censure of the "masculine vigour" of her talent kept her in her place, in effect, segregated in a ghetto of female art and unable really to compete in the art world.[11] In her case, as in many others, the illusion of success and of gallant, effusive praise—while comforting and complimentary to the presumptive fragility of the female artistic ego—may have been less helpful then genuine criticism would have been in the artist's development and career.

At first glance a less feeble image of the woman painter emerges in Samuel Baldwin's *Sketching Nature* (1857; private collection, England), in which a young lady intently studies the natural glen she transcribes with her pencil. She has put down her satchel and hat and rejected her camp stool for a more active contemplation of nature; yet, except for the presence of her pencil and sketchpad, this might be another in the endless chain of sensitive ladies awaiting suitors in the forest. Darker interpretative possibilities may also resonate in this image, as a feminist historian has recently suggested: "Far from being a threat to man's monopoly on the role of 'artist', this woman is herself the work of art: what she produces will very clearly be inconsequential, tentative, readily patronised and easily dismissed—in short, womanly."[12] It is

the pretty woman herself, solitary but not too pensive, who is the real object of attention, and her activity is almost irrelevant to most male viewers, as long as it does not significantly break with the norm. Furthermore, Baldwin's sketcher and similar representations from a late twentieth-century viewpoint raise questions: Is the woman merely imitating nature or revealing original responses to it? Might she fall into the trap of merely (feminine) diligent application and never qualify as "genius"? Can she ever progress beyond amateur standing—and is professionalism a valid goal anyway? Is she ever likely to risk public exposure by trying to sell or to exhibit her art? If so, might she succumb to masculine notions of fame or to patronizing hyperbole about the allegedly dainty, delightful, charm of feminine paintings? Or might her art sometimes flatteringly "pass" as being executed by a man? How inventive can her subject matter be, given her previous training? Will she always be segregated in exhibitions and in criticism as a "lady painter" and thus effectively be barred from the mainstream of art?

In a related vein, J. W. Haynes's *My Pupil* (private collection, England), like Augustus Oakley's *A Student of Beauty* (1861; private collection) subtly casts the female in the inferior role of student, never master. Ironically, in each the female face has been cast into the allegedly perfect form of a sculpted bust; whether classical or contemporary, it is ultimately a male notion of feminine pulchritude that the woman student is urged to study and to emulate. Whatever motivation or earnestness of purpose may exist in either case (both women have easels and hold brushes or palettes), they are instructed to use a secondhand source, not a real female nude, in order to practice their expertise. At about this time, by 1862, five of the seventeen probationary candidates in drawing for the Royal Academy art class were female, yet women stagnated in the Antique School classes and were denied access to the nude in life classes because of continual male anxiety about the effect of exposing unmarried women to nude models. (In 1863 a vote barred women students from the Royal Academy.) Even when women such as the eminent Anna Jameson repudiated this issue of "decency" for respectable young women, academy members and others remained steadfast in their desire to keep the door to life classes closed to women.[13] Thus, there may be particular significance to the inclusion of antique busts in the paintings by Oakley and others. Moreover, in these depictions the woman is often surrounded, almost suffocated, by beautiful objects, especially Oakley's artist, who rather understandably seems daunted by the challenge that confronts her.

In the realm of popular periodicals women were lampooned as artists. In a series of cartoons for *Punch* in 1866, for example, Charles Keene satirized the ambitions and adventures of a Miss Lavinia Brounjones, an aspiring female artist. Her efforts to pack for a sketching expedition to the Highlands, to settle into country lodgings, to secure models, and to deal with a recalcitrant

animal sitter are merely vehicles of amusement. She ends up in "a frightful situation" before returning home, presumably chastened by her naïveté about art and the real world.[14] It is no accident that she is shown as bespectacled, unattractive, and unmarried (that is, unwanted), an eccentric following her own interests rather than pursuing marriage or a mate. Throughout the Victorian era women are seen as incapable of practicing art seriously, and a reversal of situation with a male protagonist is unimaginable, as is demonstrated by an 1897 *Punch* cartoon by Arthur Hopkins. In "A Vocation Missed," a handsome (that is, marriageable) woman's deftness of touch with a paintbrush as she paints *en plein air* at an easel is evaluated only in terms of its loss to the culinary world. The dialogue accordingly reads, "Mr. Brown: 'Look here, Maria. Look at the young lady's light touch!', to which his wife replies, 'Eh! What a hand for pastry!' " In another turn-of-the-century example by Charles Dana Gibson entitled *Her First Painting Skied at the Royal Academy,* a male artist could hardly be substituted with equal credibility. Pitiably, the frustrated and attractive woman artist silently accepts the fact that her picture has been hung too high to be seen and dares not assert herself to question the decision of an authoritative panel of male judges. Instead, she merely looks plaintively—and prettily—forlorn, not angry or challenging of the status quo. In a literary context, Henry James's caricature in *Roderick Hudson* (1876) of a nervous, befuddled woman painter who only paints figures from behind because she is not adept at portraying faces also reinforces such negative stereotypes and low self-esteem.[15]

Portrayals on canvas of individual women artists by men of the period offer other equally problematic images. In Abraham Solomon's *A Young Girl Drawing A Portrait* (*A Sketch from Memory*) (figure 2), for example, a seemingly invalid and pensive young woman (propped against plump pillows and with fruit and water on a nearby table) pauses in a moment of reverie, her pen suspended in one hand. But she seems to have utilized her artistic talent not for its own sake but in order to recapture fond memories of a gentleman whom she has drawn on her sketchpad; whether or not he is alive or dead, a current or past suitor, remains ambiguous. Though she holds the artistic tools of the trade, her pallid expression, weakened state, and faraway gaze (she ignores a view of nature from her window and instead broods) make her less of an artist figure than a disappointed lover whose thwarted romance has presumably caused her to pine. Solomon should have known better, however, since his sister Rebecca Solomon at this point was well-known for her own genre pictures (although necessity apparently forced her to devote some of her time to copying works by John Everett Millais, Frith, and others.)[16] Among her canvases Rebecca Solomon treated the idle and industrious male student in an 1859 pair of works, and she was sporadically criticized for preferring didactic themes, such as those with impoverished protagonists in

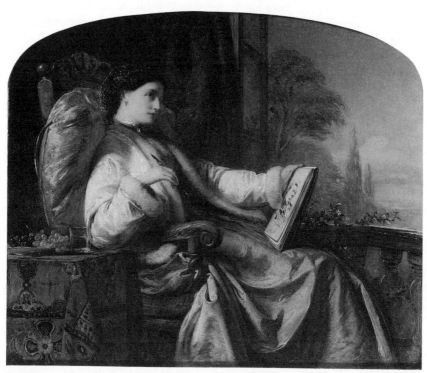

2. Abraham Solomon. *A Young Girl Drawing a Portrait* (*A Sketch from Memory*). 1850s? Oil on canvas. 11½ × 13½". *Forbes* Magazine Collection.

The Friend in Need (unlocated) and *Behind the Curtain* (private collection). Although she is not known to have tackled the subject of the female artist, she did exhibit a compelling portrait of psychological isolation and pain of a different woman worker in *The Governess* (McCormick Collection) in 1854. Tragically, in her private life, certain enigmatic alleged "irregularities" in Solomon's behavior caused her reputation to suffer, leaving her branded by some commentators (writing mostly on her brother Simeon's life) as a femme fatale and "wild beauty of the studios."[17]

One of the best-known artists of the Victorian era was Dante Gabriel Rossetti, who produced numerous medievalizing images of the male artist/female sitter relationship. As one modern writer has astutely commented, "[i]t is not surprising that almost all the artists he paints, draws and writes about are also inspired by women."[18] In a pen and wash drawing called *Love's Mirror* (Birmingham City Museums and Art Gallery), for example, a female

who decidedly resembles Rossetti's beloved (and later wife) Elizabeth Siddal is being taught to paint by a handsome youth. While he looks into a mirror and sees their reflections, he simultaneously guides her hand to paint her own portrait. She, however, looks neither at the mirror nor at her lover; instead she seems to stare at the image of herself that someone else is using her hand to create. While the degree of male control of female creativity is extreme in this example, it is not entirely unusual to find Victorian representations or descriptions of painting "masters" exercising their authority over female pupils. Rossetti, however, also frequently concentrated on the opposite side of artistic portrayal in various drawings of the ill-fated, phlegmatic Elizabeth Siddal at her easel. In some images she appears to be painting passively, almost mechanically, at least from his perspective. In one 1853 drawing entitled *Elizabeth Siddal at her Easel* (Birmingham Museums and Art Gallery), her pose and face convey intensity, but her sitter (Rossetti himself) does not seem very pleased about modeling for her. Rather than strike a formal pose, he resignedly sits under a portable lamp and takes a casual one, propping his feet up on another chair. Does he indulge her only reluctantly, in spite of the fact that she posed for him countless times? Or does the sketch imply some reciprocity in their respective needs for creativity and creative time?

This highly condensed and very selective sampling of visual bias helps to explain to some extent the dearth of parallel images by female painters of themselves at work. It is hardly surpising that women, lacking what has been called a masculine concept of "descent from the great painters of the past," did not dare to flatter themselves, their occupation, or their status by producing self-portraits or other images of this type in any great number.[19] Pride of self and of profession—and ultimately, of power—was partly at stake in such representations of the artist's persona or studio, and since women were excluded from the artistic tradition as well as from most of the more advanced curriculum, they did not pay tribute to themselves in any great numbers. Indeed, there are no women's grandiose pictures on the order of Gustave Courbet's *L'Atelier* (1855; Louvre) or Henri Fantin-Latour's *A Studio in the Batignolles* (1870; Louvre), both of which ennoble and elevate the artist as heroic. Nor do women paint commanding visits from patrons or other artists. By contrast, women's paintings mostly reveal telling omissions of self-depictions as makers; more domestic, traditional feminine roles vastly outnumber other thematic possibilities.

Images of girls studying art in a serious manner are also rare. Jane Marie Bowkett, who may well have been part of a family of talented female artists, produced numerous domestic subjects as well as *A Budding Artist* (private collection). Bowkett's viewpoint here is rather unusual; it shows a child so engrossed in examining her drawing crayon that she does not even look out at viewers. Nor is she engaged in a childish prank, such as invading a sacrocsanct

male studio. Feisty and independent rather than naughty, she has evidently gone off on her own in order to ruminate about her planned artistic undertaking. The setting is in some ways ironic (with a classic trysting stile at the right), but there are no snide undertones and the figure is neither an object of derision nor a vapid and demure china doll. This portrait might be compared with a celebrated male artist's kindred image presenting a somewhat older female protagonist—namely, Holman Hunt's *The School of Nature* (Museo de Arte de Ponce, Puerto Rico). Here a dreamy-eyed female is poised in the act of drawing, hesitant for reasons that are unclear. A faithful dog guards her nearby, but the setting is more like a garden of love than a wild corner of nature to which she has retreated in order to concentrate. Unlike Bowkett's protagonist, who has apparently not yet fully learned the limitations of her feminine role, Hunt's female may be experiencing a crisis of ability and faith in herself. Is she wondering whether she should instead be painting teacups or confining her artistic interests to the prescribed domain of needlework or crafts for the home? Is she distracted or uninspired? Perhaps, like the ingenuous Hilda, one of two women artists in Nathaniel Hawthorne's *The Marble Faun* (1860), she has no respect for her own vision or skill and does not trust her own powers of invention. In Hawthorne's tale, the talented Hilda experiences a failure of nerve and self-confidence and moves from autonomy as an artist to slavish and reverential copying of Old Masters. Whether or not Hunt's protagonist experiences a similar crisis of ability remains unclear.

Although Victorian paintings of women shown in their actual studios or at their easels do occasionally appear, more survive by men painters than by women. A historicizing example by a female artist is a painting by Margaret Dicksee, who (perhaps perdictably) had a brother and father who were both painters. An exhibitor at the Royal Academy of both landscapes and historical scenes, Dicksee often focused on imagined incidents from the lives of past famous figures such as Jonathan Swift, Oliver Goldsmith, Thomas Lawrence, and Richard Sheridan, frequently making women practice "hero worship" and act as gentle receptors or bystanders to male genius. In this category is her 1892 Royal Academy picture originally called *"Miss Angel"—Angelica Kauffman, Introduced by Lady Wentworth, visits Mr.Reynolds' Studio* (untraced), a work partly interesting for what it does *not* depict. Kauffman, who along with Mary Moser was among the original founding members of the Royal Academy, nonetheless never gained complete access to it with full membership (not granted to a woman until 1922), yet she was a prolific and recognized artist in her own time. In the hands of Victorian writers such as Anne Ritchie in her romantic pseudobiography entitled *Miss Angel* (1875), however, Kauffman was belittled as a sentimental, submissive type whose art succeeded only because she listened to her husband's advice. Dicksee's own notion of her famous female predecessor is also degrading and fails to

acknowledge Kauffman's creative side; instead, she is cast in the role of lady visitor to a great male painter's studio. Standing by another maker's picture, she daintily gestures and looks rather coyly at the eminent Sir Joshua Reynolds, not at the picture on the easel. The painting's tone depicts Kauffman more as a frivolously dressed coquette than as a serious practitioner of the arts. One modern writer has suggested that in the painting Dicksee "might well give glamour to the scene of the first president of the Academy receiving a female painter in his studio," but such "glamour" barely masks a patronizing attitude both by Reynolds in the painting and, lamentably, by the woman artist who makes Kauffman into another insipid type.[20] We see not Kauffman's masterpiece or her studio but rather that of her male colleague; we see a missed opportunity and yet also perhaps an index of the degree to which feminine self-homage and awareness of self-worth were lacking. (Indeed, a reversal of this notion would probably have been wholly unacceptable to Victorian audiences.)

Only slightly less humiliating in tone are works such as a watercolor of 1881 called *Fantastical Figures* (private collection) by Maude Goodman, who produced scores of saccharine paintings with such titles as "a little coquette," "my pets," and "mother's darling." Here a woman at the easel is shown poised to paint an elaborately costumed and dramatically posed female on the left. Both model/muse and artist are playful in their roles, and the atmosphere is superficially reminiscent of a gossiping tea party. Ultimately the canvas conveys more humor than soberness of purpose, and indeed Goodman rarely seemed to aspire to more than that. By contrast, a more serious note emerges in personal or family contexts when other women painters represented themselves in more familiar surroundings, working at home. This is the case, for example, in *Sister Arts* (private collection, England) by Edith Hayllar, which portrays two of the four female artists in the family, one playing a musical instrument and the other standing at her easel. Neither looks out but instead each concentrates on her respective art, and it is almost with a sense of relief that one finds no touch of anecdote, amusement, or tangible charm in this scene. What Hayllar offers instead is a glimpse of a family household, in which father James was a painter but so too were his daughters Mary, Edith, Jessica, and Kate. Many of their subjects, drawn from daily life, are situated in the rooms or gardens of the Hayllar home, Castle Priory, and family members often posed for one another.[21] The unself-consciousness of *Sister Arts* is noticeable, and perhaps it served more as a family document than one intended for public viewing. Similarly, in an untraced portrait of herself and her family by Laura Epps Alma-Tadema, the artist's famous husband appears only as a marginal figure at one side.[22] Lady Alma-Tadema is surrounded by her children, who eagerly gaze at the latest canvas on the easel. The younger women's expressions are particularly engrossed and rapt; indeed, one of the models,

Anna, partly followed in her stepmother's footsteps as an artist. Whether or not such images were intended primarily for private consumption is not clear, but certainly their unconventionality contrasts markedly with prevailing modes of self-portraiture during this period.

All these examples, however, are distant from the next generation's often progressive representations of women artists. Quite different pictorial realizations of self-expression and self-discovery appear, for example, in Laura Knight's *Self-Portrait* (1913) (figure 3), in which a modern woman artist is distinctive on many levels.[23] Casually dressed, wearing a rather shapeless hat, she is not a fashionplate or prisoner hampered by flounces and bustles: she is clearly a laborer and New Woman of sorts, not a stylish consumer or amateur. Knight has just been working from the nude model (the juxtaposition of female artist and nude is itself a novel subject), and both the model and the canvas of the painted nude seem to "frame" the artist figure. The model is unself-conscious and does not "pose" in either a cloying or self-important way. There is no contact between the model and maker—no sense of possessiveness by the artist, none of the latent eroticism that often surfaces in images of male artists with their models. She has studied her undressed colleague, but she has not "owned" or "used" her; in fact, she does not even look at the model but rather gazes past her. This pose serves to encourage viewers not to react as voyeurs, for neither the artist nor her model is a sexualized entity made "available" to spectators. A rather matter-of-fact relationship exists between maker and model confirming the "ordinary" appearance of things. Nor does the canvas convey any apparent self-glorification; woman's work as artist is simply a fact of life, not an exercise of ego or a cause for self-congratulation.

TWO CASE STUDIES OF VICTORIAN "LADY ARTISTS"

The self-possession of Knight's modern woman painter was unattainable for Victorian women artists, whose insecurity about their abilities and situation was almost palpable. Accordingly, they rarely strayed far from accepted norms of representation and tended to proliferate images of contented, idyllic womanhood (with occasional images of female victims of social injustice). Sometimes, however, Victorian women artists were able to inject heightened meaning into their investigation of their own roles and of the condition of women in general. Examination of a few pertinent images proves insightful. Emily Mary Osborn and Florence Claxton stand out among those who exhibited and tried to make names for themselves at mid-century, when the number and public visibility of women artists began to rise and when the Society of Female Artists was established in 1857 as a forum for exhibiting works by women.

Emily Mary Osborn was one of the rare Victorian women artists to achieve

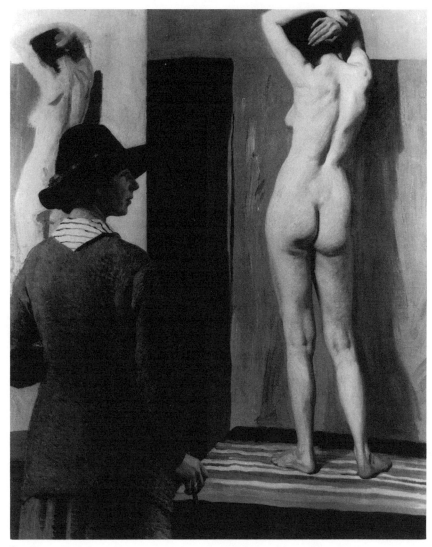

3. Laura Knight. *Self-Portrait of the Artist with Nude Model.* 1913. Oil on canvas. 60 × 50¼″. National Portrait Gallery, London.

some real commercial as well as critical success during her lifetime.[24] In spite of her father's objections, she began taking art classes while a teenager, encouraged instead by her mother, who according to a contemporary writer "had a great love for painting, and who had wished in vain to study Art profession-

ally" herself.[25] Like many women, Osborn was essentially self-taught and turned to portraiture at various times in her career as a more lucrative source of income than history or genre pictures or her later landscapes. By 1856 the young artist hit her stride in a painting called *Home Thoughts* (private collection) in which various classes of contemporary womanhood—from a wealthy girl to a female servant to an isolated and dejected governess—are compared and contrasted. Her best known picture today is *Nameless and Friendless* (1857) (figure 4, in engraved form) a rare work in which a self-effacing female artist appears in rather doomed circumstances. She is not shown at her easel or in a studio interior; instead, she is portrayed as a victim of the art market. She experiences none of the satisfaction of creation, only the degradation of trying to sell her scorned "female" art in a male art market and environment. The scenario focuses on a poorly clad orphaned amateur (in mourning garb) who has brought her pictures to a dealer in order to sell them. Instead of being taken seriously, the young woman is patronized and rebuffed by a rather contemptuous connoisseur; in another corner of the room two gentlemen "loungers in the shop," as *The Art Journal* called them, eye her somewhat lasciviously. We see the world, however, through her eyes, the heroine as an outsider in an alien realm; she stands center stage, as if on trial awaiting sentence. She fiddles with her string, anxious, but she is powerless and has not even been asked to occupy the nearby empty chair, presumably because she is not a lady. The woman looks neither out nor at the dealer: she is at the mercy of the male art world and the men in the room—from dealer, to picture hangers, to patrons (and there are tophatted figures in the street, too). The only other woman in the picture (whether she is a buyer or artist or agent is unclear) has turned her back and leaves the shop. In a setting overcrowded with men who eye and judge the lady amateur, a sense of the female artist's insignificance and suffocation is communicated to late twentieth-century eyes.

Ironically, viewers outside the picture frame are not even allowed to see the painting, only its back. The sole judge of the canvas, the dealer, seems anyway to look through the picture, taking the woman into account as much as, if not more than, her painting. She herself is the subject and object of his interest, not her ability, and this nameless, friendless victim cannot be expected to cope. In a sense, both the woman and painting remain anonymous and without support. The accompanying quotation, "The rich man's wealth is his strong city; the destruction of the poor is their poverty," may drive home the point that here the strong male bastion of opinion has completely intimidated and kept out from its realm of privilege the talents as well as the very "intrusion" of an overwhelmed, impoverished female artist. Her paintings, like those personified by Arnold in her melodramatic book, will most likely end "in the hands of some pawnbroker" and not with a patron.[26] Osborn, however, fared better,

4. Emily Mary Osborn. *Nameless and Friendless*. Engraved by J. Cooper, ca. 1864.
Photo courtesy of the Yale Center for British Art.

and this canvas "attracted the attention of Lady Chetwynd and was bought by
her for £250."[27] It was also one of numerous works by Osborn that was
described as almost too strong and solid for a woman to have produced; *The
Art Journal* indulged in the usual critical discrimination, pronouncing that "in
execution and drawing, [the picture] is much firmer than the works of ladies
generally."[28]

 In a second signal image, *The Governess* (1860) (figure 5), Osborn offered
another pictorial microcosm of the forces and boundaries of sex, class, and
domination that anonymous and powerless women workers endured. This
work, indeed, was considered by one contemporary critic to be a pendant of
sorts to *Nameless and Friendless*. Both paintings were didactic in their mes-
sages about the mistreatment of teachers and artists—the "too prevalent
vice . . . of treating educated women as if they were menial servants"—and in
each the discomfiture of the persecuted female is made acute for the audi-
ence.[29] In one case the persecutors are male, in the other the persecutor is an

5. Emily Mary Osborn. *The Governess.* 1860. Oil on canvas. 13¾ × 11½″. Yale Center for British Art.

insensitive female; in both the "test" of female fortitude occurs not in the workplace (studio or classroom) but elsewhere.

More than most women artists, Obsorn was attracted to the heroism of everyday, modern life—especially the indignities of the poor and the female. Like *Nameless and Friendless, The Governess* is a study in subtle human expression and drama, and every detail is orchestrated to underscore the teacher's social, financial, and professional pathos. This too is another unprotected orphan (that is, on her own and not taken care of by a man) in mourning

attire who also stands in front of the wealthy or influential, conspicuously not asked to sit, as a real lady would have been. Yet both subjects in Osborn's paintings have the delicacy and almost the tangible breeding of a lady—with beautiful postures, exquisite hands, and faces of a Victorian madonna. However, such physical beauty becomes a disadvantage for those who are social inferiors, in *Nameless and Friendless* an incitement to male fantasy and in *The Governess* an affront to the corpulent, boorish, and jealous mistress of the house.

When *The Governess* was exhibited at the Royal Academy, some lines from Longfellow's poem "Evangeline" accompanied the work:

> Fair she was and young; but alas! before her extended
> Dreary, and vast, and silent, the desert of life, with its pathway
> Marked by the graves of those
> Who had sorrowed and suffered before her.

A final line, "Sorrow and silence are strong, and patient endurance is god-like," underscores how Osborn's choice of verse powerfully evokes the deadly emptiness of a wasted female existence, whose only salvation was Christian forbearance. Critics who saw *The Governess* at the Royal Academy generally praised the subject as a truthful, albeit bitter, moral lesson, not a mere soap opera for viewers. To *The Art Journal* the materfamilias was "an impersonation wherein the artist has concentrated all the vulgarities" and the children were "ill-bred brats, who, sanctioned by their worst bred parent, utter with assured impunity their insulting taunts."[30]

Although Osborn was productive, generally won acclaim, and was able to support herself financially in her vocation, *The Governess* and *Nameless and Friendless* mark the high point of her career. While works like *The Governess* are powerful, they are not totally innovative, being indebted to prototypes such as Richard Redgrave's *Poor Teacher* (1843; unlocated) and *The Governess* (1845; Victoria and Albert Museum). Osborn was able to sustain a career, but not by blazing new iconographic trails; in truth, she barely seemed to hang on by following more traditional routes. Perhaps she was demoralized by various barbs (intended, like Ward's remarks, as backhanded compliments) that her subjects were at times overly "bold for a lady."[31] This was the reaction to her 1861 Royal Academy picture *The Escape of Lord Nithisdale from the Tower, 1716* (private collection), a curious "transvestite" theme in which a wife (with the assistance of a female companion) rescues her husband from prison by bringing him women's clothing to wear for his escape. What may have subconsciously offended critics in this picture is Osborn's inversion of sexual stereotypes of appearance and conduct; Nithisdale is cowering, weak, and "feminine," whereas his female deliverers are resourceful, decisive, dar-

ing, and "masculine."[32] This was an unusually iconoclastic work for Osborn, however. Some of her later pictures dealt with the consequences of poverty and death and shared a sense of personal and economic loss and emptiness for "redundant" women and orphans, but such subjects never gained her significant patronage or fortune. Still other works, from a modern perspective, appear merely to adapt male themes and concepts. Her portrayal from the life of Johnson entitled *Hero Worship in the Eighteenth Century* (1873; unlocated), for example, shows two young female admirers in the private library of the illustrious writer. One of the females effusively recites a speech prepared just for this encounter and (according to *The Art Journal*) "pant[s] for her idol's reply."[33] This kind of feminine pandering to male superiority is repugnant to modern viewers, but it was essentially no different from prevailing male depictions of such fantasized historical moments—or from Dicksee's later permutations of this sort of scene with "Miss Angel."

In contrast to Osborn's relatively predictable images stood the rare iconoclastic exceptions to the norm. One of the most astonishing works in this category is by Florence Claxton, who with her sister Adelaide was a popular illustrator and wood engraver for magazines, newspapers, and books. A contemporary woman historian made the exaggerated claim that "Florence had done what no female artist in all the world had attempted before—made a drawing on wood for a weekly illustrated paper."[34] The daughter of an artist, she, like Dicksee and Hayllar, gave up her art as a profession upon her marriage in 1868. Just a few years before abandoning her career, however, Claxton in 1858 exhibited at the Society of Female Artists a canvas that speaks to many of the issues previously discussed in this essay. *Scenes from the Life of a Female Artist,* now lost, was described in *The English Woman's Journal* as

a fit commentary on the whole exhibition; there is the "ladies' class," the studio, the woodland wide-awake, all the aspirations, difficulties, disappointments which lead in time to successes. The little dog barks with all the hidden meaning of a dog in a fairy tale; the plaster head on the shelf winks with a certain dry amusement at its mistress, who is represented as painting a picture of the ascent to the Temple of Fame: the picture is rejected, and the disconsolate young painter is seen sitting in comical despair, gazing at an enormous R. chalked on the back.[35]

Another tour de force that shed light on the contemporary art scene was Claxton's *The Choice of Paris: An Idyll,* which was exhibited in 1860 in London and appeared shortly thereafter as a full-page engraving in *The Illustrated London News*.[36] This work was a brilliant satiric pastiche of some of the most famous Pre-Raphaelite canvases of the day, including numerous motifs and inscriptions that confirmed how well she understood the artistic milieu of her time.

In 1871 roughly one hundred of Claxton's drawings were published as *The Adventures of a Woman in Search of her Rights,* a provocative title that telescopes many of the ideas conveyed in what may well have been her masterpiece, *Woman's Work, a Medley* (1861) (figure 6). This painting, displayed at the Portland Gallery that year, was accompanied by the following text derived from Aesop's fables: "A forester meeting with a lion, a dispute arose as to who was the stronger. They happened to pass by the statue of a man strangling a lion. 'See there,' said the man, 'what better proof can you have of our superiority?' 'That,' said the lion, 'is your story. Let us be the sculptors and we will make the lion vanquish the man.' MORAL: No one is fair witness in his own cause."

In addition, the author provided a long descriptive passage of the contents, which is worth citing in full:

> The Four Ages of Man are represented: in the centre youth, middle age and old age reposing on an ottoman, infancy being in the background; all are equally the objects of devotion from surrounding females. The "sugar plums" dropping from the bon-bon box, represent the "airy nothings" alone supposed to be within the mental grasp of womankind. A wide breach has been made in the ancient wall of Custom and Prejudice by Progress—Emigration—who points out across the ocean. Three governesses in the foreground, ignorant apparently of the opening behind them, are quarreling over one child. Upright female figure to the right is persuaded by Divinity and commanded by Law, to confine her attention to legitimate objects. Another female has sunk exhausted against a door, of which the medical profession holds the key; its representative is amused by her impotent attempts; he does not see that the wood is rotten and decayed in many places. An artist (Rosa B.) has attained the top of the wall (upon which the rank weeds of Misrepresentation and prickly thorns of Ridicule flourish), others are following: the blossom of the "forbidden fruit" appears in the distance.

This most extraordinary image is one of the few to flaunt custom and to question the position of women in English society and the realm of art. It is, moreover, biting and satiric to both sexes. The thinly veiled message of the fable addresses issues of sexual dominance and opportunities for women to "vanquish the man." As in Osborn's 1873 canvas, hero worship is also a focus. While Claxton offered a complicated exegesis of her painting, modern viewers are likely to extract still other levels of meaning. The central irony is that the story of nineteenth-century womankind is told in terms of the four ages of man and male needs. In the middle of the composition an overweight and obnoxious male (positioned below what is presumably a sculptural parody of the golden calf) pontificates to three women literally at his feet; the adoring pseudodisciples appear thrilled to be in his presence, and one stretches out her hand to catch whatever "pearls of wisdom"/"sugar plums" he

6. Florence Claxton. *Woman's Work, A Medley.* 1861. Oil on canvas. 20 × 30″. Photo courtesy of Sotheby's London.

deigns to dispense. Yet at least two of these figures are creative artists themselves, or are trying to be, although the image clearly lampoons their attempts. The woman at right plays a guitar from some rather simplistic music (inscribed "fa-la-la") that she has perhaps written herself, while the one in the foreground seems to be indulging in the Victorian fad of producing a phrenological analysis of the man's head. Both the allegedly superior male sage, or "idol," and his sycophantic acolytes appear ridiculous. On the edge of their circle at left is a less aesthetic type who gazes narcissistically into a mirror rather than at the books nearby; she, too, behaves foolishly. Somewhat less frivolous is a group of women at left who huddle near a cliff reminiscent of the White Cliffs of Dover. In addition to symbolizing hope of progress in the future, are they also the legendary waiting women in the ballad "Sir Patrick Spens" who vainly expect their men to return from the sea? They bear a striking resemblance to the situation depicted in Elizabeth Siddal's *Sir Patrick Spens* (1856; Tate Gallery). Emigration for spinsters is probably specifically alluded to in the figure of the homely woman with the satchel. (The surplus of females in the population at mid-century frequently prompted suggestions

that "superfluous" women emigrate to Australia and elsewhere to improve their marital prospects.)

Among other activities, Claxton depicts the mistress of the house yawning and neglecting her duties as a maidservant delivers an empty meal tray to the head of the household. While they belong to different classes, both have their primary functions defined in terms of serving men. At left in the foreground three females anxiously try to teach a boy to read from a rather improbable text of words such as "bread, brat, and pun"; they have at least temporarily turned their backs to other possible pursuits allowed by the "wide breach . . . made in the ancient wall of Custom and Prejudice."

Claxton's insistence on the obstacles placed by doctors in the way of aspiring women and their amusement at women's "impotent efforts" may subtly allude to the need for increased knowledge and practice of birth control as a way to improve female existence. The figure in the shadows at extreme right is mournful and bedraggled; in appearance she aligns herself with the fallen woman or prostitute, especially with Holman Hunt's famous 1854 Royal Academy entry entitled *The Light of the World* and its pendant *The Awakening Conscience,* which depicts a bourgeois mistress experiencing an epiphany in the love nest she shares with her paramour. This identification is made all the more plausible because the closed wooden door is inscribed with words such as "Retreat," raising the idea of metaphorical salvation communicated by Hunt's galvanizing pair of canvases.

The most overtly political and caricatural group appears at right, with a young woman surrounded by male judges, clerics, and possibly even politicians. The men hand or bring her various documents, including a long scroll full of legal mumbo jumbo and such legible words as "tracts," "single women," "district," and "charity," all part of the legal and social definitions of woman's "proper" place and role. The expression of the man holding the scroll is both leering and condescending; he presumably cannot imagine that a woman could truly understand these concepts, much less the confusing treatise he bears. Perhaps he is a solicitor or political candidate trying to sell the woman empty promises in return for some favor from her. The presentation of this document clearly responds to the controversy over female enfranchisement that raged after mid-century. The besieged woman appears confused about how Divinity and Law have forced her "to confine her attention to legitimate objects," since she presumably knows, for instance, that while single women could generally own property, sue and be sued, and retain earnings, a married woman or *femme covert* lost all these legal rights upon marriage.

While middle- and upper-class women were commonly shown in well-appointed "gilded cages," the women here are all captives of a partly walled pit or stony ruin emblematic of Custom and Prejudice, on the floor of which

engraved names suggest tombstones or a crypt. Prominent among the many words in this canvas is "Ennui" describing the bored condition endured by many Victorian ladies, who were relegated to knitting, embroidery, and amateur status in the arts (all of these represented in the foreground) rather than encouraged to pursue serious careers or knowledge. All are subservient in some respect—to children, husband, mentors, prejudicial misconceptions, to modern history itself—and escape or reprieve seems unlikely. Indeed, the very notion of emancipation may elude most of the captives, whose expressions are more caricatural than desperate or unhappy. Moreover, only a few occupants make any effort to leave this communal prison and metaphorical void—the figures on the left stand with Progress and look bravely toward the uncharted future for hope; another figure in the back tries to pull herself up higher; and two women on the right have used a ladder to reach the top. In the latter depiction, while one woman is still climbing, another perches at the top, unmoving and seemingly intent on studying or drawing directly from nature. This daring figure is an artist, probably Rosa Brett from the Pre-Raphaelite circle, who in self-defense against the double standard sometimes signed her works with a male pseudonym, "Rosarius Brett," in order to gain fair treatment.[37] But she must struggle with the weeds of ridicule before attaining in the distance the "forbidden fruit" of freedom, recognition, or self-fulfillment. In this scornful as well as witty composition, woman's work and roles are seen as diverse and almost universally unsatisfying and thwarted, and perhaps Claxton identified herself with the artist figure who attempts—but not yet with full resolve or success—to escape this situation.

Claxton had already demonstrated a scathing comic bent before she undertook *Woman's Work: A Medley,* a truly exceptional image that safely disguises its deviancy in the medium of satire. However, most Victorian women painters chose a path of less resistance and did not aspire to such pictorial censure of both tradition and traditional imagery. Indeed, it was in some respects dangerous for both personal and professional reputations not to conform. For the most part, women painters generally assimilated and seemingly accepted the status quo, avoiding confrontation or criticism and preferring subjects that were neutral and conservative, and usually only marginally different from similar themes chosen by male artists. Some women were betrayed by their own brush, proliferating negative feminine stereotypes in their own paintings even as they chafed under various restrictions in their private lives and careers. But occasionally, a sense of alienation, challenge, and defiance emerges; while sexual and sexist roles are preserved in most images, impassioned works such as *The Governess* and, more forcefully, Claxton's trenchant probe of contemporary attitudes toward women occasionally hint at women painters' desire to subvert and to elude prevailing gender codes. Given the possibilities of meaning that resonate in such examples, Ellen Clayton's lament in her 1876 book on English

female artists can only be viewed ironically. She wrote, "Perhaps one of the most enviable of modern beings is a successful, popular lady artist, admired for her talents and for her personal qualities, and consequently prosperous and content. But the result is that—'Story! Bless you, they have none to tell!' "[38]

There are indeed tales to be retold and latent lessons to be learned from the images of gender roles and role-playing that survive, as well as from the high price that numerous Victorian women painters paid for their popularity, only to achieve a paradoxical invisibility. While others chose to remain selectively blind to the harsher realities of female experience, Claxton bravely put on the spectacles of self-criticism, so to speak, in the amazing *Medley* and other works; she dared to puncture the feminine ego as well as to wound male pride. Such evidence of spirited confrontation was very unusual in the realm of art, however. As this selective iconological survey and the pejorative and reductive stereotypes generated by many portrayals of the female artist indicate, Victorian painters offered only a few testimonies to female heroism and achievement in the past and present. In the future, many more images underscoring and penetrating the codes and biases that plagued the creative female in Victorian England may still remain to be discovered and interpreted to new generations of viewers.

NOTES

1. Harriet Arnold, *A Voice from a Picture by a Female Artist of the Present Day* (London: privately printed for the author, 1839), 49.

2. Numerous historians and feminist scholars have begun to analyze this subject, including Pamela Gerrish Nunn, *Canvassing: Recollections by Six Victorian Women Artists* (London: Camden Press, 1986); Deborah Cherry, *Painting Women: Victorian Women Artists* (Rochdale: Rochdale Art Museum, 1987); Jennifer Fletcher et al., *The Women's Art Show 1550–1950* (Nottingham: Nottingham Castle Museum, 1982).

3. The best source that offers a statistical breakdown with specific lists of these subjects by female artists is Charlotte Yeldham, *Women Artists in Nineteenth-Century France and England,* 2 vols. (New York and London: Garland Publishing, Inc., 1984), esp. 1:160–66.

4. Yeldham, *Women Artists,* 1:167–68.

5. A perceptive discussion of the contemporary literature—both critical and fictional—that dealt with the woman artist is found in the appendix of Pamela Gerrish Nunn, *Victorian Women Artists* (London: Women's Press, 1987), 224–37.

6. A useful general examination of this image in the novel is Bo Jeffares, *The Artist in Nineteenth Century English Fiction* (Gerrards Cross, Great Britain: Colin Smythe Ltd., 1979).

7. George Moore, *A Modern Lover* (London: Macmillan & Co. Ltd., 1883), 1:72.

8. On these "separate spheres" of creativity in art, see Susan P. Casteras,

"Excluding Women: The Cult of Male Genius in Victorian Painting," in Linda M. Shires, ed., *Theory, History, and the Politics of Gender: Rewriting the Victorians* (London: Routledge, 1992).

9. On the artist and model relationship, see, for example, John Berger, *Ways of Seeing* (London: British Broadcasting Corporation and Penguin Books, 1972). On related subjects, see Linda Nochlin and Thomas B. Hess, eds., *Woman As Sex Object* (New York: Newsweek Books, 1972).

10. Jeffares, *The Artist*, 111.

11. On Ward's career, see Nunn, *Victorian Women Artists*, 132–46.

12. Nunn, *Victorian Women Artists*, 6.

13. On Jameson's reaction, see George Adolphus Storey, *Sketches from Memory* (London: Chatto and Windus, 1899), 83. There are many excellent commentaries on the issue of art education for women in England, above all Yeldham, *Women Artists*, as well as more general discussion, particularly Germaine Greer, *The Obstacle Race: The Fortunes of Women Painters and Their Work* (New York: Farrar Strauss Giroux, 1979), and Roszika Parker and Griselda Pollock, *Old Mistresses* (London, 1981).

14. This line is quoted from the caption of a Keene cartoon in this series appearing in *Punch* (1866), 235–55.

15. A similar point is also made about James's dithering woman artist, Augusta Blanchard, in Jeffares, *The Artist*, 156.

16. Copying other artists' work and also replicating one's own for another patron were common practices. On Solomon's endeavors in this regard, see Ellen Clayton, *English Female Artists*, 2 vols. (London: Tinsley Brothers, 1876), 2:130.

17. Quoted about a Simeon Solomon portrait possibly of his sister in an exhibition catalogue by the Geffrye Museum, *Solomon: A Family of Painters* (London: The Geffrye Museum, 1985), 58.

18. Alastair Grieve, *The Art of Dante Gabriel Rossetti: The Watercolours and Drawings of 1850–1855* (Norwich, Great Britain: Real World Press, 1978), 59. Grieve also offers a brief discussion of Siddal's oeuvre as well as mention of some of Rossetti's images of her at work. The best sources on Siddal's life and career are Jan Marsh, *The Legend of Elizabeth Siddal* (London: Quartet Books, 1989), and Deborah Cherry and Griselda Pollock, "Women as Sign in Pre-Raphaelite Literature: A Study of the Representation of Elizabeth Siddal," in *Vision & Difference: Femininity, Feminisim and the Histories of Art*, ed. Griselda Pollock (London: Routledge, 1988), 91–114.

19. Michael Levey, *The Painter Depicted: Painters as a Subject in Painting* (London: Thames and Hudson, 1981), 8.

20. Levey, *The Painter Depicted*, 62–65.

21. On Edith Hayllar and her sister painters, see Christopher Wood, "The Artistic Family Hayllar, Part 2: Jessica, Edith, Mary, and Kate," *Connoisseur* 186 (May 1974): 2–9.

22. So far no study focusing on Lady Alma-Tadema has been written, but Victorian sources include Alice Meynell, "Laura Alma-Tadema," *The Art Journal* 45 (1883): 345–47. A more recent book on the artist's husband that mentions her only in passing is Vern Swanson, *Sir Lawrence Alma-Tadema* (London: Ash & Grant, 1977).

23. An insightful reading of this image appears in Rosemary Betteron, ed., *Looking On: Images of Femininity in the Visual Arts and Media* (London and New York: Pandora Books, 1987), 4–6.

24. Little has been written about Osborn (aside from Nunn, *Victorian Women Artists;* Ann Sutherland Harris and Linda Nochlin, *Women Artists: 1550–1950* [New York: Alfred A. Knopf, 1976], 54–55 and 228; and Yeldham, *Women Artists,* 1:309–12), but a nineteenth-century source that is still useful is James Dafforne, "British Artists: Their Style and Character, No. 75: Emily Mary Osborn," *The Art Journal* 26 (1864): 261–63.

25. "Lady Artists: Miss E. M. Osborn," *The Lady* (2 September 1886): 183.

26. Dafforne, "British Artists," 262.

27. "Lady Artists: Miss E. M. Osborn," 183.

28. "The Exhibition of the Royal Academy," *The Art Journal* 19 (1857): 170.

29. Dafforne, "British Artists," 262.

30. "Exhibition of the Royal Academy," *The Art Journal* 22 (1860): 170.

31. "Exhibition of the Royal Academy," *The Art Journal* 23 (1861): 169.

32. A similar point about sexual role-playing is made in Cherry, *Painting Women,* 17.

33. "Exhibition of the Royal Academy," *The Art Journal* 35 (1873): 239.

34. Clayton, *English Female Artists,* 2:44.

35. As quoted in Yeldham, *Women Artists,* 1:168.

36. For details on this pictorial satire, see William Fredeman, "Pre-Raphaelites in Caricature: 'The Choice of Paris: An Idyll' by Florence Claxton," *The Burlington Magazine* 102 (November 1960): 523–29.

37. Given the comments that Claxton probably was acquainted personally with various members of the Pre-Raphaelite circle, it seems plausible that this is Brett and not Rosa Bonheur, the French female painter (1822–1899) who had already achieved international fame by 1860.

38. Clayton, *English Female Artists,* 2:42–43.

GEORGE P. LANDOW

MARGARET M. GILES'S *HERO* AND THE SUBLIME FEMALE NUDE

Margaret M. Giles's *Hero* (figure 1) compels the attention of those interested in the relation of gender and image. Marking a turning point in the history of New Sculpture, that brilliant period of British work in bronze and stone between 1880 and 1910,[1] this bronze statuette, major work by one of the new wave of women sculptors trained at the art schools in South Kensington during the early 1890s, exemplifies the ways a female artist newly entering what had been a male-dominated field challenged, partially rejected, and redefined male artistic and cultural traditions.

Since so little is known about Giles, I begin with a statement of what I have been able to discover about her life and art. Next, I briefly discuss the range of her work as a sculptor and place that within the context of contemporary changes in sculpture and the entrance of women in significant numbers into the art. The remainder of this essay concentrates upon the ways *Hero* reinterprets the figural tradition in a manner suited to the needs of the woman sculptor. After examining Giles's depiction of the nude in relation to those by contemporary sculptors, I examine *Hero* specifically in the light of iconographical tradition. In particular, I look at earlier versions of the Hero theme and the conceptual structure to which it belongs—the woman waiting by the water for the return of her man.

MARGARET GILES'S LIFE AND CAREER

Margaret M. Giles, an accomplished and prolific painter, sculptor, and medalist, seems to be all things to all reference works. Consulting the *Dictionary of*

British Artists Working 1900–1950, one learns that she was a "west country artist" who flourished in the 1940s and exhibited at the Royal Academy and Royal West of England Academy. Another source offers that she was a "contemporary sculptor and medallist; member of the Society of Medallists, at whose exhibition in 1897 she had a seal and impression for a Submarine Cable Co."[2]

According to the *Dictionary of Women Artists,* Giles was an English sculptor of "medallions, relief portraits and busts, genre statuettes, large groups in marble, and decorative works for houses" who also painted portraits and figures. Between 1884 and 1912 she exhibited frequently at the Glasgow Institute, the Ridley Art Club, the Royal Scottish Academy, and the Royal Academy. Her last work at the Royal Academy appeared after a thirty-three year absence in 1945.[3]

According to *Who Was Who,* Giles was born in 1868, the second daughter of Richard W. and Frances E. Giles, and died in 1949 at the age of eighty-one. She was educated at Kensington High School and at Brussels and Heidelberg. She studied eight years at the National Academy of Art Training School (now the Royal College of Art, South Kensington), chiefly under Edward Lanteri, and she also "visited galleries at Paris, Milan, Florence, Venice, Rome, Athens, Lahore, and Calcutta."[4] A member of the Royal West of England Academy, she belonged to the Society of Mural Decorators and Painters in Tempera and, as we have seen, to the Society of Medalists as well. Beattie mentions that she exhibited at the Arts and Crafts Exhibition Society, and she may have belonged to that organization or closely associated with it at some point in her career.[5] She married Bernard M. Jenkin in 1898, at which point her address changed from 60 Nevern Square to 59½ Camden Street, Camden Hill, and in 1911 to 59 Camden Street, Kensington. Sometime after 1912 she moved to 25b Durdham Park, Bristol.

As a young sculptor, Giles won prizes and recognition during her student years. *The Studio* reported, for example, that she won a gold medal for an unnamed relief at the 1893 exhibition of students' work at South Kensington. This same periodical's review of the 1893 Arts and Crafts Exhibition pointed out as "especially worthy of notice . . . a combined lamp and finger-post, by Margaret Giles, which would be a welcome relief from such objects as the groups opposite the Criterion, or defacing the centres of most of our crossroads."[6] In an 1896 notice of the South Kensington students' show, *The Studio* mentions "among notable exhibits . . . a powerfully decorative panel of the Destruction of Pharoah's Host," apparently by Giles.[7]

Between 1894, when she exhibited three portrait medallions, and 1912, the last year she is listed until 1945, she showed twenty-six works at the Royal Academy exhibition. Of the works exhibited at the Royal Academy, eleven were portrait medallions and two others medals, one described as a "Medal

for hospital nurses" (RA 1895) and the second as a "Medal for the Royal Horticultural Society, etc." (RA 1898). She exhibited four reliefs in a range of materials and on a range of subjects, the first a subject from the *Odyssey*— *Ulysses and Euryclea* in lead—and the second a *Virgin and Child* in an unspecified material (both RA 1895). In 1897 Giles exhibited an alabaster relief, *"They see the work of their own hearts,"* whose title is a Shelleyan text, and the following year she exhibited a portrait relief of Miss Clara Paul in an unidentified material.

This work in relief seems to have been part of a broad interest in sculpture as applied decoration, for Giles created a terra-cotta frieze for the facade of a now demolished house in London.[8] *Who Was Who* mentions that she "modelled frieze and spandrils for terracotta and designed finials for stone, and other architectural decoration." Giles's 1911 *Labourers in the Vineyard*, (figure 2), a work in flat relief that anticipates architectural bas reliefs of the 1930s and 1940s, illustrates the familiar scriptural passage that provided the occasion for Ruskin's *Unto This Last* and may have been intended to convey Ruskinian associations about the nobility of labor and the need for social justice—something quite likely for an artist who exhibited at the Arts and Crafts Guild. Of the works of hers that I have seen, this one appears most likely to have been designed as an architectural commission. The frieze's calm static arrangement of figures, which so differs in essential approach from the passion and movement of *Hero,* shows the artist's sensitivity to the different qualities required by different formats.

In addition to her medallions and reliefs, Giles exhibited at least eight works of freestanding sculpture (the medium of the last of the twenty-six works, a portrait, *Dorothy, daughter of John Martineau Fletcher, Esq.,* is unspecified in the Royal Academy catalogue). *Hero* was exhibited at the 1896 Royal Academy, the year after Frederick Leighton awarded her the prize, and in 1904 she was represented by another statuette, *Pilgrim with Scrip,* again in an unspecified material. Her three sculptural groups show an equivalent range of subject: she exhibited *"He shall give his angels charge over thee"* at the 1898 Royal Academy (figure 3); two years later she was represented by the marble *In Memoriam,* which employed the identical text as an epigraph. Her third group, which she exhibited in 1901, appears a more purely religious piece (rather than a memorial with religious overtones): *"After nineteen hundred years, and they still crucify"* (figure 4). In 1905 she exhibited a group, *The Son of Consolation* (figure 5), and a bust, *Mrs. Sloane.* Forty years later Giles reappears at the Royal Academy annual exhibition with *The Tortoise Boy,* a bronze statuette group.

Like most Victorian sculptors, Giles seems to have devoted a large part of her attention to portrait and memorial work. Since four of her known portrait medallions, two of which were not exhibited at the Royal Academy, are of

scientists—*Prof. Ayrton, F. R. S.* and *Dr. W. H. Tilden, F. R. S.* (both RA 1897), *Joseph Lister, Baron Lister* (National Portrait Gallery, 1898) and *William Thomson, Baron Kelvin* (National Portrait Gallery, n.d.)—she may have had scientific connections.[9] *Who Was Who* also points out that she created medals for the Society of Chemical Industry, the Institution of Electrical Engineers, and the University of Rangoon.

Hero and *Ulysses and Euryclea* represent her two Royal Academy subjects taken from the classics—the first ultimately from Museus and the second from Homer—though *Hero* may derive more directly from Marlowe's "Hero and Leander." The 1904 *Pilgrim with Scrip,* which appears to have been a medieval subject, may also have illustrated a Rossettian theme, such as that exemplified by his poem "Staff and Scrip" or W. Holman Hunt's *The Pilgrim's Return.*

Even such a brief survey of her work suggests its scope and variety. Listing her titles alone provides some small indication of her iconographical and iconological range but cannot do much more than that. Surveying the reproductions of her sculptural work available in contemporary and modern publications, however, furnishes additional information about her range as an artist. The available photographs of her work reveal, for example, that Giles worked in different styles during the relatively brief period for which reliable pictorial information about her sculpture exists. These photographs also suggest that she varied styles according to the media in which she created a work and the site or use for which she intended it.

The Labourers in the Vineyard, a bas relief of 1912, and *Immortality* (figure 6), a bas-relief of plaque of 1909, both clearly seem intended as architectural decoration, and they share elements of a linear style. *The Labourers in the Vineyard* is by far the most flat of her works, which is one of the reasons it so resembles art deco facades of the 1920s and 1930s, but the deeper carving and formalized drapery and feathers of *Immortality* produce a very different effect. Neither of these two bas-reliefs has a great deal stylistically in common with *Hero* or with her other freestanding sculpture, which also vary a great deal from one to another.

Because I have encountered only single views of each piece, I have been unable to determine if all of her free-standing work, like *Hero,* composes well from all sides and viewing angles. One can, however, determine certain obvious similarities among these works. All of them, for example, make their bases a significant part of the composition, and all emphasize emotion. Other similarities pertain only to two or three works. Thus, despite its having a far more tranquil mood than does *Hero,* "*He Shalt Give His Angels Charge over Thee,*" which might have been intended as funerary sculpture, shares some of its approach to creating space with a female form in motion. One can also point out that Giles treats the nude or partially nude form in

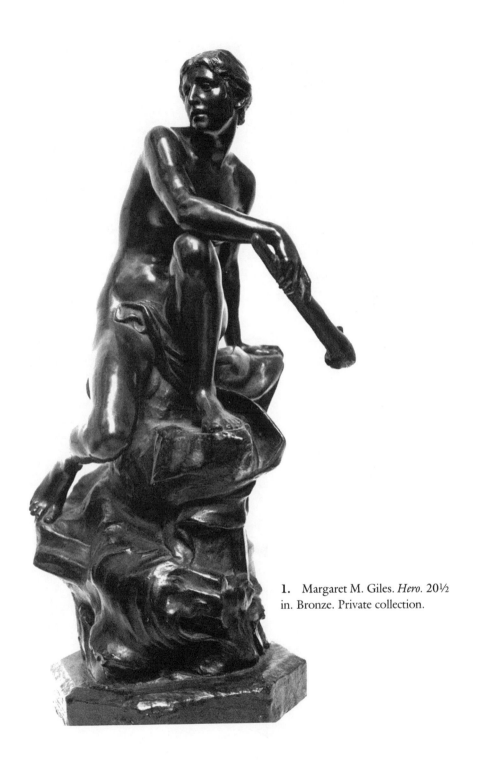

1. Margaret M. Giles. *Hero.* 20½ in. Bronze. Private collection.

2. Margaret M. Giles. *Labourers in the Vineyard.* 1911. Yale University Library.

3. Margaret M. Giles. *"He shall give his angels charge over thee."* 1898. Yale University Library.

4. Margaret M. Giles. *"After nineteen hundred years, and they still crucify."* 1901. Yale University Library.

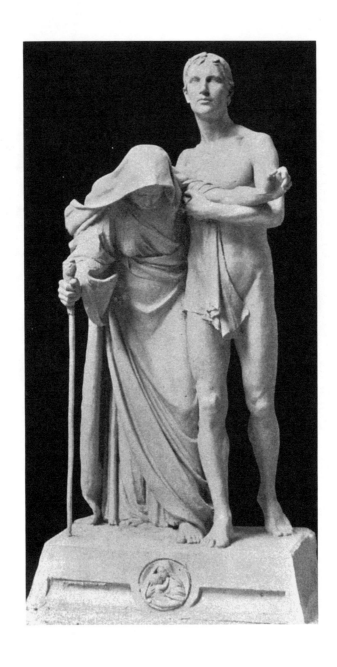

5. Margaret M. Giles. *The Son of Consolation*. 1905. Yale University Library.

6. Margaret M. Giles. *Immortality*. 1909. Yale University Library.

7. Ruby Levick. *Rugby Football*. 1901. Yale University Library.

 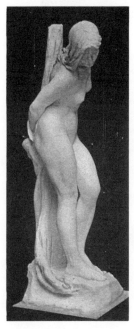 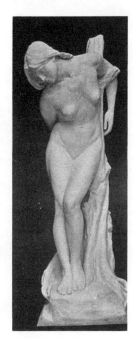

8. Benjamin Clemens. *Immolate*. 1912. Yale University Library.

9. Bertram Mackennal. *Grief.* 1898. Yale University Library.

10. Edward G. Bramwell. *Hero Mourning over the Body of Leander.* 1908. Yale University Library.

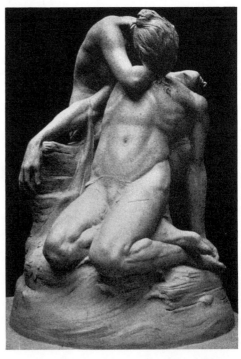

three works—*Hero, The Son of Consolation,* and *"After Nineteen Hundred Years, and They Still Crucify"*.

GILES IN THE CONTEXT OF CONTEMPORARY WOMEN SCULPTORS

Giles's *Hero* represents a major accomplishment by a representative member of an important group of young women sculptors, many of whom had trained at South Kensington. According to Susan Beattie, the authority on the New Sculpture who was the first scholar to direct attention to these young women, Giles was one of a group that included Florence Steele, Ruby Levick, Esther Moore, and Gwendolyn Williams, all of whom studied modeling in the early 1890s under Edward Lanteri at the National Art Training School (Now the Royal College of Art) at South Kensington, winning prizes in National Art Competitions during the early 1890s.[10]

The official catalogues of the annual Royal Academy exhibition show that in the mid-1890s women suddenly exhibit in large numbers. Although almost no women exhibited works of sculpture in the late 1880s, the following women appear as exhibitors in the 1896 catalogue: Esther M. Moore, Kathleen Shaw, Florence Newman, Ada F. Gell, Florence H. Steele, M. Lilian Simpson, Lilian V. Hamilton, Ella Casella, Nelia Casella, Lydia Gay, Frances A. Dudley Rolls, L. Gwendolyn Williams, Andrea C. Lucchesi, Rosamond Praeger, Countess Fedora Gleichen, Edith Bateson, Honora M. Rigby, Frances I. Swan, Hon. Lady Rivers Wilson, Edith A. Bell, Emily A. Fawcett, Alice M. Chaplin, Ruby Levick, and Margaret M. Giles. Twenty-four out of approximately eighty exhibitors were women; one cannot determine the gender of a half dozen or so of the other exhibitors.

According to Susan Beattie, "the dramatic rise of women sculptors to prominence in the 1890s was directly related to the changing image of the art. The cult, not only of the statuette, but of modeling as the sculptor's most direct means of self-expression, and the consequent revolution in the bronze founding industry, had deeply undermined the principal argument against women's involvement in sculpture, their inability to cope with the sheer physical effort it required."[11] The new emphasis on modeling clay, as opposed to stone carving, led directly to the entrance into the field of large numbers of young women. One must also point out, however, that once these women began to exhibit, many, like Giles, produced works with hammer and chisel as well as with the tools of the modeler. But the new fashion for bronze first made a radical new opportunity for women in the arts. Furthermore, these young women not only began to work with supposedly masculine tools and media but also worked with men's subjects as well. For example, R. Ruby Levick exhibited a group of boys wrestling and *Rugby*

Football (1901, figure 7), and Lilian Wade produced bas reliefs of military scenes.[12]

In *Hero,* Giles realizes much of the potential created by this new opportunity, but she does so by reinterpreting a subject and a sculptural theme usually considered particularly appropriate for women. In particular, the sculpture departs from conventional conceptions of the female nude, and it thereby demands new aesthetic standards and makes new, or at least unconventional, claims about women. In addition, *Hero* challenges not only conventional conceptions of the female figure suitable for art but also conventional interpretations of a commonplace theme.

A major part of *Hero*'s importance to the history of British sculpture derives from its relation of scale to basic conception. As Beattie points out, "[D]espite the interest taken in the statuette since the mid-1880s surprisingly little attention had been given to the question of the relationship between scale and design."[13] In fact, almost all British statuettes exhibited before the turn of the century were simply reduced versions of larger works that did not take into account the implications for design of changed size and scale. In contrast, the "complex, spiralling composition" of *Hero* derives from the "actual size of the bronze," and the sculptor has "presupposed the ability and inclination of its owner to vary its position, and so gradually discover, from a fixed viewpoint, its whole implication as a three-dimensional work of art."[14]

Although *Hero*'s brilliant reinterpretation of the statuette form owes little to the fact that it was sculpted by a woman, its reinterpretations of the female nude reflect the gender of the sculptor. Comparing *Hero* to several contemporary works makes clear Giles's originality in creating an active, powerful nude. *Captive* (1908), a work by a Miss J. Delahunt, is a clothed female figure seated in a pose roughly analogous to that of Giles's statuette. Here the image is of passivity and acceptance, if not despair. S. Nicholson Babb's *The Victim* (1905), a bas relief of an Andromeda-like nude chained to a cliff, represents another standard image popular throughout the nineteenth century, the bound woman helplessly awaiting her fate; Benjamin Clemens's *Immolate* (1912, figure 8), which dates from the same years as Giles's scriptural frieze, presents an even more extreme image of a bound nude whose nakedness is emphasized by the garment that has been peeled away from her and hangs only from her arms. The work by Delahunt represents a passively accepting woman, those by Babb and Clemens an intensification or exaggeration of that theme in the situation of the bound nude. Giles, in contrast, represents woman—even a suffering or anxious woman—as a far more free and active being.

Part of the relative uniqueness of *Hero* arises from its emphasis on a physically powerful female nude. A comparison with these others works reveals that at the time Giles sculpted her prizewinning representation of *Hero,* her

conception of the female nude must have seemed particularly androgynous. Unlike Edward Burne-Jones, who created androgynous female figures by using male proportions for female nudes, so that the resulting figure appears that of a young boy with breasts, Giles produces a nude with ample breasts and hips. The androgyny of her nude derives from its extraordinarily heavy musculature, which makes the figure appear a descendant of Michelangelo's *gnudi*. Looking at the figure's left arm, which supports her as she turns anxiously to search the darkness for Leander, one perceives tensed bicep, tricep, and forearm. Similarly, *Hero's* right upper thigh, which she has drawn slightly behind her, has a deep hollow similarly indicating mental and physical tension. Even today, when the standard of femaly beauty has moved toward greater muscularity or at least toward greater muscle tone than ever before, *Hero's* back strikes one as unusually well muscled—almost as if Giles had chosen for her model a twentieth-century woman shotputter or bodybuilder.

What else has Giles done to the conventional female nude in this representation of the anxious *Hero?* In the first place, she has rejected basic understandings of feminine beauty commonplace in her time. Within the context of contemporary figural types for the female nude that emphasize classicizing elements such as calm, dignity, balance, and stasis, *Hero* appears passionate and powerful. Within the context of female nudes that emphasize a lack of muscularity and definition as a prerequisite of female beauty, Giles's *Hero* appears an equally contradictory embodiment of power. Giles's work, which aggressively rejects the image of woman as an embodiment of roundness and softness, thereby reinterprets a convention or code created by men. In creating *Hero,* Giles has seized control of the cultural discourse in question—here that of the artistic representation of women—and given its codes, conventions, and forms her own meaning.

One can gain a notion of what else Giles has rejected by examining other representations of the female nude and of female grief. The passivity and lack of emotion that characterize many nineteenth-century female nudes appear in contemporary sculptural representations of grief as well. Bertram Mackennal's marble statuette *Grief* (1898, figure 9) presents the extreme emotion it embodies by means of a closed-in form, all emotion being expressed by the figure's curved back and hidden face. Like so many other images of women undergoing extreme emotion, this one presents the feminine in an image of powerful feeling pent within rather than radiating outward. Alfred Buxton's *Isabella* (1912), an idealized version of the Boccaccian literary theme made popular by Keats, Millais, and Hunt, presents the mad, mourning heroine crouched over the head of her murdered lover. Again, woman's grief, woman's emotion, is presented as calm enclosed within female form, and agony becomes transformed as culturally acceptable melancholy.

Considered in terms of its overall intellectual structure, *Hero* is one of

many popular nineteenth-century artistic subjects that represent what one can term the woman-waiting-by-the-water, another form of which appears in the many depictions of Ophelia playing with flowers before she enters the fatal stream. Paintings of Ophelia by Richard Redgrave and Arthur Hughes are among the best known. A second version of this theme appears in the naturalistic representations in late Victorian painting of women, usually the wives of fishermen, waiting for their overdue husbands to return. Local details that situate the image within a particular, identifiable time and place characterize Frank Bramley's *Hopeless Dawn,* Frank Holl's *No Tidings from the Sea,* and Walter Langley's *But Men Must Work and Women Must Weep.*

A more typical rendition of the Hero subject appears in Edward G. Bramwell's *Hero Mourning over the Body of Leander* (1908, figure 10), in which the grieving woman, face hidden, folds herself over the body of her dead lover. Comparing this fairly effective work to that by Giles, one is struck by the way Bramwell's Hero literally effaces herself, simultaneously creating an effective image of grief and a culturally acceptable political statement about the proper relation of woman to man. Face hidden, she folds into and around the man's body, and dead maleness dominates the work even more than properly feminine grief.

In contrast to such works, Giles has defined the female partner in an erotic relationship as more active than traditionally conceived. Her statuette's musculature, which conveys to the viewer a sense of unusual power, contrasts markedly with the usual conception both of the nude and of the Hero theme. Both are generally represented by nineteenth-century artists in paint, stone, and bronze as passive beings invaded by emotions. The conventional nude's rounded arms and flanks, which graph the ideal of male desire, embody a passive form, one smooth and graceful but completely lacking force. In fact, this lack of power provides a major source of this figure-type's complementary erotic and artistic appeal, an appeal that had been explicitly codified as an aesthetic doctrine since Edmund Burke contrasted the powerful masculine sublime to an essentially passive beauty.

Burke, whose *Philosophical Enquiry into the Origin of our Ideas of the Sublime and the Beautiful* (1757) made "terror . . . the ruling principle of the sublime," explained the opposition between it and beauty by a physiological theory.[15] He made the opposition of pleasure and pain the source of the two aesthetic categories, deriving beauty from pleasure and sublimity from pain. According to Burke, the pleasure of beauty has a relaxing effect on the fibers of the body, whereas sublimity, in contrast, tenses these fibers. Burke further underlines the opposition of the two aesthetic categories by making beauty essentially feminine and sublimity masculine, and in so doing he quite explicitly reduces the importance and value of the beautiful. He also reduces the importance and value of the feminine, since by his reasoning the feminine and

the female cannot be great. In *Hero* Giles rejects this reductive opposition of male and female by creating a sublime female nude, and she demonstrates, certainly to the satisfaction of Lord Leighton, who awarded her work first prize, that the female figure can be a source of power as well as of languid beauty.

This intonation of the traditional female nude is not the only one that Giles makes in reinterpreting the traditional figure of Hero. Her sculpture reinterprets the traditional subject of the deserted or abandoned woman by making the body type more intense and heroic and by creating an unsettling emotionality so suffused with angst that it borders on the grotesque. In so doing, Giles offers a redefinition of the feminine and the femininely appropriate. Her muscular, straining nude grounds the emotional intensity that is the second aspect of her reinterpretation—the reassertion of a woman's right to a powerful emotional life. Unlike almost all other representations of this theme, Giles's *Hero* presents a woman actively searching the world around her. In so doing, she transforms what had been a purely contemplative, or even passive and suffering, form closed in upon itself—a quiet female center cut off from the outside world—into a consciousness that actively penetrates surrounding space, radiating a sense of force and activity.

When perceived within the context of contemporary and traditional conceptions of sculpture, Giles's *Hero* embodies changes in the basic conception of the art, particularly those conceptions related to medium and scale. As we have observed, it also embodies changed attitudes related to gender, in this case the gender of the artist, and indeed the basic conception of *Hero* depends on the entrance into the field for the first time of women in large numbers. In particular, when perceived within the context of contemporary and traditional conceptions of the female nude, this work makes strong statements about the nature of women, art, and beauty. Giles also makes clear statements about the role of the woman artist and about the nature of her contributions to art and to the understanding (or redefinition) of woman. As *Hero* further reminds us, work in an ideal or mythic mode, which by definition might seem removed from contemporary concerns, in fact permits the artist to emphasize precisely those issues that most concern her. In this case, a woman artist's sculptural representation of a nude woman from an ancient narrative permits her to reject contemporary cultural constructions of female nature and replace them with those that emphasize strength, activity, and power.

NOTES

All photographs are by the author, and except for the first, which is taken from the original bronze, all are taken from contemporary illustrations in annual numbers of *Academy Architecture and Architectural Review,* ed. Alexander Koch (London:

Academy Architecture). The present owners and location of all works illustrated, except *Hero,* are unknown to the author. I would like to thank Peyton Skipwith of the Fine Art Society, London, for introducing me to the sculpture of Giles, and Duncan Robinson of the Center for British Art, Yale University, for his encouragement and valued advice.

1. See Susan Beattie, *The New Sculpture* (New Haven and London: Yale University Press, 1983), Benedict Read, *Victorian Sculpture* (New Haven and London: Yale University Press, 1982), and Charles Avery and Madeleine Walsh, "The Bronze Statuettes of the Art Union of London: The Rise and Decline of Victorian Taste in Sculpture," *Apollo* 121 (May 1985): 328–37.

2. Grant M. Waters, *Dictionary of British Artists Working 1900–1950* (Eastbourne: Eastbourne Fine Art, 1975); Leonard Forrer, *Biographical Dictionary of Medallists . . . B.C. 500–A.D. 1900,* 8 vols. (London: Spink & Son, 1904), 2:267.

3. Chris Petteys, *Dictionary of Women Artists: An International Dictionary of Women Artists Before 1900* (Boston: G. K. Hall, n.d.), 281.

4. *Who Was Who, 1941–1950* (London: Adam & Charles Black), 602.

5. Beattie, *New Sculpture,* 245.

6. "Exhibition of Students' Work at South Kensington," *The Studio* 1 (1893): 208; "The Arts and Crafts Exhibition, 1893," *The Studio* 1 (1893): 10.

7. "Studio Notes," *The Studio* 6 (1896): 120. *The Studio* lists the artist as "W. Giles," which I take to be a misprint for M. Giles.

8. Beattie, *New Sculpture,* 245.

9. K. K. Yung and M. Pettman, *National Portrait Gallery Complete Catalogue, 1856–1979* (New York: St. Martin's, 1981), 348, 316.

10. Beattie, *New Sculpture,* 195.

11. Beattie, *New Sculpture,* 195.

12. For Levick, see T. Martin Wood, "A Decorative Sculptor: Miss Ruby Levick (Mrs. Gervase Bailey)," *The Studio* 34 (1905): 100–107.

13. Beattie, *New Sculpture,* 196.

14. Beattie, *New Sculpture,* 195–96.

15. J. T. Boulton, ed. (London: Routledge & Kegan Paul, 1958), 58.

AMY KORITZ

SALOMÉ

Exotic Woman
and the Transcendent Dance

The most popular representation of Salomé in pre–World War I England was not the notorious play by Oscar Wilde, nor even Richard Strauss's operatic version of it, but a music-hall number performed by a now largely forgotten precursor of modern dance named Maud Allan. The conception and reception of her version of the story and the character illustrate the contradictory nature of dominant views of female sexuality in late Victorian and Edwardian England, particularly in the polarized dichotomy between woman as spiritual ideal and as bestial Fatal Woman. Further, the thematics of the critical response to Allan's *Salomé* repeat this dichotomy in other terms: the physical and sensual nature of the dancing body is opposed not only to the spiritual but also to music and to emotion. The presence of analogous oppositions in both Wilde's and Strauss's claims about their works and the critical reception of their versions of the story suggests that the cultural significance of Salomé and her dance transcends any one of these works. This essay will trace this significance in terms of the presence and evasion of female sexuality as represented in the character of Salomé and, especially, in her dancing body. Beginning with Wilde's *Salomé,* my analysis of this figure and her dance explores the possibilities for transcending the dichotomy between the physical and the spiritual in the representation of Salomé, and also assesses the cultural importance of maintaining the dichotomy.

Although Wilde's *Salomé* can be read as an attempt to conceptualize the unity of the spiritual and the physical, few readers have taken this approach.

In both recent and early commentary on Wilde's drama, critics have empha-
sized the sexuality of Salomé, generally containing her within the stereotype
of the Fatal Woman. Wilde, in contrast, attempted repeatedly to suggest a
highly aestheticized, symbolic reading of her character and the play as a
whole. His failure to persuade his readers of this symbolist interpretation of
the play can be explained by their needs, and their culture's needs, both to
evade and to confirm the power and the threat of the exotic woman. Strauss
faced much the same problem in relation to his operatic version of Wilde's
text. Allan's music-hall dance, however, seemed capable of eliciting both a
sexualized and an aestheticized response. Reactions to her version of Salomé
exhibit most clearly the cultural need to address—yet contain—the dichot-
omy that assigned women to the mutually exclusive realms of the sexual and
the spiritual.

*W*ilde's *Salomé* has persistently provoked critics to meditations on the
perverse. From its publication in the original French in 1893, the play inspired
responses such as that of a *Times* critic, who called it "an arrangement in blood
and ferocity, morbid, *bizarre*, repulsive, and very offensive in its adaptation of
scriptural phraseology to situations the reverse of sacred."[1] Even reviewers
sympathetic to the play and opposed to the censor's prohibition of its perfor-
mance, agreed, as Lord Alfred Douglas put it, that "the play is unhealthy,
morbid, unwholesome, and unEnglish."[2] The wisdom of hindsight has had
little effect on this critical attitude, other than to throw the weight of the play's
perversity away from its scriptural content, focusing the critical eye on the
sexuality of Salomé—that cruel beauty whose desire meant death.[3]

According to Mario Praz, "[i]t was Wilde who finally fixed the legend of
Salomé's horrible passion." While Flaubert's Salomé had been the innocent
tool of her mother's hatred of John the Baptist, in Wilde's version she denies
her mother's influence in her desire for his head: "And," Praz comments,
"having obtained the head, she fastens her lips upon it in her vampire pas-
sion."[4] Too frequently more recent critics have likewise kept Salomé encased in
the character of the Fatal Woman. Thus in 1964, Epifanio San Juan, Jr., wrote,
"Salomé's poisonous malice and her careless cruel passion lie at the heart of
Wilde's conception of her character."[5] Christopher Nassar in 1974 declared
that "the thrust of the play is to strip veil after veil from Salomé until she
emerges as a deathly pale terror feeding on the blood-soaked head of a dead
person."[6] Bram Dijkstra, in his impressive 1986 feminist study *Idols of Perver-
sity,* only adds more sophisticated psychoanalytic and materialist dimensions—
as well as a good deal of irony—to a reading of her character that remains
essentially unchanged: "The spectacle of Salomé's bestial passion makes Herod
shiver. . . . But the outrages of feminine desire continue. In a passage in which

Wilde directly equates semen and the blood which feeds man's brain, Salomé, Woman, the vampire hungry for blood, tastes the bitter seed of man, depredates the spirit of holy manhood."[7] Even those readings of the play that emphasize its symbolic structure or intellectual basis, such as those of Richard Ellman and Nicholas Joost and Franklin E. Court, do not go far enough in challenging the simple enclosure of Salomé in the realm of the flesh.[8]

The traditional critical stance that sees Salomé first and foremost as the Fatal Woman also constructs the reader as a participant in a conception of sexuality that in its obsessive repetition perpetuates rather than questions a misogynist tradition. It seems therefore imperative to open up the character of Salomé to alternative constructions.

When Mario Praz delineated the relationship of the Fatal Woman to the exotic, he laid the groundwork for one such alternative. Those figures that best fit his stereotype are also those "more highly penetrated with aestheticism and exoticism," such as, inevitably, the Oriental princess Salomé. Further, exoticism for Praz is so closely tied to the erotic that "a love of the exotic is usually an imaginative projection of a sexual desire."[9] This intertwining of the exotic and the erotic, or in Edward Said's terms, of the Orient and sexuality, constitutes a persistent element in the Western discourse of Orientalism. But the Orientalist conception of the East also, according to Said, "tends to be static, frozen, fixed eternally." It is this static conception of the Orient that gives rise to such clichés as "the wisdom of the East."[10] In noting that both pervasive sexuality and static eternality characterize Western stereotypes of the Orient and the Oriental, Said points to a tension that surfaces in Praz as well. Praz names these two sides of the Orient the "exotic," which is sensual and erotic, and the "mystic," which is transcendental and eternal. Wilde's Salomé, we shall see, fits both of these categories.

Because the Fatal Woman figure seems to rest so securely in the exotic and Salomé so firmly in the category of the Fatal Woman, Wilde's character has also been assumed to belong here—but she is, in fact, as much a mystic as an exotic. According to Praz, both the exoticist and the mystic start "from the same sensual basis" and "transfer the fulfillment of their desires to an ideal." But while the mystic

> projects himself outside the visible world into a transcendental atmosphere where he unites himself with the Divinity; the [exoticist] transports himself in imagination outside the actualities of time and space, and thinks he sees in whatever is past and remote from him the ideal atmosphere for the contentment of his senses.[11]

In Wilde's play, it is Salomé's mission to accomplish both ideals, a complexity that explains why Wilde himself called Salomé "a mystic, the sister of Salammbô, a Sainte Thérèse who worships the moon."[12]

Wilde's *Salomé* stymies Praz, for it seems to him to be a childish "parody of the whole of the material used by the decadents," and he can account for its popularity only by positing a massive, if predictable, lapse in taste: "[A]s generally happens with specious second-hand works," he writes, "it was precisely Wilde's *Salomé* which became popular."[13] Although condemning the public for their failure to corroborate a critic's aesthetic intuitions constitutes an appeal to authority rather than to reason, the weakness of Praz's reading lies not so much in its elitism as in the way he delineates his interpretive categories. Yet Praz is less reductive in his use of these categories than many other critics, for he recognized a tension in the relationship between Wilde's Salomé and the Fatal Woman stereotype, thus reading her as a failed or parody exotic—while scholars such as those already quoted place her uncritically within the stereotype.

Wilde himself can be quoted both for and against the Fatal Woman reading of Salomé.[14] This factor by itself should open to question the easy characterization of Salomé as an evil, castrating vampire, or, to give the same figure its feminist twist, either an antipatriarchal sexual terrorist or a victim of a compensatory ideology that gives women sexual power while refusing them economic and political power. The foregrounding of female sexuality required by readings of the play that emphasize Salomé as a stereotypical Fatal Woman, even if they emphasize the subversive potential of that figure, reduces the range of desires and challenges attributable to her, in effect containing her within the relatively safe confines of her biology. After briefly summarizing the action of the play, I will offer an alternative to these readings.

The opening scene presents the observations and desires of secondary characters—soldiers, a Young Syrien, the Page of Herodias. We learn that the Syrien is infatuated with Salomé, while the Page languishes for him. The first appearance of a major character—a purely verbal representation—occurs through the Syrien's description of Salomé. The first speech by a major character comes from "The Voice of Iokanaan," who, like Salomé, also has no physical presence at this point in a performance of the play. Unlike Salomé, who is seen before she is heard, Iokanaan is first heard. Salomé leaves Herod's banquet, hears and is intrigued by the voice of Iokanaan, and desires to see him. She convinces the Syrien to release him from the cistern where he is imprisoned. The attempted seduction of Iokanaan by Salomé leads to the first death of the play—the suicide of the Syrien. Next Herod enters in search of his stepdaughter, followed by his guests. Over the objections of Herodias, he asks her to dance for him. She refuses. He repeats his wish, finally promising to give her anything she wishes in return. Salomé then agrees to dance, disobeying her mother, and Wilde's stage direction states, "*Salomé danse la danse des sept voiles*" (Salomé dances the dance of the seven veils)[15] In exchange for the dance she will accept nothing but the head of Iokanaan; so, after fruitless attempts to

negotiate, Herod is forced to permit his execution—the second death of the play. Salomé's speech to the head of Iokanaan motivates Herod to leave the scene, and he orders that Salomé be left in complete darkness. From this darkness she claims that she has kissed Iokanaan. A moonbeam falls on her. Herod turns, sees Salomé, and orders her death. The soldiers crush her with their shields—the third death and final action of the play.

Salomé's invisible kiss of Iokanaan's severed head has attracted fantastic extensions of the play's text in the minds of readers. Images of Salomé sucking the blood-soaked lips of the Baptist, like images of the "frenzy of Salomé's dance"[16] imported into Wilde's laconic stage direction, derive from the cultural and conceptual presuppositions readers bring to the play.

The play's action is carefully patterned around an opposition between the visible and the audible. As noted, Salomé is seen before being heard, while Iokanaan is heard before being seen. Salomé is constantly visible to some character throughout the play—making her invisibility at the moment of the presumed kiss all the more striking—while Iokanaan often speaks without being visible. This pattern expresses the opposition between the word, that audible manifestation of the spirit, and the body, that visible manifestation of the material, the sexual, and the "natural."

The importance of this opposition is emphasized by the fact that two of the three deaths in the play directly respond to perceived threats to it. The Syrien's suicide is clearly an act of division, an attempt to halt the incursion of the body into the place of the spirit. He begs Salomé not to look at Iokanaan, but also he supplicates: "Ne lui dis pas de telles choses. Je ne peux pas le souffrir. . . . Princesse, princesse, ne dit pas ces choses" (Do not say such things to him. I cannot bear it. . . . Princess, Princess, do not say those things). And Salomé responds: "Je baiserai ta bouche, Iokanaan" (I will kiss your mouth, Iokanaan). Immediately thereafter, the Syrien kills himself, and Wilde provides the following stage direction: "*Il se tue et tombe entre Salomé et Iokanaan*" (He kills himself and falls between Salomé and Iokanaan) (31). Although one might dismiss this scene as a simple case of sexual jealousy, attention to the pattern of oppositions under discussion suggests that Salomé's behavior poses a more profound threat: the female body, ideally a mute object of the male gaze and male desire, attempts to usurp the male prerogative of the voice and use it from her own position (that of the body) for her own ends. The real dangers Salomé represents for the men in this play are not those consequent on desiring a Fatal Woman (a desire indicated in the play by their gaze) but rather those posed by her threatening the invidious distinction between the object of the gaze and the disembodied voice.[17] The exotic princess Salomé is no longer only the object of sexual desire; she has demanded possession of the mouthpiece of God. She, like the mystic, seeks a unity with divinity.

Salomé's own death follows a second attempted transgression of the separation between body and spirit. Her final speech occurs in complete darkness, and the prefix Wilde gives it parallels those given to Iokanaan's speeches from the cistern: "The Voice of Salomé." From the silent physicality in which she entered the play, Salomé has moved to the opposite pole, that of Iokanaan's invisible voice. She has, at this moment, moved figuratively outside the physical world, but her speech paradoxically concerns a woman's physical possession of a man: "Ah! j'ai baisé ta bouche, Iokanaan, j'ai baisé ta bouche" (I have kissed your mouth, Iokanaan, I have kissed your mouth) (81). Physical desire speaks from the place of the spirit. Salomé the exotic has here usurped the position of the mystic—she has colonized the spiritual realm for sensual ends. But this alone does not cause her death. Only after her return to visibility—a moonbeam reveals her once more to Herod's gaze—does he order her death. Salomé must die not because she has spoken from the place of the spirit but because she has done so without relinquishing (as if she had the choice) the place of the body.

While the threat posed by Salomé is most frequently understood in terms of female desire and sexuality, her challenge is in fact not simply sexual. Her actions reorient the relationship between the material and the spiritual. That is, the head of Iokanaan, rather than being a poor substitute for his penis, is a poor substitute for his voice—and for the authority and spirituality it represents. Her possession of his head seems to imply that the voice can be subsumed by the body, thus making it something to be looked at rather than listened to, which, in terms of the gender-schema established by the play, also makes Iokanaan into something feminine—the object rather than the bearer of the gaze. The challenge presented by this reversal has far greater implications than the Fatal Woman's threat to male virility and self-esteem, for it also challenges the foundations of that self-esteem: the greater prestige and power of male speech (associated with divinity) over the female body (associated with biology) are shaken by that body's insistent desire to possess that speech. The silent sexuality of Salomé and the invisible voice of Salomé mark the extremes of her movement between the exotic and the mystic, the sexual and the spiritual, just as her death marks the final consequences of her attempt to unite them, to disrupt an order founded on their separation.

The attempt to possess a voice by acquiring the head from which it emerged is at best a quixotic gesture toward an implicitly unattainable ideal. A woman, least of all a sexually desirable woman, cannot be a prophet as well. She cannot so easily escape her identity as object of the male desiring gaze. Nor can she create a mysticism that will share her own physicality—that will speak the spirit from the place of the body. Praz's unexamined assumption that these categories are mutually exclusive expresses precisely the dilemma, the tragedy, and the challenge of Salomé. An exotic woman imprisoned by

our culture's stereotypes of the Orient and the Fatal Woman truly lacks the power to speak as a prophet of God.

In his criticism, Wilde plays out this dilemma on the philosophical level of the split between the objective and the subjective. In a letter to Lord Alfred Douglas he writes, "I had taken the Drama, the most objective form known to art, and made it as personal a mode of expression as the Lyric or the Sonnet, while enriching the characterization of the stage, and enlarging—at any rate in *Salomé*—its artistic horizon" (*Letters*, 589). In 1897 Wilde thus expressed the need for art to establish continuity between the individual psyche and the least individualized mode of artistic representation—in other words, the need for art to bridge the distance between subjective isolation and the commonality of objective forms. Earlier in the same letter he had reminded Douglas, "One can really, as I say in *Intentions*, be far more subjective in an objective form than in any other way." The pertinent passage in *Intentions* seems to be from the second part of Wilde's dialogue, "The Artist as Critic," in which Gilbert explains that "the real artist is he who proceeds, not from feeling to form, but from form to thought and passion," for in art, though not only in art, "the body is the soul."[18] Thus, although his readers cannot see Salomé as anything except body, Wilde could imagine her equally as soul.

Yet, as suggested, Salomé's desire for the head of Iokanaan is on one level the story of her failure to attain this relation between body and soul. To the extent that Salomé does not achieve unity with Iokanaan, she remains trapped in the physical. This is not completely so, however, for if the severed head of Iokanaan is the image of Salomé's failure to unify body and soul, her dance is the image of her success.

The dance, in Wilde's text, might be thought of as purely objective—it is physical, silent, an object of the gaze—the opposite of Iokanaan's prophetic voice or Herod's oath. This positioning of the dance, however, depends on accepting its relation of opposition to these uses of the voice. Rather, the oath and the dance are as much equivalent as opposite. Salomé dances in exchange for the word of Herod that he will give her whatever she wishes. The dance and the word form a transactional unity; they become commodities through which the relationship between Herod and Salomé is mediated. Insofar as the dance and the word become equivalents, the binary opposition that kept them apart is undermined. It is further weakened by Wilde's refusal to provide any description of the dance in his text; any concrete sense of its form, length, or style is elided in the one-sentence stage direction, "*Salomé danse la danse des sept voiles.*" That this exclusion was deliberate is clear from Wilde's inscription of a copy of the play to Aubrey Beardsley: "for the only artist who,

besides myself, knows what the dance of the seven veils is, and can see that invisible dance" (*Letters,* 348). Wilde again undercuts the polarization of the body and the soul, for the textual absence of the dance in effect spiritualizes the most purely physical moment of the play, just as the moment of the kiss is spiritualized by its invisibility.

In performance, of course, this subversion would not necessarily be evident,[19] and the question of whether Wilde wrote the play to be performed has been controversial. Robert Ross and Lord Alfred Douglas claimed that performance was not intended. Ross is vehement on the subject and singles out performances of the dance as particular abuses of Wilde's intentions: "Salomé was *not* written for Madame Sarah Bernhardt. It was *not* written with any idea of stage representation. . . . In no scene of Wilde's play does Salomé dance around the head of the Baptist, as she is represented in music-hall turns."[20] Wilde did not appear averse to its performance, however, particularly with Sarah Bernhardt as Salomé (*Letters,* 335–36), although he insisted that "the actable value of a play has nothing to do with its value as a work of art" (*Letters,* 310).[21] The difficulty of performing an invisible dance is no reason to reject the importance of its conceptual implications. Indeed, Wilde's aesthetic goal of unifying subjective expression and objective form applies uniquely to dance. The most physical or objective of the arts, dance may also be considered the most individual and subjective, since it is inseparable from, in the case of Salomé, the creation of its performer. In dance, then, the realization of an aesthetic ideal of "unity of being" in which "the body is the soul" becomes possible. As Frank Kermode has argued,[22] this aspiration to unity defines the poetic image as it emerges in symbolist and modernist writing, and its figurative expression often takes the form of the dance and the dancer. In terms of this aesthetic, the dance of Salomé becomes the utopian moment of the play, representing a unification of a physical, objective form with pure subjectivity.

But an inability to imagine Salomé's spiritualized dance characterizes its representation and reception and indicates the difficulty of abstracting this figure from her historic and cultural meaning as a sexually aggressive woman. The elements of sexual provocation in the dance, along with religious and sexual transgression in the narrative, make her a magnet attracting cultural anxieties over the place and nature of women in the face of feminist challenges. There are thus good reasons why Wilde's characterization of his play as a "beautiful coloured, musical thing" (*Letters,* 492) has not been persuasive. Linda Dowling delineates one manifestation of this anxiety in the tendency of late Victorian critics to identify the New Woman and the decadent, and to see in both a threat to culture, state, and the survival of the race, for "in a cultural context of radical anxiety, the decadent and the New Woman were twin apostles of social apocalypse."[23] The power of such concerns is further

evidenced by the ineffectuality of institutional forces in suppressing its representations, as is clear from the history of the first British production of Richard Strauss's opera *Salomé,* which uses a condensed version of Wilde's text (in German) for its libretto.

Thomas Beecham, who produced the British premiere on 8 December 1910, had sought the intervention of Asquith, then prime minister, to circumvent the otherwise inevitable banning of the opera by the Lord Chamberlain. In order to make its performance possible, Beecham collaborated with the censor to excise from the script those elements thought offensive to British morals, and he required the singers to learn this new version of the opera. Beecham reports that, among other changes, the text now omitted the name of John the Baptist, and "the mundane and commonplace passion of the precocious princess was refined into a desire on her part for spiritual guidance."[24] Of course, the head of the Prophet could not appear on stage, and Salomé sang her finale to a cloth-covered platter. The cast had dutifully learned the new script but half an hour into its performance began to slip back "into the viciousness of the lawful text"; Beecham, who was conducting, was powerless to stop them. To his amazement, however, the Lord Chamberlain congratulated him after the performance "for the complete way in which you have met and fulfilled all our wishes."[25]

The reception of this bungled attempt to purify *Salomé* was popularly spectacular and critically mixed. The house was sold out less than one and one-half hours after tickets went on sale. When Beecham added two additional performances to the two originally planned, these sold out as well.[26] It is doubtful that even a successful rendition of the laundered text would have made much difference to its reception, since the story Wilde told was so well known and the decadent connotations of Salomé so strong. The *Times* critic assumed Salomé's "abnormality" and preferred the "solemn utterences of the Prophet" to her "hysterical confessions of fleshly desire and the would-be licentious 'Dance of of the Seven Veils.' "[27] *The Spectator,* in an extremely negative review, criticizes the censor for allowing this "glorification of the erotomania" to take place at all. This critic specifically abhors the heroine's crimes against "womanliness," comparing Strauss's choice of subject unfavorably with that of Beethoven, "who ultimately fixed upon a story of pure and unconquerable womanly devotion for his subject."[28] In a more positive review, Ernest Newman, in *The Nation,* ignores the morality of the subject and concentrates on Strauss's music and the singers' performances.[29]

Strauss was first attracted to the subject by Reinhardt's Berlin production of Wilde's play, at least in part because of its inherent musicality. He wrote in his memoirs, "[T]he dance and especially the whole final scene is steeped in music,"[30] and this quality of Wilde's text has been remarked as well by modern critics.[31] In *"De Profundis,"* Wilde himself drew attention to the

"recurring motifs [that] make Salomé so like a piece of music and bind it together like a ballad" (*Letters*, 475). To emphasize the musicality of a literary work is also to indicate the importance of formal structuring to its aesthetic purpose and to lessen the significance of narrative and discursive content. In such a context the dance is less of an interruption in the action than in a more narrowly dramatic one, and Strauss, in fact, saw it as "the heart of the plot" in *Salomé*.[32] Strauss's dance has appeared to commentators, however, as more of an afterthought: Ernest Newman called it "an obvious 'inset' in the score," and Norman Del Mar, who argues that Strauss composed this music last, wrote that it "is a super-potpourri of the main themes of the opera."[33]

Strauss's emphasis on the musicality of the play was no more successful than Wilde's in distracting performers and viewers from their insistence on its sexual and decadent connotations. He had great difficulty, for example, obtaining the kind of dance he wished to see performed, and the critics inevitably appraised the dance in terms of its "lasciviousness." Strauss insisted that

the capers cut in later performances by exotic variety stars indulging in snakelike movements and waving Jochanaan's head about in the air went beyond all bounds of decency and good taste. Anyone who has been in the east and has observed the decorum with which women there behave, will appreciate that Salomé, being a chaste virgin and oriental princess, must be played with the simplest and most restrained of gestures.[34]

Such a characterization sounds very close to that of Sarah Bernhardt, who according to Charles Ricketts intended to play Salomé without rapid movements and with stylized gestures. He blames the Germans for "the music-hall tigress and blood lust" of subsequent Salomés.[35] There appeared to be such a strong expectation that Salomé would represent the darkest, most fearful side of "female nature" that even the most rigorously decorous intentions could not hold their own against the cultural mythology of the Salomé figure.

This mythology constantly reinforced the depiction of Salomé as a Fatal Woman and overwhelmed the "beautiful coloured, musical thing" that Wilde claimed he was writing. Wilde's own criminal conviction for sexual transgressions further weakened the case for an aestheticized reading of *Salomé*. A striking photograph, reproduced in Richard Ellmann's biography, shows Wilde dressed as Salomé, kneeling and gesturing gently toward a platter on which rests the head of Iokanaan. No aesthetic formalism, no carefully patterned interpenetration of body and spirit, of exotic and mystic, can overcome the play's concrete attack on his society's gender norms implied by that photograph. Likewise, the continual representation of Salomé's dance as a music-hall striptease, the repeated reduction of Salomé to her sexuality, re-

flects this figure's cultural place in the escalating battle over woman's nature and her proper sphere.

The first production of Wilde's *Salomé* took place in Paris, at the Théâtre de L'Oeuvre, in 1896. British performances, held privately to evade the censorship, were given in 1905 and 1906, but it was Max Reinhardt's 1903 Berlin production that inspired the most enthusiastic response.[36] This production was responsible for Strauss's decision to write his opera,[37] first performed in 1905, which, despite a cool critical reception, also became quite popular. Institutional resistance persisted, however, and the attempt to present it in New York at the Metropolitan Opera House failed after the first performance was found objectionable by the board of directors.[38] The British censor stood by his prohibition of the play and refused to permit an unexpurgated production of the opera, but he could not have prevented a dance version of the story from being presented in a music-hall, over which his office had no jurisdiction. This is precisely what happened when, in 1908, Maud Allan arrived at the Palace Theatre with "A Vision of Salomé."

Maud Allan was born in Canada, raised in California, and had been studying music in Germany when she decided to devote herself instead to dance.[39] She had no formal training and relied on the improvisational methods of "barefoot" or "classical" dancing, which were at the time only vaguely defined. Like Isadora Duncan, Allan came from a middle-class family not sufficiently well-off to free her from earning her own livelihood if, as was to be the case, she did not marry. She had artistic ambitions, and since Duncan's German performances just prior to Allan's emergence as a dancer had been well received, she may have seen in Duncan's dancing a likely career for herself.[40] Allan's "Vision of Salomé" was controversial from the start, perhaps intentionally so in order to revive a flagging career and to separate herself from Duncan.[41] She used music composed by Marcel Remy (though reviewers frequently mistook it for authentic oriental music) and dressed herself in a daringly scanty costume of gauze and beads.

Allan's break came in 1907 when she was invited to perform this dance for King Edward VII at Marienbad. From the start, Allan's success relied heavily on the patronage of London's social elite. As a result of her performance for the king, Alfred Butt, manager of the Palace Theatre, arranged for her appearance as a "turn" in a program of typical music-hall acts. Allan would provide twenty minutes of "classical" dancing every evening. Her public debut occurred on Monday, 8 March 1908, but Butt had carefully prepared the press and the public beforehand by presenting a private performance the previous Friday for a select audience of critics and members of London's social, political, and cultural elite. The Saturday papers thus carried reviews, and Butt

excerpted these to provide the text for an advertisement in the Monday papers. Besides the benefit of advance publicity, Allan gained from this performance an immediate social legitimacy, the unquestioned status ensuing from upper-class favor. Butt, however, did not rely on snob appeal alone; he published and distributed a pamphlet describing the charms of her dancing in lurid, quasipornographic language. Although no copies seem to have survived,[42] sufficient passages appear in reviews to indicate the nature of the appeal. A writer in *Truth,* for example, quotes the following description of the Salomé dance:

> Her naked feet, slender and arched, beat a sensual measure. The pink pearls slip amorously about her throat and bosom as she moves, while the long strands of jewels that float from the belt about her waist float languorously apart from the sheen of her smooth hips. . . . The desire that flames from her eyes and bursts in hot gusts from her scarlet mouth infect [sic] the very air with the madness of passion. Swaying like a white witch, with yearning arms and hands that plead, Maud Allan is such a delicious embodiment of lust that she might win forgiveness for the sins of such wonderful flesh. As Herod catches fire, so Salomé dances even as a Bacchante, twisting her body like a silver snake eager for its prey, panting with hot passion, the fire of her eyes scorching like a living furnace.[43]

Butt presents the press, and through them the public, with conflicting messages about Allan's dancing. On the one hand, it is patronized by the highest of high society, both male and female, and thus has an implicit moral seal of approval; on the other, it is risqué, a titillating and dangerous pleasure.

Consequently the wide range of reactions to Allan's Salomé is not surprising. The English public, according to one of the more skeptical critics, "loves to be tickled with anticipation of extreme wickedness and to be horribly disappointed," and this, he believes, accounts for the success of both the dance and the advertising.[44] This review, however, was written several months after Allan's debut, when she was an established celebrity in the midst of an unprecedented run of over two hundred and fifty performances at the Palace Theatre. The reviews written in March were generally favorable, though not as complimentary about the Salomé dance as some of her other pieces. Only after the public had responded enthusiastically, particularly to the "Vision of Salomé," did critics begin writing negative evaluations. These, including an article by Max Beerbohm in the *Saturday Review,* often suggest that her success owes more to the astute manipulation of the media than to her own talent or originality.[45] They also take exception to the Salomé dance—sometimes on the grounds of its immorality, sometimes on the grounds of its triviality. Commenting on this dance, Beerbohm draws attention to the discrepancy between the description given in Butt's publicity

pamphlet and his own experience of the performance—not, as the sympathetic reviewers do, in order to assure the audience of the dance's decorum but in order to criticize Allan's failure to embody the tragedy of its subject:

> Here the thing to be interpreted is no mere interplay of moods, but a grim and definite tragedy, a terrible character, a terrible deed. It is said of Miss Allan's Salomé by an ardent pamphleteer that "the desire that flames from her eyes and bursts in hot gusts from her scarlet mouth infects the very air with the madness of passion." For my own part, I cannot imagine a more ladylike performance.

Beerbohm's reaction to the "Vision of Salomé" sharply contrasts with those of viewers who, like the Manchester Watch Committee, found it offensive. While Beerbohm is concerned not with propriety but with genius, the editor of the *Spectator* concurs with the moral objections raised by a reader, adding in an editorial note, "[T]he taste of the Salomé writhings and contortions is . . . deplorable." He further alludes to Wilde's play as Allan's source, writing,

> Unless we are greatly mistaken, the notion [of Salomé's love for the Baptist] had its origin in the depraved imagination of one whose literary gift was in essence flashy and mechanical, and who cannot rightly be called a poet and a man of letters, unless the notoriety of impudence, scandal and aberration is held to confer that title.[46]

Wilde's "depravity" is also used as a stick to beat Maud Allan by Walter Higgins, who wrote in the *Labour Leader* that the "Vision of Salomé" was "the incarnation of the bestial in Oscar Wilde and Aubrey Beardsley."[47]

On the one hand, the moral outrage provoked by the implicit mingling of sex with religion and exacerbated by the memory of Wilde's sexual transgressions led to Allan's condemnation; on the other hand, her failure to live up to precisely these implications also doomed her to condemnation—thus repeating the double message presented in the advance publicity. Predictably, the vast majority of positive reviews do not mention Wilde, and a more central issue in many of these is not the relation between Wilde's and Allan's Salomé but the relation between her dance and the "authentic" dances of the East.

Since the subject of the "Vision of Salomé" required critics to judge the propriety of Allan's dress and actions, they pay a good deal of attention to the similarities and differences between what she does and "Eastern" dance, with its questionable moral status. A favorable review printed in the *Academy* clearly identified Allan's dance as Eastern, placing it in the genre of "posture-dancing," which, the writer claims, is not Western in origin, having evolved in the East from "the mere provocative posturing of the body." But while he praises her for educating the British public in a form of beauty that "racial

instinct, island prejudice, and national conceit" had hitherto led them to condemn, he simultaneously assures the reader that Allan, being a great artist, does not "slip back into the old and gross appeal" from which this dance arose.[48] With less subtlety, the *Times* critic likewise both raises the specter of Eastern sexual licence and distances Allan's dance from it:

> It is of the essence, of course, of Eastern dancing to show rhythmic movements of the body round itself, so to speak, as a pivot, which means, of course, that it may become, as in the notorious case of the *danse du ventre*, something lascivious and repulsively ugly. Now it is obvious that this dancer could make no movement or posture that is not beautiful, and, in fact, her dancing as Salomé, though Eastern in spirit through and through, is absolutely without the slightest suggestion of the vulgarities so familiar to the tourist in Cairo or Tangier.[49]

Eastern dance is supposedly meant to call attention to the highly sexualized body of a woman, making it "ugly," but Allan's dance is both "Eastern" and "beautiful"—it both alludes to and evades the sexual. The dance expresses the "East" without its sensual physicality, in effect translating it into a "spirit" or "essence" and rendering safe for Western consumption the (supposedly) aggressive sexuality of the Eastern woman. The dancer's body thus mediates between a physical and ideological threat and its redefinition or recuperation on the level of idealized abstraction. Both gender and imperialist ideologies play a role in this process. The prevalent belief in (middle-class) woman's inherently spiritual nature was under attack by the suffragettes' publicly aggressive demonstrations and thus required reinforcement; Salomé was just such an aggressive woman, but Allan's version turns out in the end to be true to "woman's nature."[50] Salomé, however, is not just a woman but an Eastern woman, and thus she represents an alien subject of the British Empire. If, as one historian writes, "the dehumanization of alien peoples . . . was arguably crucial to making imperialism work,"[51] Allan's representation of Salomé was contributing to this project on the home front.[52] First of all, she held out the option of defining the East in opposition to her representation, thus reinforcing stereotypes of barbarism and vulgarity attached to it. Second, and in seeming contradiction to this, her dance embodied for its viewers another East, equally alien, of essential qualities, "the spirit of the East." The contradiction may be better characterized as a dispersal that locates its object at the two poles of primitive nature and disembodied ideal—effectively denying it a place within the realm of the human.

In their treatment of the relationship between the body of the dancer and the dance itself, the critics also frequently treat the dancer's body as a mediator between two nonhuman terms. Many reviewers comment on Allan's ability (or failure) to make music visible, to translate music into movement or,

alternately, to translate emotion into movement. The most striking of these commentaries treat the dancer's body as an instrument. For example, one reviewer explains that Salomé's reaction to John the Baptist's head was conveyed "by the transformation of the whole body into a musical instrument striking that one note"; in the same review, he describes the dance's "marvelously beautiful sinuous movements in which the dancer's will and emotions play upon the lovely instrument of her body to produce what music she will."[53] The *Times* critic was particularly taken with this image, though not explicitly in relation to the Salomé dance. In one review he declared that in Allan's dancing "[t]he music speaks through a new and lovely instrument; there appear to be no rules, no science to come between the music and its expression in movement and gesture."[54] And the following year, he reiterated her ability to translate music into its visible equivalent, imagining "the stage as a vast keyboard from which the notes should be actually called forth by skillful feet."[55] The reviewer for *Truth* was impressed with her expression of emotion, praising the "Vision of Salomé" for "the extraordinary way in which the dancer can express emotion with every movement."[56]

Negative reviews likewise assume the importance of this ability to translate from one mode to another. Christopher St. John criticizes Allan precisely for failing to "translat[e] beautiful sound into beautiful form."[57] Beerbohm complains that her movements are pretty but meaningless (in other words, that the translation has not been successful), and Titterton objects to the "Vision of Salomé" because its movements do not seem to convey authentic emotion: "I cannot imagine anything more immoral and less artistic than this intoxication hammered out cold."[58]

Although translating music and translating emotion into bodily movement are two different tasks, both translations make something nonmaterial and invisible into something material and perceptible. The audience thus can experience the former on a level it does not by nature inhabit. The dancer's movements make visible the music or emotion that the dance should communicate, without intruding her personality, her idiosyncrasies, her sexuality. The dancer's body should not, therefore, call undue attention to itself but should function like a transparent signifier, an innocent instrument of a greater power, a field on which the unity of incommensurates might be imagined—where music becomes visible and the intangible becomes definite. Although it is the purely physical presence of the dancer's body that mediates this unity, its successful accomplishment depends on the erasure of that presence at the moment it fulfills its function. That body is, insofar as it draws attention to itself, an intrusion, an alien presence in the dance.

Both essentializing the East and erasing the mediating body reinforce the positioning of the dance as a transcendent expression of some higher, because

less material, realm. This process of abstraction is, as Lukács wrote of the use of the exotic in nineteenth-century literature, "a negation of the present."[59] That is, the "Vision of Salomé" evades, and thus negates, both the historically specific reality of the Orient in which it is supposedly set and the body of the woman who performs it. For most critics, and for Allan herself, this dance becomes an occasion for reinforcing representations of the Oriental and of woman's nature that dehumanize and dehistoricize them. Such a representation of women's nature is clearly evident in Allan's discussions of women's suffrage and the Salomé dance in her 1908 autobiography, *My Life and Dancing*, written to commemorate her two-hundred-and-fiftieth performance at the Palace Theatre.

"Woman," Allan wrote in her autobiography, "should be the refining, the inspiring, the idealising element of humanity." Her role is to elevate the men and children in her life through beauty, and, "with woman swaying man to nobler and loftier ideals, the world will move to higher things, and humanity progress nearer divinity." Allan expresses these convictions in a chapter that explains and justifies her opposition to women's suffrage. Women, she argues, are by nature or training unsuited to political life and action; they are overly emotional, indifferent to principles, easily swayed by personalities. "Careful weighing of evidence," she argues, "exhaustive analysis free from emotional bias, is antagonistic to our instincts."[60] Her statement of faith in antisuffrage assumptions about woman's nature and proper sphere[61] was perhaps essential to Allan's success in society, if not in art. She was accepted into important political and social circles, most significantly that of the Asquiths, whose patronage added considerably to her wealth and whose sympathies were not with the suffragettes.[62]

Allan's chapter on Salomé, which follows the discussion of suffrage, seems to treat the character as a naturally spiritual and innocent child, sharing those qualities Allan had used to characterize true womanhood. But the ambivalent, or perhaps disingenuous, nature of Allan's own description of the dance enacts the same double movement between the sexual connotations and spiritual "actuality" of the dance found in the publicity and the reviews. Allan presents Salomé as a young girl, fourteen years old, whose secluded life has kept her innocent of the world. She knows only Oriental luxury and her duty to obey her parents. Thus when word comes from Herod that she is to dance, she does so—"blind to the circle of inflamed eyes that devour her youthful beauty."[63] Her request for the head of John the Baptist comes from her mother, and Salomé, terrified by her prize, runs away panic-stricken to her room. It is at this point in the narrative that Allan added a second dance, the dance for which the whole of her performance is named the "Vision of Salomé." Compelled by a mixture of remorse, fear, longing, and some unnamed but irresistible force, Salomé reenacts the events leading up to John

the Baptist's death and seeks out his head. She dances with the head, and the spiritual power it represents "makes of little Salomé a woman":

> Now, instead of wanting to conquer, she wants to be conquered, craving the spiritual guidance of the man whose wraith is before her; but it remains silent! No word of comfort, not even a sign! Crazed by the rigid stillness, Salomé, seeking an understanding, and knowing not how to obtain it, presses her warm, vibrating lips to the cold lifeless ones of the Baptist! In this instant the curtain of darkness that had enveloped her soul falls, the strange grandeur of a power higher than Salomé has ever dreamed of beholding becomes visible to her and her anguish becomes vibrant.[64]

By proclaiming Salomé's innocence and her purely spiritual hunger in language that sexualizes her spiritual submission and awakening, Allan codes the spiritual as a version of female sexuality—uncontrollably masochistic, begging to be dominated.

But Allan either did not see or refused to acknowledge the sexual content of her narrative, claiming again in 1918 that Salomé's attraction to the head of John the Baptist was purely spiritual.[65] In fact, her construction of the dance and the narrative it expressed shifted the emphasis of the dance of Salomé from the provocation of desire to its expression: from being a dance desired by Herod but used by Salomé or her mother for ulterior ends, it becomes a dance expressing Salomé's personal desire (whether spiritual or not) for John the Baptist. In addition, the kiss in Wilde's play is in Allan's version enacted in dance and made visible to the audience, thus magnifying its eroticism.

The sexuality of Salomé is inescapable, making inevitable the persistent denial and condemnation of that sexuality by both artists and audiences. Allan's allegory of aggressive female sexual desire as a spiritual awakening (whether or not it was consciously conceived as such) embodies the inherent contradiction of an ideology that divided female sexuality in two, containing one extreme by spiritualizing it and its opposite by relegating it to the bestial nature of an Oriental (or working-class, or demonic) Other.[66] In contrast to Wilde's *Salomé,* which managed to represent only one side of this dichotomy for his audience despite authorial and textual support for a more complex interpretation, "A Vision of Salomé" was extraordinary in its ability to represent both of these sexualities at once, while not threatening their polarity. It embodied the masochistic self-denial that allows a spiritualized Salomé to become the subject of a higher power, or a self-effacing instrument for translating music into movement, as Allan herself became in the eyes of critics. And it conveyed the sadistic sexuality of the Fatal Woman, the Oriental princess whose desire means death. The threat of this latter representation is

in turn neutralized by its absorption into an imperialist ideology that dehu-
manizes the Oriental and distinguishes Allan's dance from that alien sexuality
in order, once again, to evade the female body of the dancer—translating it
this time into the "essence" of the East.

Readings of the Victorian and Edwardian Salomé that ignore her "spiri-
tual" aspect—that align her with a single pole in a dualistic conception of
female nature—neglect the complex ideological maneuvering that surround-
ed this figure. Wilde's and Strauss's failure to make the British public see a
Salomé different from the bestial, oversexed Fatal Woman demonstrates the
power of that stereotype. Their attempt to transcend it suggests, however, the
emergence of alternatives to the dualistic system that had so far governed
Salomé's representation. Allan's success in inhabiting both a sexualized and a
spiritualized femininity, while maintaining the polarity of the sexual and the
spiritual, might be seen as a "solution" to the problem of placing women
within an ideological system increasingly under pressure. Allan as Salomé
both is and is not a "good" woman; she both is and is not a sexual woman.
She transcends, yet remains defined by, the terms of this dualistic ideology.
Allan's depiction of Salomé and the popular response it engendered speak to
both the power and the instability of Victorian and Edwardian constructions
of female nature.

NOTES

1. Karl Beckson, *Oscar Wilde: The Critical Heritage* (New York: Barnes and Noble, 1970), 133.

2. Beckson, *Oscar Wilde,* 139.

3. Wilde wrote *Salomé* in 1891. In June 1892, the censor banned a production then under rehearsal with Sarah Bernhardt as Salomé—ostensibly because it portrayed biblical characters. See *The Letters of Oscar Wilde,* ed. Rupert Hart-Davis (New York: Harcourt Brace & World, 1962), 316 (hereafter cited parenthetically in the text as *Letters*). Wilde then published the play—in French in 1893 and in English in 1894. For the composition and publishing history of the play, see Rupert Hart-Davis's notes in his edition of *Letters,* 305, 326, 344; see also Richard Ellmann, *Oscar Wilde* (New York: Knopf, 1988), 339–45, 374–76, and on the English translation, 402–4.

4. Mario Praz, *The Romantic Agony,* trans. Angus Davidson, 2d ed. (London: Oxford University Press, 1970), 312–13.

5. Epifanio San Juan, Jr., *The Art of Oscar Wilde* (Princeton: Princeton University Press, 1967), 21.

6. Christopher S. Nassar, *Into the Demon Universe: A Literary Exploration of Oscar Wilde* (New Haven: Yale University Press, 1974), 82.

7. Bram Dijkstra, *Idols of Perversity: Fantasies of Feminine Evil in Fin-de-Siècle Culture* (New York and Oxford: Oxford University Press, 1986), 398.

8. Nicholas Joost and Franklin E. Court, in "Salomé, the Moon, and Oscar

Wilde's Aesthetics: A Reading of the Play," *Papers on Language and Literature* 8 (Fall 1972): 96–111, recognize the importance of reconciling the spirit and the flesh for Wilde and treat Salomé as a victim of this dichotomy. Richard Ellmann, however, despite his reading of the play as an intellectual encounter between the Paterian and the Ruskinian sides of Wilde, assumes that Salomé is a "villainous" woman of "perverse sensuality"; "Overtures to *Salomé*," in *Oscar Wilde: A Collection of Critical Essays,* ed. Ellmann (Englewood Cliffs, N.J.: Prentice Hall, 1969), 75, 90. Two important exceptions to this reading are found in Jane Marcus, "Salomé: The Jewish Princess Was a New Woman," *Bulletin of the New York Public Library* 78 (Autumn 1974): 95–113, and Regenia Gagnier, *Idylls of the Marketplace: Oscar Wilde and the Victorian Public* (Stanford: Stanford University Press, 1986). Gagnier regards the play as an attempt to confront the Victorian public with their own repressed sexuality by portraying, in Salomé, a nonpurposive sexuality—"sex for sex's sake" (165). Gagnier's discussion is particularly useful in its acknowledgment of how Wilde's own unproductive (homosexual) sexuality contributes to the play. She also provides an excellent rebuttal to Ellmann's argument for placing Herod at the center of the play (in "Overtures to Salomé" and in his biography *Oscar Wilde*).

 9. Praz, *The Romantic Agony,* 205, 207.

 10. Edward W. Said, *Orientalism* (New York: Random House, 1979), 188, 207, 208. Linda Nochlin, in "The Imaginary Orient," *Art in America* 71 (May 1983): 119–31, 186–91, notes the ahistorical quality of representations of the Orient (in the context of French nineteenth-century Orientalist painting) and also analyzes the element of erotic fantasy informing many of these paintings.

 11. Praz, *The Romantic Agony,* 210–11.

 12. Charles Ricketts, *Oscar Wilde: Recollections* (London: Nonesuch, 1932), 51–52.

 13. Praz, *The Romantic Agony,* 312, 316.

 14. The best example of this double attitude toward Salomé can be seen in Carrillo's recollections of Wilde's conversations about the character—at times, "[h]er lust must be an abyss, her corruptness, an ocean"; at other times, "his Salomé was almost chaste. . . . Her beauty has nothing of this world about it"—in *Oscar Wilde: Interviews and Recollections,* ed. E. H. Mikhail, 2 vols. (London: MacMillan, 1979), 195.

 15. *Salomé,* in *The Works of Oscar Wilde* (1908), ed. Robert Ross, 15 vols. (London: Dawson, 1969), 2:66 (hereafter cited parenthetically in the text by page number).

 16. San Juan, Jr., *The Art of Oscar Wilde,* 128.

 17. In analyzing the position of women in performance, feminist film critics have developed the concept of the male gaze to name a major structuring device in this positioning. In "Is the Gaze Male?," *Powers of Desire: The Politics of Sexuality,* eds. Ann Snitow, Christine Stansell, and Sharon Thompson (New York: Monthly Review Press, 1983), 309–27, E. Ann Kaplan modifies the ahistorical argument first presented by Laura Mulvey to explain the male-centered manipulation of point of view in film. For Kaplan, the filmic positioning of women as "objects-to-be-looked-at" represents a culturally specific manifestation of polarized gender roles in which the male is

dominant and the female submissive (319). Particularly relevant to my point is Kaja Silverman's discussion of the threat posed by a disembodied female voice to a system that identifies the female subject with her body, in "Dis-Embodying the Female Voice," *Re-vision: Essays in Feminist Film Criticism,* eds. Mary Ann Doane, Patricia Mellencamp, and Linda Williams (Frederick, Md.: American Film Institute, 1984), 131–49. Although Silverman analyzes this threat in Lacanian terms, and specifically in relation to narrative cinema, the desire to position the female body "in ways which are accessible to the gaze and . . . [which] attest . . . to dominant values" (135) does not depend on this conceptual system, nor is it limited to narrative film. See also Teresa de Laurentis, *Alice Doesn't: Feminism, Semiotics, Cinema* (Bloomington, Ind.: Indiana University Press, 1984), who argues for greater "awareness that spectators are historically engendered in social practices" (156).

 18. Oscar Wilde, *The Artist as Critic: Critical Writings of Oscar Wilde,* ed. Richard Ellmann (Chicago: University of Chicago Press, 1969), 398, 399.

 19. When Robert Wilson staged Strauss's *Salomé* in Milan in 1987, he substituted for this dance, which the reviewer for the *New York Times* considers "an embarrassment in most . . . productions," a "gradual banishment of the darkness" to represent "Salomé dropping her veils"; John Rockwell, "Opera: 'Salomé' in Milan, Staged by Robert Wilson," *New York Times* 13 January 1987, 20.

 20. Robert Ross, "Note on 'Salomé,' " *Salomé: A Tragedy in One Act Translated from the French of Oscar Wilde with Sixteen Drawings by Aubrey Beardsley* (London: John Lane, 1934), viii.

 21. Ross seems to be referring specifically to the Salomé dance of Maud Allan and her imitators. For Douglas's opinion, see his 1893 review in *The Spirit Lamp,* reprinted in Beckson, *Oscar Wilde.* Francis Winwar, *Oscar Wilde and the Yellow Nineties* (New York: Harper, 1940), 205, claimed that Wilde was eager to have it performed.

 22. Frank Kermode, *Romantic Image* (London: Routledge and Kegan Paul, 1957).

 23. Linda Dowling, "The Decadent and the New Woman," *Nineteenth Century Fiction* 33 (March 1979): 447.

 24. Thomas Beecham, *A Mingled Chime: An Autobiography* (New York: Putnam's, 1943), 169.

 25. Beecham, *A Mingled Chime,* 171, 172.

 26. Alan Jefferson, *The Operas of Richard Strauss in Britain, 1910–1963* (London: Putnam, 1963), 46, 49; and Beecham, *A Mingled Chime,* 172.

 27. "Music: Strauss and 'Salomé,'" *Times,* 10 December 1910, 12e.

 28. "Music: Salomé," *The Spectator* 24 December 1910, 1136, 1135. It should be noted that less than one month prior to this performance militant suffragettes had marched on the House of Commons, on what became known as Black Friday (18 November 1910). Over one hundred women were arrested and several were seriously injured (two of whom died); see Antonia Raeburn, *The Militant Suffragettes* (London: Michael Joseph, 1973), 246. Women had for the past five years shown themselves increasingly and violently unwilling to accept the role of "womanly devotion" praised by *The Spectator,* and its attack on a performance portraying a woman aggressively pursuing her own desires should not be abstracted from the real aggressiveness

women were exhibiting in pursuit of the vote. The editor of *The Spectator,* St. Loe Strachey, was an antisuffragist who "often produced helpful editorials" for the Antis; see Brian Harrison, *Separate Spheres: The Opposition to Women's Suffrage in Britain* (London: Croom Helm, 1978), 118, 153.

29. Jefferson, *The Operas of Richard Strauss,* 48.

30. Richard Strauss, *Recollections and Reflections,* ed. Willi Schuh, trans. L. J. Lawrence (London: Boosey and Hawkes, 1953), 150.

31. See, for example, George Steiner, "The Retreat from the Word," *Language and Silence* (New York: Atheneum, 1967), 29, who calls *Salomé* "a libretto in search of a composer," and Nassar, *Into the Demon Universe,* who believes that it aspires to the condition of music. As Steiner notes, the tendency "toward an ideal of musical form" is a retreat from language and from the kinds of meaning most successfully conveyed by words. Kermode, *Romantic Image,* argues that such a retreat from discursive meaning was an inevitable consequence of the Symbolist aesthetic.

32. Strauss, *Recollections and Reflections,* 154.

33. Ernest Newman, *More Opera Nights* (London: Putnam, 1954), 5; Norman Del Mar, *Richard Strauss: A Critical Commentary on His Life and Works,* 3 vols. (London: Barrie and Rockliff, 1962), 1:270.

34. Strauss, *Recollections and Reflections,* 151.

35. Ricketts, *Oscar Wilde,* 53.

36. Graham Good, "Early Productions of Oscar Wilde's *Salomé,*" *Nineteenth Century Theatre Research* 11, 2 (Winter 1983): 86.

37. Strauss, *Recollections and Reflections,* 150.

38. Jefferson, *The Operas of Richard Strauss,* 45.

39. Biographical information on Maud Allan comes from Felix Cherniavsky's series of articles: "Maud Allan, Part 1: The Early Years, 1873–1903," *Dance Chronicle* 6, 1 (1983): 1–36; "Maud Allan, Part 2: First Steps to a Dancing Career, 1904–1907," *Dance Chronicle* 6, 3 (1983): 189–227; "Maud Allan, Part 3: Two Years of Triumph, 1908–1909," *Dance Chronicle* 7, 2 (1984): 119–58; "Maud Allan, Part 4: The Years of Touring, 1910–1915," *Dance Chronicle* 8, 1 and 2 (1985): 1–50; "Maud Allan, Part 5: The Years of Decline, 1915–1956," *Dance Chronicle* 9, 2 (1986): 177–236.

40. Allan's relationship to Isadora Duncan is unclear. Reviewers often treated her as an imitator or student of Duncan, but Allan consistently denied any influence. Cherniavsky, "Maud Allan," provides evidence to the contrary and reports Maud Allan's own attempts to distinguish her dance from Duncan's (2:200; 3:120, 149).

41. Cherniavsky, "Maud Allan," 2:198.

42. Cherniavsky, "Maud Allan," 3:121.

43. "Maud Allan at the Palace," *Truth,* 18 March 1908, 702.

44. W. R. Titterton, "The Maud Allan Myth," *The New Age,* 27 June 1908, 171.

45. Max Beerbohm, "At the Palace Theatre," *The Saturday Review,* 4 July 1908. See also Christopher St. John, "All We Like Sheep," *The Academy,* 2 May 1908, 735–36; and Walter Higgins's article in the *Labour Leader* (26 June 1908), quoted in Cherniavsky, "Maud Allan," 3:128.

46. *The Spectator,* 24 October 1908, 628.

272 A M Y K O R I T Z

47. Cherniavsky, "Maud Allan," 3:128.

48. "Miss Maud Allan's Salomé Dance," *Academy,* 21 March 1908, 598–99.

49. "The Drama: The New Dancer," *Times Literary Supplement,* 26 March 1908, 102.

50. Elizabeth Fox-Genovese, in "Culture and Consciousness in the Intellectual History of European Women," *Signs: Journal of Women in Culture and Society* 12, 3 (Spring 1987): 542, comments that the greater visibility of a separate spheres gender ideology in the nineteenth century was due to the fact that "those societies in which separate spheres has the least justification insisted most firmly on their basis in biology and natural law. Societies in which women's competition for men's places was becoming a real possibility, if not yet a general practice, raised the doctrine of separate spheres to a new ideological prominence."

51. H. John Field, *Toward a Programme of Imperial Life: The British Empire at the Turn of the Century* (Westport, Conn.: Greenwood Press, 1982), 112.

52. See also John M. Mackenzie, *Propaganda and Empire: The Manipulation of British Public Opinion, 1880–1960* (Manchester: Manchester University Press, 1984), particularly chapter two entitled "The Theatre of Empire."

53. *Academy,* 21 March 1908, 598–99.

54. "Palace Theatre," *Times,* 23 July 1908, 13.

55. "Palace Theatre," *Times,* 13 February 1909, 13.

56. *Truth,* 18 March 1908, 701–2.

57. St. John, "All We Like Sheep, 736.

58. Titterton, "The Maud Allan Myth," 172.

59. Georg Lukács, *The Historical Novel,* trans. Hannah and Stanley Mitchell (Lincoln: University of Nebraska Press, 1983), 232.

60. Maud Allan, *My Life and Dancing* (London: Everett, 1908), 118, 119, 116.

61. See Harrison, *Separate Spheres,* 79–83.

62. Cherniavsky, "Maud Allan," 3:140, reports that she received at least 200£ for each private performance. He also documents the intimacy of her friendship with the Asquiths, the public knowledge of which, he notes, is evident from the existence of a skit (published in *The Referee*), "Salomé and the Suffragettes," in which she is kidnapped by the suffragettes from the terrace of the House of Commons, where she is having tea with the prime minister, Lloyd George, and Winston Churchill. Alfred Butt arrives to declare that the public will riot if Salomé does not perform, and Asquith finally agrees to the suffragettes' demand that women be given the vote in return for Maud Allan's release ("Maud Allan," 3:154).

63. Allan, *My Life and Dancing,* 123.

64. Allan, *My Life and Dancing,* 127.

65. Michael Kettle, *Salomé's Last Veil: The Libel Trial of the Century* (London: Granada, 1977), 70. The circumstances of Allan's disclaimer are fascinating. Allan had been engaged by J. T. Grien to play Salomé in a production of Wilde's play. The *Vigilante,* a right-wing paper operated by Pemberton-Billing, published a paragraph on this production entitled "The Cult of the Clitoris," implying Allan's homosexuality. Allan sued for libel and lost. Kettle analyzes the political subtext of the trial. On the

subject, see also Gagnier's appendix in *Idylls of the Marketplace*. Allan did not lose because her homosexuality was established; it wasn't the real issue, as Kettle shows. According to Cherniavsky, "Maud Allan," 5:206–7, however, she was most likely a lesbian.

66. Thus when Allan, during her trial, responds to Billing's question "that any pure-minded woman would demand for her own sensual satisfaction the head of a man she loved," she replies that "Salomé lived in the Eastern world at a time when our rules were not in vogue" (Kettle, *Salomé's Last Veil*, 74).

CONTRIBUTORS

ALISON BOOTH is Assistant Professor of English at the University of Virginia. She is author of *Greatness Engendered: George Eliot and Virginia Woolf* (1992) and editor of a forthcoming collection, *Famous Last Words: Women Against Novelistic Endings*. With Kathleen M. Balutansky, she edits an interdisciplinary series at the University Press of Virginia, "Feminist Issues: Practice, Politics, Theory." Currently she is engaged in a historical study of feminist writings, from a variety of genres, that record a crosscultural search for feminine deity or heroism; the writers studied range from Anna Jameson and Harriet Martineau to H. D. and Adrienne Rich.

SUSAN P. CASTERAS is Curator of Paintings at the Yale Center for British Art and a member of the Yale History of Art Faculty. A specialist in Victorian art, she has lectured extensively in England and throughout America and has also taught at the Graduate Center of the City University of New York. Among her many exhibition catalogues are *The McCormick Collection of Victorian Painting* (1984), *Victorian Childhood* (1986), *Virtue Rewarded: Morality and Faith in Paintings from the* Forbes Magazine *Collection* (1988), and *Pocket Cathedrals: Pre-Raphaelite Book Illustration* (1991). Her books include *Images of Victorian Womanhood in English Art* (1987), *Richard Redgrave* (with Ronald Parkinson, 1988), and *English Pre-Raphaelitism and its Reception in America in the Nineteenth Century* (1990). In addition, she has had numerous essays, articles, and reviews published in *Victorian Studies, The Journal of Pre-Raphaelite Studies,* and elsewhere. The recipient of numerous awards, grants, and fellowships, she is currently working, with funding from a National Endowment for the Humanities grant, on research for a forthcoming book, *Parables in Paint: Victorian Religious Painting.*

DIANE D'AMICO is Associate Professor of English at Allegheny College. She has published numerous articles on Christina Rossetti in such journals as *Victorian Poetry, The Victorian Newsletter,* and *The Journal of Pre-Raphaelite Studies.* She is currently working on a book that will examine the life and poetry of Christina Rossetti within the context of Victorian social issues.

DEIRDRE DAVID is Professor of English at Temple University. She writes regularly about Victorian culture and is the author, most recently, of *Intellectual Women and Victorian Patriarchy: Harriet Martineau, Elizabeth Barrett Browqning, George Eliot* (Cornell, 1987). Her current project, " 'Grilled Alive in Calcutta': Imperialism and the Victorian Novel," examines the participation of the Victorian novel in colonial/imperial discourse.

MARY ELLIS GIBSON is Associate Professor of English and Women's Studies at the University of North Carolina at Greensboro. She is the author of *History and the Prism of Art: Browning's Poetic Experiments* (1987) and editor of *New Stories by Southern Women* (1989) and *Homeplaces: Stories of the South by Women Writers* (1991). She is currently editing *Critical Essays on Robert Browning* (forthcoming 1992) and completing a book on Robert Browning and Ezra Pound. In 1991 she served as Fulbright Lecturer at the National Taiwan University in Taipei.

ANTONY H. HARRISON is Professor of English at North Carolina State University. He is author of *Swinburne's Medievalism: A Study in Victorian Love Poetry* (1988), *Christina Rossetti in Context* (1988), and *Victorian Poets and Romantic Poems: Intertextuality and Ideology* (1990). He has published numerous articles on Victorian and Romantic writers and edited a special issue of the *John Donne Journal,* "The Metaphysical Poets in the Nineteenth Century." He is currently editing *The Collected Letters of Christina Rossetti* (4 vols.) and completing a book entitled *Victorian Poetry and the Politics of Culture.* He has been awarded fellowships by the National Humanities Center, the National Endowment for the Humanities, and the Folger Shakespeare Library.

DEBORAH A. HOOKER is currently serving as a visiting lecturer in the Department of English at North Carolina State University while she completes her Ph.D. at the University of Florida. She has published on Shakespeare's *Troilus and Cressida* and Alice Walker. Currently she is involved in research on childbirth narratives written by American men and women in the 1960s and 1970s.

AMY KORITZ is Assistant Professor of English at Tulane University. She has published articles in *Modern Drama* and *Theatre Journal,* and is currently completing a book on gender, dance, and drama in late nineteenth- and early twentieth-century British culture.

GEORGE P. LANDOW is Professor of English and Art at Brown University and a Faculty Fellow at the Institute for Research in Information and Scholarship. He has written on nineteenth-century literature, art, and religion as well as on educational computing. He has been a Fulbright Scholar, a Guggenheim Fellow, and a Fellow of the Society for the Humanities at Cornell University, and has received numerous grants and awards from the National Endowment for the Humanities and the National Endowment for the Arts. He has helped organize several international loan exhibitions includ-

ing *Fantastic Art and Design in Britain, 1850 to 1930,* and his books include *The Aesthetic and Critical Theories of John Ruskin* (1971), *Approaches to Victorian Autobiography* (1979), *Victorian Types, Victorian Shadows: Biblical Typology and Victorian Literature, Art, and Thought* (1980), *Images of Crisis: Literary Iconology, 1750 to the Present* (1982), *Ruskin* (1985), *Elegant Jeremiahs: The Sage from Carlyle to Mailer* (1986), and *Hypertext: The Convergence of Contemporary Critical Theory and Technology* (1991).

ELIZABETH LANGLAND is Professor of English at the University of Florida. She is the author of *Society in the Novel* (1984) and *Anne Brontë: The Other One* (1989), and coeditor of *A Feminist Perspective in the Academy: The Difference It Makes* (1983), *The Voyage In: Fictions of Female Development* (1983), and *Out of Bounds: Male Writers and Gender(ed) Criticism* (1990). She is currently working on a book about Victorian domestic ideology and representations of the middle-class woman.

THAÏS E. MORGAN is Associate Professor of English at Arizona State University. Besides publishing several articles on critical theory and on Victorian poetry, she has edited *Victorian Sages and Cultural Discourse: Renegotiating Gender and Power* (1990) and coedited *Reorientations: Literary Theories and Pedagogies* (1990). A former Mellon Fellow in Humanities at the University of Pennsylvania, she is currently working on a book about the construction of masculinities and the literary canon.

WILLIAM W. MORGAN is Professor of English at Illinois State University, where he teaches courses in the Victorian period, in poetry as a genre, and in gender and literary study. He writes the annual review of scholarship on Hardy's poetry for *Victorian Poetry,* and every other summer he conducts a residential Hardy course on location in Dorset. He has published essays in *PMLA, Critical Inquiry, Victorian Poetry,* and other journals, and he is currently working on a book on Hardy's poetry.

BEVERLY TAYLOR is Associate Professor of English at the University of North Carolina at Chapel Hill. She is co-author of *The Return of King Arthur: British and American Arthurian Literature Since 1800* and *Arthurian Legend and Literature: An Annotated Bibliography,* and co-editor of *The Cast of Consciousness: Concepts of the Mind in British and American Romanticism.* She is the author of *Francis Thompson* and is currently completing an edition of Thompson's complete poetry. She has published articles on Byron, Shelley, Carlyle, Tennyson, Browning, and Arnold, as well as on Chaucer and Gottfried von Strassburg.

INDEX